THE ACROPOLIS IN THE AGE OF PERICLES

This book is an abridged and revised edition of the author's monumental *The Athenian Acropolis: History, Mythology, and Archaeology from the Neolithic Era to the Present*. It focuses specifically on the development of the Acropolis in the fifth century BC and the building program initiated by Pericles. Placing the century-long development within its historical and cultural contexts, Jeffrey Hurwit explores the physical nature of the Acropolis itself, the character of the goddess Athena, and how the building program exploits and reveals the Acropolis's own venerable history. He also offers an interpretation of the thematic unity that links the many structures of the Periclean Acropolis. Incorporating the latest discoveries and research on individual monuments of the Acropolis, this edition is illustrated with 144 halftones as well as a CD-ROM including 180 color images of the monuments of the Acropolis.

Jeffrey M. Hurwit is one of the leading scholars of ancient Greek art in the United States. A professor of art history and classics at the University of Oregon, he is the author of numerous articles on Greek art and archaeology, and is the author of *The Art and Culture of Early Greece* (1985). A Guggenheim Fellow (1987–88), he was appointed in 2000 to the prestigious Martha S. Joukowsky Lectureship for the Archaeological Institute of America.

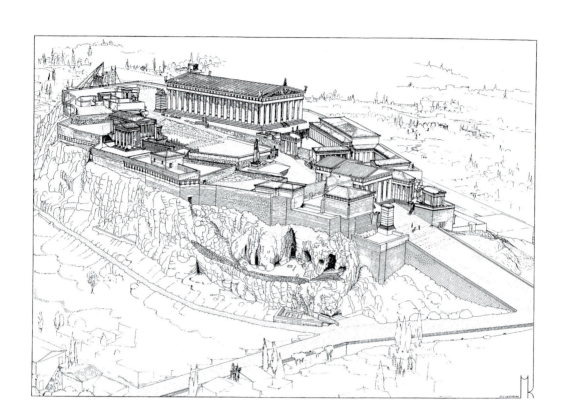

THE ACROPOLIS IN THE AGE OF PERICLES

JEFFREY M. HURWIT

University of Oregon

PUBLISHED BY THE PRESS SYNDICATE OF THE UNIVERSITY OF CAMBRIDGE
The Pitt Building, Trumpington Street, Cambridge, United Kingdom

CAMBRIDGE UNIVERSITY PRESS
The Edinburgh Building, Cambridge CB2 2RU, UK
40 West 20th Street, New York, NY 10011-4211, USA
477 Williamstown Road, Port Melbourne, VIC 3207, Australia
Ruiz de Alarcón 13, 28014 Madrid, Spain
Dock House, The Waterfront, Cape Town 8001, South Africa

http://www.cambridge.org

First published 2004

Printed in the United States of America

Typeface ITC New Legacy Book 10.5/15 pt. *System* LaTeX 2$_\varepsilon$ [TB]

A catalog record for this book is available from the British Library.

Library of Congress Cataloging in Publication Data
Hurwit, Jeffrey M., 1949–
 The Acropolis in the age of Pericles / Jeffrey M. Hurwit.
 p. cm.
 Includes bibliographical references and index.
 ISBN 0-521-82040-5 – ISBN 0-521-52740-6 (pb.)
 1. Acropolis (Athens, Greece) 2. Athens (Greece) – Antiquities. I. Title.
 DF287.A2H86 2004
 938′.5 – dc22 2003065452

ISBN 0 521 82040 5 hardback
ISBN 0 521 52740 6 paperback

For my family

CONTENTS

ILLUSTRATIONS

"VIEWS OF THE ACROPOLIS"
CD-ROM IMAGES

III. The Periclean Age

The Parthenon

The Propylaia

IV. Classical Sculptures from the Acropolis

PREFACE

This book is an abridged, revised, updated, and reorganized version of *The Athenian Acropolis: History, Mythology, and Archaeology from the Neolithic to the Present* (Cambridge, 1999). It focuses on the Acropolis during the Classical period, specifically during the age of Pericles. Readers interested in the earlier and later history of the site are invited to consult the earlier book.

Much new and important scholarship has appeared even in the relatively few years since I completed the manuscript of *The Athenian Acropolis* in 1997, and I am happy to have the opportunity to incorporate it here. I have changed my mind about some things, which I hope is permissible. I have not changed my views on many others, which I know is normal.

Included in this book is a CD-ROM ("Views of the Acropolis"), produced by Adam D. Newton, which contains 180 of my own color images of the Acropolis and its monuments. I hope this will be a useful supplement to the black-and-white illustrations in the book itself.

I continue to have many people and institutions to thank for many things. For first igniting my interest in the Acropolis so many years ago, there is J. J. Pollitt. For generously supplying photographs and permitting their publication, there are John Boardman (Oxford), P. Massouras (TAP, Athens), E. Schwichtenberg (Staatliche Museen zu Berlin, Antikensammlung), Kristine Gex (*Antike Kunst*), Hans R. Goette (Deutsches Archäologisches Institut-Zentrale), Michael Krumme (Deutsches Archäologisches Institut-Athens), I. D. Jenkins (British Museum), Wesley

Paine (Nashville), A. Choremi (Acropolis), and Natalia Vogeikoff (American School of Classical Studies, Athens).

For permission to reproduce their own excellent drawings and plans, I am heavily indebted to John Boardman, Ernst Berger, Hans R. Goette, Evelyn Harrison, Ira Mark, Mary B. Moore, Olga Palagia, Candace Smith, and especially Tasos Tanoulas and Manolis Korres, whose brilliant studies of the Propylaia and Parthenon have so changed and deepened our understanding of those monuments and their history. The book would be much poorer without their exquisite work.

Once again, I would like to thank Beatrice Rehl for her patience and encouragement and Nancy Hulan for her editorial labors and skill.

A few random notes: Translations are my own unless otherwise stated. My transliteration of ancient Greek is admittedly inconsistent (using "c" in "Acropolis" but "k" in "Herakles," for instance). Finally, all dates (even little ones like "27" or "2") are "BC" unless otherwise stated, and they are often expressed in slashed terms such as "424/3" because the Athenian calendar year began in the summer of one of our years and ended in the summer of the next.

January 2004

ABBREVIATIONS

AA	*Archäologischer Anzeiger*
AD	*Arkhaiologikon Deltion*
AE	*Arkhaiologike Ephemeris*
AJA	*American Journal of Archaeology*
AJP	*American Journal of Philology*
AM	*Mitteilungen des Deutschen Archäologischen Instituts, Athenische Abteilung*
ANRW	*Aufstieg und Niedergang der römischen Welt*
AntK	*Antike Kunst*
AR	*Archaeological Reports*
ARV²	J. D. Beazley, *Attic Red-Figure Vase-Painters,* 2nd. ed. Oxford, 1963
ASAtene	*Annuario della Scuola archeologica di Atene e delle Missioni italiane in Oriente*
BABesch	*Bulletin antieke beschaving*
BCH	*Bulletin de correspondance hellénique*
BICS	*Bulletin of the Institute of Classical Studies of the University of London*
BM	British Museum
BSA	*British School at Athens, Annual*
ClAnt	*Classical Antiquity*
CJ	*Classical Journal*
CP	*Classical Philology*
CRAI	*Comptes rendus des séances de l'Academie des inscriptiones et belles-lettres*
DAI	*Deutsches Archäologisches Institut*
EM	Epigraphical Museum, Athens

FGrHist	F. Jacoby, *Die Fragmente der griechischen Historiker, I–II* (Berlin 1923–26), *III* (Leiden 1940–58)
GRBS	*Greek, Roman, and Byzantine Studies*
IG	*Inscriptiones Graecae*
JdI	*Jahrbuch des Deutschen Archäologischen Instituts*
JHS	*Journal of Hellenic Studies*
JMA	*Journal of Mediterranean Archaeology*
JRA	*Journal of Roman Archaeology*
JRS	*Journal of Roman Studies*
LIMC	*Lexicon Iconographicum Mythologiae Classicae*
NM	National Archaeological Museum, Athens
OJA	*Oxford Journal of Archaeology*
OpAth	*Opuscula Atheniensia*
Pliny, NH	Pliny the Elder, *Natural History*
RA	*Revue archéologique*
REA	*Revue des études anciennes*
SEG	*Supplementum Epigraphicum Graecum*
ZPE	*Zeitschrift für Papyrologie und Epigraphik*

THE ROCK AND THE GODDESS

The Rock

The Acropolis (Fig. 1; CD 001–003) is not the tallest hill in Athens – Mt. Lykabettos, not quite 2 kilometers to the northeast, is nearly twice as high – but it had the right combination of accessibility, usable summit, natural defenses, and water to make it the obvious choice for ancient Athens's "high city" or "city on the hill" (for that is what *akropolis* means).[1] Almost every Greek city–state (or *polis*) had one, but no other acropolis was as successful as the Athenian: a massive urban focus that was always within view and that at various times throughout its virtually uninterrupted 6,000-year-long cultural history served as dwelling place, fortress, sanctuary, and symbol – often all at once.

The Acropolis is about 270 meters (885 feet) long at its longest and about 156 meters (512 feet) wide at its widest, but it is rugged and irregularly shaped, and the builders of its later, faceted walls merely regularized its essentially polygonal form (Fig. 2). They also created its flat-topped appearance: the rock actually slopes markedly from a ridge at its center down to the south (Fig. 3b), and only a long and complex series of retaining walls and artificial terraces on that side, together with a huge stone platform originally built to support a Parthenon planned decades before Pericles's great building (Fig. 4), extended the natural summit in that direction. Originally, then, the Acropolis was most sheer on the north and the east, and these sides especially are marked by virtually perpendicular cliffs about 30 meters (100 feet) high: the fortification walls built by men

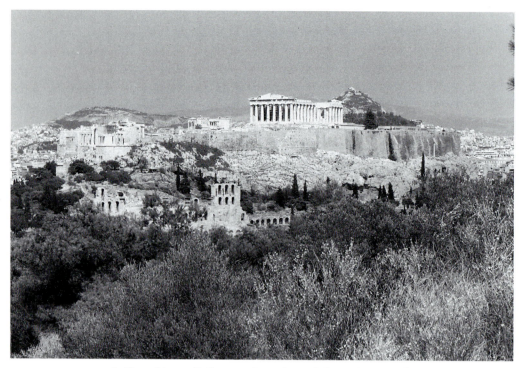

1. View of Acropolis from southwest; Mt. Lykabettos is seen in the distance, to the right of the Parthenon. Photo: author.

almost seem to emerge from them, as if the natural form had somehow transformed itself into architecture. But even the south side of the rock is marked by great rocky bulges and escarpments (Fig. 1; CD 001–002), and the only easy ascent was (and is) on the west side (Fig. 5), where the

2. (facing page). Plan of the Acropolis by I. Gelbrich (after Travlos 1971, Fig. 91, and Korres 1994b, 43), with revisions by author.

1 Propylaia	17 Klepsydra Fountain
2 Sanctuary of Athena Nike	18 Shrine of Aphrodite and Eros
3 Monument of Eumenes II (later, of Agrippa)	19 Cave of Aglauros
4 Northwest Building	20 Odeion of Pericles
5 Sanctuary of Artemis Brauronia	21 Theater of Dionysos
6 Chalkotheke	22 Temple of Dionysos
7 Bronze Athena	23 Monument of Thrasyllos
8 Building III (House of the Arrhephoroi)	24 Monument of Nikias
9 Erechtheion	25 Asklepieion
10 Pandroseion	26 Ionic Stoa
11 Opisthodomos?	27 Stoa of Eumenes II
12 Altar of Athena	28 Boundary of the Spring
13 Parthenon	29 Temples of Isis and Themis
14 Sanctuary of Zeus Polieus	30 Odeion of Herodes Atticus
15 Temple of Roma and Augustus	31 Sanctuary of Aphrodite Pandemos
16 Building IV (Heroon of Pandion?)	32 Beulé Gate

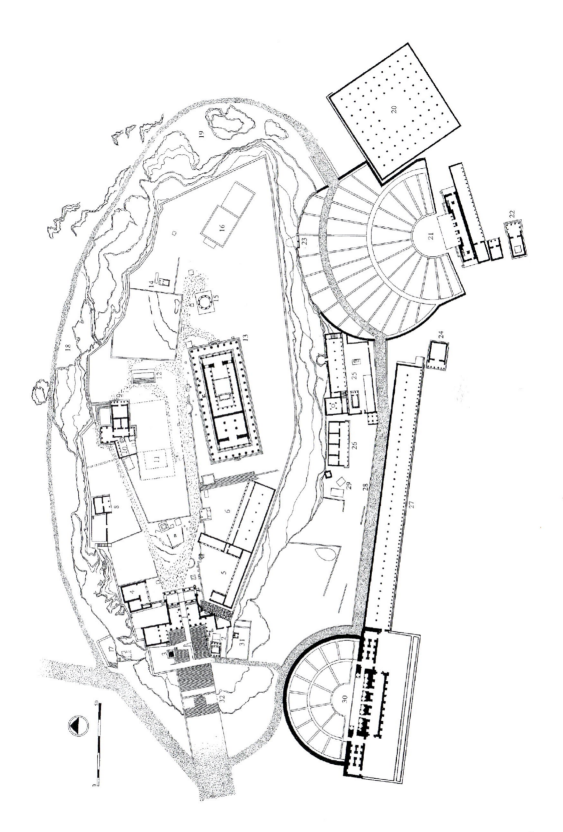

3

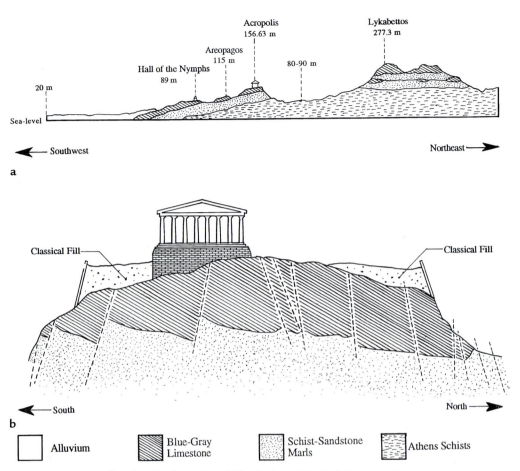

3. a. Section through the hills of Athens (after Judeich 1931, Fig. 7). **b.** Section through Acropolis (after Higgins and Higgins 1996, Fig. 3.4). Drawings by I. Gelbrich.

Acropolis is joined by saddles to lower, smaller hills nearby (above all, the Areopagos and the Pnyx, Fig. 6; CD 014) that would themselves play significant roles in the political history and civic life of Athens.

The Acropolis itself is a complex, soft mass of schist, sandstone, marl, and conglomerate capped by a thick layer of hard, highly fractured limestone formed in the late Cretaceous period, around the time the dinosaurs died off (Fig. 7; CD 010–011). The stone is fundamentally bluish to light gray in color, but it is also frequently tinged pink, and irregular streaks of almost blood-red marl or calcite course through it (CD 012–013). The brecciated, veined character of the stone is especially clear in those exposed portions of the rock that, over the centuries, have been heavily polished by feet. In places, the stone is nearly crystalline and its character thus approaches that of marble (because marble is simply limestone that has undergone a lot of high pressure and heated

metamorphosis, the line between them is sometimes hard to draw). At all events, this same "Acropolis limestone" caps the other outcrops and hills of Athens (Fig. 3a; CD 014). Eons ago, they were all part of the same continuous physical feature, bumps on a long mountain ridge that was eventually broken down by such forces as earthquake and erosion. In other words, the Acropolis is basically an ancient mountaintop, a remnant of a once much greater limestone formation that, like the other hills of Athens, came to be partly buried by the levelling sediments that created the Athenian plain.

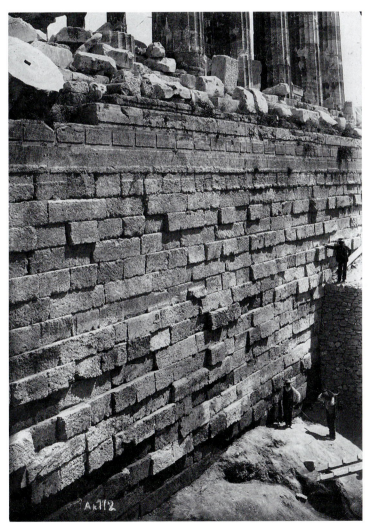

4. Foundations of Periclean Parthenon, originally built for Older Parthenon, 489–480. Courtesy DAI–Athens (Neg. Akr. 112).

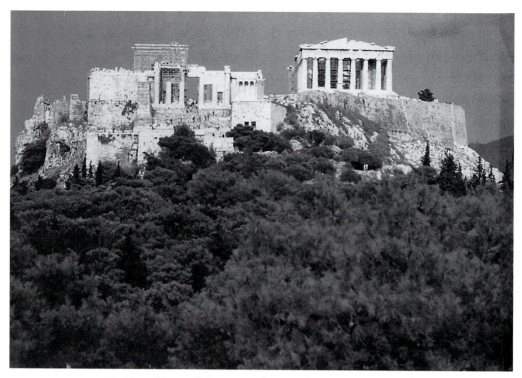

5. View of Acropolis from west. Photo: author.

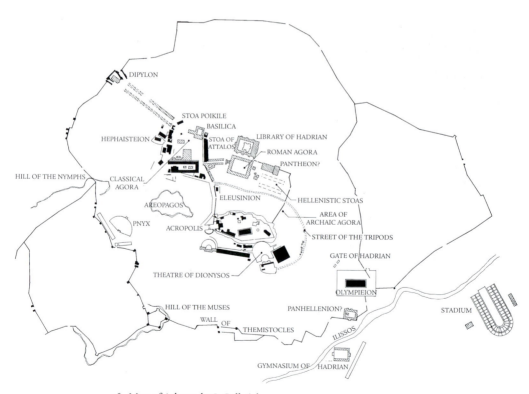

6. Map of Athens, by I. Gelbrich.

7. View of Acropolis limestone, south slope. Photo: author.

The rock is characterized on all sides by hollows and projections, by deep folds and fissures, and by caves large and small. A series of caves (once sacred to Pan, Zeus, and Apollo) marks its northwest shoulder (Fig. 8; CD 004). A high, deep cave gouges the middle of the north side (CD 005). A huge, rounded grotto – the Cave of Aglauros, as it is known – is the principal feature of the east (Fig. 9; CD 008–009). On the south, ancient architects, having shaved smooth the bulging face of the limestone, collaborated with the caves nature provided to create such structures as the Monument of Thrasyllos, built to commemorate the victor of a choral competition in the year 320/19 (Fig. 10). The effects of natural erosion are everywhere palpable, and the action of earthquakes, taken together with the seepage of water channeled through widening fractures in the limestone – in places the Acropolis has split or has been in danger of

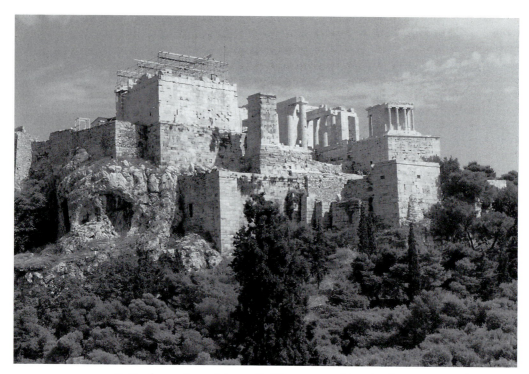

8. Northwest slope of Acropolis. The caves marking the slope were sacred to Apollo Pythios/Hypoakraios (Under the Long Rocks), Zeus Olympios, and Pan. Photo: author.

9. Grotto on east slope (Cave of Aglauros). Photo: author.

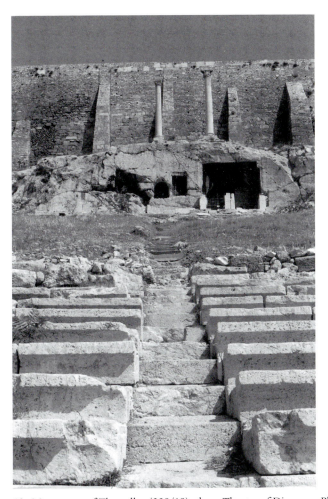

10. Monument of Thrasyllos (320/19), above Theater of Dionysos. Photo: author.

splitting apart – have at various times sent great pieces of the rock to the ground below. An inscription marking the extent of the *peripatos*, the ancient roadway that encircles the Acropolis (Fig. 2), is carved on such a fallen boulder, for example (Fig. 11), and in the first century AD another large chunk smashed into the center of the paved court of one of Classical Athens's most splendid fountainhouses, the Klepsydra, on the northwest slope (Fig. 2; no. 17). The interior mass of the Acropolis now appears to be stable, and the citadel seems in no danger of splitting deep at its core.

The limestone that caps the Acropolis, though hard, is porous and water-soluble; the schist–sandstone foundation of the rock, though soft, is neither. Thus, water percolates down through the limestone only to be stopped by the impermeable layer below. It collects atop the seam and,

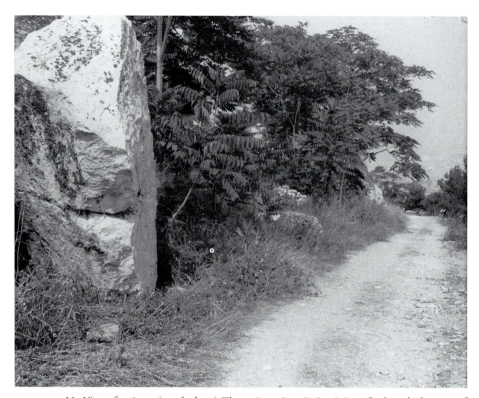

11. View of *peripatos* (north slope). The *peripatos* inscription is inscribed on the bottom of the upright block of Acropolis limestone at left. Photo: author.

as a result, it could be tapped at relatively shallow depths on the periphery of the Acropolis, where the limestone meets the schist–sandstone layer, where the forces of erosion have hollowed out caves or rock shelters, and where the water naturally emerges again in springs.[2] In essence, then, the lower slopes of the Acropolis were full of natural reservoirs, and it was this ready supply of water that early on made it an attractive site for human occupation. At the northwest corner of the rock, shallow artesian wells tapped the supply as early as habitation can be documented at Athens, in the Neolithic period, and this is the area that became the location of the Klepsydra. Midway along the north side of the rock, Late Bronze Age (or Mycenaean) Athenians dug a well at the bottom of a deep, hidden fissure and built a remarkable stairway of wood and stone to reach it.[3] On the south side, natural springs were thought sacred and played important roles in Classical cult (for example, in the Sanctuary of Asklepios [Figs. 12, 13; CD 153, 156]).[4]

This, then, was the easily defensible, relatively water-rich rock that would dominate the political, military, religious, and cultural history of

12. View of Asklepieion from east. Photo: author.

Athens – the hub of what the oracle of Delphi knew as "the wheel-shaped city."[5] Historical Athenians called it the "Acropolis" or even just "polis."[6] What the prehistoric inhabitants of Athens called it (and what divinities they first worshipped upon it), we do not know. There was a Classical memory of a distant time when the Athenians themselves were known as the Kekropidai or Kranaoi, after their prehistoric kings Kekrops and Kranaos, though there is no memory of what they called the Acropolis then.[7] However, it is entirely plausible that they called it (and the small clusters of houses they eventually planted atop it and its slopes) *Athene* or, in the plural, *Athenai*, words that seem, etymologically, pre-Greek. If that is so, the rock lent its name to the patron deity who would be so particularly and strongly associated with it, the city goddess who was, in effect, imminent in the rock and whose principal sacred emblems or symbols – the owl, the snake, and the olive tree – dwelled or grew upon it. Some small trace of that primeval identity may, in fact, be preserved in Homer's *Odyssey*[8] when *Athene* (an epic form of Athena) is said to travel to *Athene* (the city, in the singular): the words are the same and so, linguistically, the goddess visits herself. In short, it seems that Athena was in the beginning named after the rock. No matter what later myths, mythographers, and tragedians suggest, the city was not named after her.

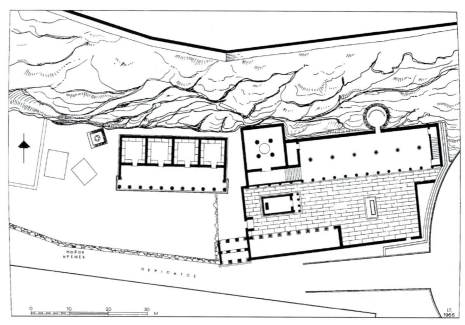

13. Plan of the Asklepieion. After Travlos 1971, Fig. 171. Reproduced by permission of DAI–Zentrale, Berlin.

And yet, in the end, who was named for what did not matter much. What mattered was the special relationship the city forged with the goddess and how completely Athena came to be regarded as Athens itself. The Athenians virtually spoke her name (*Athena* or *Athenaia*) every time they named their city (*Athenai*) and themselves (*Athenaioi*).[9] In fact, because the Athenian *polis* eventually encompassed all of Attica (Fig. 14) and not just the city itself, the Athenians might more accurately have called themselves *Attikoi* (inhabitants of Attika). That they did not do so suggests the strength of their special bond to their goddess. For although Athena was a goddess for all Greeks, the Athenians claimed her as their own, identifying themselves with her, and claimed for themselves many of the very qualities Athena herself embodied: military valor, boldness, love of the beautiful, love of reason and moderation, and knowledge. Athena was their guide and their security. She was the Athenian ideal and in the Athenian mind, where religious belief and secular patriotism dwelled so easily, so inextricably together, the goddess and the city were one.[10]

The Goddess

We do not know where the Greek gods came from, but the conventional view is that most of them came from somewhere else. It is widely believed,

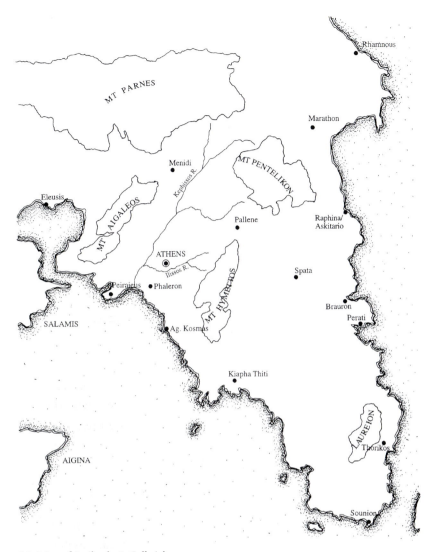

14. Map of Attika, by I. Gelbrich.

for example, that when the Indo-European people who would in time become the Greeks arrived on the mainland early in the Bronze Age, they superimposed their own system of "sky gods" (mostly male) upon a stratum of chthonic, or earthly, powers worshipped by the peoples they found in place – above all, fertility and earth-mother goddesses (such as Gaia, or Earth, herself) of Neolithic and even Palaeolithic origin, the very embodiments of fecundity. It was indeed typical of most ancient peoples to respect and absorb, or else co-opt, the gods of others rather than reject them. (Why take chances, and why fight holy wars?) And so, the Greek pantheon has often been considered the result of a Bronze Age blend

of more or less indigenous nature divinities (broadly responsible for the welfare and fertility of human beings, plants, and animals) and newly arrived Olympians, with their own more specific functions and limited spheres of action – "special department gods," as they have been called.[11]

Things are not likely to have been that simple. Although the distinction between "earth gods" and "sky gods" was taken for granted even in antiquity,[12] the notion that one set of divinities (the chthonic ones) was "native" and the other set (the Olympians) consisted of "Indo-European invaders" is hard to prove. It is remarkable, for example, that only one of the canonical twelve Olympian gods can confidently be said to have an impeccable Indo-European pedigree, and that is Zeus, god of the shining sky and thunderbolt. Yet, some gods outside the canon (the sun god Helios, for example) are almost certainly Indo-European, too. On the other hand, Demeter, the principal goddess of the cultivated earth, is also an Olympian, whereas the canonical Aphrodite is probably a post–Bronze Age eastern immigrant to Olympus from Cyprus. (She is not nicknamed "the Cyprian" for nothing.) As for Athena, who is firmly entrenched as one of the Olympian twelve, her name at least seems to predate the arrival of the people who would worship her.

The formation of Greek religion was clearly a long and complex process, and the origins of individual divinities often cannot be precisely tracked. In fact, Greek religion had already undergone many centuries of combination, assimilation, and transformation by the time Athena (or her prototype) first enters the archaeological record. Interestingly, she first appears not in Athens or on its Acropolis but on the acropolis of Mycenae, the heavily fortified citadel that was the leading cultural and political center of Late Bronze Age Greece. She also appears in a cluster of images – a gold ring, a painted tablet, a fragment of fresco (Fig. 15) – that present her very much as later Greeks knew her: as an armed, helmeted, warrior goddess.[13] It is no surprise to find that the Mycenaeans – best known for their fortified citadels, weapons, and armor – worshiped a female deity charged (apparently) with the defense of the citadel and royal house. Warrior goddesses were commonplace elsewhere in the eastern Mediterranean and Near East. (The Mesopotamians, for example, had Ishtar or Astarte, the Egyptians had Neith.) There is no reason why such a goddess should not have figured in the pantheon of Bronze Age Greece.

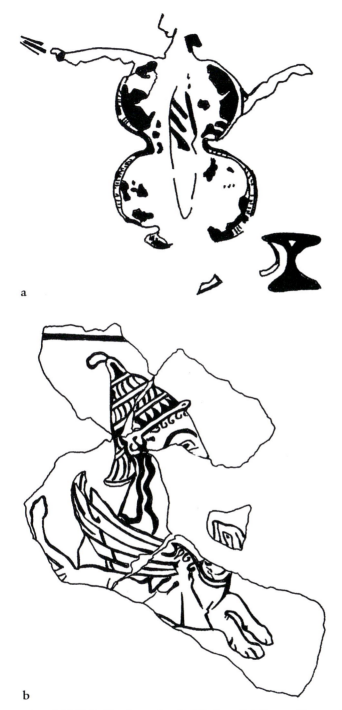

a

b

15. a. "Shield Goddess" on painted tablet from Cult Center, Mycenae (Athens NM 2666). Late thirteenth century. Drawing after Rehak 1984, 537. **b.** Helmeted Goddess holding griffin. Drawing of fresco from Cult Center, Mycenae (Athens NM 11652). Late thirteenth century.

Whether Mycenaean Greeks actually called their warrior goddess "Athena," we do not know. She may be mentioned – once – in the Bronze Age linguistic record, but the record is controversial, and it comes from neither Mycenae nor Athens but from Knossos on Crete. On a narrow clay tablet baked hard in the fire that destroyed the Palace of Minos (possibly around 1375, possibly later), two inscribed lines of Linear B (a syllabic script that is the earliest known form of written Greek) seem to record gifts issued to four deities.[14] The top line reads *a-ta-na-po-ti-ni-ja*, and that, as soon as the text was deciphered, rang a loud bell. The almost identical phrases *potnia Athenaia* and *potni' Athana* (both meaning "Lady Athena") are found many centuries later in Homer and, later still, on inscriptions from the Acropolis.[15] The trouble is that the title *potnia* ("lady" or "mistress" in the sense of "she who masters") is apparently applied to more than one deity in Linear B (including one goddess who seems a *Potnia* par excellence),[16] and that when names are linked to it they are normally toponymns, or place names. So, *a-ta-na-po-ti-ni-ja* means not "Lady Atana" (that is, Athena) but "Lady of Atana," and we have no idea whether the Átana referred to is "our" Athens or another one on Crete, or whether the lady of the place is Athena herself or some other goddess closely associated with it.

All in all, though, it is likely that the Greeks of the Mycenaean Age worshipped a goddess like Athena – a goddess of cities or citadels, at the very least – and it is a very good bet that Athena is what they called her after all. Although the goddess will not appear again in the archaeological record for some 500 years, that record was still Greek, and some degree of religious and linguistic continuity across the centuries is assured. It certainly seems more than coincidence that when an Archaic temple was built directly atop the ruins of the Bronze Age palace of Mycenae in the seventh century, it was (it seems) dedicated to Athena.

In a sense, the Greeks did not worship one Athena; they worshipped many. Like any Greek god or goddess, Athena was a force of multiple powers, with many roles and manifestations, with the capacity to intervene in human life in a variety of ways. The wide range of her associations with special spheres of human activity is reflected in the dozens of epithets or titles by which Athena was known. Athena loomed large in the lives of Greeks other than the Athenians, of course. At Sparta, for example, she was worshipped as *Chalkioikos*, Athena of the Bronze House, and she is

The Statue of Athena Polias

The cult image of Athena Polias was so old that the Athenians themselves were not sure where it had come from, and so simple that one later Christian author (a hostile witness, to be sure, writing when the statue had probably deteriorated) called it "a rough stake and a shapeless piece of wood."[19] According to one tradition, it had miraculously fallen down from heaven. According to others, either the legendary Kekrops or Erichthonios had it made when he was king of the city. However it got there, it was surely among the oldest cult-statues to be seen anywhere in Greece. Although there is the possibility that the statue was a Bronze Age or Mycenaean relic – a prehistoric fetish that somehow survived the centuries – and whereas we can be confident that throughout its long history, it always inhabited a series of shrines built on the north side of the Acropolis, culminating in the late fifth-century building we call the Erechtheion but whose official title was "the temple on the Acropolis in which the ancient image is" (Figs. 16–17), we know, strangely, very little about it. We think it was life-size or less because we can infer from a variety of evidence that it was evacuated from the Acropolis in 480 just before the Persians came, and that women could dress it, undress it, and possibly even carry it around like a mannequin as part of various festival rituals. Several inscriptions inventory an impressive array of ornaments somehow attached to the statue – "a diadem [or crown] which the goddess wears, the earrings which the goddess wears, a band which the goddess wears on her neck, five necklaces, a gold owl, a gold *aigis*, a gold gorgoneion, and a gold *phiale* [a shallow libation bowl] which she holds in her hand."[20] But, we are not sure when or over how long a period she acquired the

items, and she may also have worn a bronze helmet that (because of its relatively poorer material) did not make it into the inventories. We do not even know for sure whether the statue was seated or standing. There are a number of small painted terracotta seated goddesses from the Acropolis that might crudely imitate the Athena Polias (cf. Fig. 18), but there are standing terracottas that might imitate her, too, and it is likely that the ancient statue stood postlike, rigidly upright, with a gold *phiale* in one hand and an owl in the other.[21] Indeed, it is just possible that it – or something like it – was represented in south metope 21 of the Parthenon (Fig. 19).[22]

It is certain, however, that the statue wore cloth as well as gold. Every year, the statue was dressed in a new saffron-colored woolen robe or *peplos* (measuring perhaps 5 by 6 feet) woven by select Athenian girls and women and principally decorated (in contrasting purple) with inwoven scenes from the battle between the gods and giants, the savage sons of Earth (Gaia) who tried to overthrow the Olympians. (There are a few hints that other subjects, such as chariots and Athenian soldiers, appeared as well.) No detailed representation of the *peplos* survives (though the cloth depicted in the center of the Parthenon's east frieze is probably it; Fig. 20; CD 092), but it must have been an especially grand version of the sort of richly figured garments worn by women in many vase-paintings, by Athena herself in a late statue in Dresden, and (their paint now mostly faded) by Archaic Acropolis *korai* (cf. Fig. 45).[23] At all events, the presentation of a new *peplos* to Athena Polias was the highlight of the grand midsummer civic festival known as the Panathenaia.

The fate of the statue is unknown, but it is likely to have finally crumbled or been destroyed by the early fifth century AD, after serving as the focus of the most important cult on the Acropolis for a thousand years or more.

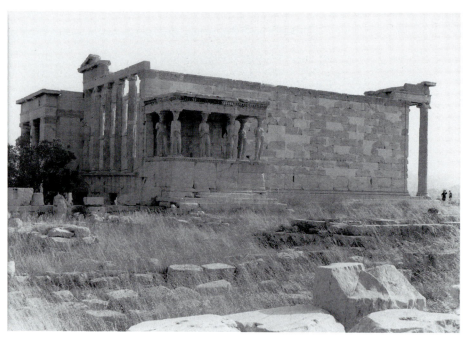

16. View of Erechtheion from southwest. Photo: author.

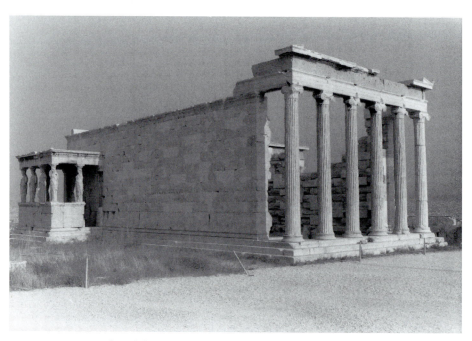

17. View of Erechtheion from southeast. Photo: author.

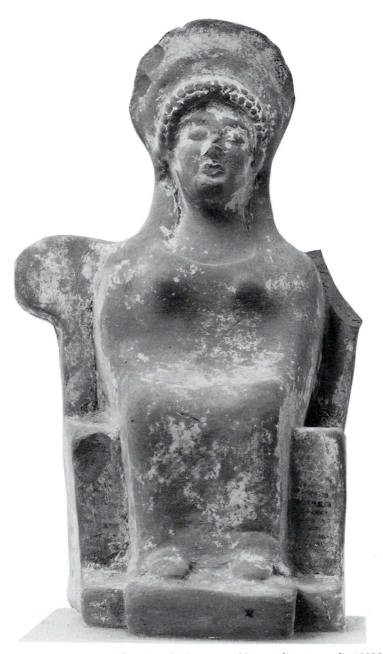

18. Terracotta seated figurine of Athena, possibly as Polias. Acropolis 10895, c. 500. Courtesy Acropolis Museum.

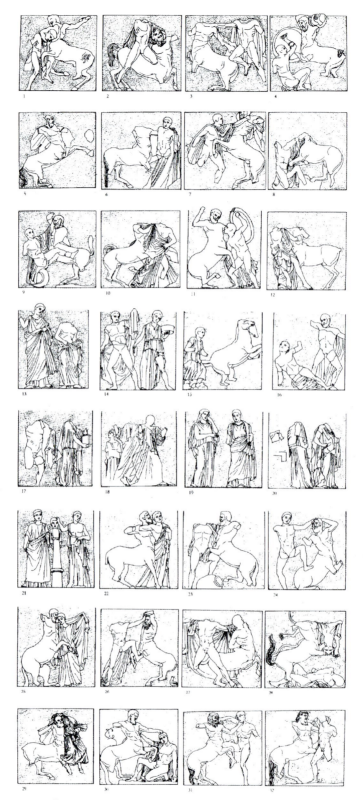

19. Parthenon, south metopes. From Boardman and Finn 1985, 236–237 (after Carrey drawings), used by permission.

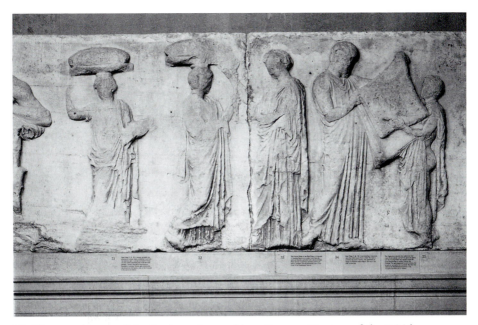

20. The central scene of the Parthenon's east frieze. Courtesy Trustees of the British Museum.

the second most popular Olympian on the vases of Corinth.[17] However, it is in Athens and on the Acropolis that her cultic persona was most developed. There she was Athena Polias (originally, perhaps, "she who dwells on the [acro]polis," later "[guardian] of the city").[18] Athena was called "Polias" in cities other than Athens, but Athena Polias was, along with Zeus Polieus, Athens's principal civic deity. This was the Athena who was honored at the midsummer Panathenaia, the major festival in the Athenian religious calendar. She was embodied in an ancient olivewood statue that was always the holiest image on the rock (cf. Fig. 18). However, the goddess was also Athena Parthenos (Fig. 21; CD 099–100, 102) and Pallas Athena (or sometimes just Pallas). Parthenos means "maid" or "virgin" but we do not know what Pallas means (and it is not certain that the Greeks did either) (cf. Fig. 22).[24] At all events, Athena's virginity – so crucial to her mythology and Athenian ideology, as we shall see – was inviolable and pugnacious, and so it was a symbol for and guarantor of the impregnability of her citadel: to breach the walls of the Acropolis would be to violate Athena herself. She was Athena Promakhos ("fighter in the forefront" or "champion"), a goddess who delights in battle (cf. Fig. 72). And she got results, for she was also Athena Nike, goddess of victory (cf. Fig. 76).[25] Still, though a warrior goddess, she is mostly the

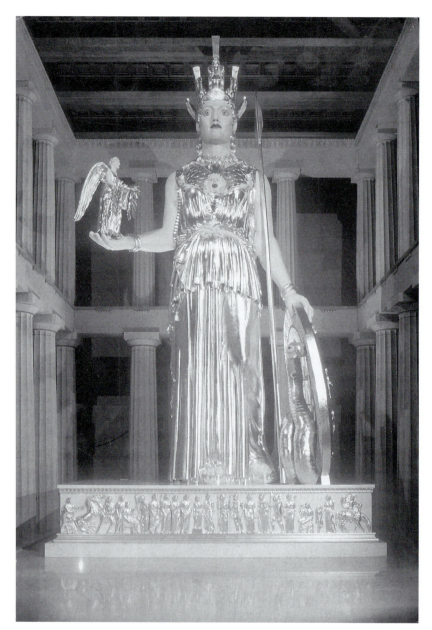

21. Athena Parthenos, reconstruction by Alan LeQuire in Nashville, Tennessee (1990). Photo G. Layda for the Metropolitan Government of Nashville and Davidson County. Courtesy Wesley Paine and the Nashville Parthenon.

goddess of tactics, not the goddess of the wild chaos and rage of war (that domain is proper to Ares, the brutish and bloodthirsty god she despises in Homer).[26] On the other hand, in a more peaceful vein, she is Athena Ergane, the Work Woman,[27] and Athena Hippia, goddess of the horse,

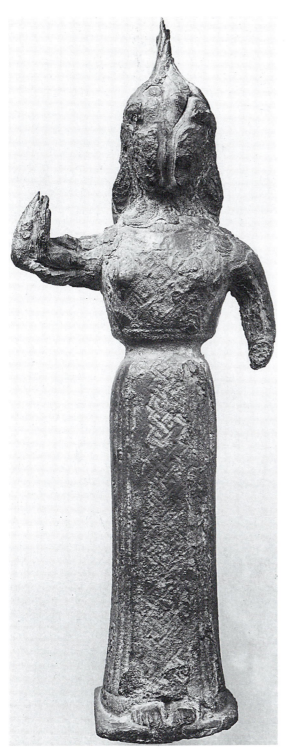

22. Bronze Palladion (figure of Pallas Athena) from Acropolis, Athens 6457, c. 575–550. Courtesy DAI–Athens (Neg. Nr. NM 5119).

23. Shrine of Athena Hygieia. Photo: author.

and Athena Hygieia, goddess of health. Most of these and the other epi-
thets by which she was known on the Acropolis and in Athens designated
her as an object of cult, as the focus of particular patterns of worship and
ritual: Athena Hygieia, for example, had her own little shrine abutting
the southernmost column on the eastern facade of the Propylaia (Fig. 23;
CD 111–112), and Athena Ergane may have had a small, older shrine pre-
served in the north colonnade of the Parthenon (Fig. 24). And it is clear
that she acted by means of many interventions. Still, many of her roles
in Greek life are subsumed under her overarching functions as goddess
of *tekhne* (skill or craft) and *metis* (intelligence, ingenuity, or craftiness),
and in Greek art and legend she functions above all as the active patron
of heroes.

24. Pre-Periclean *naiskos* ("little temple") preserved in north colonnade of Parthenon. Drawing by M. Korres, used by permission.

"I am famed among all the gods for my *metis* and tricks," Athena tells her protegé Odysseus, who is no slouch in the *metis* and tricks department himself.[28] And it is by her *metis* that we principally know her. The word denotes "intelligence" both cunning and practical: it is the quality that guarantees success in many different fields of action (for example, in the *agon* or athletic competition).[29] And Metis, personified, is in some accounts Athena's mother (though of a special sort, as we shall see). Athena is, at all events, not only the goddess of wiles and artifice but also the goddess of invention and technology, and so she can intervene in a variety of domains or divine departments that are not strictly her own. She is sometimes associated with agriculture, for example, but she is no fertility or grain goddess like Demeter: she is the inventor of the plow, the instrument by which the soil is exploited for the benefit of mortals.[30] The earth is Demeter's natural province, but it is Athena's technology that tills it. Similarly, the sea in all of its power and unpredictability is Poseidon's, but Athena is, according to various myths, the designer of the first ship, the goddess of shipwrights, and the guide of seagoers like Odysseus's son Telemakhos and pilots like the Argonaut Tiphys. She is not a sea goddess; she is the goddess whose craft and *metis* makes the sea navigable. She is, again, called Hippia ("of the horse"), but she is not so much goddess of the beast itself (the animal in all of its wild, fiery passion is properly Poseidon's, and he was called Hippios) as she is the inventor of the bridle and bit that bring the beast under control and the chariot and wagon that allow men to harness its power.[31] Athena Hippia means, we might say, "Athena, tamer of the horse," whereas Poseidon Hippios is the god of the animal untamed, its wild spirit. It cannot be accidental, then, that statues of horsemen were common dedications on the Acropolis or that on the west pediment of the Parthenon, where Athena (goddess of the *agon*) and Poseidon competed for rights to Athens, rearing horses were so prominent (Figs. 25, 28; CD 047), or that on the Parthenon's west and south metopes the violence of wild horses is associated with Amazons (Fig. 29; CD 060) and embodied in centaurs (Figs. 19, 30; CD 064–070), while on about half of the Parthenon frieze horses of nearly demonic force are mounted and ridden around the building by youths who seem to control them as much with the power of their intellects as with reins (Fig. 31; CD 075–076, 083). The horse, then, is itself a major theme of the Parthenon sculptural program. Through it, the power of

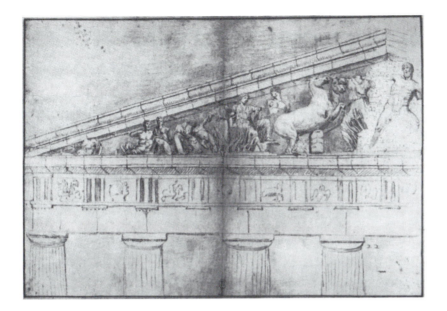

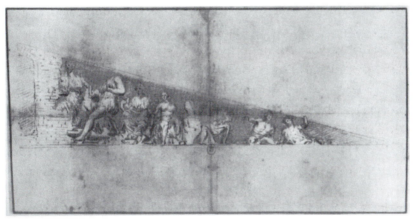

25. Drawings by Jacques Carrey of Parthenon west pediment. After Omont 1898, pls. II and III.

Athena Hippia (and, perhaps, her superiority to Poseidon Hippios) is made visible.

When in the *Odyssey* Athena boasts of the fame of her *metis*, it is in the shape of a "tall, beautiful woman, skilled in splendid handiworks" – in other words, it is as Athena Ergane – that she speaks.[32] Athena's "cunning intelligence" extends to the practical, mundane realms of domestic craft and commercial industry, and she (along with Hephaistos, with whom she is closely associated in art, myth, and cult [Fig. 32; CD 094]) is patron of both professional artisans and women who work at home. Athena

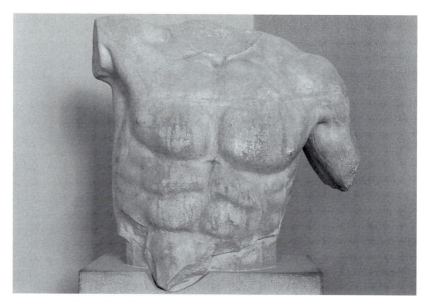

26. Torso of Poseidon, from Parthenon west pediment (Acropolis 885 and British Museum). Photo: author.

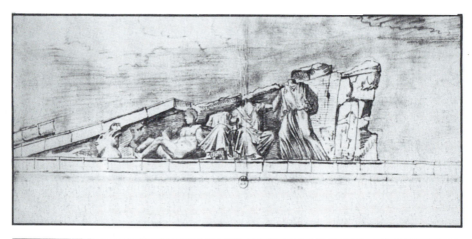

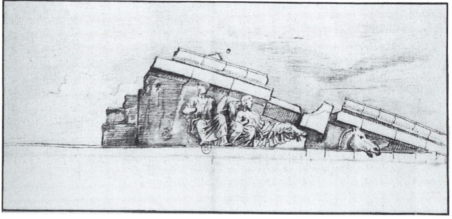

27. Drawings by Jacques Carrey of Parthenon east pediment. After Omont 1898, pl. I.

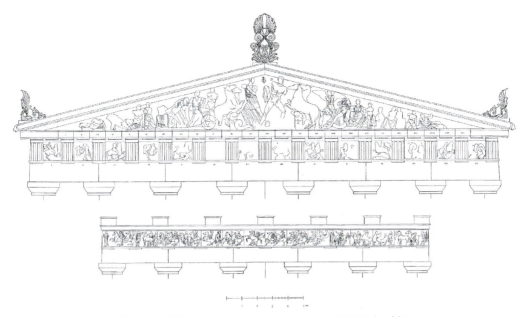

28. Parthenon, west pediment and frieze. Reconstructions from Berger 1977, Falttafel III. Used by permission of *Antike Kunst*.

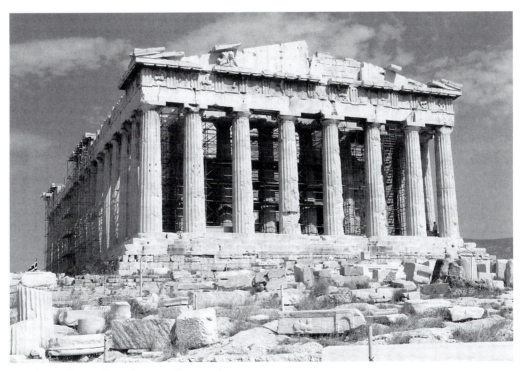

29. The Parthenon, from the west. Photo: author.

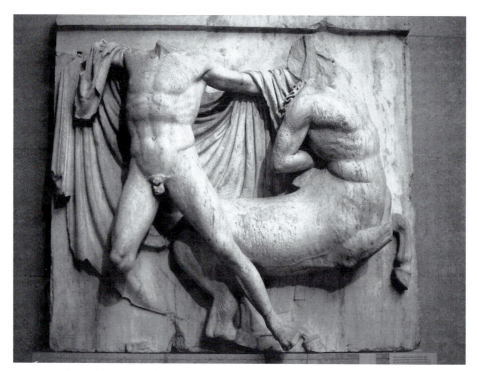

30. Parthenon, south metope 27 (British Museum). Photo: author.

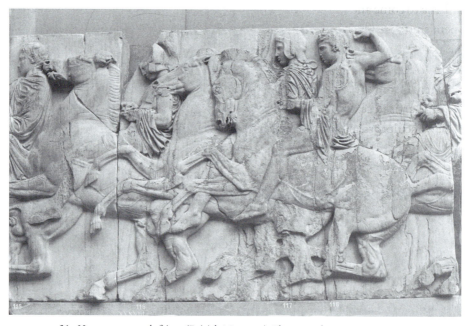

31. Horsemen, north frieze (British Museum). Photo: author.

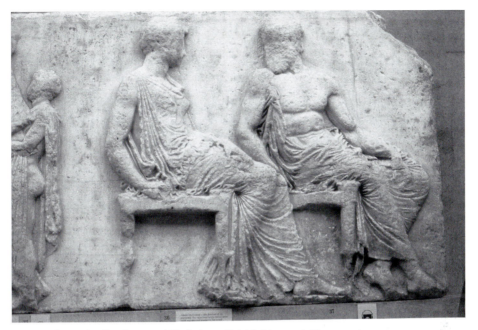

32. East frieze, detail: Athena and Hephaistos (British Museum). Photo: author.

Ergane is the goddess of those who work "on the anvil with heavy hammer," as Sophokles said.[33] An old potter's song begins with a prayer to Athena to come and hold her hand over the kiln for protection.[34] When a metalsmith works gold and silver, Homer says, it is with the skill (*tekhne*) taught to him by Athena and Hephaistos.[35] The Rhodians, Pindar says, excel all others in art because of Athena's gift.[36] It is Athena Ergane who, on a relief from the Acropolis (Fig. 33), receives an offering of some kind from an artisan seated behind his workbench, and it is she who sits amid potters, sculptors, and metalworkers on a fragmentary cup (dated c. 515–500) from the Acropolis (Fig. 34). And whether it is a metalsmith's or a potter's studio that is shown on a famous vase in Milan, the goddess arrives with a band of Nikai (Victories) to crown the artisans, winners of some competition or other.[37] In myth, Athena helps Epeios create the Trojan Horse, the wooden stratagem that epitomizes both her practical skill and her cunning, her *metis* and her trickiness (the results were to be seen on the north metopes of the Parthenon [Fig. 35]). There are even portraits of the goddess as a young artist. On a vase in Berlin, for example, Athena is shown in a workshop (tools hang behind her) modeling a horse (Fig. 36); here, she is both Athena Ergane because she makes and Athena Hippia because of what she makes.

33. Relief, Athena receives offering from craftsman. Acropolis 577, c. 480–470. Courtesy Acropolis Museum.

34. Red–figure cup by Euergides Painter (Acropolis 166), c. 515–500. Courtesy DAI–Athens (Neg. Nr. Akr. V 805)

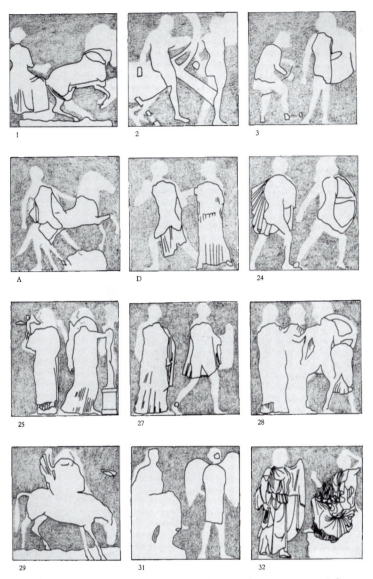

35. Parthenon, north metopes. From Boardman and Finn 1985, 234 (after Carrey drawings). Used by permission.

Still, the craft with which she is most intimately associated is weaving. This is, after all, a goddess who makes her own clothes (as well as garments for other goddesses), and who may actually be shown spinning wool on a series of terracotta votive plaques from the Acropolis (Fig. 37).[38] Penelope knows beautiful crafts and the famous trick of her loom (the symbol of her own formidable *metis*) because of the knowledge Athena bestows upon her, and the women of Phaiakia have received the same benefits.[39]

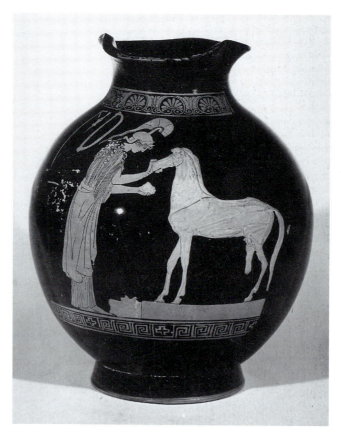

36. Athena fashioning horse. Berlin F 2415, c. 470. Courtesy Antikensammlung, Staatliche Museen zu Berlin, Preussischer Kulturbesitz.

The art of weaving, a silvery dress, and an intricate veil are Athena's gifts to Pandora, the first mortal woman, at her creation, which happens to have been depicted on the base of the statue of Athena Parthenos (cf. Fig. 21).[40] A fine woven, human-scaled robe, or *peplos* (an object that becomes nearly an attribute of Athena) was offered to Athena Polias annually at the Panathenaic Festival (cf. Fig. 20; CD 092) and clothed her old olivewood image; a far grander tapestry (also known as a *peplos* but as large as a ship's sail) was presented to her and displayed every four years at the Greater Panathenaia.[41] Athena herself presents a robe to her favorite, Herakles, upon his retirement from labor and struggle.[42] She is, in short, the goddess who provides human beings with the technological power to control their environment and the skill to manufacture images, utensils, and necessities.

37. Terracotta plaque (Athena Ergane or her devotee), Acropolis 13055, c. 500. Courtesy Acropolis Museum.

We can tell a lot about a goddess by the company she keeps and if in life Athena was friend to artisans; in myth and art she is, above all, friend to heroes. In art even more than in literature, she enjoys a particularly close relationship with Herakles, which is a mild surprise, because his mighty and unsubtle heroism largely consists of superhuman strength and endurance rather than the sort of mental agility we might expect from a protegé of Athena. Herakles relies on his biceps, not his *metis*. However, it is *metis* that Athena regularly supplies him (in the *Iliad*, she even complains that Zeus sent her down to help the hero every time his labors proved too much and he cried out to heaven),[43] and it is Athena who is his constant ally in battle against assorted villains and monsters and who eventually leads him to godhead upon Mt. Olympos.

Athena frequently keeps the company of other heroes who, like her, have tricks up their sleeves, or who accomplish their tasks through the good counsel, artifice, or tools she provides. At the very beginning of Greek literature, for example, in the first book of the *Iliad*, an enraged Achilles prepares to draw his sword to slay Agamemnon when Athena suddenly appears (to Achilles alone), grabs him by the hair, looks at him with flashing eyes, and talks him out of it: here, she is Intelligence personified, and the little conversation goddess and hero have (a dialogue no one else can hear) is a representation of the victory of reason over wrath.[44] She is almost an actor in the play of his mind. The time for fighting and vengeance will come, though, and when it does Athena covers Achilles with her shield-like *aigis*,[45] causes fire to blaze from his head, and adds her terrible war cry to his own. Goddess and hero nearly fuse; it is almost a case of possession.[46]

The roster of Athena's heroes includes Perseus, whose hand she guides when he severs the Gorgon Medousa's head (he, in turn, awards it to her and she places it either in the middle of her shield or upon her *aigis*) (cf. Fig. 91; CD 099).[47] There is Bellerophon, who captures the winged horse Pegasos (Medousa's offspring) with a golden bridle Athena provides and who appropriately builds an altar to Athena Hippia in thanks.[48] There is Jason, whose marvelous ship, the *Argo*, was built to Athena's specifications.[49] There is Theseus, the quintessential Athenian hero, who, though he is rarely linked to Athena in extant literature, is nonetheless seen with her from time to time in art. There is, above all, Odysseus, her closest mortal counterpart, a hero who lives by his wits and deviousness, whose special affinity with Athena is a major theme of the *Odyssey* and whom she could never abandon because, she says, he is a smooth-talker, shrewd, and always keeps his head – a man after her own heart.[50] In short, virtually wherever there is a hero in Greek legend or art, Athena, the special patron of heroes, cannot be far away. It was this relationship that the military hero Peisistratos may have exploited in the middle of the sixth century when he drove through the city in a chariot beside an Athena impersonator to confirm his second tyranny – a new hero for Athens.[51] It must have been Athena's flair for action and her inventiveness that appealed most to the Athenians themselves. Their natural affinity with this innovative and manipulative goddess

was close and apt. If we can trust the words Thucydides puts in the mouths of Corinthian ambassadors to the Spartans, it was sensed even by Athens's foes: the Athenians, the Corinthians say, are "innovative and quick both to plan and to execute in deed what they plan."[52] She was their intellectual and spiritual "mother" and they – adventurous, daring, and restless – were, in effect, chips off the old block.

Four Myths

Besides playing an important supporting role in the careers of many heroes, Athena is, of course, the principal character in a large mythological corpus of her own. As far as the art, cults, and ideology of the Acropolis are concerned, four stories are particularly significant: the myth of her birth, the story of her role in the battle of the gods against the giants, her contest with Poseidon for patronage rights to Athens, and the myth of her relationship to Erichthonios/Erechtheus. As is the case with most Greek myths, these stories are known in several versions, not all of them reconcilable in detail. Myth is not dogma.

All versions of the myth of Athena's birth, however, agree that she was born miraculously from the head of Zeus and had no mother in the conventional sense. Still, her conception was not exactly immaculate, either. Hesiod tells the tale:

> Zeus, king of the gods, took Metis as his first wife,
> she who knew more than gods and men.
> But when she was about to give birth to the bright-eyed goddess,
> Athena, then he, deceiving her mind with treachery
> and wily words put her inside his belly,
> as Earth and starry Heaven advised.
> They counseled this, so that none but Zeus
> should ever be king of the gods who live forever.
> For from her it was destined that wise children be born:
> first, the bright-eyed girl, Tritogeneia,
> her father's equal in strength and wise counsel.
> But next she would bear a son, with overbearing heart,
> to rule as king over both gods and men.
> But Zeus put her in his belly first,
> so that the goddess might ponder for him both good and evil.[53]

So Metis apparently grew large with child in Zeus's belly, and the gestation period lasted while Zeus married a series of other goddesses (first Themis, last Hera) until, somehow, Athena passed from Metis's womb to Zeus's stomach to his skull and popped out fully formed:

> Zeus himself, from his own head, gave birth to bright-eyed Tritogeneia, the terrible one, rousing the battle din, leader of armies, unwearied *Potnia*, who delights in war-noise, wars, and battles...[54]

Elsewhere Hesiod, Stesikhoros, a *Homeric Hymn to Athena*, and other sources add the details that Athena was born beside the banks of the river Triton (perhaps a rationalization of her perplexing epithet, Tritogeneia, "Triton-born");[55] that she leapt from Zeus's head doing an armed dance (the *pyrrhike*), shaking her shield and raising her spear; that Metis, despite being swallowed up in Zeus's belly, nonetheless fashioned the armor Athena was born wearing; that the immortal gods looked upon the birth with awe; and that Olympos shook, the earth cried out, and the sea heaved. It is Athena's militarism and ferocity that these accounts emphasize, not her wisdom or craftiness, and there is nothing allegorical about the goddess of *metis* emerging from Zeus's brain: for the early Greeks, the seat of wisdom was located elsewhere, in the diaphragm. At all events, Greek art – vase paintings above all, but possibly the East Pediment of the Parthenon, too (Fig. 38) – informs us that Hephaistos, Athena's future colleague as patron of craft and industry (and a god whose own reputation for cunning was as old as Homer), split Zeus's laboring head open with his axe to allow the mighty, already mature goddess to escape.[56] For Hephaistos, god of *tekhne*, to practice obstetrics in this way may be fitting, but there is a chronological problem: according to the *Theogony*,[57] an angry Hera, jealous of the child Zeus brought forth by himself, conceived Hephaistos all on her own, without intercourse, and gave birth to him only after Athena appeared. (Hephaistos's lameness is a sign of Hera's inferiority as a single parent.) Again, it is not always possible to reconcile the variants of Greek myths, but the anachronisms and contradictions probably did not bother the average Greek very much.

Even if Hephaistos did help, we should still think of Athena as fighting her way out of Zeus's head: she was, after all, born shaking her spear and terrifying the cosmos. Sometime afterward (with mythological time it is hard to tell how long), she put her martial arts to good use against the

38. Parthenon, east pediment and frieze. Reconstructions from Berger 1977, Falttafel II. Used by permission of *Antike Kunst*.

giants, sons of Gaia, who attempted to overthrow the Olympian gods. Though literary references to the giants appear as early as Homer and Hesiod, the most complete account is found in the *Library* attributed to Apollodoros (probably written in the first century AD). This mythological compendium tells how the gods (according to an oracle) could not defeat the giants, huge and fearful, hairy and scaly, without the aid of a mortal; how Athena enlisted Herakles as their ally; and how, at Phlegra or Pallene (in the Chalkidike peninsula of northern Greece), the gods took on the giants one on one. Zeus, with help from his son Herakles, killed their ringleader Porphyrion; Herakles, following Athena's advice, disposed of Alkyoneus; Athena herself killed Enkelados by throwing Sicily at him and then flayed Pallas and used his skin as armor; Hephaistos threw red-hot iron at Mimas; and so on.[58]

Although the myth would be a popular subject for artists elsewhere in Greece, nowhere was it more popular (or more important) than on the Athenian Acropolis. In fact, the city's greatest festival, the Panathenaia, which culminated in the presentation of the new *peplos* to the olivewood statue of Athena Polias, may have celebrated not Athena's birth (as is usually assumed) but the gods' victory over the giants: the Gigantomachy, again, was woven into the *peplos* as its principal decoration. It was also in

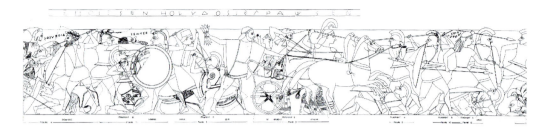

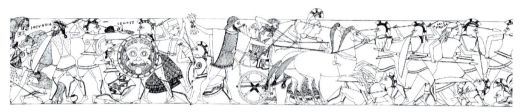

39. Reconstructions of portion of Gigantomachy on fragmentary black-figure dinos by Lydos, c. 550 (Acropolis 607). Drawings by Mary B. Moore, after Moore 1979, Figs. 1 and 2, used by permission.

this battle that she apparently earned the epithet "Nike."[59] The earliest indisputable representations of the Gigantomachy, in fact, decorate a series of large black-figure vases dedicated on the Acropolis beginning around 560–550, not far from the traditional date of a major reorganization of the Panathenaia in 566/5 (Fig. 39). By the end of the sixth century, the battle filled one pediment of a large temple of Athena Polias on the north side of the Acropolis (the *Archaios Neos*): the aggressive figure of Athena, holding her *aigis* outstretched, striding mightily over a fallen giant, stood (according to one reconstruction) to the right of a central group of Zeus riding in a frontal chariot (Figs. 40–41; CD 027–028).[60] At least one smaller Archaic pediment (or freestanding narrative group) and several Archaic marble reliefs depicted excerpts from the battle.[61] The Gigantomachy was a recurrent theme on the Classical Acropolis, too. By the end of the fifth century, the visitor to the Acropolis would have seen Athena and the other gods defeating the giants over and over again: in relief on the east metopes of the Parthenon (where, in metope 4, a flying Nike crowns a fighting Athena – the same Nike the statue of Athena Parthenos, presumably after the battle, held in her hand [Figs. 21, 42; CD 062, 099]); inlaid on the inside of the shield of the Athena Parthenos; and, inside the Classical Erechtheion, woven onto the woolen *peplos* that dressed the ancient statue of Athena Polias. If all the *peploi*, large and small, periodically presented to Athena Polias were stored or

40. Athena and Giant, from west pediment of *Archaios Neos* (c. 500). Photo: author.

displayed like tapestries in the Erechtheion,[62] the visitor would have been presented with scores of variations on the theme at once. This array of Gigantomachies received a particularly grandiose addition around 200, when a Hellenistic king of Pergamon dedicated a huge group of 1-meter-tall historical and mythological foes of civilization, including the giants, against the wall of the Acropolis southeast of the Parthenon (cf. Fig. 131). Gigantomachies were thus added constantly to the narrative inventory of the Acropolis, the theme undergoing nearly constant reinterpretation in a variety of media over a very long time. No better example exists of how a particular theme endures – of how the imagery of the Classical Acropolis echoes the imagery of the Archaic or the Hellenistic or the

41. Restoration of Gigantomachy Pediment based on M. B. Moore 1995, Fig. 7. Drawing by D. Scavera.

Classical – or how the same theme could be seen in different versions, in different inflections, at any one time. The spectator's experience of the place would have reverberated with different tellings of the same tales, over and over.

The victory over the giants assured the gods' domination of the cosmos, but Athena's victory over her own uncle, Poseidon, god of the sea and earthquake, assured her right to Athens and guaranteed her preeminence in the self-representation of the city. The famous contest between the two gods, it was said, took place on the Acropolis during the reign of Kekrops, the first king of the city who – born miraculously from Earth – was part man and part snake. However, the variants of the myth do not agree whether Kekrops or the Olympian gods judged the contest (Kekrops serving merely as chief witness), or whether the prize was supposed to go to the divinity who merely won a race from Mt. Olympos to the Acropolis, or to the god who was judged to have created on the rock the better gift or the more eloquent token of their power, or to the god who won a popular vote of the Kekropidai, the primordial inhabitants of the land. The confusion on all these points is odd if the myth, as some think, is a fifth-century invention. But, the earliest literary reference to the story is, in fact, Herodotos,[63] and the earliest known representation of the contest was the west pediment of the Parthenon, completed in the 430s (Figs. 25, 26, 28; CD 045–052). Even here, it is not clear exactly which version of the myth, or what point in the narrative, the pedimental sculptures depict. The fullest description of the contest, however, is once again found much later, in Apollodoros:[64]

> In [Kekrops's] time, they say, it seemed best to the gods to take possession of cities where each would receive his own honors. Therefore Poseidon came to Attica first, and striking his trident on the middle of the Acropolis, he produced the sea which they now call the Erechtheis. But after him came Athena and, making Kekrops witness to her claim of possession, planted an olive tree which can still be seen in the Pandroseion. When the two of them argued over the land, Zeus separated them and appointed as judges, not Kekrops and Kranaos, as some have said, nor Erysichthion, but the twelve gods. When they gave their verdict, the land was judged Athena's, since Kekrops testified that she was the first to plant the olive. Athena therefore named the city Athens after herself, and Poseidon, furious, flooded the Thriasian plain and placed Attica under water.

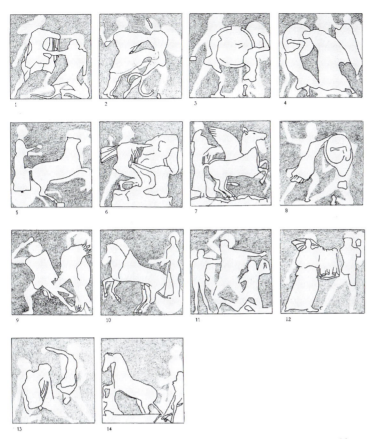

42. Parthenon, east metopes. After Boardman and Finn 1985, 235. Used by permission.

The olive tree, the salt spring, and the marks of Poseidon's tridents were some of the most venerable and sacred spots on the rock (though Pausanias was not terribly impressed with the spring),[65] and they were certainly regarded as marvelous signs of the primeval contest. (The tree, burned by the Persians in 480, was said to have miraculously sprouted a cubit-long shoot overnight, a sign of continued divine favor.)[66] The earliest Classical traditions seem to agree that they were merely tokens of priority, and that the inherent value of the olive and the salt sea – or, rather, their value as symbols of Athenian agricultural or naval power (which would be judged to be better for Athens?) – was not the point. If Apollodoros is right that Poseidon did indeed reach the Acropolis first, then he was robbed, or else his claim was disallowed because no one saw him arrive – something that Athena made sure did not happen to her by enlisting Kekrops as her witness (the goddess of *metis* in action again). In any case,

the west pediment seems to have shown Athena arriving first, dashing for Kekrops (shown in the left angle of the pediment) to claim her victory after the olive tree has sprouted, with Poseidon about to hurl his trident just seconds too late.

Despite his imminent loss, Poseidon (if we can fairly judge from a famous seventeenth-century drawing of the pediment) seized the center of the composition and Athena was, slightly, in the background (Fig. 25). The focus seems to have been on the god, and the question arises why this should be so on the temple of the goddess. It is true that the two divinities fought on the same side at Troy and, obviously, against the giants. Poseidon's name (po-se-da-o) appears with "Lady Athena" (a-ta-na-po-ti-ni-ja) on that Linear B tablet from Knossos.[67] They often appear together (with no apparent hostility) on sixth-century Athenian vases. As we have seen, they also shared an association with horses. Nonetheless, in myth they are more often antagonists than allies. Athena's protegé Perseus, again, decapitated Medousa, yet Medousa had been Poseidon's lover,[68] and Athena wore her head as a trophy on her *aigis* or shield (or both) – a constant, bristling reminder. In the *Odyssey*, Poseidon's wrath drives much of the plot in opposition to Athena, and torments her most simpatico hero. In addition, in the fabulous myth he makes up in his dialogue *Kritias*, Plato pits Athens, the city of Athena, against Atlantis, the city of Poseidon.

However, no god as powerful as Poseidon could be ignored, and the centrality of the sea god in the west pediment may be, after a fashion, an expression of gratitude to the divinity who, told by Zeus to stop his floods, held no grudges and still granted Athens naval supremacy, ensuring their victory over the Persian armada in the waters of Salamis in 480. It may be, in fact, that a cult of Poseidon was first installed on the Acropolis in the 470s to thank (or appease) him. The myth of the contest between Athena and Poseidon may actually have been invented or reformulated in the fifth century as a way of expressing the immense significance of Salamis and the importance of the maritime empire Athens built in its aftermath, and of acknowledging the god who, despite his quarrels with Athena, had nonetheless looked favorably upon her city. There is no way to be sure about all this, and the possibility that Poseidon was the subject of an Acropolis cult before the Persian Wars remains.[69] But, whatever their relationship before Salamis, by the end of the fifth century

43. Inventory of the treasures of Athena and the Other Gods for 398/7 (IG II2 1392, NM 1479), with relief of Athena and Erechtheus. Photo: author.

at least Poseidon and Athena Polias (as well as several other divine figures) shared the same temple on the north side of the Acropolis: the Classical temple called the Erechtheion though officially known, presumably like its late sixth-century predecessor, as the *Archaios Neos*, the Old Temple of Athena (Figs. 16–17; CD 120–129).[70]

The temple takes its nickname from Erechtheus, a hero (and, according to mythological genealogies, the sixth king of Athens) with whom Poseidon shared an altar and priest and whose very identity Poseidon seems to have absorbed. Around 450 (long before the construction of the Erechtheion), two brothers dedicated a marble basin to "Poseidon Erechtheus" (as if the names were hyphenated, or the god had taken on the hero's name as an epithet).[71] Erechtheus is himself a shadowy figure, though. Herodotos says it was during his kingship that the Athenians first took that name (*Athenaioi*) for themselves, and he is said to have

fought an early war against Eleusis and its ally Eumolpos, the son of Poseidon, who tried to avenge his father's loss to Athena by invading Athens. The battle was evidently represented in a statue group located near the Erechtheion, and the war may even have been alluded to in the angles of the Parthenon's west pediment.[72] Compelled to sacrifice a daughter for the public good (other daughters are said to have committed suicide in solidarity – so ends the lesson for all good, patriotic Athenian girls), Erechtheus slew Eumolpos, but was in turn killed by Poseidon (who then subsumed his identity). The myth represents a continuation of Athena's rivalry with Poseidon by other means, through heroic proxies, and the fusion of Poseidon-Erechtheus in cult may have been another fifth-century attempt at reconciliation.

Erechtheus's identity also seems to have been fused or confused with the even more mysterious Athenian king Erichthonios (the similarity in names, if they are not simply variants, obviously contributed to the confusion). The careers of the two kings are (as later mythologies reconstructed them) distinct and, according to Apollodoros, Erichthonios, the fourth Athenian king, was even Erechtheus's grandfather. But there can be no doubt that at some point early in the tradition, Erechtheus and Erichthonios were one and the same: their names mean essentially the same thing ("very earthy" or "very earth-born"), they are said to have married the same woman (Praxithea), and they share the remarkable circumstance of being the virgin Athena's foster child.[73]

On the one hand, Homer says that the grain-bearing earth bore greathearted Erechtheus and that Athena raised him, installing him in her own temple on the Acropolis where he himself became the object of cult and annual sacrifices (the rock of Athena, then, was also the hill of Erechtheus, and Athena and Erechtheus are sometimes shown together in Acropolis art [Fig. 43]).[74] On the other hand, later literary sources and vase paintings substitute Erichthonios – he does not seem to have taken mythological shape before the early fifth century – and it is as if Erechtheus's infancy and youth were taken from him and given over to that other hero, a supposedly earlier king.[75] But, Erechtheus always seems to have been first in the hearts and minds of the Athenians (which is why they could call themselves "Erechtheidai" but never "Erichthoniadai").[76] And his story – his birth, his war with Eumolpos, perhaps even the

sacrifice of his daughter – may have been the subject of a portion of the sculptured frieze of the Erechtheion (cf. Fig. 120; CD 131–132).

The fullest version of the tale is told once again in Apollodoros. According to some, he says, Erichthonios was the son of Hephaistos and Athena:

> Athena once came to Hephaistos, wanting him to forge her new weapons. But he, having been abandoned by Aphrodite, was filled with desire for Athena and chased her. She ran away. But when with great effort (for he was lame) he got near her, he tried to make love with her. She, being chaste and a virgin, would not yield, but he ejaculated on the leg of the goddess. In disgust she wiped off the sperm with some wool and threw it on the ground. As she fled and the sperm hit the ground, Erichthonios was born. She brought him up without the knowledge of the other gods, wishing to make him immortal, and putting him in a basket she gave him to Pandrosos, the daughter of Kekrops, forbidding her to open the basket. But the sisters of Pandrosos [Aglauros and Herse] opened it out of curiosity and saw a snake coiled around the baby. Some say they were killed by the snake itself, but others say that they were driven mad by Athena's anger and threw themselves down from the Acropolis. But having been reared in the sacred precinct [presumably on the north side of the Acropolis] by Athena herself, Erichthonios drove out Amphictyon and became king of Athens. And he set up the *xoanon* [wooden image] of Athena on the Acropolis, instituted the Panathenaic festival, and married Praxithea, a nymph, by whom his son, Pandion, was born.[77]

To put all this another way, Hephaistos, Hera's lame fatherless son, sired Erechtheus/Erichthonios, and Athena, Zeus's mighty motherless daughter, raised him as her own. In myth, this passes for parentage. Thus, the hero, though "autochthonous" (that is, "born of the earth"), was at the same time the child of the gods and, by extension, so were his "descendants" – the Athenians themselves, the "sons of Hephaistos" (as Aeschylus calls them)[78] and of Athena, too. Autochthonous and of Olympian descent at once, the Athenians, ever resourceful, had it both ways.

Myth was central to the self-definition and self-representation of any Greek city-state, and the proper understanding of the Acropolis and its complex of buildings and images in large measure depends on the use, power, and resilience of the myths of the birth of Athena, the

Gigantomachy, the contest with Poseidon for the possession of the land, and the birth of Erechtheus/Erichthonios. Taken together, the myths confirm and validate Athena's role as a mighty warrior goddess and deserving patron and protector of Athens – as, in fact, the "mother" of her country.[79]

LANDSCAPE OF MEMORY: THE PAST ON THE CLASSICAL ACROPOLIS

The battle lasted no more than two or three hours. It began just after sunrise around the twelfth day of August in the year 490, when, on the coastal plain of Marathon in northeast Attika (Fig. 14), ten thousand Athenian foot soldiers (aided by a small contingent of troops from Plataia) charged twenty thousand Persian invaders at a run, turned their flanks, slaughtered thousands caught in the marshes at the northern end of the plain, and drove the rest back into the sea. It was over by mid-morning. The greatest empire the world had ever known lost 6,400 men. Astonishingly, the city of Athens lost only 192. The battle of Marathon must have seemed a miraculous, divinely inspired victory: Athena herself and the heroes Herakles, Theseus, and Echetlos were seen fighting on the Athenian side that day. Marathon was the single most important event in Athenian history and early on became the stuff of legend. It is impossible to understand the Classical Acropolis, its art, and its ideology without understanding that.

The victory, however, was not final. Ten years later, led by their great king, Xerxes, the Persians came back and took their revenge. In September of 480, an army of perhaps 100,000 men and a fleet of some 1,200 ships descended into Greece around the northern rim of the Aegean and, despite a heroic Spartan defense at the pass of Thermopylai, swept into Attica. The population of Athens had been evacuated and, after laying waste to the city, the Persians laid siege to its religious and symbolic center, its fortified "high city," its Acropolis. Xerxes used the small limestone

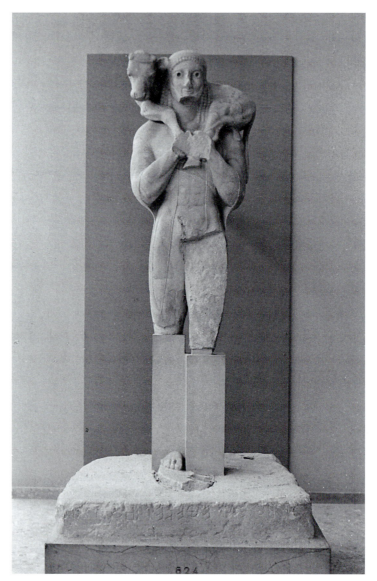

44. Moschophoros ("Calf-Bearer," Acropolis 624), c. 570–560, h. 1.65m. Photo: author.

outcropping known as the Areopagos (the Hill of Ares), just west of the Acropolis, as his camp and base of operations (Fig. 6; CD 014).

A small contingent of Athenians – priests, temple treasurers, and patriots, some too stubborn, some too pious, and some (we are told) too poor to flee – remained to defend the sanctuary against overwhelming odds, believing, perhaps, that when an oracle hastily issued by Apollo's priestess at Delphi declared "a wooden wall" would prove safe for the

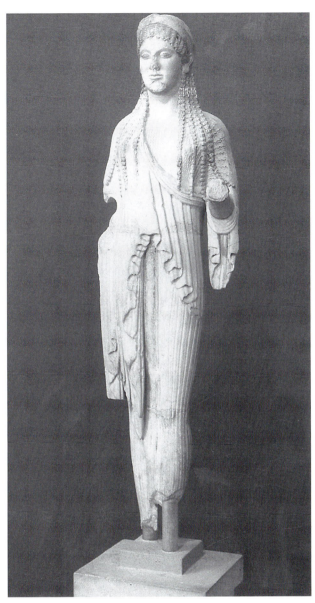

45. Acropolis *kore* 685, c. 500. Photo: author.

Athenians, it meant a barricade. They were wrong. They refused a negoti-
ated surrender and could only watch as the timbers used to plug a gap in
the Acropolis defenses went up in smoke, ignited by flaming arrows shot
by archers on the Areopagos.[1] The defenders rolled round stones down
the west slope when Persian soldiers tried to ascend, and still the Acrop-
olis held. But the Athenians made the crucial mistake of concentrating

their defense on the west and north, believing that the other sides of the Acropolis were too sheer and rugged for anyone to climb.[2] In a famous passage, the historian Herodotos describes how the siege finally ended:

> Toward the front of the Acropolis [that is, on the east slope], opposite the gates and the ascent, where no guard was stationed and where no one expected that any man could climb up, there beside the Sanctuary of Aglauros (Fig. 9; CD 009), the daughter of Kekrops, some Persians made their way up, though the place was steep. When the Athenians saw them upon the Acropolis, some hurled themselves down from the wall and were killed, but others took refuge within the *megaron*. The Persians who had ascended the rock then ran to the gates [or doors], and opening them, murdered the suppliants. When all lay dead, they pillaged the temple and set all of the Acropolis on fire.[3]

The Persians missed almost nothing. They demolished the citadel walls and burned shrines and temples. They smashed vases and terracotta dedications. They pushed over reliefs and inscriptions and mutilated and toppled marble statues. They carted off bronze ones to be melted down for their valuable metal or to show off as trophies back in Persia. Works like the Calf-Bearer (Fig. 44), perhaps the first large-scale marble statue ever dedicated on the summit; a winged figure of Victory (*Nike*) set up to commemorate Marathon and Kallimachos, the Athenian chief of staff who died there; and scores of *korai*, or maidens (Fig. 45), the most common form of marble dedication on the sixth-century Acropolis, were pulled down from their pedestals and shattered upon the rock. The history of early Athenian art was essentially compressed into this one place and it was this accumulated achievement that in just a few hours' time fell victim to the Persian massacre of images. Perhaps only a few days later, an allied navy scored a stunning victory over the Persian fleet in the straits of Salamis – the "wooden wall" of the oracle turned out to be the hulls of the Greek ships – and Xerxes, who watched the battle from a portable throne or silver-footed stool, thought it prudent to head home, leaving his army in Greece but taking with him what was left of his fleet and the spoils taken from Athens and the Acropolis.

Now, according to a fairly arbitrary but still useful convention, the Acropolis that the Persians sacked was an "Archaic" Acropolis, and the destruction marks the end of one era (the Archaic period, c. 750–480)

and the beginning of another (the Classical period, 480–323). Yet, for the next three decades (480–450), the Athenians evidently undertook no monumental building program atop the sacred citadel. At the very beginning of this Early Classical period, Athenian leaders might have been too preoccupied with defense to initiate a massive rebuilding program, and Athens's treasury might have been too depleted to fund much. Still, there is a story that before the decisive battle of Plataia in 479 (where the Persians, after decimating Athens again, destroying what they had left standing the first time, suffered another horrendous defeat and were driven from Greece once and for all), the Greek allies swore an oath that they would not rebuild the temples the Persians had cast down but leave them as "memorials for men hereafter." Perhaps by not rebuilding very much, Early Classical Athenians were simply fulfilling this sacred vow. But, it would have been an odd oath for, say, the Spartans or indeed the majority of Greeks to swear: the Persians had not invaded or destroyed their sanctuaries. So, perhaps, the Athenians on their own were content to leave their Acropolis in ruins as a reminder of Persian impiety: preserving the spectacle of broken images and charred remains would have been a calculated means of keeping the psychological wound of the desecration fresh and raw, and so of inciting further action against the barbarians from the east.

As it happens, there was more architectural and sculptural activity on the Acropolis in the years between 480 and 450 than is often thought,[4] and military successes in the 470s and 460s, when Athens established itself as the power in the Aegean, rapidly replenished the city's coffers. Some of the broken images and pottery and dedications that littered the citadel after the sack were swept up and buried in the ground, though the "Persian debris" was not completely cleaned up for many years.[5] A massive new fortification wall was begun on the north side of the citadel in the 470s and on the south side in the 460s, and an old wall was repaired on the west. Some Archaic monuments were restored or replaced. New statues and reliefs were dedicated on the summit, very likely including, at the start of the period, the introspective marble youths known as the Kritios Boy and Blond Boy (Figs. 46–47; CD 160–161, 163), a couple of life-size bronze statues by the famous team Kritios and Nesiotes (cf. CD 162),[6] a small Athena dedicated by one Angelitos (Fig. 48; CD 164–165), and the so-called Mourning Athena relief at the

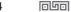

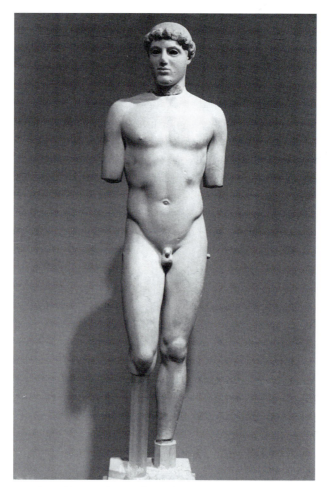

46. The Kritios Boy (Acropolis 698), c. 479–475. Photo: author.

period's end (Fig. 49; CD 168). There is evidence as well for the construc-
tion in the 460s of a few new modest buildings on the Acropolis: the
Klepsydra fountain on the northwest slope (Fig. 2, no. 17), for example,
and possibly the so-called Northwest Building (Fig. 2, no. 8; Fig. 50).
On the spot of the later temple known as the Erechtheion, a complex of
colonnaded halls (stoas) and a small shrine or temple of Athena seems
to have been reorganized – a "Pre-Erechtheion" (Fig. 51).[7]

But, it remains true that no monumental temple to Athena, goddess of
the rock, was begun in those years, and so there was nothing to compare
with what would take place after 450 or 449 when the great Pericles (Fig.
52) initiated a public works program that transformed the Acropolis and
gave western civilization one of its most familiar and enduring cultural

icons – a marble tableau consisting of the Parthenon, the Erechtheion, the Propylaia, and the Temple of Athena Nike (Figs. 1, 53; CD 001–003).

The spirit of the High Classical (450–400) remaking of the Acropolis is vividly captured in Plutarch's *Life of Pericles*, which, though it was written more than five centuries after the death of its subject and is full of misconceptions (more on that in Chapter Three), famously asserts that:

> what brought the greatest pleasure and embellishment to Athens, and the greatest astonishment to the rest of men, and what is now Greece's only evidence that her vaunted power and ancient wealth is no fiction

47. The Blond Boy (Acropolis 689), c. 479–475. Courtesy DAI-Athens (Neg. Nr. 72/2944).

48. Angelitos's Athena (Acropolis 140), made by Euenor, c. 470. Photo: author.

[was] the construction of the dedications [that is, the buildings dedicated to Athena on the Acropolis].... But as the works rose, overwhelming in size yet also inimitable in form and grace, with the craftsmen striving to surpass their craft in the beauty of their workmanship, the most wondrous thing of all was the speed of their work. For while it was thought that each one of these works would take many successive generations to reach an end, all of them were completed at the height of a single administration.... For which reason the works of Pericles are to be especially wondered at, being made in so short a time, for all time. For in beauty each one was then immediately ancient, yet each seems fresh and newly made even now. Thus a kind of newness always blooms over them, preserving their appearance untouched by time, as if his works were infused with an ever-fresh breath and ageless soul.[8]

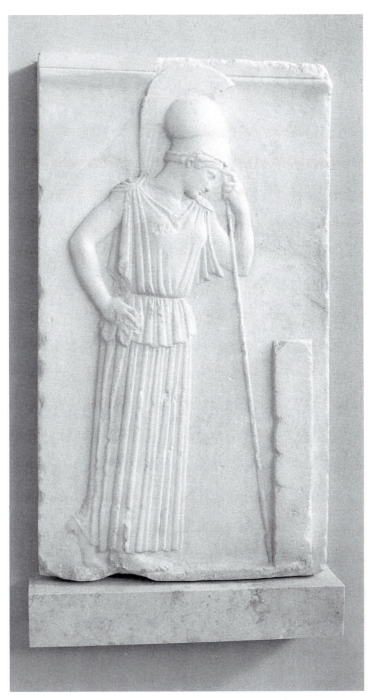

49. The "Mourning Athena" relief (Acropolis 695), c. 460. Photo: author.

50. Plan of Northwest Building. Drawing by T. Tmoulas, used by permission.

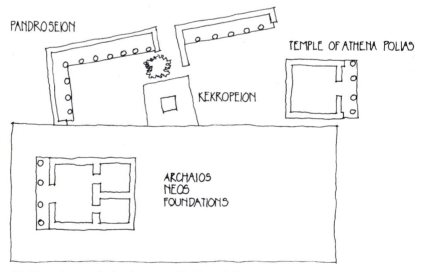

51. Tentative sketch plan (not to scale) of Erechtheion area in the Early Classical period, c. 460 (the "Pre-Erechtheion"). Drawing by I. Gelbrich.

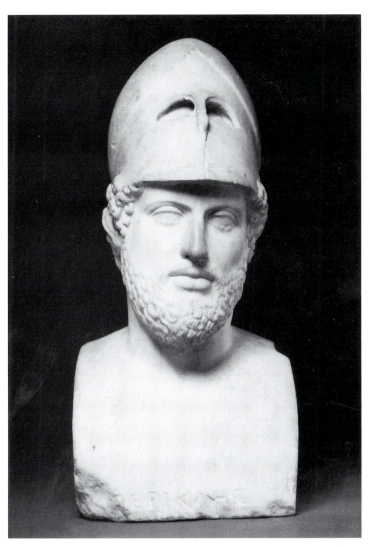

52. Portrait of Pericles, Roman copy after full-length original by Kresilas (?). Courtesy Trustees of the British Museum.

Plutarch's description of the Periclean building program – a program that was already ancient when he described it – has always shaped modern ideas of it. When we focus on the freshness and "newness" of Pericles's Acropolis, when we conceive of his program as a radical remaking of the summit, when we assume that Periclean architects and sculptors began with a slate wiped clean by the Persian destruction, we are looking at the Acropolis through Plutarch's distant lens.

But the view, however seductive, is distorted. In fact, what must have struck the ancient visitor is how completely and ingeniously the Periclean Acropolis preserved older, pre-Periclean walls, buildings, and statues

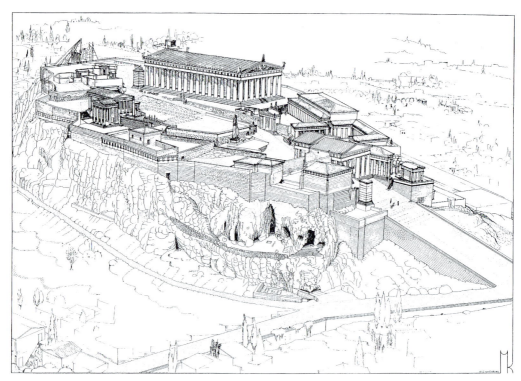

53. Reconstruction of the Athenian Acropolis. Drawing by M. Korres, used by permission.

within it, how the remains of the past were carefully incorporated into the Periclean present, and how largely the sanctity and meaning of the Periclean transformation of the citadel in fact depended on the conscientious acknowledgment and display of the past.[9]

It is true that the physical remains of any ancient Greek sanctuary would have revealed, at any one moment, a temporal continuum, with old and new monuments set side by side. The visitor to Classical Delphi or Olympia, for example, would have seen a variety of monuments set up over a very long time, in close array. However, in these other sanctuaries, such a juxtaposition of old and new was the result of an organic aging process: without something cataclysmic like a Persian sack to wipe the slate clean, it just could not be helped. On the Acropolis, the victim of almost total destruction in 480, the situation was different: the composition of monuments – the playing off of one against another – was carefully calculated. Pericles's architects and designers had the opportunity, as few others did, to make their sanctuary completely new. What is remarkable is how reluctant they were to do so and how much

they wanted to bind what was new with what was, even for them, old. The Periclean Acropolis not only acknowledged the remains of previous Acropolises; it prominently revealed and exploited them, and with that gave the new sanctuary the authority, the venerability, and the legitimacy of the ancient.

The Cyclopean Wall and Bastion

The earliest monumental construction in the history of the Acropolis was a massive fortification wall (in places, 10 meters high) thrown around the brow of the citadel in the late thirteenth century BC – a Late Bronze Age or Mycenaean wall built to protect a royal palace on the summit.[10] This Bronze Age palace (of which virtually nothing remains) probably went out of use around 1100 or so, but the wall, consisting of large irregular boulders with small stones filling the cracks in between (so-called Cyclopean masonry), remained the principal defense of the citadel for another 600 years. It was, in fact, this wall, little changed, that still defended the Acropolis when the Persians besieged it in 480. Much of its

54. Stretch of Cyclopean fortification wall (at right) adjacent to Classical Propylaia, late thirteenth century. Photo: author.

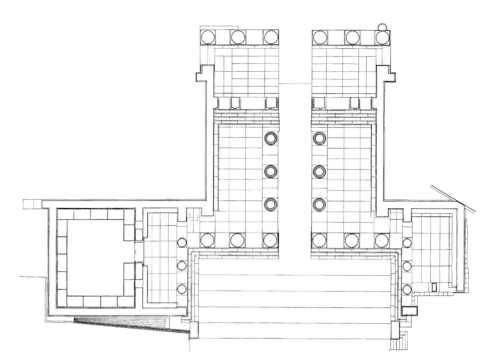

55. Plan of the Propylaia of Mnesikles, 437–432. Drawing by T. Tanoulas, used by permission.

length was thrown down by the Persians during the sack, but some parts apparently escaped their wrath. When Pericles's builders and landscapers got to work after 449, they buried some of this Cyclopean wall deep in the fill of their new Acropolis. But, one impressive stretch, still some 20 meters long and 6 meters wide, was left standing. It can still be seen in the southwest corner of the Acropolis, abutting the southwest wing of the Classical Propylaia, built between 437 and 432 (Fig. 54; CD 015). Rather, the Propylaia abuts *it*, and Mnesikles, the architect of the new marble gateway to the Acropolis, purposefully took its prior existence into account. Rather than dismantle this mighty Bronze Age monument so that he could build his Propylaia without hindrance, he bevelled the southeast corner of the Propylaia's southwest wing (Fig. 55) so that the new would snugly fit against the old – fine, squared, Classical marble masonry set neatly against a wall of crude limestone boulders originally built nearly 800 years before, a wall that was repaired a number of times in its history (testifying to its importance as a relic)[11] and that still stood almost 5 meters high in the fifth century (it stands 3.25 meters high even today). Mnesikles and the Periclean age seem to have regarded these old stones with special awe.

And this was not the only Mycenaean relic that Classical architects on the Acropolis both respected and revealed. The royal palace protected by the Cyclopean walls was built on a series of terraces supported by walls of rough masonry (cf. CD 017–018). The principal terrace was retained on the west by a wall (running north–south) standing as high as 4 or 5 meters and on the south by a wall that diminished in height as the natural level of the Acropolis rock rose to the east. Though the Mycenaean palace atop it disappeared, this artificial terrace remained the Acropolis's central terrace for the rest of antiquity. The original Bronze Age walls that defined it (though certainly repaired over time) remained prominent features of the Periclean sanctuary and formed a backdrop for some of its most impressive monuments (Figs. 2, 56).

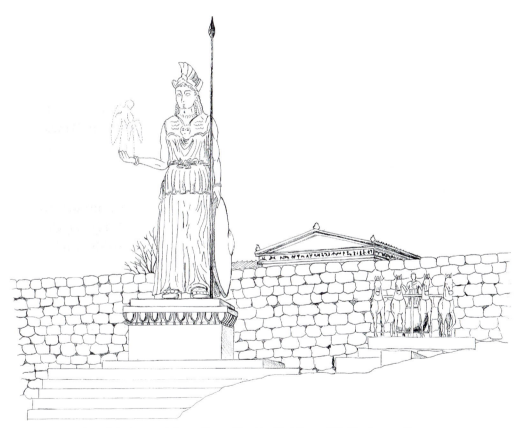

56. Reconstruction of the Bronze Athena (Promakhos) by Pheidias, c. 460. The (restored) chariot group commemorating an early Athenian victory over Boiotia and Chalkis is seen at right. Behind is the west retaining wall (originally Mycenaean) of the Acropolis's central terrace. Drawing by D. Scavera.

57. West elevation of Mycenaean remains within later Nike Temple bastion. After Mark 1993, Fig. 16, used by permission.

Moreover, on the west slope, a tall Cyclopean tower or bastion formed part of the heavy fortifications protecting the entrance to the Bronze Age citadel (Fig. 57).[12] Built into its west face was a double-niched shrine. In the sixth century, this bastion became, appropriately, the site of the cult of Athena Nike – Athena, goddess of victory. Along with so much else, this sanctuary was destroyed by the Persians in 480. But it was remade in the second half of the fifth century and, by around 425/4, the elegant little marble Temple of Athena Nike had been built atop a new, finely sheathed limestone bastion (Fig. 58; CD 133). The old Mycenaean tower was, however, encased within it and, remarkably, the architect of the Classical project, in a kind of *homage*, recreated the Bronze Age double-niched shrine in its west face with fine ashlar masonry (CD 134). Even more remarkably, a polygonal hole was left in the north face of the bastion through which the stones of the Mycenaean tower at its core could be

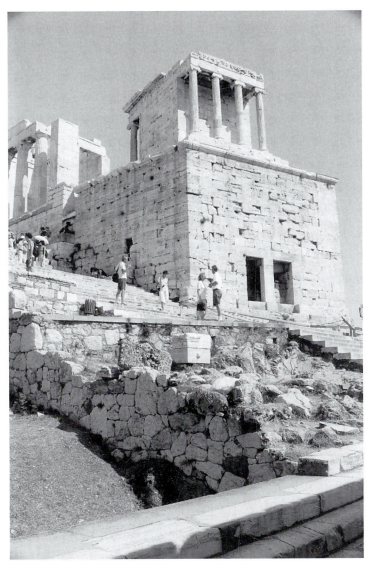

58. Nike Temple bastion, with niches built into its west face and a polygonal window onto the Mycenaean core left on its north face. Visible in the foreground is the polygonal retaining wall for the mid-sixth-century ramp leading up to the summit. Photo: author.

viewed (CD 135). The strikingly irregular shape of this hole, left in a wall of otherwise fine rectangular blocks and set at eye level for anyone climbing the Classical ramp up to the Propylaia, was meant to grab one's attention. This is, quite literally, a Periclean window upon the Bronze Age past, and the visitor was supposed to look through it. The new Nike Temple bastion literally opens itself up to a perception and recognition of its own ancient history.

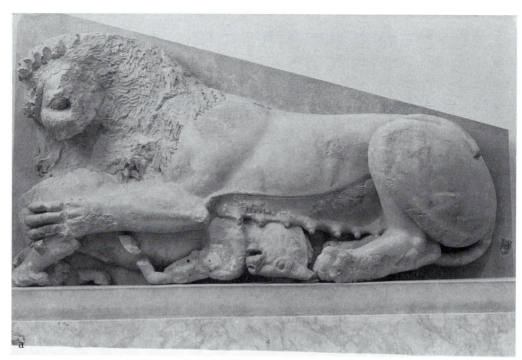

59. Sculptures from the pediments of the "Hekatompedon" or "Bluebeard temple." **a.** Lioness savaging bull. **b.** Herakles and sea god (left) and "Bluebeard" (right). Photos: author.

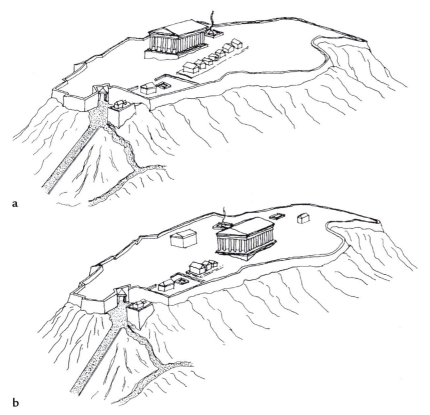

a

b

60. a. Reconstruction of mid-sixth-century Acropolis, with the "Bluebeard temple" on north site and a precinct with smaller structures (*oikemata*) on the south. After Schneider and Höcker 1990, Fig. 62. **b.** Reconstruction of mid-sixth-century Acropolis, with "Bluebeard temple" on south (Parthenon) site. Drawings by I. Gelbrich.

The Temple of Athena Polias and Older Parthenon

The development of the Acropolis after the Bronze Age, and especially in the Archaic period, is a controversial issue. For example, we know that around 560 a large temple – its pediments decorated with brightly painted limestone groups of lions attacking bulls, Herakles wrestling a sea monster, and a three-headed creature known as Bluebeard doing nothing in particular (Fig. 59; CD 019–023) – was built somewhere on the Acropolis, but it is not clear just where. Some put the building on the north side of the summit and envision an open-air precinct with a row of smaller buildings across the way (Fig. 60a). Others put the Bluebeard temple on the south – the site of the later Periclean Parthenon (Fig. 60b) – and recent explorations of the area suggest they may be right.[13]

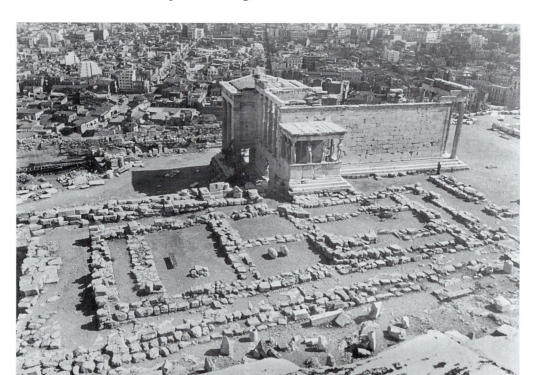

61. Foundations of the Temple of Athena Polias, or *Archaios Neos* (late sixth century). Alison Frantz Collection, Courtesy American School of Classical Studies.

There is, however, general agreement on one or two things. One of them is that, sometime in the late sixth century, a monumental limestone temple was built on still impressive foundations near the center of the Acropolis summit (Fig. 61; CD 024–26). It was in this temple – often known as the *Archaios Neos*, or ancient temple, an epithet it no doubt inherited from still earlier shrines on the spot – that the venerable olive-wood image of Athena Polias (the most sacred image of the goddess) was kept. This, then, was the principal temple on the late Archaic Acropolis, and it was this temple – its pediments filled with marble sculptures depicting (like the *peplos* of the cult image) the battle of the gods against the giants (Figs. 40–41; CD 027–028) – that the Persians must have attacked with special glee, setting fire to its wooden roof and pulling down columns.

Another point of some agreement: across the way, on the south side of the Acropolis, a massive foundation up to 11 meters deep, consisting of nearly 10,000 two-ton blocks of limestone, was built to support a

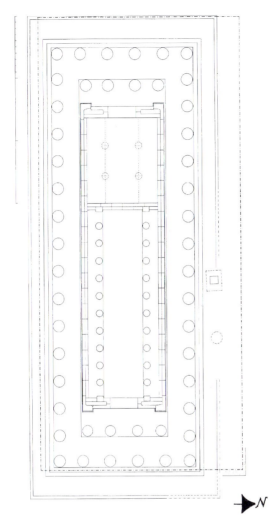

62. Plan, Older Parthenon, 489–480. Drawing by M. Korres, used by permission.

new temple that was going to be built completely of marble (Fig. 4). This was the so-called Older Parthenon (Fig. 62; CD 030–032), and it was probably begun in the exhilarating first few years after the battle of Marathon as an architectural expression of the Athenian self-confidence engendered by the victory, an offering of thanks to the goddess who assured it.[14] The building was still under construction in 480 – only the lower blocks of its inner walls and the two or three lowest (and still unfluted) drums of its columns had been set in place – when the Persians set fire to its scaffolding, destroying what there was of it to destroy (Fig. 63).

63. The state of the Older Parthenon in 480, just before Persian sack. Drawing by M. Korres, used by permission.

But, the destruction of these two buildings – the Temple of Athena Polias (*Archaios Neos*) on the north, the embryonic Older Parthenon on the south – was not total after all, and neither their physical reality nor their memory could be completely erased. The Temple of Athena Polias, or much of it, must have fallen, and many blocks and column–drums of the Older Parthenon remained unfinished (CD 031). But, in the 470s, Early Classical Athenians took parts of both buildings – triglyphs and metopes from the Temple of Athena Polias and unfluted column–drums from the Older Parthenon – and built them into the new north citadel wall, a moving display of ruins high above the city of Athens, looming testimony to Persian sacrilege, an eternal lament (Figs. 53, 64; CD 005–007).

So, the Archaic Temple of Athena Polias and the Older Parthenon were ruined, but parts of them were transformed into an Early Classical war memorial, and their heavy foundations remained in place: it

is easier to knock down columns and roofs and walls than it is steps and platforms. The builders of both the Classical Erechtheion (which, it now appears, was begun or at least conceived during Pericles's lifetime) and the Classical Parthenon – the Periclean Parthenon – exploited these Archaic remains as well.

The Erechtheion (Figs. 16, 17, 65, 66; CD 120–124) was not so much a temple as it was a composition of many shrines. It rose directly over the "Pre-Erechtheion" (Fig. 51) and encased the still-functioning Early Classical shrine of Athena Polias within it: the pilgrim entering the building from the east needed to take a few steps down to reach it.[15] However, the Erechtheion was not just a new marble shell for an older shrine. It also contained altars to Hephaistos and Poseidon–Erechtheus and a hero named Boutes. Adjoining it on the west were the supposed tomb of the legendary King Kekrops and the precinct of his obedient daughter, the heroine Pandrosos. Like Kekrops's tomb, Pandrosos's cult had probably always been located here, but the architects of the Erechtheion remodeled

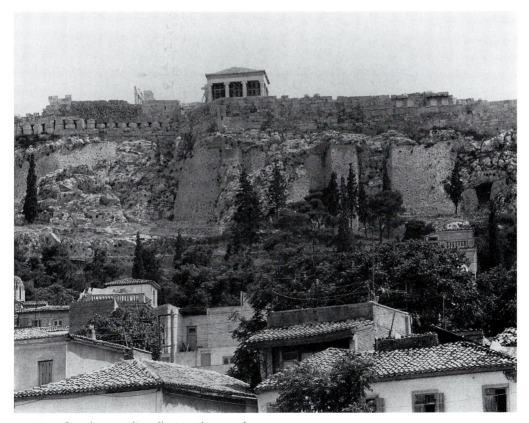

64. View of north Acropolis wall, 470s. Photo: author.

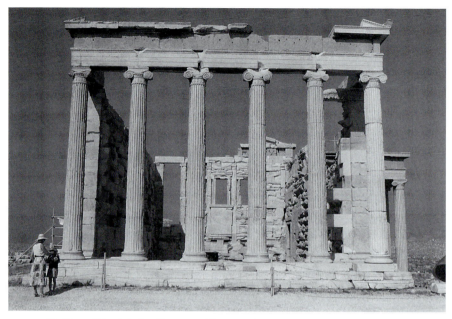

65. View of Erechtheion from east. Photo: author.

the Pandroseion and used the north foundations of the Temple of Athena Polias as its southern boundary. That is, an Archaic wall helped define the area of the Classical sanctuary. And it is upon this same wall that the famous Karyatid porch of the Erechtheion rests (Fig. 67): the Classical Temple of Athena Polias was partly built atop the foundations of the Archaic Temple of Athena Polias. Not only that but the Karyatids also stood directly atop the Tomb of Kekrops, and it is possible that the libations those somber maidens were imaginatively about to pour from the offering bowls they once held down at their sides were meant for that legendary hero – Classical statues perched atop an Archaic wall and a supposedly Bronze Age tomb, imaginatively honoring a hero of distant legend.

It is nearly the same across the way, on the south side of the Acropolis. For there the greatest of all Classical buildings was built upon the deep and mighty foundations originally laid for its late Archaic predecessor: that is, the Periclean Parthenon largely rests atop the podium of the Older Parthenon (Fig. 4). Although this was certainly an economical thing to do, the decision was also ideological. The Periclean Parthenon was in many ways a reconstruction of the Older Parthenon, a temple almost certainly begun in the early 480s to celebrate and thank Athena for the

victory at Marathon. The Parthenon's plan was essentially an expansion of the plan of the earlier building (Figs. 62, 68), and hundreds of column-drums and blocks originally quarried for use in the Older Parthenon were reused or recut for the Periclean building (thus, for example, the diameter of the columns of the Periclean Parthenon was exactly the same as the diameter of the columns of the Older Parthenon). Now, the recycling of so much material was, of course, cost effective, and any economy in a building as expensive as the Parthenon would have been appreciated. But the reuse of Older Parthenon stones had a symbolic value as well: if the fabric of the Classical Parthenon was largely made up of marble from the unfinished Older Parthenon destroyed by the Persians in 480, the Periclean Parthenon was, in a sense, a completion and a reincarnation of it. The Periclean building could thus be considered a monument both to Marathon, as its predecessor was (and as later orators actually said it

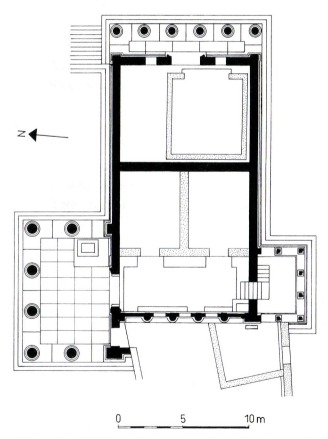

66. Plan of Erechtheion. After Goette 2001, Fig. 10, used by permission.

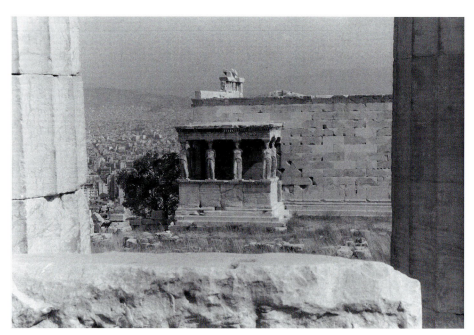

67. Erechtheion, south porch (original Karyatids in Acropolis Museum and British Museum). Photo: author.

was), and to all those victories won over the Persians in the meantime, in the decades after their desecration of the Acropolis in 480.

The Naiskos

The recycled nature of so much of the Parthenon's marble would not have been obvious to most Periclean-era visitors even if they were aware of the history of the material: a column–drum looks like a column–drum. However, there was another feature of the new Parthenon that tied the building even more overtly to its past and that directly revealed the architectural and sacred history of this spot on the summit. In the floor of the Parthenon's north colonnade, evidence has come to light for the existence of a small temple (or *naiskos*) and round altar (Figs. 24, 68). This shrine existed on this spot long before the construction of the Parthenon; it was probably older than the Older Parthenon, and perhaps as old as the middle of the sixth century. Whatever its date, when the Parthenon was built, it was regarded as too important or sacred to destroy. The Parthenon, in essence, was built over and around this pre-Periclean structure – it was actually slightly repositioned – just

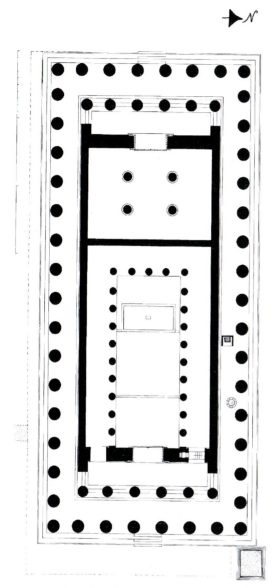

68. Plan of Periclean Parthenon by M. Korres; used by permission.

as the Erechtheion was built over and around the earlier shrine of Athena Polias in the Pre-Erechtheion; the Classical building contained, acknowledged, and absorbed an Archaic one within it. At all events, we do not know what divinity was worshipped in the Parthenon's *naiskos*, but it is a safe bet that the shrine held an ancient statue of Athena herself, perhaps in her role as goddess of work and craft, Athena Ergane.[16] This statue was just one of many images of Athena to be found in or on the

Periclean Parthenon, and it is interesting that another statue of Athena (in a more warlike pose) appeared almost directly above in the north metopes of the Parthenon, which showed episodes from the story of the Trojan War – especially the night of Troy's destruction. Perhaps the stiff, stylistically Archaic statue depicted in north metope 25 – the Trojan Palladion, the statue of Athena to which Helen flees for protection (Fig. 69) – was a kind of reference to the statue once displayed in the little old "temple within the temple" located within the Parthenon colonnade below.

The Opisthodomos Problem

If the Erechtheion and Periclean Parthenon had earlier shrines embedded within their very fabric, so, it is generally believed, the Classical Acropolis had an Archaic structure standing at its very center. This is the building or chamber referred to in Classical texts (in and after 434/3) as the *Opisthodomos*. Literally, *opisthodomos* means "the room behind," and normally the term refers to the shallow back porch at the rear of the cella, the rectangular room within the typical Greek temple. However, the consensus is that when the word appears in Classical Athenian inscriptions or orations, it refers specifically to the western part (the back rooms *and* porch) of the Temple of Athena Polias destroyed by the Persians (Fig. 61), and that Early Classical Athenians, who clearly had to keep the sacred olivewood image of Athena somewhere after 480, restored that part of the Archaic temple to house it, oath of Plataia or no (Fig. 2, no. 11). It is also generally thought, first, that this *Opisthodomos* continued to occupy the center of the Acropolis during and after the Periclean building program (even after the Erechtheion was built just to its north); second, that it not only housed the statue of Athena Polias but also functioned as the central repository for the treasures (mostly gold and silver) of Athena and the other gods; and, third, that it remained standing until at least the middle of the fourth century (when it is referred to for the last time in our sources) and possibly much longer.[17]

The problem with all this is that the existence of the *Opisthodomos* rests primarily on ambiguous epigraphic and literary rather than solid archaeological grounds. For example, there is no evidence at all for the restoration of any part of the Temple of Athena Polias, whereas there is

69. Parthenon, north metope 25. Courtesy DAI–Athens (Ng. Akr. 2308).

some evidence that the Pre-Erechtheion (Fig. 51) just to its north was remodeled in the Early Classical period, presumably to accommodate the statue of Athena Polias and its cult (in which case the *Opisthodomos* would not have been needed, at least not for that).[18] Moreover, if any part of the old temple were restored, it might have made more sense to restore the *eastern* part of the cella anyway (because that was the original home of the statue of Athena Polias). Above all, it is hard to see how any self-respecting architect could have designed the Erechtheion as he did if the *Opisthodomos* loomed so close. Why, for example, build so luxurious and impressive a Karyatid porch (Fig. 67; CD 120–122) only to have it so badly crowded and from many angles obscured by the older, charred limestone building? Finally, there are some grounds for believing that the *Opisthodomos* of the inscriptions was really the back (west) room of the Periclean Parthenon (which may be why the first mention of it occurs only in 434/3 – just a few years after the Parthenon was architecturally complete).[19]

The jury should perhaps stay out: it is possible that a separate structure known as the *Opisthodomos* existed, but it is not provable. Still, it is important to appreciate what it meant if it did exist, especially if it continued to stand after the completion of the Erechtheion directly to the north. Anyone making his way through the Periclean Acropolis would have found, in the very center of a sanctuary consisting of elegant and grandiose buildings made of freshly cut Pentelic marble, a damaged (if restored) Archaic limestone relic, with gaps and missing parts and with its surviving walls and columns undoubtedly still bearing the scars of the fires of 480. The incongruity could not have been sharper, but it would have made a point consistent with the use and display of other pre-Periclean architecture in the fabric of the Classical sanctuary. The Periclean Acropolis would have been bound directly to – it would have figuratively revolved around – the Archaic Acropolis destroyed by the Persians. It was another way of recording and exhibiting the history of the place.

Archaic and Early Classical Images on the Periclean Acropolis

Whether part of the Archaic Temple of Athena Polias survived as the *Opisthodomos* or not, we know that at least a few Archaic statues managed to survive the Persian destruction and decorate the Classical citadel. During his tour of the Acropolis in the mid-second century AD, for example, Pausanias, the author of an invaluable travel guide to Greece, saw an Archaic bronze lioness that the Persians evidently missed or ignored, as well as a seated Athena by the Archaic sculptor Endoios; a badly weathered statue in the Acropolis Museum may be it (Fig. 70). Pausanias also saw a number of other expressly Archaic statues of Athena (of what material he does not say) that still had all their limbs but which were, he says, still blackened by Persian flames. Various Archaic cult statues, too, remained the foci of worship on the Periclean Acropolis: the statue of Athena Polias itself, for example, and the image set inside the elegant little Temple of Athena Nike in the 420s, a statue made originally in the middle of the sixth century.

And just as some Archaic statues continued to stand (or sit) in the Periclean, High Classical sanctuary, so did any number of Early Classical monuments. There was the war memorial built into the north Acropolis

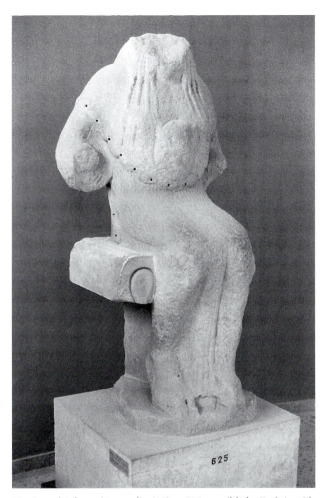

70. Seated Athena (Acropolis 625), c. 525, possibly by Endoios. Photo: author.

wall in the 470s (Fig. 64; CD 006–007). There was also a monument in the form of a four-horse bronze chariot, originally dedicated to commemorate an early victory of the Athenian democracy over armies from nearby Chalkis and Boiotia. The victory was won in 506, and the bronze monument was originally set up soon after. Though the Persians destroyed this, too, in 480, the Athenians replaced it in the Early Classical period, and this replacement remained on view for centuries.

The greatest Early Classical monument on the summit, however, was a colossal bronze statue of Athena (much later known, in only one ancient source, as the Athena Promakhos, or Defender), made by Pheidias (Fig. 56).[20] Pausanias twice says that the huge statue, officially known as the

Pausanias on the Bronze Athena (Promakhos)[21]

Apart from the listed monuments, there are two tithes the Athenians dedicated in the aftermath of war. First, a bronze Athena, financed from the spoils of the Medes who landed at Marathon, a work of Pheidias. The fight of the Lapiths and Centaurs and the rest of what has been wrought on the shield were, they say, engraved by Mys but designed for him, like the rest of his works, by Parrhasios, son of Euenor. The point of the spear of this Athena and the crest of her helmet are visible to sailors soon after they round Sounion. Second, there is a bronze chariot, a tithe of the spoils taken from the Boiotians and Chalcidians in Euboia.

Bronze Athena, was paid for from the spoils of Marathon. Demosthenes (a much earlier witness, writing in the middle of the fourth century) says more broadly that "it was dedicated as a monument to victory in the war against the barbarians, with the Greeks supplying the funds."[22] It is often inferred from Demosthenes that the money for the statue (like that used to build the south Acropolis wall) came from the spoils of the battle of Eurymedon (c. 466), a monumental victory over the Persians won by the great Early Classical general and conservative politician Kimon, and that the members of the Athenian alliance known as the Delian League contributed the funds. However, Demosthenes does not specifically link the statue to Eurymedon, and it is possible that the Bronze Athena was created to commemorate not a specific victory but rather the long history of Athenian success against the Persians, metaphorically represented by the Centauromachy made by Mys and Parrhasios on its shield (probably sometime after Pheidias made the statue itself).

A long inscription listing the costs of labor (both wages for Pheidias's workers and salaries for the public commissioners in charge) and raw materials (copper and tin for the bronze, goat's hair to mix with clay for the core and mold, coals and firewood for the smelter, lead, and silver for ornamental details) suggests that the project cost around 83 talents in all and took nine years to complete.[23] Because this inscription was carved at the end of the project and can itself be dated (subjectively, by the style of its letters) to around 455–450, work on the statue – it was possibly cast in an installation on the south slope of the Acropolis itself (Fig. 71)[24] – could have started at any point between, say, 465 (that is, just after Eurymedon) and 460. But, whether the Bronze Athena was a product of Kimonian patronage or an early commission of Periclean

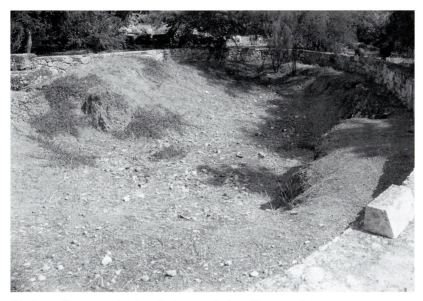

71. Area of bronze-casting installation, south slope. Photo: author.

democracy, perhaps Pausanias and Demosthenes were both right about its sources of funding, and the Bronze Athena should be understood as commemorating the sum total of major Athenian victories from 490 onward. The victory at Marathon was surely implicit in the symbolism of the statue, and it may not be coincidental that around the same time that the Bronze Athena was created, the Athenians set up a new, monumental marble monument at Marathon itself to commemorate the victory.[25]

Wherever the money came from, the Bronze Athena stood as the very transfiguration of enemy spoils – as Persian wealth recast into the brightly polished image of the goddess who had assured Athenian victory. Athena had always stretched her protective hands over her city (as the Archaic poet and lawgiver Solon had said long before). But, this Athena, though on guard at the entrance of her sanctuary, probably stood at rest, leaning on her shield rather than brandishing it, not aiming her spear but allowing it to rest in the crook of her arm (and so she did not truly belong to the "Athena Promakhos type" known from many bronzes and vase paintings, showing the goddess striding forward, shield and spear raised and ready for action; cf. Fig. 72).[26] It stood tall: 30 feet tall, if a bronze Athena seen by a Byzantine chronicler in Constantinople in the early thirteenth century was *the* Bronze Athena, possibly taller if it was not the same statue. In any case, it was tall enough for its helmet crest and spearpoint

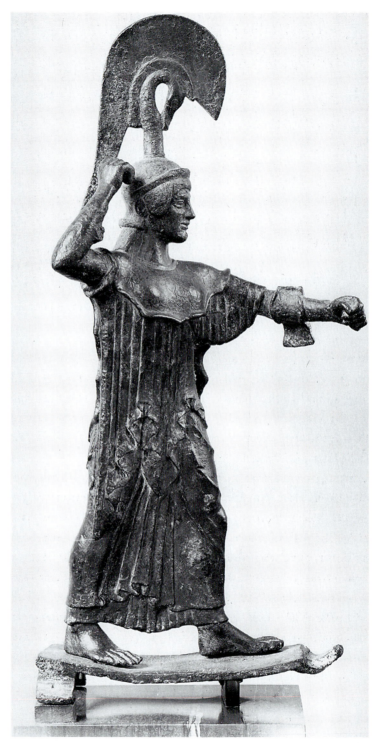

72. Athena Promakhos, dedicated by Meleso, c. 480–470 (NM 6447 and *IG* I^3 540). Courtesy DAI–Athens (Neg. Nr. NM 4742)

73. Fragments from base of Bronze Athena (from a Roman repair). Photo: author.

to rise above its architectural surroundings and reflect light seen by sailors coming into port from Sounion. It stood on an elegantly moulded pedestal of Pentelic marble and dark Eleusinian limestone set into a large rock cutting (about 5.465 by 5.58 meters) just in front of the ancient (originally Mycenaean) wall retaining the west side of the central terrace (Fig. 2, no. 7; Figs. 56, 73; CD 166–167).

This location, and the fact that the base was not set flush against the terrace wall but was rotated slightly away from it, is surely significant. The Bronze Athena stood precisely on axis with the ruins of the Archaic Temple of Athena Polias, yet it turned to the southwest, toward Salamis – the site of a victory to rank with Marathon and Eurymedon. If the goddess did not hold a Nike (an obvious enough symbol of victory) in one hand, then she may have held an owl – and owls, it was said, were seen before both Marathon and Salamis, omens of Athena's favor.[27] Thus, the Bronze Athena, strategically placed to dominate the view of anyone entering the Early Classical Acropolis, stood at a kind of intersection of history, topography, and allusion, at a symbolic nexus of destruction, victory, and renewal. Aligned with the holiest temple destroyed by the Persians, directing her lofty gaze toward the waters where the Persians met disaster, the statue was cast from the fruits of victory (or a series of victories) to be, in Demosthenes's words, "the goddess's own *aristeion*," her own prize of

valor.[28] The Bronze Athena was, in short, Pheidias's (and Athens's) first great essay on the course and meaning of the Persian Wars, and no one entering the Acropolis could have missed the colossal, gleaming message. Like a phoenix rising from the ashes of the Acropolis, it embodied a material splendor and political symbolism that would culminate just a decade or two later, when the restored Boiotian/Chalkidian monument, commemorating the democracy's very first military success, was finally moved to a spot just beside it (Fig. 56) and when, under the auspices of Pericles, the entire Acropolis was transformed into a vast and intricate dissertation on victory itself (Fig. 53).

And its symbolism endured. The Periclean building program left it alone and in place – the Classical Propylaia was virtually aligned with it – with the result that this Early Classical "Statue of Liberty" remained as much a part of the Periclean visitor's experience of the Acropolis as the colossal gold-and-ivory Athena Pheidias made and installed within the Parthenon itself in 438 (Fig. 21). These two statues, the Bronze Athena and the Athena Parthenos, both adorned with myths repeated throughout the imagery of the Acropolis (for example, the battle of Greek Lapiths against the Centaurs), bracketed the visitor's experience of the Acropolis: the Early Classical statue at the start of the tour, the Periclean statue near its end. Together, they largely established the thematic unity – the iconographic and ideological choreography – of the place.

Thus, every major element of the Periclean building program was materially, thematically, or compositionally bound to at least one predecessor – the Propylaia and Nike bastion to Mycenaean walls and towers, the Erechtheion and Parthenon to late Archaic temples and shrines, the Athena Parthenos to the Bronze Athena – and the Classical sanctuary exhibited and exploited earlier statuary and dedications as well. The Periclean Acropolis was thus not completely new: its makers did not write upon a clean slate. Instead, the Acropolis was a composition in which new buildings and monuments stood upon or beside old ones, and the links were in most cases obvious – as easy to grasp as peering through the window in the Nike temple bastion (Fig. 58).

Again, like Delphi or Olympia or any Greek sanctuary, the Acropolis throughout its history had always assimilated relics of past Acropolises, so that its long history was always in evidence. But, the fifth-century Acropolis experienced something those other sanctuaries did not:

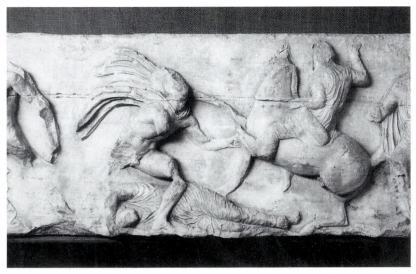

74. South frieze (detail), Temple of Athena Nike: Battle of Marathon. Courtesy Trustees of the British Museum.

virtually complete destruction, a destruction that gave the Athenians the opportunity to rebuild upon a tabula rasa – an opportunity the Athenians pointedly refused to accept. What is significant about the Periclean Acropolis – what differentiates it from other sanctuaries whose continuities were taken for granted – is the *self-consciousness* of its use and overt

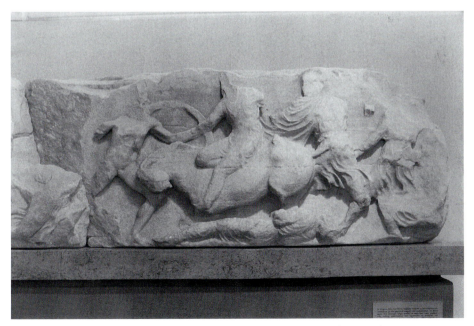

75. South frieze (detail), Temple of Athena Nike: Battle of Marathon. Photo: author.

exploitation of earlier remains. The Periclean Acropolis, to a degree unknown in any other Greek sanctuary, especially acknowledged, revealed, and reveled in its own archaeology, in the sense of its own past.

It may not be coincidental, then, that at least one frieze of the Temple of Athena Nike represented not a mythological battle, as one would expect, but – and this is unique in fifth-century architectural sculpture – a historical one, the Battle of Marathon itself (Figs. 74–75; CD 142–143), the same battle commemorated by both the Bronze Athena and the Periclean Parthenon. The Periclean Acropolis was not only conscious of its own archaeological history, it also *represented* Athenian military history. And so it is probably also not coincidental that the era of the Periclean building program saw the writing of the first great historical narratives, the *Persian Wars* of Herodotos (finished by 425 or so) and the *Peloponnesian War* of Thucydides (begun around 431) – two very different works, to be sure, with two very different conceptions of what history is, but which nonetheless reveal an awareness of the antiquity of monuments. Thucydides, for example, was well aware of the prehistoric origins of the Cyclopean walls around the Acropolis (Fig. 54) and of how the present is founded upon the deeds of the past, like the Parthenon atop the podium of its late Archaic predecessor (Fig. 4). Like the histories of Herodotos and Thucydides, the Periclean Acropolis, by incorporating and displaying earlier monuments within it, was a record. It was an attempt to explain itself – how it came to be as it was. And so it was an attempt to reveal its own history – a history as old as the Bronze Age – and so to bind present realities both to past glories (such as Marathon) and to past traumas (such as the Persian sack, the single greatest disaster the ancient Acropolis ever experienced). Despite Plutarch's influential description of its making, of its "agelessness," its "freshness," and its "newness," the Periclean Acropolis was never intended to be completely new or to pass as "untouched by time." The passage of time – the documentation of its own archaeology – was one of its principal themes. The Periclean Acropolis was meant, above all, to be a landscape, or marblescape, of memory.

PERICLES, ATHENS, AND THE BUILDING PROGRAM

Historical Background

At the start of the year 447/6, Pericles (Fig. 52) was easily the dominant (though not unchallenged) political figure in Athens, and his position would only grow stronger. The wheels of the democracy he had helped engineer (limited though it was) were running smoothly. The number of citizens – and that meant free adult males born of both an Athenian father and an Athenian mother – ranged healthily somewhere between 40,000 and 45,000 (as it is, they constituted only a minority of the population of Attika, which of course included women and children as well as slaves and *metoikoi*, or resident aliens).[1] Athens, center of an empire on land and sea, had accumulated power and wealth unprecedented in Greece. And construction of the Parthenon, the building that would come to symbolize the greatness of Periclean Athens, had just begun (Fig. 29; CD 036–037).

By the fall of 404, Athens had been utterly defeated by Sparta in the Peloponnesian War. It had lost its fleet, its empire, and its tribute – and, facing starvation, it had unconditionally surrendered to Spartan besiegers the preceding spring. The number of adult male citizens had plummeted toward 20,000. The democracy had been overthrown and a junta known as the Thirty Tyrants, installed under pressure from the victorious Spartan admiral Lysander, now ruled, canceling laws, eliminating rights, confiscating property, and putting 1,500 of their opponents to death within a matter of months. The Parthenon had been finished

nearly thirty years before, the Temple of Athena Nike (Fig. 76; CD 137–138) nearly twenty, and with the recent completion of the Erechtheion in 406/5 (Fig. 16; CD 120), the making of the Classical Acropolis as a whole was almost complete. But, humiliatingly, the sanctuary-citadel was no longer in Athenian hands. The Thirty Tyrants needed foreign reinforcements, and Lysander duly sent them 700 troops under the authority of a Spartan military governor named Kallibios. He made the Acropolis his garrison, apparently using the Odeion (Concert Hall) of Pericles on the south slope (Fig. 2, n. 20) as his barracks. This was not the first time the Spartans had taken the Acropolis,[2] but they did so now to defend a gang of murderers.

Few heroes of Greek tragedy ever suffered so complete (or complex) a reversal of fortune as Classical Athens itself between 447 and 404. Serious troubles were, in fact, already brewing at the start of the period. Athens had been waging an intermittent conflict with Sparta and its allies for about a decade, and the year 446 did not begin well at all. In short order, Athens lost its land empire and faced a rebellion by the island of Euboia from its maritime empire. As if that were not bad enough, the army of the Spartan King Pleistoanax invaded and ravaged western Attica. The situation was so severe that work on the Parthenon, begun just the year before, was temporarily suspended. But, Pericles deftly persuaded (or bribed) Pleistoanax to leave Attic soil, thoroughly crushed the Euboian revolt, and then (in 445) negotiated a peace treaty with Sparta and her allies that was supposed to last thirty years. It lasted fourteen. Yet, it was in those years that the Parthenon, Propylaia, and other works were built, and it was in those years that Pericles reached the peak of his authority and prestige. In 444/3, he forced the ostracism[3] of his strongest opponent (the conservative Thucydides, son of Melesias) and won election as one of ten Athenian *strategoi* (generals) then and every year thereafter until his death. *Strategos* was the only major constitutional office Pericles ever held (he was never *archon*, or the chief official of the city, for example), but it did not matter. In the famous words of that other Thucydides, the historian, "in name there was democracy, but in fact political power was exercised by the first man."[4]

The Thirty Years' Peace came undone when Athens intervened in a dispute between Corinth (a powerful but insecure Spartan ally) and its old colony Korkyra (Corfu); began the siege of Poteidaia (another Corinthian

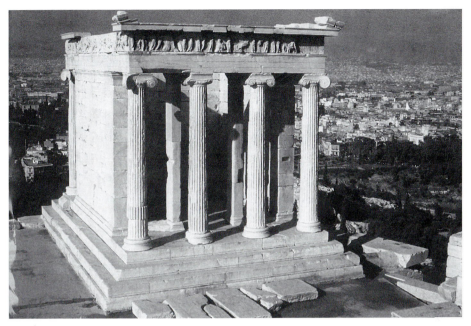

76. Temple of Athena Nike, from east (before restoration). Photo: author.

colony that was nonetheless a member of the Athenian Empire and in 432 wanted out); and issued a decree (proposed by Pericles in 433 or 432) that Megara, an ancient enemy and Corinthian ally, be excluded from the Athenian Agora and the harbors of the empire – an economic death penalty. There were some attempts to resolve these disputes diplomatically but, in the spring of 431, Sparta's ally Thebes launched a surprise attack on Athens's ally Plataia and the Peloponnesian War was on. Korkyra, Poteidaia, the Megarian decree, and Plataia may have lit the fuse, but in Thucydides's opinion, "the real cause, though the one least noted, is, I think, that the Athenians, growing powerful, scared the Spartans and forced them into war."[5]

The Athenians had apparently been convinced for several years that the Peloponnesians would be coming. They were ready, and the Acropolis loomed large in their preparations. As early as 434/3, for example, the assembly passed two financial measures known as the Kallias Decrees. After noting the presence on the Acropolis of "3,000 talents belonging to Athena" that the assembly had sometime earlier voted to transfer to the citadel (a talent was a unit of weight equaling approximately 57 pounds; in this case, the talents were probably silver), the decrees provided for the management of the "treasures of the other gods" brought from temples

in rural Attika and the lower city to the Acropolis for safekeeping: they were to be kept on the left side of the *Opisthodomos*, whatever it was. They called for the completion of some things "made of worked stone" (almost certainly marble statues and very likely the last of the Parthenon pedimental sculptures) and the first of the so-called Golden Nikai, which were essentially bank deposits in divine form (six-foot-tall statues, replicas of the Nike held by the Athena Parthenos [cf. Fig. 21], covered with 2 talents of gold plates apiece). The decrees apparently suspended work on the Propylaia (it was, in fact, never finished) and provided funds (10 talents a year) for the final arrangement, landscaping, and securing of the Acropolis itself (the architect of the Propylaia – unnamed in the decrees though we know him to be Mnesikles – was put in charge).[6] The Kallias Decrees, in short, represent precisely the sort of measures a city anticipating armed conflict and imminent invasion might take.

In 431, on the brink of war, Pericles himself went before the people to assess their resources in men and money, and his accounting, paraphrased by Thucydides,[7] must have put them at ease. Apart from the usual sources of revenue (meaning silver from the mines at Laureion, harbor fees, and so on), they received, he said, 600 talents annually from their allies in tribute. They still had 6,000 talents of coined silver on the Acropolis, and while Pericles would not have needed to remind anyone that this was after sixteen years of his costly building program, Thucydides adds parenthetically that there had once been 9,700 talents in all but that the Poteidaia campaign and the cost of the Propylaia and "other public buildings" had drawn down the reserve (presumably one of those "other buildings" was the Parthenon and it is surprising that it goes unmentioned).[8] There were, Pericles went on, at least 500 additional talents in the form of private and public dedications in silver and gold, sacred vessels and equipment, and Persian booty (the Golden Nikai mentioned in the Kallias Decrees must have been among the treasures he had in mind). Other temples still had assets, too – and, if pressed, they could even strip the statue of Athena Parthenos of the 40 (or 44) talents of removable gold plates that covered her (though this gold, he warned, they would be obligated to restore). It could be significant that Pericles did not list the gold adorning the ancient statue of Athena Polias (jewelry, an *aigis*, an owl, a libation bowl or *phiale*) among the assets of the state. Perhaps that gold was not enough, relatively speaking, to matter.

Or perhaps that statue was too holy to touch even in emergencies. If so, that tells us something about the relative sanctity of the Polias and the Parthenos: only one was inviolable.

Soon after this public audit, in the spring of 431, King Archidamos of Sparta led his army into Attika, and Pericles did nothing to stop him. His strategy was to sacrifice the land to Spartan invasions, to counterattack the Peloponnesian coast by sea, and to move the rural Athenian population within the walls of the city and to the space between the Long Walls that joined it to the Peiraieus – walls that essentially turned Athens into an island. Because the Athenian fleet ruled the waves and could import whatever it needed, the city was theoretically safe. And, despite severe overcrowding – space was so limited that some Athenians had to be housed for a time in temples and shrines, though not on the Acropolis[9] – the strategy might have worked had Pericles been there to manage it. However, in 430, something even mightier than a Spartan army invaded Attica, and the crowded conditions meant it struck hard. For two years, an epidemic (typhus? smallpox? a mystery plague out of Africa?) decimated Athens and the Peiraieus, killing perhaps one third of the population, including, in the fall of 429, Pericles himself. In 427/6, the plague struck again and, as if that were not bad enough, Attica was rocked by a series of earthquakes: one was powerful enough to damage the Propylaia and knock columns in both Parthenon façades 2 centimeters off line.[10] But, even natural disasters and the loss of Pericles did not derail the war effort; in fact, during the first ten years of the struggle, Athens won at least as often as it lost. A particularly important victory occurred at Sphacteria (Pylos) in 425 and was commemorated by a bronze Nike set up on the Acropolis.[11] Still, the Archidamian War (as the first phase of the conflict is known) ended in stalemate and mutual exhaustion; in 421, Athens and Sparta negotiated the so-called Peace of Nikias.

The treaty was so defective that Sparta's most powerful allies refused to sign on; this time, the peace, meant to last fifty years, broke down after only six. In the summer of 415, a great Athenian expeditionary force departed for Sicily to prevent the island from falling completely under the domination of its preeminent city, Syracuse; in 414, the Spartans responded by sending a general to command the Syracusans. In 413, the Spartans resumed their annual invasions of Attika and the Sicilian expedition ended in catastrophe. The Athenian fleet was destroyed, and

nearly all of the 45,000 Athenians and allies who had sailed west were killed or sold into slavery. Major building activity on the Acropolis was now apparently suspended for several years. But, remarkably, the Athenians fought on for nearly a decade more – even though their tributaries revolted one after another; even though their old enemy, Persia, began to subsidize the Spartans; even though in 407/6 they were forced to melt down, in addition to other dedications, eight Golden Nikai from the Acropolis reserves (yielding 16 talents worth of gold coins). After 410, in fact, Athens turned the tide and was actually on the verge of winning the war. But, when a smashing victory was won in 406/5 off the islands of Arginusai in the eastern Aegean, the Athenians snatched disaster from its jaws: thousands of shipwrecked and badly needed seamen were abandoned because of a sudden storm and the commanders of the fleet were (illegally) condemned to death for failing to rescue them. In the same year, misfortune struck the Acropolis as well. We are told that "the old temple of Athena" somehow caught fire, though it is not absolutely clear which building is meant.[12] Yet, the Athenian treasury in the last months of the war seems to have been in surprisingly good shape. Soon after "the great meltdown" of 407/6, the treasury began to be replenished (the growth in dedications can be detected in the Parthenon inventories as early as 406/5),[13] and the Athena Parthenos never seems to have been in danger of losing her gold. But, in late summer of 405, at the mouth of the Aigospotamoi River in the Hellespont, the Spartan admiral Lysander caught the Athenian fleet by surprise and annihilated the city's last great fighting force. His siege of a helpless Athens ensued, and terms of surrender were accepted the next spring (404). What was left of the Athenian empire disintegrated, and flute-girls played as the Long Walls linking Athens to the sea were torn down.

The course of the war naturally had an impact on the Athenian democracy and it, too, suffered upheavals and disasters. After Pericles's death, Athenian politics were dominated by a long list of radical democrats and oligarchs (moderates of any stripe were few). There was, for example, Kleon, a democratic warmonger with an unremittingly bad press whose death in battle in 421 encouraged the making of peace; and Nikias, the moderate conservative who made it, only to be butchered later in Sicily, the victim of a campaign he had strongly opposed. There were demagogues named Hyperbolos (no kidding) and Kleophon, a

lyre-maker who was a leading imperialist and the leading democrat during the last years of the war. There were sly oligarchs like Theramenes and ruthless ones like Socrates's friend and Plato's older cousin Kritias, who is irrefutable proof that intellectuals can be violent thugs. And there was, above all, the brilliant but unstable Alkibiades, who could be democrat or oligarch depending on how the wind blew, who was the driving force behind the Sicilian expedition, who went over to the Spartans and back again, and who was finally put to death by Persians. The political intrigues in which such men engaged were largely tied to the fortunes of war, and a series of regimes with numbers in their names rose and fell. In the aftermath of the Sicilian disaster, for example, an oligarchy overthrew the discredited democracy and established a Council of Four Hundred to rule the state and dismantle many of the provisions of the democratic constitution, such as pay for government service (411). Vicious extremists, the Four Hundred were in turn overthrown by a more moderate and inclusive oligarchy, the Five Thousand, led by Theramenes. They themselves lasted only a matter of months. In 410, the success of the Athenian fleet, its ships manned by commoners (the *thetes*), led to the restoration of the radical democracy (cf. CD 175). This endured until the end of the war, when the Thirty Tyrants, led by Kritias and Theramenes, took over with Lysander's blessing and the muscle of Kallibios's 700 Spartans (disgracefully, the Thirty melted down two of the last Golden Nikai to pay the foreigners garrisoned on the Acropolis).[14] But, Theramenes himself quickly fell victim to the Thirty's reign of terror, and the junta did not survive him very long. Exiled democrats and patriots led by Thrasyboulos defeated the forces of the oligarchs in the streets of the Peiraieus, killing Kritias in the process. The Spartan king Pausanias then outmaneuvered his rival Lysander, entered Attika, and negotiated a general reconciliation. In the fall of 403, the democracy was restored once more.

Clearly, Athens experienced all the history it could handle in the second half of the fifth century, and that makes the development of its Acropolis all the more remarkable. For, despite plague, disasters, and interruptions necessitated by the costs of military campaigns and the vicissitudes of politics, the Acropolis continued to be adorned with splendid buildings, sculptures, and dedications during and even after the Peloponnesian War, as it had been before, in the brief age of Pericles himself.

Plutarch, Pericles, and the Building Program

It is usually thought that the Oath of Plataia sworn in 479 (assuming it is genuine) was annulled by a peace treaty Athens signed with Persia – the so-called Peace of Kallias (assuming *it* is genuine). That is, the Athenians were freed from their vow not to rebuild the temples destroyed by the Persians when their war with the Persians officially came to an end. The odds are that both the oath and the peace are authentic, but the date of the Peace of Kallias is in dispute. It is possible that a peace was first negotiated in 465 but, if so, the result was only a tense, uneasy truce that soon broke down. Architectural projects (such as new citadel walls) were undertaken on the Acropolis in the years between 479 and 450 but, again, the late Archaic Temple of Athena Polias (*Archaios Neos*) (Fig. 61) and the Older Parthenon (Figs. 62–63) were not at that time rebuilt. Thus, even if the Oath of Plataia was no longer considered binding after 465, the Athenians, for whatever reasons – practical, philosophical, or moral – acted as if its "temple provision" were still in effect.

It is possible, too, that an oath said to have been sworn by all the Greeks who fought at Plataia had to be reconsidered by all the Greeks who fought at Plataia, not just the Athenians, and that a more satisfactory renegotiation or renewal of the Peace of Kallias in 449 gave Pericles the opportunity to seek a panhellenic annulment of the oath.[15] At some point, we are told, Pericles officially invited all the Greeks to meet in congress at Athens to discuss the rebuilding of the temples that the Persians had cast down, the sacrifices that they owed the gods, and ways of keeping the peace and guaranteeing freedom of the seas. Now, both the authenticity and date of this so-called Congress Decree are (surprise!) debatable, but its authenticity holds up to examination and a date of around 449 makes some sense.[16] In any case, we are also told that the Spartans recognized the invitation for what it was – an unsubtle attempt on Pericles's part to get the Greeks to acknowledge Athenian supremacy – and prevented the congress from ever taking place. But, Pericles did not let this rejection stand in his way and, Oath of Plataia or no, he quickly brought his proposals for the remaking of the Acropolis before the assembly, probably late in 449.[17]

The standard ancient account of the Periclean building program is found in an entertaining place: the biography of Pericles written by

Plutarch (c. 45 AD to c. 120 AD), a prolific author, rhetorician, moral philosopher and, for the last part of his life, chief priest at Delphi. He is most famous for his *Parallel Lives*, a set of twenty-three pairs of biographies of leading figures from Greek and Roman history, written as studies of the kind of virtue and character that produced "great men." As colorful as they sometimes are, the *Lives* are primarily anecdotal and didactic works meant to edify and improve young men with good examples. Rigorous, analytical history they are not.

Although Plutarch knew Athens well (he went to school there), the fact remains that he wrote his *Life of Pericles* more than five centuries after Pericles's death, probably during the reign of the Roman emperor Trajan (98–117 AD). In fact, in the famous description of the building program that *Pericles* contains, Plutarch in some respects seems to have in mind the kind of highly centralized projects that characterized the Roman Empire of his own day rather than Classical Greece, and in other respects he is misleading or incomplete. For example, the close relationship between Pericles and the sculptor Pheidias that Plutarch describes is suspiciously like the one Trajan had with his master architect Apollodoros, and the implication that one of Pericles's major objectives in starting the program was to put the idle masses to work seems just as anachronistic (unemployment was a big problem in Plutarch's time, but not in Pericles's Athens). Although Plutarch states that Pheidias was in charge of the entire building program, a director of public works supervising virtually everything down to the last detail, the heterogeneous styles and compositions of the Parthenon sculptures tell a different tale, and Plutarch himself lists different architects for different buildings. Moreover, we know from inscribed building accounts from the Acropolis that separate boards of commissioners (known as *epistatai*), elected annually by the people, oversaw each individual project, yet Plutarch knows nothing of their existence, and there is no evidence these boards were under the authority of any coordinating super-commissioner.[18] The kind of wide-ranging, all-powerful appointment that Plutarch imagines for Pheidias would simply not have been in character for radically democratic Periclean Athens.

Although Plutarch says Pheidias died in prison in Athens, the sculptor actually left the city around 438 for Olympia (where he was commissioned to create the gold-and-ivory statue of Zeus, one of the seven wonders of

the ancient world). This was a year or so before the inception of the Propylaia and before the carving of the Parthenon pediments had even begun (or at least had progressed very far). It is thus hard to see how Pheidias's role could have been as comprehensive as Plutarch says it was.[19] To be sure, Pheidias may well have acted as Pericles's general artistic advisor and he may even have sketched designs or fashioned clay models for others to execute in marble (it is not hard to imagine his big-name pupils Agorakritos and Alkamenes in charge of the Parthenon pediments or frieze). However, the only work we know Pheidias himself created for the Periclean program was the gold-and-ivory Athena Parthenos itself (probably dedicated at the Greater Panathenaia of 438) (Fig. 21). Finally, the story Plutarch recounts that Pheidias impiously put a self-portrait and a portrait of Pericles on the shield of the Athena Parthenos (and for that reason was imprisoned) is likewise apocryphal, a patently post-Classical invention.[20]

Plutarch and other sources also strongly imply that the Periclean building program was funded entirely by money diverted from the treasury of the Delian League, that alliance of Greek city–states formed in 478/7 and led by Athens to carry on the war against the Persians. Each member of the league was assessed dues or tribute, and in 454 5,000 talents of the League's treasury were transferred from the sacred island of Delos to (probably) the Acropolis, ostensibly for safekeeping. If there was a single point when the supposedly voluntary Delian League became the Athenian Empire, that was it.

We do, in fact, know of at least one Periclean public work – a well-house built somewhere in Athens in the 430s – that was funded entirely from tribute. But we also know from inscribed building accounts that the financing of the grander program on the Acropolis was not that simple. Pericles surely drew upon the accumulated reserves of the Delian League, and he may also have specifically used that portion of annual imperial tribute that "legitimately" belonged to Athena and was deposited in her own treasury (the *aparkhai*, or "first fruits," 1/60th of the total levy): that could have been one pillar of his successful defense against the politically motivated accusations recounted by Plutarch. Yet, the *aparkhai* by themselves would not have funded very much,[21] and so far as we know, the so-called Treasurers of the Greeks (the *hellenotamiai*, who managed the imperial tribute) contributed to the costs of the Parthenon and its

sculptures only five times in fifteen years. Far outweighing their contributions were those of the regular Treasurers of Athena (the *tamiai*), the chief financial officers of Athens and general managers of the Acropolis, who supplied the bulk of the funds from Athenian reserves accumulated over previous decades (from the spoils of war, for example) and regular internal public revenues (harbor fees, court fines, rents, taxes, and so on).[22] There were additional funds from less regular sources. A silver mine at Laureion in eastern Attika, for example, is singled out as a financial backer of the Parthenon in 439/8 and of the Propylaia in 434/3. Rent from houses belonging to Athena helped finance the Propylaia. Even private contributions helped defray both the cost of the Athena Parthenos (they were applied to the costs of the Parthenon after the statue's completion) and the Propylaia.[23] It is, in any case, easy to overestimate the drain the Periclean building program put on the Athenian economy. Expensive it was but, to put things in perspective, it is worth noting that the total cost of the Parthenon (700–800 silver talents), the statue of the Athena Parthenos inside it (700–1,000 talents), and the Propylaia (perhaps 200 talents) – representing fifteen years of intense construction and artistry atop the Acropolis – may not have been much higher than the cost of a single military campaign at the start of the Peloponnesian War.[24]

All in all, Plutarch's vivid description of the building program and his engaging picture of Periclean Athens in action must be used with considerable caution. Yet, Plutarch's list of the projects that Pericles initiated both on and off the citadel remains fundamental. These are, in the order Plutarch gives them: the Parthenon (built, Plutarch informs us, by Iktinos and Kallikrates), the Telesterion (Hall of Mysteries) at Eleusis in western Attika (built by Koroibos, Metagenes, and Xenokles),[25] the middle Long Wall linking Athens to the Peiraieus (by Kallikrates), the Odeion on the south slope of the Acropolis (architect unnamed), the Propylaia (by Mnesikles), and the statue of Athena Parthenos (by Pheidias).

It is difficult to know precisely the extent of Pericles's vision for Athens, but his program was certainly not limited to the six projects on Plutarch's list. Other ancient sources credit Pericles with building a grain warehouse in the Peiraieus and a gymnasium (the Lykeion) at Athens,[26] and we know from an inscription that in the 430s Pericles and his sons offered to finance a new springhouse somewhere in the city (the assembly, though

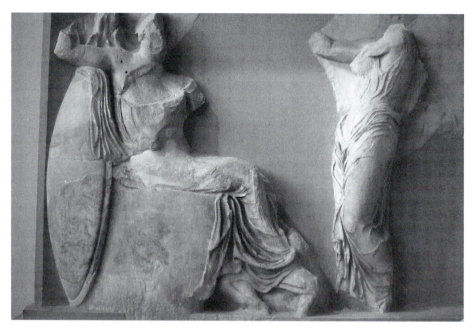

77. Nike Temple parapet: Athena (seated) and a Nike. Photo: author.

commending them for their generosity, decided to use imperial tribute instead).[27] These works probably failed to make the list because of their relatively modest or utilitarian nature. But it is not as easy to understand why Plutarch omits a number of Acropolis projects that were almost certainly Periclean initiatives: the completion of the south citadel wall, for example; or the remodeling of the sanctuaries of Athena Nike, Artemis Brauronia, and Zeus Polieus; or the construction of the Erechtheion, now thought to have been conceived and begun in the 430s.

On the other hand, just because something may have been built or initiated in Athens during Pericles's period of dominance does not guarantee that he had anything to do with it. A distinction should be made between works that are "Periclean" because Pericles actually proposed them and works that are "Periclean" merely because they were under construction during the period of his greatest political influence. For example, an unknown public work of some magnitude begun around 455 while Pericles was ascending the ranks of Athenian politics and apparently still under construction in 446/5, just after the building program got underway, is "Periclean" only in the latter sense.[28] So, too, a number of "Periclean" temples built on the outskirts of the city or in the Attic countryside in

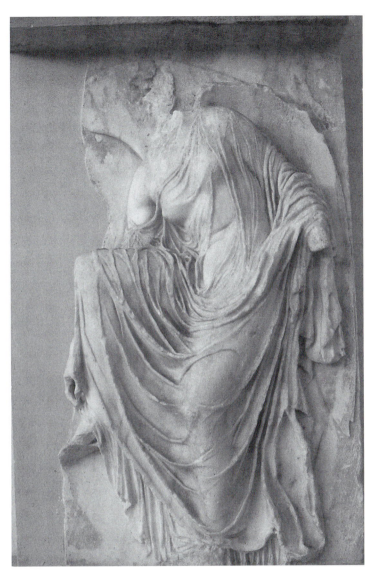

78. Nike Temple parapet: Nike unbinding her sandal. Photo: author.

the 440s and 430s – a temple built along the Ilissos River that was very similar in design to the Nike temple on the Acropolis, for example, or the temples of Poseidon at Sounion and Athena at Pallene – have no known connection with Pericles himself.[29] As for the sculpture-rich Temple of Hephaistos and Athena (or Hephaisteion) overlooking the northwest corner of the Classical Agora (Fig. 6), opinion has always been divided. Some date it precisely to 449 (which makes it just fit into the Periclean

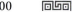

79. Nike Temple parapet: Nikai restraining sacrificial bull. Photo: author.

program) or more generally to the 440s. But, dates as early as 460 and 454 – that is, considerably before the Parthenon – have been offered for at least the inception of the project, and the fact that its completion was apparently long delayed and its sculptural decoration created in stages over several decades (the cult statues seem to have been created between 421 and 415) suggests that the Periclean building program (which paid little attention to the Agora anyway) bypassed it altogether, that it was an overlapping but separate project, even that laborers and resources were diverted from it to the Periclean Acropolis as required.[30]

It remains to reiterate that, for all the monumental achievements of the last half of the fifth century, not everything on the High Classical Acropolis was High Classical in origin, and that evidence of the Acropolis's Bronze Age, Archaic, and Early Classical history was always on display (see Chapter Two). Periclean architects consciously incorporated earlier remains into their designs (cf. Fig. 24) – archaeological revelations that stressed the continuity of the Periclean Acropolis with Acropolises past.

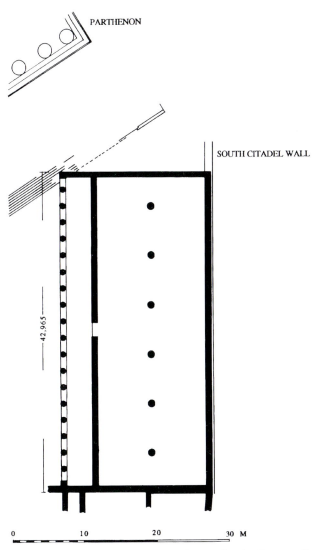

PARTHENON

SOUTH CITADEL WALL

42,965

0　　　　10　　　　20　　　　30　M

80. Plan of the Chalkotheke. Drawing by I. Gelbrich, after La Follette 1986, Fig. 3.

Finally, we should note that the Periclean Acropolis was by no means finished at Pericles's death in 429. It is likely that Pericles and his designers developed a master plan for remaking the Acropolis, architecturally integrating, for example, the various buildings and precincts in the area between the Propylaia and the Parthenon (Fig. 2) and creating an appropriately impressive setting for the Parthenon itself, including a massive terrace surrounding it.[31] How long range Pericles's plan for developing the sanctuary was we do not know, but most of the construction

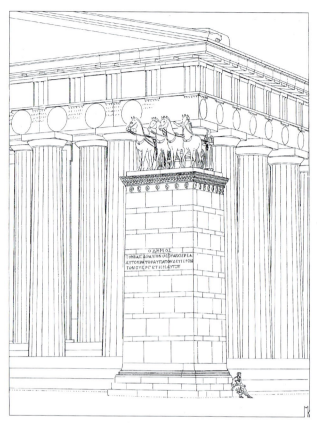

81. Reconstruction of Attalid Victory Monument, northeast corner of Parthenon, probably after 178. A similar monument was at the same time set up west of the Propylaia (later rededicated to Marcus Agrippa). Drawing by M. Korres, used by permission.

of the Erechtheion and the building of the Temple of Athena Nike (projects undoubtedly conceived while he lived) took place well after his death. There are, as well, a few Classical additions that may not have figured in Pericles's original design – the parapet of the Nike temple (Figs. 77–79; CD 146–152), for example, or the warehouse-like Chalkotheke, probably the last major Classical addition to the summit (Fig. 2, no. 6; Fig. 80).

The following chapters survey in roughly chronological order (so far as we can determine it) the principal structures built atop the Acropolis and its slopes from the initiation of the Periclean program around 450/49 to the end of the fifth century. The few Hellenistic and Roman-era contributions to the architecture of the summit (cf. Figs. 81, 82) were by comparison mere embellishments, with no significant effect on the plan or flow of the sanctuary.[32]

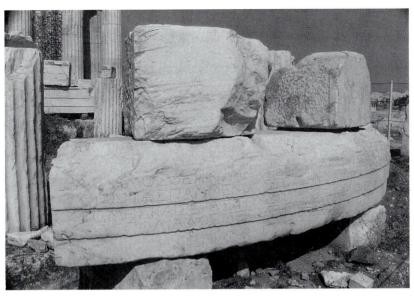

82. Temple of Roma and Augustus, inscribed architrave (c. 20/19). Photo: author.

Plutarch on the Periclean Building Program

(XII.1) But what brought the greatest pleasure and embellishment to Athens, and the greatest astonishment to the rest of men, and what is now Greece's only evidence that her vaunted power and ancient wealth is no fiction – namely, the construction of the dedications [that is, the buildings dedicated to Athena on the Acropolis] – this, of all the political acts of Pericles, is the one his enemies used to malign and slander in the assemblies most of all, shouting that "the people has lost its reputation and is ill-spoken of because it has transferred the common funds of the Greeks from Delos to itself, and that the most seemly excuse it had to use against its detractors, namely that it took the funds from Delos for fear of the barbarians and was now guarding them in a safe place, this excuse Pericles has destroyed. **(2)** And Greece must obviously think she is being terribly insulted and tyrannized, when she sees the tribute we have taken from her by force for the war used to gild and prettify our city like some vain woman, bedecking itself with expensive stones and statues and temples worth a thousand talents."

(3) Pericles would then instruct the people that they "did not owe the allies any accounting of their money so long as they defended them and kept the barbarians back, since they pay as tribute not a horse, not a ship, not a hoplite, but only money, which belongs not to those who give but to those who receive, if they indeed furnish what they receive the money for.[33] **(4)** And it is necessary for the city, once it has sufficiently equipped itself with what is required for the war, to apply its surplus to those things that, when complete, will bring it everlasting glory and, while underway, supply immediate prosperity, since all kinds of work and diverse needs develop, which stir every craft and rouse every hand, putting nearly the whole city under hire, so that it adorns and sustains itself at once."**(5)** For while the military campaigns supplied strong men in the prime of life with plenty from the common funds,

he wanted the disorganized multitude of craftsmen neither to go without its share of income nor to receive money for idleness and leisure; and so with a rush of enthusiasm he proposed to the people projects for great constructions and plans for works requiring many skills and much time, so that those who stayed at home, no less than sailors, guards, and soldiers, might have an excuse for laying claim to and profiting from state funds. **(6)** Since the raw materials were stone, bronze, ivory, gold, ebony, and cypress, the crafts needed to work and perfect them were those of woodworkers, modelers, bronzesmiths, workers in stone, gilders, and shapers of ivory, painters, inlayers, engravers, but also the conveyors and deliverers of the materials, merchants and sailors and pilots by sea, and by land wagonmakers and keepers of oxen and muleteers and ropemakers and stonehaulers and leatherworkers and roadbuilders and miners. And since each craft, like a general with his own army, had in organized array its own mass of unskilled menial laborers, as the instrument and body of service, the requirements of the program distributed and scattered the city's wealth to virtually every age and condition.[34]

(XIII.1) But as the works rose, overwhelming in size yet also inimitable in form and grace, with the craftsmen striving to surpass their craft in the beauty of their workmanship, the most wondrous thing of all was the speed of their work. **(2)** For while it was thought that each one of these works would take many successive generations to reach an end, all of them were completed at the height of a single administration **(4)** For which reason the works of Pericles are to be especially wondered at, being made in so short a time, for all time. **(5)** For in beauty each one was then immediately ancient,[35] yet each seems fresh and newlymade even now. Thus, a kind of newness always blooms over them, preserving their appearance untouched

by time, as if his works were infused with an ever-fresh breath and ageless soul.

(6) Pheidias administered everything for him and was the overseer of everything, although the works also had great architects and artisans. **(7)** For example, Kallikrates and Iktinos built the Hekatompedon Parthenon,[36] while Koroibos began to build the Telesterion at Eleusis. It was he who set the columns on the ground floor and joined them with the architrave, but after he died Metagenes of Xypete carried out the frieze and the upper columns, and Xenokles of Kholargos crowned it with the opening in the roof above the inner shrine.[37] For the long wall, which Socrates says he himself heard Pericles propose, Kallikrates was the contractor. **(8)** Kratinos lampoons this work for progressing so slowly:

> For so long (he says) Pericles has advanced
> the thing in words,
> but he does not move it forward at all in deed.

(9) The Odeion, built with an internal arrangement of many rows of seats and many columns, and with a roof that was steep and sloped down from a single peak, was, they say, a replica of the pavilion of the [Persian] king, and Pericles served as this project's supervisor.

(10) And because of this, Kratinos, in his Thracian Women, pokes fun at him again:

> The squill-headed Zeus! Here he comes,
> wearing the Odeion on his noggin,
> since ostracism-time has gone.

(11) At that time Pericles, ever ambitious, first passed a decree to hold a musical contest at the Panathenaia, and he himself was appointed contest-manager and decided how it was necessary for the competitors to play the flute, sing, and play the kithara. They watched these musical contests, both then and afterward, in the Odeion.

(12) The Propylaia of the Acropolis was built in five years, and Mnesikles was architect. A wondrous stroke of good fortune happened during construction and revealed that the goddess did not stand aloof from the project but took part in it and helped complete it. **(13)** For the most active and eager of the skilled workmen lost his footing and fell from a great height; he was in a sorry state, given up for dead by the physicians. Pericles was greatly disheartened, but the goddess appeared to him in a dream and prescribed a treatment which Pericles quickly used and easily healed the man. To commemorate this, he set up a bronze statue of Athena Hygieia on the Acropolis beside the altar which had existed before, so they say.

(14) Pheidias himself made the golden statue of the goddess, and his name is inscribed as its creator on the stele. But nearly everything else was under his supervision as well, and he oversaw, as we have said, all the artisans through his friendship with Pericles. And this brought envy upon the one and slander upon the other, namely that Pheidias procured for Pericles free-born women who came to see the works underway....

(XIV.1) When Thucydides [son of Melesias] and his political supporters denounced Pericles for squandering money and destroying the public revenues, he asked the people in the assembly if they thought he spent too much. And when they replied "Much too much," he said, "Then let the cost be charged not to you but to me, and I will put the inscription listing the dedications in my own name." **(2)** When Pericles said these words, either because they were struck by his magnanimous spirit or because they jealously wanted to take the credit for the works themselves, they cried out and urged him to spend and manage the public funds as he saw fit, sparing nothing. **(3)** And finally, setting down and risking a contest of ostracism against Thucydides, he banished him, and so destroyed the party that had been aligned against him …

(XXXI.2) [Plutarch has been recounting various criticisms of Pericles's conduct of Athenian affairs.] But the worst charge of all, yet the one that has the most witnesses, goes like this. Pheidias the sculptor was contractor for the statue [of Athena Parthenos], as I have said, and having become Pericles's friend and having the greatest influence with him he made enemies – some because he inspired envy, while others used him to make trial of the people and see what sort of judge of Pericles it would be. And these persuaded a certain Menon, one of Pheidias's assistants, to sit in the Agora as a suppliant and ask for immunity from prosecution in return for information and an accusation against Pheidias. **(3)** But when the people accepted the man's offer and the prosecution was held in the assembly, the charges of theft were not proven. For Pheidias, at the advice of Pericles, from the very beginning worked and affixed the gold on the statue in such a way that it was possible to take it all off and weigh it, which is precisely what Pericles bid his accusers to do. But the fame of his works weighed Pheidias down with others' jealousy, and especially [the charge] that when he made the battle against Amazons on the shield [of the Athena Parthenos] he carved a figure something like himself as a bald old man lifting up a rock in both hands, and that he put in a very beautiful image of Pericles fighting an Amazon. **(4)** The position of the arm, holding a spear in front of Pericles's face, is ingeniously made as if it desired to hide the likeness, though it is clear from either side. **(5)** Therefore, Pheidias was taken to prison and died there of illness, though some say he died of poison provided by Pericles's enemies to discredit him. At the motion of Glaukon the people gave Menon, the informer, an exemption from public obligations and ordered the generals to take charge of the man's safety.

THE PARTHENON

Name and Function

The centerpiece of the Periclean building program was the grandiose, magnificently decorated building we call the Parthenon (Fig. 29; CD 036–039). What Pericles and his contemporaries would have called it, strangely, we do not know. We are not even entirely sure what it was.

How the Parthenon got its name is unclear. A few fifth-century inscriptions refer to it as *ho neos*, "the temple," but the term is generic rather than an official title, and the temple of *whom* is not explicitly stated. The Periclean architects Mnesikles (who designed the Propylaia and possibly the Erechtheion) and Kallikrates (who was one of the builders of the Parthenon) are said to have called it *Hekatompedos* (the Hundred Footer) in a treatise they coauthored, but the source of the story is late and the contemporary building accounts of the structure give no name at all. The evidence is so sparse, it is almost as if this spectacular addition to the Acropolis originally *had* no name.[1] It was only in the fourth century that the term "Parthenon" seems to have come into general use.[2] Even then, the building could still be called the *Hekatompedos* (or *Hekatompedon*) and, in any case, both terms seem to be popular nicknames rather than official titles. Even much later authors seem a little unsure about what to call it: "the temple they name the Parthenon" is how Pausanias introduces the building, while Plutarch, hedging his bets, calls it the *Hekatompedon Parthenon*.[3]

In fact, the terms *parthenon* and *hekatompedon* are both applied to the Periclean building in fifth-century inscriptions, but there they refer only to parts of the structure, rather than to the whole thing (Fig. 68). Beginning in 434/3, the officials known as the *tamiai* (treasurers of Athena) routinely published inscribed inventories (cf. Fig. 83; CD 171) listing the sacred property – the gold, silver, and other precious goods; the booty; the furniture, the dedications – stored in the various parts of the building: its *proneos* (the east, or front, porch), its *hekatompedon* (the large eastern room, just over 100 feet long, which contained the statue of Athena Parthenos), and its *parthenon* (apparently the smaller but still imposing western room, with four tall interior Ionic columns; Fig. 84).[4] Other inscriptions, as we have seen, inventory the holdings of the *opisthodomos*, which, if it was not a separate structure altogether (the rebuilt western half of the *Archaios Neos* destroyed by the Persians; Fig. 61), would have been the back (western) porch of the Periclean building. In this view, *parthenon*, which originally designated only one room of the building, in time came to be applied to the entire structure. The implication is that Pheidias's great gold-and-ivory statue of Athena (Fig. 21) owed its name to the terminology developed for the temple: the goddess was called Athena Parthenos because her image stood in the Parthenon.

That is not likely, simply because Athena had attracted the epithet *parthenos* (maiden or virgin) long before the construction of the Periclean building.[5] Moreover, it is unclear why the western chamber of the building should have been called *parthenon* in the first place. The word means "[room] of the virgin (or virgins)." Some have supposed that the maidens referred to were the little aristocratic girls known as the *Arrhephoroi* (who, chosen each year to assist the priestess of Athena Polias, helped weave the *peplos* presented to Athena Polias at the Panathenaia and who lived for a time on the Acropolis). Others have suggested that the maidens in question were the daughters of the legendary kings Kekrops or Erechtheus. But there is nothing to commend either of these theories. The room with the four columns (Fig. 84), with its high ceiling and windowless walls (and, in the fifth century at least, jam-packed with treasure besides), was surely not an ideal place to work a loom, and the *Arrhephoroi* had their own house elsewhere on the Acropolis, anyway (Fig. 2, no. 8).

83. Inventory of the Treasury of Athena for the years 430–426 (*IG* I³ 296–299, Epigraphical Museum 6788). Photo: author.

On the other hand, there is some evidence that the western room of the building (together with the west porch) was, in fact, the *opisthodomos* of the inscriptions. We are told, for example, that in the winter of 304/3, the Athenians, to their everlasting discredit, allowed the Macedonian nabob

84. Reconstruction of west room of the Parthenon. Drawing by I. Gelbrich, after D. Harris 1995, Fig. 1.

Demetrios Poliorketes and a number of his female companions to lodge "in the *opisthodomos* of the Parthenon."[6] The shallow and partly exposed west porch (*opisthodomos* in the normal terminology of Greek temples) was no place for a grand potentate like Demetrios to reside and hold his orgies (especially not in winter), and the story only makes sense if he and his entourage occupied the spacious and closed room behind – the room usually thought to be the *parthenon*. The anecdote implies that the nomenclature for the parts of a Greek temple was flexible. As for *hekatompedon*, it was likely an inherited term, a legacy of two or three architectural generations on the south side of the Acropolis. It could be that the original *hekatompedon* was a 100-foot-long, open-air precinct laid out in the mid-sixth century, in which small but colorfully decorated shrines or treasury-like structures (known as *oikemata*) were set in a row (Fig. 60a). It could also be that the mid-sixth-century temple adorned with Bluebeard and other painted pedimental sculptures (Fig. 59) stood

on this spot and was popularly known as the Hekatompedon (Fig. 60b). If so, its successor, the Older Parthenon (Fig. 62), had it been finished, might have been called the same thing (its large eastern room was also about 100 Attic feet long). It may even be that the term serendipitously designated an actual (if rounded off) dimension of the Periclean building (the interior length of the east room, or even the width of the stylobate). But by the fifth century, 100 feet was no longer a spectacular architectural dimension, and it is thus likely that the term *hekatompedon*, besides linking the new building to its architectural heritage, primarily bestowed a certain grandeur upon it. In other words, the word became a traditional epithet connoting not so much length as venerability.[7]

As for the chamber called *parthenon*, no inscription mentioning it antedates Pheidias's completion of the Athena Parthenos itself in 438, and it is hard to see why any other room but the one in which the gold-and-ivory statue of Athena Parthenos stood should ever have been called the "room of the virgin." For some, then, *parthenon* and *hekatompedon* are interchangeable names for the same room: the large eastern room. But, there are serious difficulties with this view, too. For example, the inventories of the treasures stored in the *parthenon* and *hekatompedon* were inscribed on separate marble blocks, indicating that they were distinct rooms and not just alternative names for the same thing.[8] The problems of nomenclature may not be entirely resolvable, and it is probably best to follow the orthodox view that the spaces of the Parthenon (Fig. 68) were, as a rule, called (from east to west): *proneos* (front or east porch), *hekatompedon*, *parthenon*, and *opisthodomos* (back or west porch). Still, the Periclean building surely came to be called the Parthenon because "Parthenos" was the epithet of the goddess whose great image loomed within it. The building did not give its name to the statue; the statue gave its name to the building.

It may be, too, that our terminological problems, and perhaps even the vague "namelessness" of the building in the Classical period, have something to do with the unusual nature of the Parthenon itself. For, however much the Parthenon looks like a canonical Greek temple (Fig. 29), it may not have exactly functioned like one. Certainly, it was surrounded by a colonnade like a standard temple (even if its peristyle of forty-six columns – eight in the facades, seventeen along the flanks, counting corner columns twice – is unusually grand). It had a cella like a normal

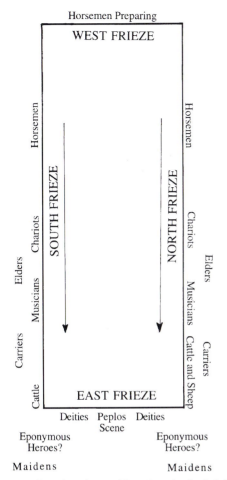

85. Plan of Parthenon frieze. Drawing by I. Gelbrich.

temple, even if it was divided into two large and unconnected rooms set between proportionally shallow porches, instead of the usual one room between deep porches – in this respect, it was like its predecessor, the Older Parthenon (Fig. 62), and other "double temples" built on the Acropolis (Figs. 61, 66). It housed a statue of a divinity, like a normal Greek temple (even if this image was exceptionally large and costly; Fig. 21). It was adorned with mythological sculptures, like many Greek temples. It could even be referred to, generically, as *ho neos* ("the temple"). Yet, no ancient source ever explicitly calls it the "Temple of Athena Parthenos." Significantly, we hear nothing of any "priestess of Athena Parthenos" in any literary source or in any of the hundreds of inscriptions from the Acropolis, and Athena Parthenos had no festival of her own. Moreover,

there is no evidence for an altar – the *sine qua non* of a cult – in front of the building. The principal altar on the Acropolis was always the one on the north side of the rock (Fig. 2, no. 12), the one sacred to Athena Polias, whose olivewood statue was the principal object of worship and whose possessions and dedications could even be stored inside the Parthenon. Sometimes divinities did share altars but, so far as we know, no Periclean-era sacrifices or state dedications were ever made to Athena Parthenos. And, by representing (in the opinion of most scholars) the Panathenaia, the most important Athenian festival, culminating in the presentation of a new robe to Athena *Polias*, the frieze that decorated the top of Athena Parthenos's own cella (Figs. 20, 85) acknowledged the priority of that other Athena across the way. Finally, while visitors must have marveled at Pheidias's great chryselephantine statue (Fig. 21), it apparently did not (in their eyes) add anything to traditional Greek religion the way Pheidias's other great gold-and-ivory creation, the Zeus at Olympia, is said to have done. In short, the Athena Parthenos does not seem to have been the focus of official cult.[9] If it was not, then the Parthenon looked like a temple without actually being one.[10]

Now, it could be that it is not the character of the Parthenon that needs to be reevaluated but our idea of what a Greek temple was. The canonical definition is a building, often with a colonnade, that housed a statue of a divinity that was the recipient of dedications and that was the object of a sacrificial cult focusing on an altar in front of the temple and supervised by a priest or priestess. The Parthenon was hardly the only Classical temple that did not fit that mold exactly; there were others that lacked cult statues, for example, or altars.[11] But, whatever kind of temple it was, the Parthenon functioned principally as a treasury, as a votive, and as a symbol. In effect, the Parthenon was the central bank of Athens, where a large percentage of Athena's (and, thus, the city's) material assets was stored, and where its single greatest treasure, the statue of Athena Parthenos itself (Fig. 21), wore robes plated with some 40 or 44 talents (about 2,500 pounds) worth of gold – the very gold Pericles said could be removed and spent if the (mis)fortunes of war required (which is no way to treat a supposedly sacrosanct cult statue). The cella of the building, in fact, had the character of a strongbox: the spaces between the columns of both the east and west porches were screened by grilles (Figs. 86–87) and the great doors to the west and east rooms – the east door was slightly

An Inventory of the Treasures Stored in the Parthenon in 434/3[12]

In the proneos:

1 gold phiale, from which they make lustrations

104 silver phialai, weight 10,500+ drakhmai

3 silver drinking horns, weight 528 dr

3 silver drinking cups, weight ?

1 silver lamp, weight 38 dr.

9 silver phialai, weight 970+ dr.

a small drinking cup in a case, made of wood, gilded

In the hekatompedon:

2 gold phialai, weight 1,344 dr.

A gold kore on a stele, unweighed

1 silver lustral basin, unweighed

1 gold phiale, weight 1,200 dr.

In the parthenon:

1 gold wreath, weight 60 dr.

5 gold phialai, weight 782 dr.

Unmarked gold, weight 1 dr. 4 obols

1 gold drinking cup with a silver base, sacred to Herakles in Elaious, weight 138 dr.

2 silver-and-gold nails, weight 184 dr.

1 mask of silver and gold, weight 116 dr.

? silver phialai, weight ... 723+ dr.

6 golden Persian swords, overlaid with gold

12 golden wheat stalks

2 wooden boxes, gilded

1 wooden thymiaterion [incense burner], gilded

Golden kore on a stele

1 wooden box, gilded

Gorgoneion, worm, gold-leaf

Horse, griffin, griffin's head, griffin, lion's head, flowery wreath, snake, all gold leaf

1 gold-plated helmet

13 wooden shields, gilded

7 Chian couches

10 Milesian couches

9 sabres

4 swords

14 breast plates

6 blazoned shields

31 bronze shields

6 thrones

4 stools

9 campstools

1 gilt lyre

3 ivory lyres

4 wooden lyres

1 ivory-inlaid table

3 bronze helmets

13 feet for couches, overlaid with silver

narrower but both were richly decorated with such ornaments as the heads of lions, rams, gorgons, and poppies – could be locked. Even before the finishing touches had been put on the Parthenon in 432, the Athenians had deposited considerable holdings within it. The inventories of 434/3, for example, list scores of gold and silver vases, lamps, statues, crowns, lyres, couches, shields, and so on, and the holdings increased year by year, even during the Peloponnesian War. The west room of the building (*parthenon*) stored most of the items by far; those kept in the east room (*hekatompedon*) were probably set on shelves placed against the wall, and would have been partly illuminated by light from two large windows set high into the east wall of the cella (Figs. 68, 87).[13] All told, the value of all the treasures stored in any given year may not have

86. Detail of columns of Parthenon *proneos*, with cuttings from iron grills. Photo: author.

exceeded 10 talents or so. However, like the gold of the Athena Parthenos, they were potentially expendable assets and, although the Athena Parthenos managed to survive the Peloponnesian War intact, all but a few of the objects listed in the inventories were melted down at the war's end to help pay the bills.[14]

Whatever else it was, then, the Parthenon was a vast, spectacular treasury, a monumental Periclean version of the kind of sculpture-filled storehouses (*oikemata*) that we think dotted the Acropolis (and perhaps particularly the south side – the Parthenon side – of the Acropolis) in the

87. Reconstruction of *proneos* of Parthenon. Drawing by M. Korres, used by permission.

Archaic period (Fig. 60). It was at the same time a votive, a dedication to Athena, as well as a renewal of the Older Parthenon, that very late Archaic temple built as a thank offering to the goddess for the Athenian victory at Marathon in 490. It is not clear whether the Older Parthenon would have been any more of a temple in the conventional sense of the word than the Periclean Parthenon was, and we have no idea what sort of statue was planned for its interior. But there is no question that the

architects of the Classical building were highly conscious of its aborted predecessor. Its remains – still scorched and cracked by Persian fire – had, after all, stood on the south side of the Acropolis for more than thirty years, and whereas scores of unfinished column-drums were built into the north citadel wall in the 470s (Fig. 64), scores more still lay about the summit (CD 031) when work on the Parthenon began. These remains constituted both an enormous challenge to the Periclean architects and an opportunity.

The Architecture

The plan of the Periclean Parthenon (Fig. 68) essentially represents a noticeable widening (by two columns) and a slight lengthening (by one column) of the plan of the Older Parthenon (which would have had a peristyle of 6 by 16 columns) (Fig. 62). In other respects, it is a variation or an elaboration of the Older Parthenon (it, too, was to have two great rooms within it and it, too, included Ionic features). The Classical building rests, for the most part, on the same massive Peiraieus limestone platform that supported the Archaic one (Fig. 4). But, whereas the Older Parthenon was set symmetrically atop this podium, the new building was shifted to the west and north. More bedrock had to be prepared and additional foundations laid for a width of almost 5 meters on the north (CD 042). This expansion, again, had to adjust and preserve the older shrine just to the north of the Older Parthenon – the small *naiskos* and its circular altar – and incorporate it into the space between the north colonnade and the cella wall (Fig. 24). On the other hand, the eastern edge of the podium is left unoccupied for a width of 4.26 meters (CD 030) and the southern edge for 1.68 meters. Much of the stepped platform (or *krepidoma*) of the Older Parthenon was encased within the Periclean one – the old steps can be seen through the cracks in the new ones – and most of its unfinished column-drums and column capitals were cut (as we have noted before) for reuse in the Periclean building, in a massive recycling effort that was not only cost-effective but also symbolic, materially binding the new Parthenon directly to that momentous event that had inspired the older one: Marathon. In the fourth century, in fact, it could be said that the Parthenon was paid for not from imperial tribute (as Plutarch much later implies) but from the spoils taken from the Persians, and this may

not be far off the truth. At the same time, the Periclean Parthenon was more broadly a monument to the wealth and power of Periclean Athens, and thus it was also said (somewhat surprisingly, if it were just a conventional temple) that the building was an *anathema* (votive), offered not in honor of Athena but of her glory-seeking, democratic, imperial city. It was, we might say, a dedication by the *demos* (people) to the *demos*.[15]

Plutarch says the architects were Iktinos (who probably was not an Athenian) and Kallikrates (who probably was). The Roman architect Vitruvius[16] says that Iktinos and someone named Karpion wrote a book about the project (probably a technical manual dealing with matters of engineering and proportion but also, perhaps, with such unusual features as the windows and staircase, leading to the ceiling, built into the east cella wall) (Figs. 68, 87). About Karpion we hear absolutely nothing more anywhere, and one suspects that the name is a mistake for Kallikrates (who, again, is elsewhere said to have coauthored a book with Mnesikles).[17] Iktinos ("The Kite," presumably a nickname) is said to have been the architect of the Temple of Apollo at Bassai and one of the architects of the Periclean Telesterion at Eleusis; and Kallikrates, we know, was in charge of several Periclean projects on the Acropolis and off (for example, the Long Wall to Peiraieus). How they divided up work on the Parthenon we do not know for sure, but to judge from the other works attributed to him, Kallikrates was probably the building's "general contractor," the one charged with organizing the enormous, practical effort of construction, while Iktinos was more likely the actual designer of the Parthenon, its true architect, the one most responsible for its originality.[18]

What Iktinos designed was the largest and most sumptuous building that had ever been constructed on the Greek mainland,[19] an essentially Doric structure with prominent Ionic features (the four columns in the west room, a continuous frieze, various mouldings) that was surely meant to surpass in size and grandeur the purely Doric Temple of Zeus at Olympia (finished less than a decade before) and so to seize the architectural field for Athens.[20] It is now clear that the unique plan of the Parthenon (there is no other such octastyle peripteral Doric temple in Greece) underwent many changes and adjustments as work progressed – not an unparalleled course of events on the Acropolis – and the ability to make such adjustments in so vast an undertaking must have been

part of Iktinos's genius. The finished product is remarkable, above all, for the harmony of its carefully calculated proportions and for its so-called refinements. Critical dimensions of the Parthenon, for example, are governed by a ratio of 9:4; that is, the proportion of the length of the stylobate (the top step) to its width, and of the width of the stylobate to the height of the order (the column and entablature together), and of the axial spacing (the distance between the centers of two neighboring columns) to the lowest diameter of a single column. It is a fair assumption that Iktinos (and Karpion, whoever he was) outlined the principles behind this proportioning in the book that Vitruvius had available to him.

The book would presumably have also discussed the techniques and explained the purposes of the many kinds of refinements that characterized the Parthenon. These consisted of a series of slight but intentional deviations from the straight and perpendicular, from the horizontal and vertical. The west façade of the building – the façade one sees first upon crossing through the Propylaia (Fig. 29; CD 036–038) – is 3 to 5 centimeters higher than the east façade.[21] The peristyle columns do not stand perfectly straight, but tilt inward (extrapolated infinitely upward, the lines of the flank columns would meet at a point approximately 2,000 meters above the floor of the building; those of the façade columns, about 4,800 meters above the floor) (Fig. 88); the side walls of the cella tilted inward too. The column shafts do not taper perfectly but swell out slightly at the center – a refinement known as *entasis* – and the cella walls swelled outward too.[22] The corner columns of the peristyle are a little thicker than the others. The metopes tilt outward, the triglyphs in; the Ionic frieze atop the cella walls inclines outward too.[23] The stylobate itself curves noticeably upward along both the façades and the flanks (CD 043),[24] and the curve was carried up through the peristyle to the entablature.

Refinements such as these were nothing new (*entasis* is far more pronounced in some sixth-century Doric temples, for example, and the upward curvature of the stylobate, which also first appears in sixth-century temple architecture, had been planned for the Older Parthenon – it actually starts in the foundations; Fig. 4). Refinements were utilized in other Periclean buildings on the Acropolis as well (some of the columns of the Propylaia, for example, incline even more than the Parthenon's). But, the

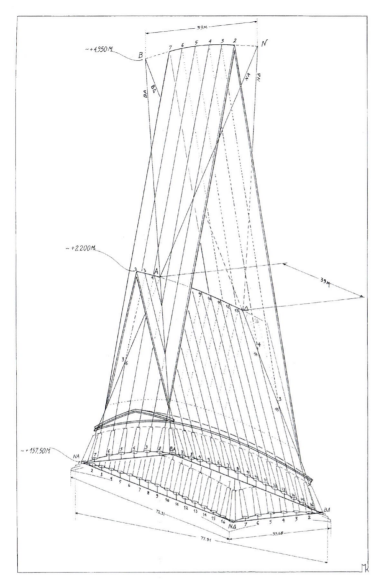

88. Exaggerated rendering of upward curvature and inclination of columns of Parthenon. Drawing by M. Korres, used by permission.

Parthenon presents an extraordinarily rich combination of refinements and represents the climax of the practice.[25]

To create such subtle deviations from the purely horizontal and vertical meant that virtually every block had to be cut on the spot to its own distinct specifications. This was normal Greek architectural practice anyway. But the Parthenon's wealth of refinements demanded even more painstaking work than usual and thus the building, so economical

in recycling Older Parthenon marble, was extravagant in their use. Basically, there could have been only one justification for the greater expense they required: appearances. The refinements were intended to make the Parthenon look good. It may be true that the curvature of the steps has a practical (if incidental) function: it drains off rainwater, like the crowning of a football field. But, there is no such prosaic explanation for why *all* the horizontals of the building are curved, or for why the columns swell or tilt, or for why the west façade is higher than the east, and it has been far more common to think of the refinements as either corrective or aesthetic devices.[26]

That the refinements corrected or compensated for unwanted effects in a perfectly straight or regular temple is an idea as old as antiquity itself. Vitruvius, who (it is important to remember) had many ancient architectural manuals on his bookshelf besides Iktinos's, clearly believed that refinements generally counteracted "optical deceptions." A perfectly straight stylobate, he thought, would appear to sag if not given a slight curve; a corner column silhouetted against the sky would appear weaker than its neighbors unless thickened; architectural members high up on a temple should tilt so that they will appear plumb, and so on.[27] Whether the optical illusions and corrective effects Vitruvius describes, in fact, occur – whether, for example, a long straight line will really appear to sag and only an upward curvature can make it look straight – is not the point. The point is that Vitruvius, himself a practicing architect, apparently followed a long tradition in believing they did. The Vitruvian explanation, we should also note, assumes that buildings like the Parthenon were *meant* to look absolutely straight and precisely perpendicular.

What the refinements were supposed to do and what they, in fact, do are, however, two different things. And most modern scholars (with a little ancient literary support) have found them at least to some degree aesthetic or expressive. The theory is that a building (especially one as large as the Parthenon) displaying absolutely straight lines and precise right angles and perfectly evenly spaced columns and so on would appear dull, stiff, and mechanical. The refinements mitigate that static effect by introducing nuance. Even if they are only intuitively sensed, they create subtle, unexpected variations, and variations create visual interest. In other words, the refinements enliven the building by establishing a tension between what one assumes is or should be there (say, a straight line

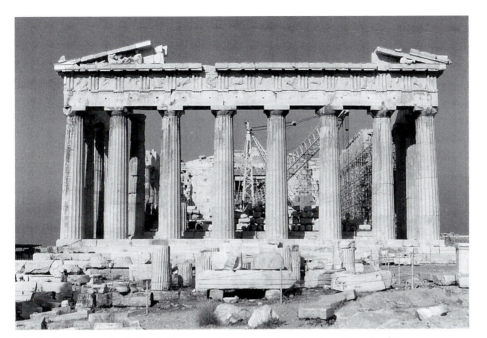

89. Parthenon, east façade (in the foreground are the remains of the later Temple of Roma and Augustus). Photo: author.

or taper) and what one actually sees (a curve or swelling). The resulting tension intrigues the eye by offering it deviations from normal visual experience. Whatever their original purpose, the effect of the refinements is very much in the eye of the beholder: the experience is subjective. The greater height of the west façade accentuates the building's grandeur. For some, the curvature of the stylobate seems to lighten the Parthenon, making it seem as if it were ready to lift off the rock (Fig. 29; CD 037). For others, or from a different angle (Fig. 89; CD 039), the curvature creates an impression of weightiness, as if the building were conforming itself to the shape of the summit or hugging the ground, or were being pulled down at the corners by the forces of gravity. Similarly, a column's *entasis* (the word, incidentally, means "tension") makes it appear to "feel" or respond to the weight it supports, as if it were somehow a muscle or living mass, a body under pressure; or as if it were taking a deep breath, like a man filling his lungs under exertion.[28] But, however we read them, the refinements give the Parthenon an extraordinarily plastic or sculptural quality. The curves, the inclinations, and the swellings seem the result of an architect "modeling" the building the way a sculptor models a statue. The Parthenon has, in fact, been called "a sculptor's temple" and, in

one overarching sense, if we can trust Plutarch, this is literally true: Ikti-
nos the architect labored under the supervision of Pheidias the sculptor,
supposedly the overseer of the entire Periclean building program.

We cannot, in fact, trust Plutarch completely and, again, Pheidias's role
on the Acropolis was surely not as pervasive as he implies (see Chapter
Three). Still, in the case of the Parthenon, it was apparently the sculptor's
conception of the building that mattered most, and Pheidias apparently
conceived of it, above all, as an appropriately lavish container for his
chryselephantine Athena Parthenos – a statue, it should be emphasized,
that cost at least as much as the Parthenon itself (700–800 talents), and
maybe a lot more (Fig. 21). It was probably to accommodate Pheidias's
enormous statue – to give it more elbow room, as it were – that Iktinos
widened his building so markedly over its predecessor, and it was to give
the statue a more interesting backdrop that Iktinos introduced the first
important change in Doric interior design in more than a century. He
extended the interior double-decker columns of the cella (normally set
in two parallel rows) around the back of the statue (Fig. 68), so that the
Athena was virtually surrounded by its own two-storyed colonnade (10
by 5) – a colonnade clearly meant to enrich the setting of the rich statue –
and beyond that by a π-shaped ambulatory illuminated by the windows
in the east wall.[29] So, too, changes made to the cella during construction
were apparently driven by changes in sculptural decoration. It is likely
that Pheidias originally planned to set a conventional Doric triglyph-
metope frieze over the columns of the *proneos* and *opisthodomos* but then,
while the building was underway, changed his mind, deciding on a long,
continuous Ionic frieze around the top of the exterior cella wall instead.[30]
The architectural features known as *regulae* (rulers or bars) and *guttae*
(drops or pegs), normally found beneath the triglyphs in a Doric frieze
(cf. Fig. 90), are still to be found beneath the Ionic frieze on the west and
east sides of the cella (cf. Fig. 87). They make no sense there and can only
be the relics of an abandoned architectural idea. At all events, the change
necessitated subtle alterations and adjustments in the plan of the cella.[31]
The construction of the Parthenon was, thus, a cooperative effort that
underwent continuous revision. Kallikrates had his role. Iktinos had a
greater, more creative one. But it was Pheidias's evolving vision that in
the end governed what they built.

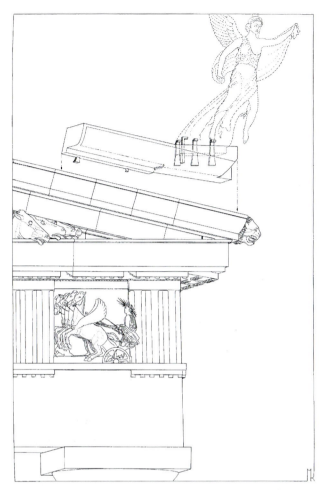

90. Reconstruction of northeast corner of Parthenon roof. Drawing by M. Korres, used by permission.

The Sculpture

Although the only Parthenon sculpture we know Pheidias created himself was the statue of Athena Parthenos, it is often assumed that he was also the master of the rest of the sculptural program of the building – the metopes, the frieze, the pediments, even the great marble Nikai that probably alit on the four corners of the roof (Fig. 90), just as one perched in the hand of the Athena within (Fig. 21). Pheidias could not have executed very much (if any) of this marble sculpture himself. Before 438, he was too busy with the Athena Parthenos. After 438, Pheidias was in

Olympia creating the gold-and-ivory statue of Zeus. Incidentally, the only other Parthenon artist whose name we definitely know was an assistant and turncoat named Menon, but Pheidias's big-time pupils Agorakritos and Alkamenes are often thought to have been responsible for the execution of the pediments and frieze after his departure.[32] Whereas the name "Pheidias" can be used as shorthand for all the designers of the Parthenon sculptures, it is nonetheless possible (though not provable) that the conception or design of the overall program really was his; that he was responsible for assembling and training the sculptors necessary to do the job; that he (in consultation with Pericles, the *tamiai*, or the citizen assembly) decided upon the subject matter of the various parts of the program; even that he made the sketches for the metopes and frieze and the clay models for the pediments and akroteria.[33]

The Metopes

The sadly damaged and corroded west metopes (Fig. 29; CD 038, 060) represented duels between Greeks (nude or nearly so, on foot) and Amazons (elaborately dressed, some on horseback). Greeks fought Amazons – formidable women–warriors from the east, or at least from beyond the boundaries of the civilized (i.e., Greek) world – on more than one mythological occasion, and an Amazonomachy had already filled at least some of the metopes of an enigmatic building built on the Acropolis (or its south slope) around 480.[34] But, the battle represented in the west metopes was fought to repel an Amazonian (and, hence, foreign) invasion of Athens itself. The same story – specifically, the Amazons' attack on the Acropolis – was depicted on the exterior of the shield of the Athena Parthenos (Fig. 91; CD 101), and the allusion to the Persian invasion of 480 would have been lost on no one. In their oriental garb and hats, the Amazons even looked like Persians. The mostly indecipherable north metopes (Fig. 35; CD 061) – like those on the west and east sides, they were mutilated by Christians and Moslems – evidently depicted a series of separate episodes from the Trojan War (yet another struggle pitting west against east), particularly from the night of the sack of Troy. The main narrative was set between two metopes, giving it a cosmic setting (a common Parthenon motif): North 1 represented Helios rising in his chariot, North 29 showed Selene plunging below the horizon on horseback.[35]

91. Reconstruction of the Amazonomachy on the exterior of the Shield of Athena Parthenos. Drawing by E. B. Harrison (1981), used by permission.

The most easily readable reliefs in between showed Menelaos in one metope rushing toward Helen in the next (Fig. 69); Helen seeks refuge at an archaistic statue of Athena (the Trojan Palladion) while Aphrodite and a tiny Eros head off her enraged husband and, across the intervening triglyph, try to talk him out of doing her harm. The three westernmost metopes on the north depicted other gods and goddesses who had an interest in the Trojan proceedings: North 32, the best preserved (the Christians thought it was an Annunciation and left it alone), shows a formidable goddess seated on a rock, talking things over with a standing goddess. One is probably Athena herself and is thus one of the many Athenas or representations of Athena that the visitor would see on and

within the Parthenon (for example, the Palladion in Fig. 69; possibly the statue in South 21, Fig. 19; the Archaic Athena that stood in the *naiskos* in the floor of the north colonnade, Fig. 24; and, of course, the Athena Parthenos herself, Fig. 21). The east metopes (Figs. 42, 89; CD 062–063) depicted the Battle of the Gods against the Giants, who tried to take Olympos and overthrow the cosmic order. The story, of course, had already had a long history on the Acropolis (cf. Figs. 40–41). It had been woven into all the Panathenaic *peploi* that had been (and would ever be) presented to Athena Polias, and it was shown on the inside of the shield of the Athena Parthenos. These metopes are in such bad shape that the identification of many figures is guesswork, but Athena (crowned by Nike) was certainly shown in East 4 and Zeus, near the center, in East 8. Herakles, the hero whose presence was essential for the triumph of the gods, was perhaps shown in East 11, where he would have occupied a position symmetrical to Athena's in East 4.[36] Helios, also shown rising around the corner on North 1 (Fig. 35) drove his four-horse chariot in the other direction on East 14 (Fig. 90). The south metopes were the least conspicuous of the four sets – most Acropolis traffic passed down the north side of the Parthenon. But, perhaps because of their position – it is often assumed they were harder for post-antique occupants of the Acropolis to hack away at – and certainly because of Lord Elgin (whose agents began removing many of them to England in 1801) they are the best preserved of the lot (Figs. 19, 30; CD 064–070). Most of the metopes (South 1–12 and 22–32) showed the Greek Lapiths fighting the centaurs, whose drunken violence disrupted the wedding of their king Peirithoos (best friend of Theseus, hero of Athens, who may be the Greek in South 32, CD 070) to Hippodameia, by some accounts the daughter of the Athenian hero Boutes, who had an altar on the north side of the Acropolis, eventually in the Erechtheion. The myth had appeared in Greek wall and vase painting before, but this is the first Athenian treatment of the story in stone. A few metopes show centaurs carrying off women from the wedding feast. Most show individual duels. And this is no rout: the centaurs (who occasionally use wine jugs as weapons) win their share of battles, and some Lapiths fall and die (CD 067).

The central eight or nine metopes (South 13–20 or 21) are, however, an enigma. They were blown off the building in 1687 and were thus not there to be taken by Elgin. Fortunately, all the south metopes had been

drawn thirteen years before the explosion by a journeyman artist called Jacques Carrey. Because centaurs are absent from the missing metopes, it seems they did not represent the same story, or the same stage of the story, as the others (centaurs are absent from South 21, too, but here two women, one of whom is apparently disheveled with her breasts exposed, may have been shown escaping to the protection of a cult statue). In recent years, important fragments of these "intrusive" metopes have been identified but nothing that clinches their interpretation or their exact relation to the centauromachy on either side.[37] Possibly, they depicted legends of early Athenian kings, heroes, and heroines, or rituals concerning important images of Athena, in which case they would have had clear associations with metopes depicting Athena and her statues elsewhere. South 15 and 16 might, for example, depict the story of the arrival in Athens of the Palladion when, we are told, an Athenian youth was trampled by a chariot team (the Palladion itself was, again, shown at Troy on the other side of the building, in North 25; Fig. 69). South 19 seems to have represented the spinning of cloth, south 20 the removal of a robe in a roll from a loom, and South 21 (which, again, might belong to the centauromachy) the disrobing of a stiff, old-fashioned cult statue in anticipation of the presentation of a new dress: the central events of the *Plynteria* festival (when the statue of Athena Polias was apparently washed and dressed in a clean *peplos*) and the *Panathenaia* come readily to mind (cf. Fig. 20).[38]

In any case, the south metopes (the only ones preserved well enough to allow more than superficial analysis) vary greatly in form and style. Some panels have projecting bands of stone as groundlines for their figures, some do not. The faces of some centaurs resemble grotesque masks (South 31), others are handsome and idealized (South 4) or even grandfatherly (South 29; CD 068). One or two compositions (for example, South 10, in the Louvre) are disasters; many (for example, South 30; CD 069) are merely mediocre; a few are masterpieces (the composition of South 27 [Fig. 30; CD 066] depends on the crossing of two powerfully oblique figures, creating a "V" often thought to characterize Pheidian design as a whole). The usual explanation is that the metopes were the first Parthenon sculptures to be executed (they had to be, because they needed to be inserted as the building rose) and that Pheidias had not yet had the time in the mid-440s to homogenize the styles of his various

teams and so gave his sculptors their heads (if, however, Pheidias supplied the sketches, he might fairly be blamed for the awkwardness of some compositions). But, the unevenness of the south metopes, as well as the apparently intrusive subject matter of south 13–20/21, may also have had something to do with Pheidias's rethinking of the Parthenon's sculptural program. It is possible that some of these metopes were originally carved for placement above the *proneos* and *opisthodomos* and were moved to the south side where they would be less obvious, after the decision was made to go with an Ionic frieze atop the cella wall instead. The Parthenon, as we have seen, was full of reused material, and the economic recycling of metopes that had originally been designed for another location on this very building – perhaps above all the middle south metopes, whose presence seems iconographically forced – would not have violated the spirit of the project.[39]

The Pediments

Pausanias does not mention the Parthenon's metopes, perhaps because they were overshadowed in his eyes by the building's huge pediments – 28.8 meters wide and 3.4 meters high at their center, each one filled to the brim with about twenty-five over-life-size and often dramatically posed marble figures. These works he does mention and, fortunately, he also identifies their subjects. Now, even without Pausanias's testimony, we would eventually have been able to figure out that the west pediment (Fig. 29) depicted the contest between Athena and Poseidon for patronage rights to Athens. There is no earlier representation of the myth to compare it to, but we have Carrey's drawing, made when many of the sculptures were still in place (Fig. 25); we possess large fragments of the central figures (Fig. 26; CD 047–050); and there are a couple of slightly later vase paintings that seem partly or indirectly dependent on the Parthenon's version. But, without Pausanias's testimony that the east pediment (Fig. 89) depicted the birth of Athena, we would have had no idea what was shown up there. The central sculptures had apparently been removed (none too gently) more than a thousand years before Carrey arrived (Fig. 27), when Christians transformed the Parthenon into a church and built an apse on this side; the figures they left in the angles are by themselves not enough to help (CD 053–059).

The west pediment (Fig. 29; CD 036–038) was the first to be seen by the ancient visitor to the Acropolis, though one would have to have viewed it above the mass of monuments, walls, and shrines that cluttered the field of vision of anyone passing through the Propylaia, obscuring much of the Parthenon itself (cf. Fig. 53). The pediment still loomed over all, its drama enlivened by colorfully painted and even partly gilded figures, some with bronze additions or attributes, all set off by the (probably) red background of the pedimental back wall.[40] Appropriately, the location of the depicted myth was the Acropolis itself – specifically, the area now covered by the Erechtheion (Fig. 2, no. 9). Again, it is not clear which version of the myth of the contest between Athena and Poseidon, or what point in their dispute, was shown: the moment Athena and Poseidon actually create their tokens (the olive tree, the salt sea); or the moment Zeus hurls his thunderbolt to prevent his daughter and brother from coming to blows; or even the moment when Poseidon, denied the victory, floods the Attic plain in anger. It is thus not clear whether Athena and Poseidon are to be thought of as leaping down from their braking, rearing chariots (Athena's driven by Nike, Poseidon's by his wife Amphitrite) after their race to the citadel; or whether, having swept in from either side, they are now recoiling from the force of their own miracles (the eruption of the olive tree from the pedimental floor or the blow of Poseidon's trident); or whether they are taken violently aback by the shock of Zeus's intervention.[41] What is clear is the explosiveness of the composition, as the figures of Athena and Poseidon cross in a great "Pheidian V" – Poseidon actually overlaps Athena and thus seizes the foreground in what may be an acknowledgment of the power of the sea god, in whose province the Athenian navy had been so successful since Salamis – and the agitated figures to the left and right react to the violence of the center. The figures in the angles represent the royal population of Athens before it was Athens – mortals (or at least heroes) rather than gods (Fig. 28). The semireclining figure near the north angle is surely the autochthonous Kekrops, king at the time of the contest and chief witness according to some accounts; he is identified by the snake coiled on the ground beside him. The young woman wrapping her arm around his shoulder should, therefore, be one of his daughters, probably the good Pandrosos (father and daughter had adjacent shrines on the north side of Acropolis in the Erechtheion complex). Logically, Herse and Aglauros should be there,

too, and the boy between them could be either Erichthonios or Kekrops's rather insignificant son Erysichthon. Hermes appeared behind Athena's Nike-driven chariot (CD 046), and a strange, legless but perhaps originally snaky-tailed male figure (another autochthonous Attic hero like Kekrops?) rose from the pedimental floor to support Athena's horses. The identities of the figures in the other wing, behind Iris (CD 051), Poseidon's chariot (his team was supported by a Triton), and its charioteer Amphitrite (who apparently used a toothy sea monster as a running board), are more problematic (cf. CD 052). That they are Attic heroes and heroines (or nymphs) of some sort seems indisputable. But, some see in them the family of Erechtheus (whose cultic identity had by the mid-fifth century fused with Poseidon's, hence his position on the sea god's side of the pediment), whereas others (preferring to place Erechtheus, Athena's foster child, on her side of the pediment) see in them Poseidon's son Eumolpos and his Eleusinian entourage, and find in the contest between their "parents" a foretelling of Eumolpos's future invasion of Athens and battle with Erechtheus.[42] Whoever the figures in the wings are, the prominence of women and children is noteworthy. As for the reclining figures in the very angles, they are often identified as local river deities: the one on the north (CD 045), whose anatomy is genuinely fluid, is usually identified as the Ilissos, though the Kephissos (which runs to the north of the Acropolis; Fig. 6) would perhaps make better geographical sense.

In any case, the identification of these figures as personifications would mean that features of the Athenian plain below appear in a locale otherwise depicting the Acropolis summit, but the topographical compression would not have disturbed anybody. This, after all, was myth, and it was all Attika. The analysis of the west pediment is further complicated by post-Periclean repairs or additions. Athena's newly sprouted olive tree almost certainly stood against the pedimental wall at the center of the composition, but marble fragments usually thought to come from the tree are, in fact, Roman in date and the best preserved piece, with a snake coiling around a tree trunk (Fig. 92; CD 049), was not even found on the Acropolis. The original tree might have been bronze (so might Zeus's thunderbolt, if it was there at all).

The problems presented by the west pediment are nothing, however, compared to those presented by the east (Figs. 38, 89). There are the

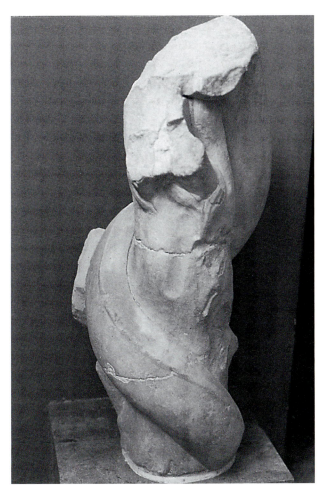

92. Marble fragments of olive tree encoiled by snake (Acropolis 6510). Photo: author.

usual disputes over the identity of most of the figures preserved in the angles. Is the powerful male nude reclining on an animal skin near the south angle Dionysos or Herakles (CD 053–054)? The consensus favors Dionysos (who would then have been holding a wine cup in his raised right hand and would be looking down toward his theater on the south slope), even though a beardless and naked Dionysos would be at this time unique. On the other side (CD 057), is the woman in whose lap the sensuous Aphrodite lies Dione (her mother, according to Homer), Themis, or Artemis? (Artemis is an appealing choice because she appears beside Aphrodite on the east frieze below; CD 095.) There are disagreements over the relevance of such impressive pieces as the so-called Laborde head in the Louvre or the torso known as H (Acropolis 880). But, the

major debate hinges (naturally) on what has been almost totally lost: the nature of the center. Given the subject of the pediment, Zeus and Athena obviously appeared here. Hera did, too; there are two pieces of a colossal, stately *peplos*-wearing figure that may belong to her (cf. Fig. 93). However, we do not know whether Zeus was standing or enthroned (as he almost always is in other images of the birth), or whether Athena appeared on his right or left, or whether the central triad was flanked by recoiling figures (Hephaistos, with his axe, and Poseidon, perhaps a little concerned about his future competition, would make sense) and rearing horses or chariot teams (as in the west pediment) or by heavy groups of more gods. The basic question is whether the central composition was dynamic and V-shaped, like the west pediment, with Athena, having exploded from Zeus's head, rushing outward from the center, with the shock waves of her birth rippling through the attendant divinities on either side; or whether it was more static, dominated by the three sedate, standing, and more or less frontal figures of Athena, Zeus, and Hera. Recent analyses favor the static option (Fig. 93), though that would mean Pheidias (or whoever the designer was) radically abandoned the long-established tradition of showing Zeus seated at the birth only to mimic rather conservatively the compositional scheme at the center of the east pediment of the earlier Temple of Zeus at Olympia.[43]

Unlike the contest with Poseidon, the birth of Athena had appeared on Athenian vases before; like the contest, the birth had probably not appeared in earlier sculpture. The birth itself took place on Olympos, in the presence of divinities (there are no mortals or heroes here, unless the reclining nude is Herakles, after all), and probably there was some favorable equation intended between the mountain of the gods and the mountain of the Athenians: the Acropolis, the scene of the other pediment. Here, however, the birth is given a heavenly rather than an earthly frame (another of several in the Parthenon sculptural program). In the south angle, Helios (Sun), flat on his back, rises in his chariot; the real pedimental floor becomes an imagined horizon (CD 053). (Like all the pedimental statues, incidentally, Helios and his horses were carved on the ground, but these figures evidently had to be recut when actually installed so that they would better fit their allotted space – another mid-course correction or adjustment so typical of the making of the Parthenon in general.)[44] In the other corner, Selene (Moon) drives her tired team – it

93. Reconstruction of center of east pediment by K. Iliakis. From Palagia 1993, pl. 20. Used by permission.

has just traversed the night sky – below the horizon floor; two of her horses stick their muzzles out of the frame of the pediment, gasping for one last breath before descending (Fig. 89; CD 059). Helios and Selene are, in fact, the only extant figures whose identity is beyond dispute, and the event taking place between them is thus of cosmic significance. It is the time of the rising sun and setting moon. It is dawn, and there is a new order on Olympos. The coming of Athena has changed the world.

The Frieze

The Acropolis had already had a fairly strong dose of the Ionic architectural order before the building of the Parthenon, and the insertion of a continuous frieze – an Ionic sculptural form – into an otherwise Doric

fabric was not unprecedented. Still, as we have noted, the original design of the Parthenon did not call for an Ionic frieze atop the cella. A Doric triglyph-metope frieze was planned at first for the east and west ends of the cella – the presence of Doric *guttae* and *regulae* below the Ionic frieze are proof enough of that (Fig. 87) – and the decision to place an Ionic frieze around the top of the cella's north and south walls and over the columns of the *proneos* and *opisthodomos* was made only after construction was well underway (Figs. 68, 85; CD 071). It should not be regarded as heresy to wonder whether the decision was the right one. As a public monument – as an image obligated to speak readily and comprehensibly to a broad civic audience – the Parthenon frieze, as brilliantly executed as it is, was not a complete success simply because it was not easily seen. Now, light was not a big problem. Though the frieze was tucked up behind the peristyle, high atop the cella walls, just beneath the coffers of the ceiling, and though the light reaching it was thus indirect or diffused (its strength varied depending on the side of the building and time of day), enough bounced off the freshly cut white marble stylobate, walls, and columns for adequate illumination. Moreover, steps were taken to enhance the visibility of the frieze. Its face inclines outward slightly and, though the relief is only about 5 centimeters (2 inches) deep, it is cut a little deeper at the top than at the bottom. The half-lifesize figures (set against a rich blue-painted background) were also brightly painted – strong color contrasts would have helped the ancient viewer distinguish figures and horses in even the most complex passages (cf. Fig. 31; CD 075–076) – and were enlivened by bronze additions (the reins and bridles of horses, for example, or accessories such as spears and wreaths, or, in one case, sandal straps).

The real problem was not lighting but position (Fig. 94). In one sense, the closer one got to the frieze, the harder it was to see. The flanks and porches of the Parthenon are comparatively shallow. Anyone wishing to view the frieze from within the peristyle – it stood about 12 meters above the floor – had to crane his neck uncomfortably, and even then the figures (no matter how well lit) would be extremely foreshortened and the compositions difficult to make out. The best place to view the frieze was, in fact, from a "zone or belt of observation," only a few feet wide, running all around the terrace of the Parthenon about 30 feet (a little more than 9 meters) distant from the stylobate – much farther away than that and

94. Reconstruction of west peristyle. Drawing by D. Scavera.

the top of the frieze would be cut off by the entablature of the building.[45] Even for someone standing in this optimum zone, however, painted or bronze details might have made little impression and only small portions of the frieze would have been visible at any one time because the columns of the peristyle rhythmically interrupted each and every view of the work. Now, Pheidias seems to have recognized the problem and designed the frieze so that the spectator could pause at certain significant spots – on axis with the eastern door of the cella, for example – and so frame particularly dramatic, unified, or significant passages of the frieze between two columns (Fig. 95). Still, the only way to see the whole frieze was to move all around the building – the direction and momentum of the stone figures helped carry the flesh-and-blood spectator along – and

95. Reconstruction of center of east frieze seen through peristyle. After Stillwell 1969, pl. 69.14.

so each viewer essentially created his own experience of the work.[46] This can be considered a positive thing – ancient interactive sculpture, as it were. But, the Parthenon program may have sent mixed directional messages: the generally west-to-east direction of the figures in the north frieze (CD 073–082) was countered by the generally east-to-west direction of the figures in the more conspicuous north metopes (Fig. 35). Few viewers would have kept religiously to the narrow zone of observation in any case; few would have been motivated to follow the frieze all around the building in a single visit; and only ancient art historians are likely to have paused consistently to frame just the right figures between just the right columns. Most ancient visitors had more important things to do. Given all the other monuments in their sight (and in their way), typical visitors to the Acropolis would have had only an obscured, fragmented, and thus discontinuous experience of the continuous frieze. It is not really fair to use Pausanias, who does not mention the frieze, as an indication of just how inconspicuous it was. After all, Pausanias does not mention the metopes, either. Still, whereas he could not possibly have missed the metopes, he may well have missed the frieze. So, probably, did many others.

But, this could be the wrong way of looking at it. Perhaps the frieze was not really a public monument after all, at least not in the sense that its principal concern was to be entirely and immediately perceptible to the Athenian populace walking below. Perhaps the frieze was more in the nature of a votive relief – a spectacularly grandiose version of the kind of

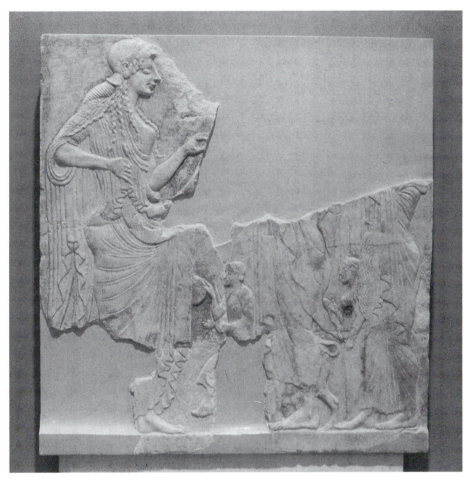

96. Family sacrifice relief (Acropolis 581), c. 500–490. Photo: author.

reliefs that had long been dedicated by private citizens on the Acropolis, as in other sanctuaries, but with the entire Athenian *demos* acting as dedicator instead of an individual or family (cf. Fig. 96).[47] In that case, the success of the frieze did not depend so much on how conspicuous it might have been, or how legible its individual figures or general composition were. For its intended audience was not the Athenian on the ground but Athena on Olympos, the ultimate and ideal spectator, the recipient of the grandest votive of them all – the Parthenon itself.

Most (if not all) of the frieze was carved in place by sculptors standing on scaffolding: on the north and south sides, for example, the figures overlap the seams between the slabs as if they were not there (Figs. 31, 97). On the west and east sides, however, the figures generally stay clear of the

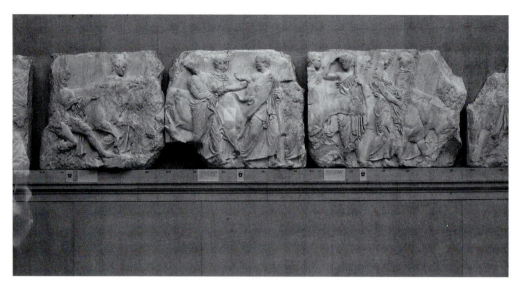

97. Youths leading sacrificial cattle, south frieze (British Museum). Photo: author.

seams (cf. Figs. 28, 98, 99); the compositions here may have been sketched or roughed out on the ground before the separate blocks were hoisted into place and carved.[48] At all events, all 115 frieze blocks, carved or not, had to be in place by 438 for architectural reasons, and theoretically the sculptors could have continued carving them down to 432.[49] It is possible, too, to detect in the details many "hands" at work: one horse's mane is treated differently from another's, for example. More broadly, there are enough differences in the compositions of the east and north

98. East frieze. Drawing by J. Boardman, used by permission.

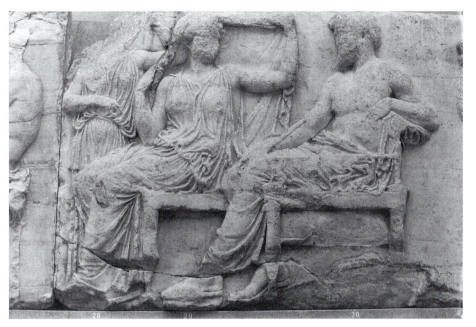

99. East frieze, detail: Hebe (?) standing, Hera unveiling herself before Zeus (British Museum). Photo: author.

sides on the one hand, and the west and south sides on the other, to suggest that the frieze may have had two designers instead of one.[50] Still, the overall effect of the frieze (as opposed to the earlier metopes) is one of remarkable stylistic unity. The faces of the youths on the frieze, for example, all look very much alike, and a number of horses repeat identical (or nearly identical) poses or patterns, as if the same cartoons (sketches transferable to the stone) were used over and over.[51] No matter how the labor was apportioned, Pheidias had by now moulded his frieze sculptors into a single, homogeneous team (led, perhaps, by Alkamenes). It was the business of any one of them to know well what the others were doing, and how they were doing it, and blend in.

The interpretation of the frieze is perhaps the most difficult and frustrating problem in the study of Classical art, which is painfully ironic because we have about 80 percent of it (some 420 out of 524 feet), plus Carrey's (occasionally ambiguous) drawings to fill in many of the gaps. (Would we not be so perplexed if less of the frieze had survived?) Students of the frieze agree that it depicts a procession. They agree that the procession is "bifurcated," or divided into two streams: the longer stream starts at the southwest corner of the cella, runs north along the west side, turns

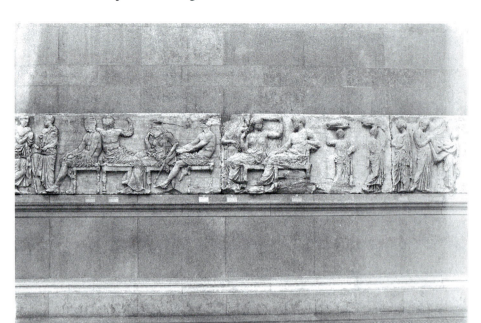

100. The south side of east frieze with two Eponymous heroes (?), the seated gods Hermes, Dionysos, Demeter, Ares, Hebe (or Iris or Nike, standing), Hera, and Zeus, and *peplos* scene. (British Museum). Photo: author.

the northwest corner, and then runs east along the north side before turning the northeast corner. The second, shorter stream begins at the southwest corner, runs east along the south side of the cella, and then turns the southeast corner. The two streams, all agree, converge on the east side (Fig. 85). It is also agreed that the gods are depicted in two groups on the east frieze (Figs. 38, 98, 100; CD 090, 094–095). And they agree that between the gods something is going on involving a piece of cloth (Fig. 20; CD 092–093). However, they agree on little else, and the recent discovery (or hypothesis) that a second Ionic frieze may have existed within the *proneos*, over the east door (Fig. 87), suggests the whole debate has been missing something important. This inner frieze (if executed) may have depicted a completely different subject, but it may also have been the culmination of the frieze we have, or else an epilogue, a key to its meaning.[52] Even a bare rundown of the surviving cast of characters cannot avoid controversy. Still, it will be useful to give one here, and to reserve discussion of the frieze's place in the Parthenon's sculptural program (and its significance in Periclean ideology) for the concluding chapter.

On the west frieze (Fig. 28; CD 071–072), there are twenty-six horsemen, two young attendants, and two marshalls; eleven riders are still

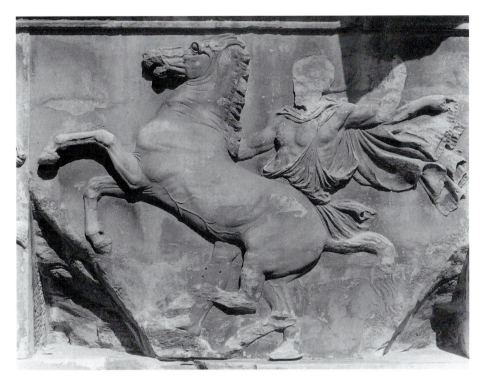

101. Horse-taming scene, center of west frieze. Alison Frantz Collection. Courtesy American School of Classical Studies.

unmounted and one horse is apparently being rejected upon inspection for having its mane improperly dressed.[53] Near the center, in another powerful V-shaped composition, one of only two bearded horsemen on the entire frieze tries to tame a magnificent, fiercely rearing steed who seems a relief version of the horses in the west pediment (Fig. 101; cf. Fig. 25).[54] So here, the cavalcade is just getting underway (it has been often and rightly said that the general mood of the frieze as a whole is one of preparation and anticipation rather than of culmination or climax).

The parade is in full swing on the north side, where there are sixty horsemen on saddleless mounts (they are arranged in ten ranks, each marked by a horse shown fully in the plane closest to the viewer, though the number of riders in each rank varies) (Fig. 31; CD 073–076).[55] One horseman wears full armor, most others just tunics and cloaks, a few so-called Thracian caps; some are nearly nude. The procession continues with eleven, mostly charging, four-horse chariots with drivers and *apobatai* (CD 077) – armed soldiers whose sport consisted of jumping off moving chariots and racing to the finish line (their brand of chariotry undoubtedly recalled that of Poseidon and Athena in the west pediment). A few grooms and marshals appear among them. Then come the

102. Elders, north frieze. Courtesy Acropolis Museum.

pedestrians: first sixteen elders, some casually conversing, some adjusting their hair, some possibly clenching something that was once painted in their right hands (Fig. 102; CD 078);[56] then four musicians playing the kithara (CD 079) and four more playing flutes; then four youths carrying *hydriai* (Fig. 103; CD 080) and three more carrying *skaphai* (troughlike trays for honeycombs and cakes); and then attendants leading four sacrificial sheep and four sacrificial cows (CD 081–082). Once past the ten ranks of horsemen and the eleven chariots (and with the exception of the three tray-bearers), the number four and its multiples stand out.

The south frieze seems to have closely mirrored the north, though the mood is more staid and the numerology is different (ten is the magic number here). There are, again, sixty horsemen (CD 083), this time proceeding more formally and arranged more neatly in ten ranks of precisely six riders each, all the members of each group wearing identical, distinctive garb (everyone in the first rank wears Thracian caps, chitons, and

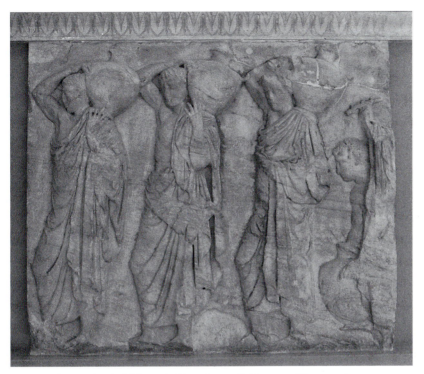

103. Youths carrying *hydriai*, north frieze. Acropolis Museum. Photo: author.

high boots, for example);[57] then ten chariots (not eleven, as on the north side) with drivers and *apobatai* (none of whom have yet leapt to the ground as some do on the north frieze) (Fig. 104; CD 084); then more elders and, probably, musicians, *hydriaphoroi* and *skaphephoroi*; then attendants leading ten sacrificial cows (and no sheep) (Fig. 97; CD 086). Two of the cows have to be restrained, as if they are eager to be sacrificed upon the altar of the goddess.

On the east side (Fig. 98), the two streams approach one another. At the very south end, a marshal gestures for the figures on the south frieze to turn the corner and follow him. Then comes a group of sixteen thickly draped women (CD 087–088), most carrying something (*phialai*, *oinochoai*, an object with a flaring base that could be an incense burner, or *thymiaterion*).[58] This group is roughly balanced on the other end of the east frieze by thirteen more women and four more marshals (Fig. 105; CD 097–098); many of these women also carry *phialai*, *oinochoai*, and a *thymiaterion*, but at least one has handed over an offering basket (*kanoun*) to a marshal. She is a *kanephoros*, a high-born maiden (a *parthenos* like Athena herself) who had the honor of leading sacrificial processions and so, probably, are many more of the maidens in the east frieze, recognizable

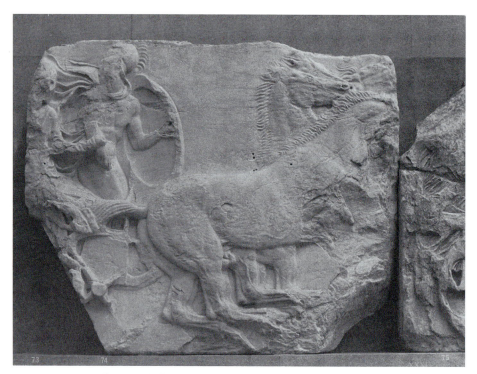

104. *Apobatai*, south frieze (British Museum). Photo: author.

105. Maidens and marshals, east frieze (Louvre MA 738). Photo: author.

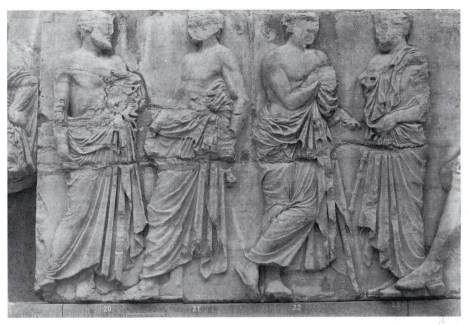

106. Male figures (Eponymous heroes?), east frieze (British Museum). Photo: author.

as *kanephoroi* by the costumes they wear.[59] These are, incidentally, the first women we have seen on the frieze, and the objects they carry are almost certainly some of the gold and silver vessels listed in the inventories of the Parthenon treasures (cf. Fig. 83), loaned out for the occasion. Next, moving toward the center from both left and right, come two groups of apparently nonprocessional male figures. Some are bearded (hence mature or elderly), some are unbearded (hence youthful), and most (if not all) lean on staffs (because they occupy the full height of the frieze even as they lean, their scale seems a little larger than the other males on the frieze) (Fig. 106; CD 089, 096). Whether there are actually nine or ten of them (one could be a standard marshal) and whether they are the Eponymous Heroes of the ten Athenian tribes, or generic magistrates, or generic Athenian elders (the fathers or brothers of the nearby maidens or *kanephoroi*) are matters of dispute. If they are (as is likely) the ten Eponymous Heroes – and it should be noted that Pheidias had already made a group of them in the round for the sanctuary of Apollo at Delphi[60] – they would form a neat transition to the next level of being, for there is no question that the Olympian gods come next, again in two groups (six seated and a winged quasi-Olympian – Iris, Nike, or Hebe – standing on the left, six seated and another quasi-Olympian – Eros – standing

on the right) (Figs. 32, 98–100; CD 090–091, 094–095).[61] It is not clear whether the gods are to be thought of as watching the procession from their home on Olympos, or in the Agora (where there was an Altar of the Twelve Gods beside the Panathenaic Way), or on the Acropolis itself. But, on the left Hera unveils herself before Zeus and on the right Athena sits quietly beside Hephaistos (Figs. 32, 99). This Athena is one of the most remarkable of all Acropolis Athenas: she has no shield or helmet (though holes drilled into the stone prove she cradled a bronze spear in her right arm). She has taken off her *aigis* (it lies in her lap, a snake or two from its fringe writhing over her left arm). And she is seemingly unfazed by all the commotion that fills the rest of the frieze. This is Athena at ease, and there is no point searching for a single epithet – Polias, Parthenos, Pallas, or anything else – to apply to her here. In iconography and mood, this Athena seems beyond compartmentalization.

Wherever the gods are imagined to be, however they are imagined to be arranged, in the actual relief space between Zeus and Athena, perfectly aligned with the east doorway below and behind, we are probably on the Acropolis, and here we find the most controversial passage of all (Figs. 20, 107; CD 092–093).[62] Here, there are five smaller (hence mortal) figures. Two young women carrying something (cushioned stools?) on their heads and other things in their hands (a footstool?) are greeted by a taller matronly woman who helps one girl with her load. She is actually the central figure of the entire east frieze, but she stands back to back with a bearded male, dressed in a long unbelted robe, who appears to be folding up a piece of cloth with the help of a child. Who these people are and what they are doing – even the gender of the child – are crucial to the interpretation of the frieze as a whole, and every point is fiercely disputed. But, most scholars, seeing a grandiose, sacrificial procession on the frieze and a piece of cloth at its center, and remembering the importance of the Panathenaia in Athenian life, believe the frieze depicts the Panathenaic procession and preparations for delivering the *peplos* to Athena Polias. As we shall see in Chapter Nine, they may be only partly right.

The Athena Parthenos

A decade or so after the installation of his Bronze Athena in the open near the entrance of the Acropolis (Fig. 56), Pheidias created the Athena Parthenos in gold and ivory for the interior of the Periclean Parthenon

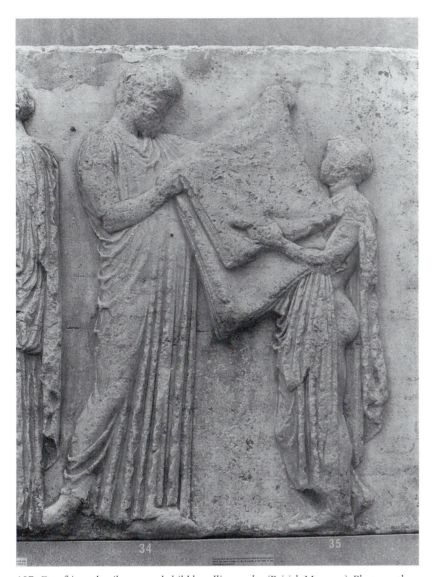

107. East frieze, detail: man and child handling *peplos*. (British Museum). Photo: author.

(Fig. 21). The statue was begun in 447 – probably in a temporary *ergasterion* or workshop south of the Parthenon – only to be reassembled in the building's east room in time for dedication at the Greater Panathenaia of 438.[63] This time, the appearance of the statue seems reasonably well known from literary descriptions like Pausanias's, a vase painting of Athena based on the statue dating only a few decades after its dedication, and a wide assortment of some 200 late Classical, Hellenistic, and Roman reliefs, statues, medallions, intaglios, tokens, gems, and coins (cf. Figs. 108–112).[64]

Pausanias on the Statue of Athena Parthenos[65]

The statue itself is made of ivory and gold. In the middle of her helmet there is set an image of the Sphinx - what is said about the Sphinx I will write down when I come to Boiotia - and on each side of the helmet there are griffins carved in relief. In his poems Aristeas of Prokonnesos says these griffins fight for gold with the Arimaspians beyond the Issedonians: he says the earth produces the gold the griffins guard, that the Arimaspians are all men born with one eye, and that griffins are beasts resembling lions, but have the wings and beak of an eagle. But let that be enough about griffins. The statue of Athena is standing erect, with her dress reaching to her feet, and on her chest the head of Medousa is made of ivory. In one hand she holds a Nike [Victory] about 4 cubits [c. 6 feet] tall; in the other she holds a spear; and at her feet rests a shield and next to the spear there is a snake - this snake would be Erichthonios. On the base of the statue the birth of Pandora is carved in relief. It is said in Hesiod and other poets how Pandora was the very first woman; before her the race of women did not yet exist.

The Athena, some 10 meters tall, stood on a base decorated with the creation of Pandora.[66] Her exposed flesh was made from pieces of bent and moulded ivory; her eyes were made of ivory and precious stones; and her *peplos* and equipment were made of removable gold plates (around 1 millimeter thick) weighing 40 or 44 talents – that is, well over a ton (the gold and ivory were fixed by means of nails, wire, and adhesive upon a core or armature made of cypress and citrus woods).[67] She was fully armed with elaborate helmet, *aigis*, spear, and shield. And she was covered with myth and mythological creatures, literally from head to foot. On her helmet were a sphinx, winged horses (pegasoi), and griffins. In the center of her golden *aigis* was the head of the Gorgon Medousa in ivory. Inlaid, engraved, or painted on the ivory of the interior of her monumental shield (itself nearly 5 meters in diameter) was the Battle of Gods and Giants, which the visitor entering the cella had just seen distributed over the fourteen east metopes of the Parthenon (Figs. 42, 89). The Gigantomachy (to judge from a later Athenian vase painting of the subject) may have been arranged in concentric rings, and Helios may have been shown driving his team above the (here curved) horizon as he did in the east pediment (Fig. 38) and (probably) in both north metope 1 (Fig. 35) and east metope 14 (Fig. 90). The exterior of the shield carried a circular Amazonomachy - the subject of the west metopes - revolving around another gorgoneion. Roman-era copies of the shield, both large scale and small, excerpt many of the duels between Greeks and Amazons

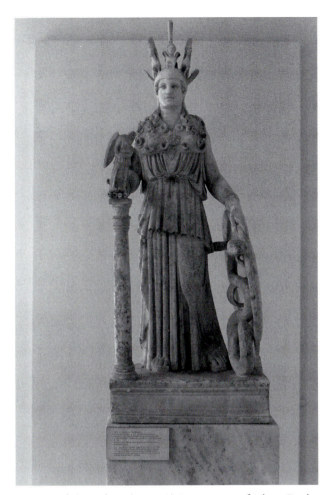

108. Varvakeion Athena (NM 129), Roman copy of Athena Parthenos. Photo: author.

(Figs. 110–111; CD 101), and some suggest that the Amazonomachy was played out on rising terrain around and even atop the walls of a citadel (Fig. 91).[68] In other words, this is the Amazons' attack on the Acropolis itself, though the background of the shield probably represented a topographically imaginative panorama. In any case, the parallel with the Persian attack of 480 – the equation of barbarian Amazons and barbarian Persians – was unmistakable, though here, in a mythological, wish-fulfilling reversal of reality, the Greek defenders emerged victorious. Again, the fable that Pheidias slyly inserted portraits of Pericles and himself among the Greek defenders (and was for that reason thrown in jail, where he died) is probably a Hellenistic invention.[69] On the edges of Athena's sandals there was a centauromachy, the subject of the south

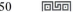

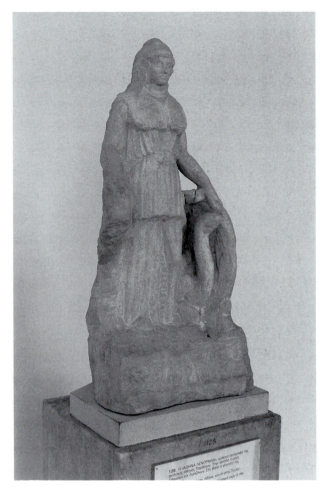

109. Lenormant Athena (NM 128), unfinished Roman copy of Athena Parthenos. Photo: author.

metopes (Fig. 19), but no copy even hints at its appearance. At all events, three of the four battles represented on the Parthenon metopes reappeared somewhere on the Athena Parthenos (only the Trojan saga of the north metopes was not reprised). So, too, the great snake coiled beside Athena in the concavity of her shield – it was the guardian of the Acropolis or (as Pausanias supposed) the incarnation of Erichthonios[70] – was not the first the visitor would have noted; there was another serpent beside Kekrops, and perhaps yet another wrapped around the olive tree of Athena, in the west pediment (Fig. 28). Nike, whose 1.85-meter-tall, victory-wreath-bearing figure the goddess literally held in the palm of her outstretched right hand (Figs. 21, 108),[71] had also been seen before:

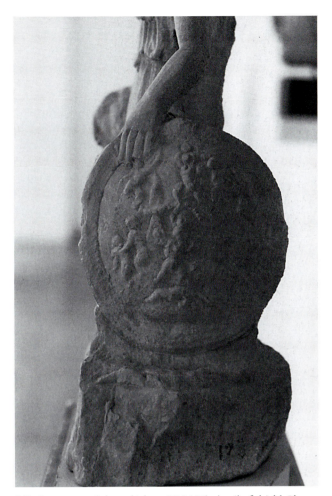

110. Lenormant Athena (Athens NM 128), detail of shield. Photo: author.

she drove Athena's chariot in the west pediment; she may have appeared in the lost center of the east pediment (she is often found in images of Athena's birth) and on the east frieze; she certainly appeared hovering beside Athena in east metope 4 (Fig. 42); and, again, four marble Nikai probably landed on the corners of the roof of the Parthenon, as *akroteria* (Fig. 90).

Only the myth depicted on the base of the statue – the creation and provisioning of Pandora in the company of twenty divinities (Figs. 21, 112; CD 102–103), the figures being made of gilt bronze – seems to have had no iconographic preparation elsewhere on the building. In fact, however, the base was related to the east pediment by the theme of birth itself, and to that pediment, the east frieze, and the east metopes

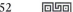

111. Peiraieus relief (Roman in date), excerpting scene from shield of Athena Parthenos. Courtesy DAI–Athens (Neg. Nr. Pir 150).

by the theme of divine assembly.[72] The choice of this myth is still a surprising and ambiguous one. Pandora (the first woman and thus the mother of the human race) may have been regarded locally as a fertility or earth goddess who bestowed benign gifts upon the Athenians. (Pandora means "all-gifts," though on the base it was almost certainly the gods who were shown bestowing gifts, such as beauty and the art of weaving, upon *her*.) She was also directly and positively linked to Athena in cult: whenever a cow was sacrificed to Athena, we are told, a sheep had to be sacrificed to Pandora. And so, for many, the image of the gods adorning and provisioning Pandora was a kind of metaphor for the blessings the gods had showered upon Athens, or even for the blessings of civilization that Periclean Athens had showered upon Greece. Pandora is, in this reading, a glamorous icon of beneficence and delight.[73] But, others read the base more darkly. The myth of Pandora, as the epic poet Hesiod tells it (and as Pausanias knew it), was, after all, the Greek explanation for the existence of evil in the world. Zeus ordered her creation to punish mortals for Prometheus's theft and delivery of fire (which made men more like gods), and her letting loose of evils from her famous jar (not box) was the gods' revenge. She was a beautiful figure of dread, created to beguile men with her beauty, to introduce falsehood and treachery and

112. Detail of base of Hellenistic version of Athena Parthenos from Pergamon (cast). Courtesy John Boardman and the Cast Gallery, Ashmolean Museum.

work to their lives. In this view, what was shown on the base of the Athena Parthenos was not a pretty picture after all, but one ominously loaded with the reassertion of the difference between mortals and immortals, with the knowledge that, through Pandora, humankind would – unlike the gods – know pain, labor, and suffering.[74]

It is possible that the image of the birth of Pandora spoke differently to different audiences, and that it worked on more than one level – one self-congratulatory, the other more aware of the fragility of the human condition. But, above the base, at least, the statue of Athena Parthenos stood as a kind of reiteration or summary of Parthenon myth and theme (Fig. 21). Through its images, the visitors' experience of the building's exterior and interior was unified; and through its images, the messages of the Parthenon's sculptural program were drilled into them one last time.

Again, it was from this magnificent statue – at least as costly as the building that contained it[75] – that the Parthenon probably took its popular name, and it was to house and protect the gold-clad image that the Parthenon was possibly conceived in the first place. That is why Pheidias, a sculptor, is said to have been in charge of the project, not its architects, and that is why special measures were taken to illuminate the temple interior and enhance its mystery. Windows were cut in the east wall of the main room to provide more light than the door could alone (Figs. 68, 87), and a large rectangular pool of water was set in front of the image

(probably by the end of the fifth century) to capture its reflection and reflect shimmering light back upon it.[76]

There is, once more, no evidence that this great and grandly displayed image was ever the object of official cult in Classical antiquity, and there is some evidence that its "person" was not even regarded as sacrosanct: Pericles himself was prepared to strip the statue of its gold to pay Athens's wartime bills if circumstances demanded. The implications of this are worth pondering again. The Parthenon should perhaps be considered not so much a temple to Athena – a site or focus of worship – as a temple to Athens, a storehouse of its wealth, a marble essay on its greatness, and the focus of its ideology.

CHAPTER FIVE

THE PROPYLAIA

Plutarch says the Propylaia, Mnesikles's monumental entrance to the Acropolis (Fig. 113), was built in five years,[1] and this time he gets it right. Inscribed building accounts indicate that construction began in 437 (just after the Parthenon was architecturally completed) and ended (prematurely) in 432. The name Propylaia ("gateways") is plural, not because this unusually complex and innovative building has several elements (and was originally designed to have even more), but because five doors of different sizes pierced the cross-wall of its central hall (the "Propylaia" proper) (Fig. 55). It is this cross-wall that marks the entrance to the sanctuary of Athena. Technically, then, the Propylaia sits astride the boundary of the sacred precinct, and most of the complex – the large western portion of the central hall, the northwest wing, the southwest wing – actually lies outside it, in secular space.

The Propylaia is not just topographically liminal, it is also both termination and prelude. The west slope of the Acropolis is naturally steep and rugged, and earlier entrances more or less conformed themselves to the lay of the land.[2] Instead of allowing the landscape to dictate to him, Mnesikles imposed his great edifice upon it, fundamentally reshaping the experience of the visitor (Fig. 5; CD 104). Mnesikles designed the building, first, to provide a monumental setting for the end of the Panathenaic Way (the long road that led from the Dipylon gate at the northwest corner of the city, across the Agora, and up the west slope of the Acropolis; Fig. 6) and, second, to prepare the visitor for what would be found within the gates – above all, the Parthenon (CD 036).

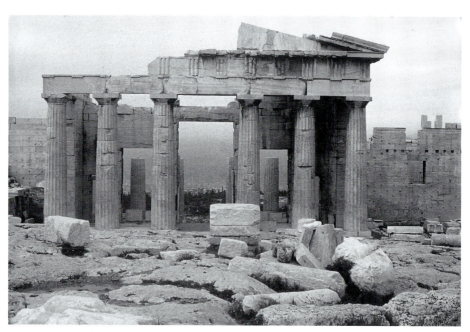

113. The Propylaia of Mnesikles, 437–432, from the east. Photo: author.

In the Archaic and Early Classical periods, a straight ramp (probably of packed earth) about 80 meters long and 10 meters wide led up the slope to the entrance (Fig. 58). Mnesikles (or someone working with him) essentially doubled its width to about 21 meters and converted it to stone (undoubtedly grooved for traction), monumentalizing this last great stretch of the sacred road. The Propylaia, looming over the ramp, embracing it with its wings, would have afforded an appropriate space for spectators to await the arrival on the summit of the Panathenaic procession. It would also have introduced the visitor to many of the features he would see within the sanctuary, in the Parthenon. The roughly east–west axis of the Propylaia is almost exactly parallel to the axis of the Parthenon (Fig. 2, nos. 1 and 13), so that the visitor's path through one building established a spatial alignment or orientation with the other. The dimensions of the deep west portion of the central hall are close to those of the Parthenon's west room. The Propylaia shares some of the same proportions as the Parthenon (the ratio of column height to lower column diameter, for example) and it displays most of the same optical refinements, too (for example, inward inclination and *entasis* of some columns and upward curvature in the architrave, though here the stylobate is level). Like the Parthenon, the Propylaia combines architectural

orders; the exterior is Doric (Fig. 113; CD 105, 109) but, because of the
sharply rising ground on which the building is set – it had five different
floor levels – Ionic columns (which have a greater height relative to their
diameter) were required within the west part of the central hall, three on
each side of the 4-meter-wide central rock-cut passageway (Fig. 55). This
was the course taken by the sacrificial animals in the Panathenaiac pro-
cession and other rituals. The four other, smaller doors in the cross-wall,
each aligned with an intercolumnation in both the east and west façades,
were approached by a flight of four steps and were thus meant for hu-
man traffic (the threshold of the northernmost door happens to show
the most wear, though much of that could be post-Classical). In any case,
the close visual relationship between the Parthenon and Propylaia can be
explained not only by the authority of a grandly comprehensive Periclean
design for remaking the citadel and Mnesikles's conscious desire to har-
monize his gateway with the great temple within but also by the identity
of the labor force. The workmen who finished building the Parthenon
in 438 were simply transferred to Mnesikles's project, and they brought
a honed technique and a Parthenonian architectural style with them.

One of the tasks Mnesikles set for himself was to unify or integrate an
area that had been previously marked by several discrete late Archaic
structures: an Older Propylon (begun around 500 or 490, destroyed

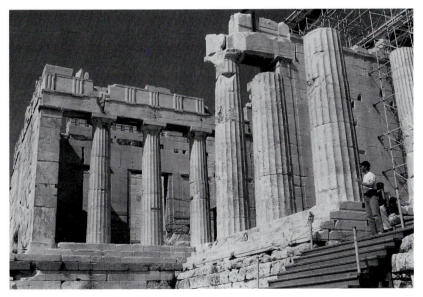

114. The northwest wing of the Propylaia (the Pinakotheke). Photo: author.

during the Persian sack, and then repaired), a stepped entrance court beside it, and, possibly, an apsidal structure known as Building B.[3] The Periclean Propylaia might even be considered a reinterpretation and regularization of those earlier buildings. The central gatehouse, for example, represents an enlargement and clockwise rotation of the Older Propylon, and the northwest wing (Fig. 114) a squaring and realignment of Building B, linking it with and setting it at right angles to the main hall.[4] But Mnesikles's initial design was even more grandiose than this. He intended (perhaps in a second architectural campaign) to attach great halls to the Propylaia on both the northeast and southeast sides; doorjambs, a spur wall at the northeast corner of the northwest wing, and cuttings for rafters and ridge beams in the walls of the Propylaia suggest his plans reached a fairly advanced stage. Both halls would have been accessible only from the east (that is, from within the sanctuary of Athena), with no direct access from the interior of the Propylaia itself. Although plans for these halls were eventually scrapped, it is clear that Mnesikles originally conceived of the Propylaia as a massive juxtaposition of five rectangles (central gatehouse, western wings, and eastern halls).

He may not, however, have originally conceived of the complex as perfectly symmetrical. A few details suggest that the eastern halls would not have been exactly the same size.[5] And although it is often supposed that Mnesikles initially intended the southwest wing (CD 106) to be a mirror image of the northwest (Fig. 114; CD 105), as built, it is a very different structure. Certainly, the columnar façade of the southwest wing echoes the one across the way, so that it is easy for a visitor at the top of the ramp to think himself flanked by symmetrical wings (CD 104). But, the impression is false: the southwest wing is just a small open space defined by its short colonnade, a large "double anta" at the northwest corner, two walls, and (on the west) a single pier. At any rate, perfect symmetry between the southwest and northwest wings would have required dismantling much of the still-impressive stretch of Cyclopean masonry south of the Propylaia (Fig. 54; CD 016). But, this Mycenaean wall was not touched and, again, the southeast corner of the southwest wing was even bevelled to fit snugly against it. Thus, if there had been some early plan to build a larger wing here, it went nowhere. Nonetheless, there are indications that whatever the original design, the southwest wing was, in fact, adjusted several times to take the rebuilding of the adjacent

Nike temple bastion into account.[6] It was by no means uncommon for Greek architects to alter the designs of their buildings as construction proceeded and problems or opportunities arose. As we have seen, the Parthenon displays such changes in progress, too. The fact remains that the Propylaia Mnesikles ended up building was substantially different from the Propylaia he originally had in mind in 437.

Changing the design of a building in the course of construction is one thing. Not finishing what *was* built is another, and it is clear that the Propylaia was never completed (neither, incidentally, were its building accounts). Protective, working surfaces on the steps and floor of the building were never removed and, most conspicuously, scores of lifting bosses (lumps of stone left on blocks to aid in their positioning during construction) were never chiseled off (Fig. 115; CD 110). Most of these lifting bosses are found on the east walls of the northwest and southwest wings and on the north and south walls of the central gatehouse – on the "back" of the Propylaia, as it were. But there are a few even on the west wall of the northwest wing and elsewhere, where they would have been quite obvious to anyone ascending the Acropolis. Not even the wide new ramp leading up to the Propylaia was finished in the Classical period.[7]

The usual explanation for the scaling-down of Mnesikles's original, multi-winged plan for the Propylaia is religious conservatism. The usual explanation for its unfinished state is economic belt–tightening. Neither explanation is totally satisfactory by itself. It is true that building the putative southeast hall would have meant razing a large portion of the surviving Mycenaean wall (Fig. 54) and expropriating the western portion of the adjacent Sanctuary of Artemis Brauronia, at least as that sanctuary was eventually defined (Figs. 115, 126). It is possible, too, that the Athenians resisted tearing down so conspicuous a memory of their heroic, Bronze Age past as the Mycenaean wall, and that the officials of the cult of Artemis might have opposed the loss of some of their precinct. But in fact, it is not clear that the nearly religious awe or veneration in which the Cyclopean wall was held would alone have saved it from destruction (the Athenians had no problem tearing down or burying other parts of the Mycenaean fortification on the Acropolis), and it is not even clear how far west the Artemis sanctuary extended in 437 (as we will see, the Classical Brauronion was developed with the Propylaia in mind, not vice versa). Besides, there was no organized "church" in ancient Athens,

115. Propylaia from southeast, over the precinct of Artemis Brauronia. Blocks from the base of Strongylion's bronze Trojan Horse are in middle ground, just right of center. Photo: author.

and the priesthood of Artemis would not by itself have had the clout to oppose Mnesikles's original design. It was the democratic assembly that exercised such power and the assembly, under Pericles's influence, had presumably approved Mnesikles's plan by 437. There are, it is true, hints that just before the Peloponnesian War broke out, an Athenian "religious right" began to strenuously defend traditional religion and state cults.[8] But, more likely, it was simple economics that dictated the decision not to build the eastern halls and not to remove the lifting bosses and protective surfaces from the walls and floor. As early as 434/3, when the Kallias Decrees were passed, the Athenians knew that war with Sparta was inevitable; resources needed to be husbanded, and work on the Acropolis needed to be wrapped up. In 433/2, the date of the last building account of the Propylaia, it was. On the other hand, frugality does not explain why the finishing touches were not applied to the Propylaia later. A city that could in 434/3 allot 10 talents a year to get the Acropolis in shape (one of the provisions of the Kallias Decrees) and that in the last third of the fifth century could afford to complete the Erechtheion and Nike sanctuary and create the Nike parapet could surely have afforded to return to the

gateway and shave off a few unsightly lumps of stone from its walls. Here, religion might enter the picture after all: during the war years, Athens could still afford to build temples, but the Propylaia, essentially a secular structure, may have not merited additional expense.[9] It may also be that after the passage of time, those lumps (and the shadows they cast upon the walls, enlivening them) had taken on a kind of visual appeal. There is something alluring about the unfinished.

At any event, the Propylaia did more than just channel traffic into the sanctuary of Athena, and its parts served a variety of functions. Besides optically balancing the northwest wing, the southwest wing served as a waiting area and provided access to the Nike sanctuary (Fig. 116). The unrealized eastern halls would likely have served as dining rooms for ritual feasts, and this was almost certainly a function of the northwest wing (Fig. 114). One reconstruction places seventeen couches for reclining banquetters or resting pilgrims around the interior of the inner room (Fig. 55), and it may be no coincidence that after 434/3 (when the northwest wing might have been essentially complete), inscriptions

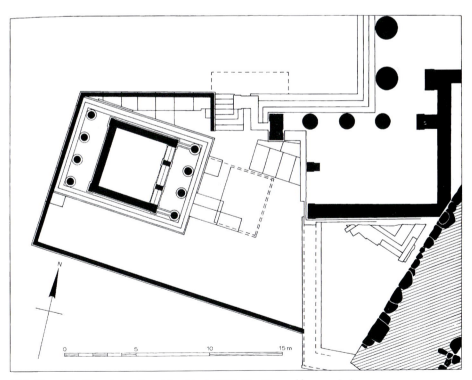

116. Plan, Nike Temple bastion. After Mark 1993, Fig. 17, used by permission.

happen to list a large number of couches among the inventories of the Parthenon.[10]

Pausanias does not mention any couches in the northwest wing on his visit, but he does say it was full of paintings (including an "Achilles among the Virgins of Skyros" and an "Odysseus Surprising Nausikaa" by the great Early Classical artist Polygnotos, as well as a portrait of the mercurial Alkibiades). How many of the paintings he saw in this "building (*oikema*) with pictures," or Pinakotheke,[11] were already there in the late fifth century we do not know (the earliest reference to paintings there dates to the early second century), but we do know that they must have been portable panel paintings rather than murals (this is the only explanation for the presence of works by Polygnotos, who was not around in the 430s to fresco walls). Windows in the south wall of the room would have helped illuminate the art.

Although it contained a picture gallery for the pleasure of both visitors and sacred diners, and although dedicatory statues were set up within it and votives hung from its walls, the Propylaia lacked architectural sculpture of its own. Its many metopes and its three pediments (a third was required because of the building's split-level plan) were empty, and *akroteria* (roof ornaments), if planned, were never executed.[12] Yet, the Propylaia was not a visually dull building. The contrasting use of dark Eleusinian limestone for prominent features (such as orthostate blocks; CD 107) and details (below the windows of the Pinakotheke) enriched and varied its surfaces (this stone is also used decoratively in the Erechtheion, which may point to a connection between the two buildings), and it did not lack ornament. Pausanias raves that its famous ceiling was unsurpassed even in his day: the marble coffers were decorated with gold or gilded stars against a blue background, and outlined (and unfinished) floral patterns are still preserved on the lower surface of the east cornice.[13]

Though the Propylaia is not likely to have cost the 1,000 talents one fourth-century orator says it did (much less the 2,012 talents cited by another source) – 200 talents is more like it[14] – the building was famous, even notorious, for its magnificence. Indeed, it was far more extravagant a structure than its basic function called for. Temples and treasuries were expected to be rich and costly. Gatehouses were not, and so the beauty and expense of the Propylaia was, in its way, an even stronger assertion of the grandeur of Periclean Athens than the Parthenon itself. It is perhaps

for this reason that in his various encomia to the Periclean era, the fourth-century orator Demosthenes lists the Propylaia first and the Parthenon second, or cites the Propylaia without mentioning the Parthenon at all. With this, even Demosthenes's political opponent, Aeschines, agrees: when in one speech he urges the Athenians to recall the great achievements of their ancestors, it is the Propylaia and not the Parthenon that he singles out.[15]

CHAPTER SIX

THE ERECHTHEION: THE CLASSICAL
TEMPLE OF ATHENA POLIAS

Only two ancient sources mention a building on the Acropolis called the
Erechtheion – that is, the Shrine of Erechtheus – and both are relatively
late. One source has virtually nothing to say about it.[1] The other, Pausa-
nias, has a lot to say, but is notoriously confusing. The relevant passage
begins with a discussion of the Erechtheion itself, a "double building"
with a variety of altars both outside (Zeus Hypatos) and in (Poseidon–
Erechtheus, Boutes, and Hephaistos), with paintings of the Boutadai
family (also known as the Eteoboutadai) hanging on the walls, with a sea-
water well (or cistern) that makes the sound of waves when a south wind
blows, and with the form (*skhema*) of Poseidon's trident somewhere "on
the rock" (presumably bedrock).[2] Next, without giving any clear indica-
tion that he has yet left the Erechtheion, Pausanias mentions the ancient
olivewood cult statue of Athena Polias and the golden lamp of Athena
Polias (with its eternal flame) made by the late fifth-century sculptor
Kallimachos.[3] It is only after noting the statue and lamp of the goddess
that Pausanias first explicitly mentions the Temple of Athena Polias, and
he does so in passing – he is interested in its contents, not its architec-
ture – without giving it his usual introduction (such as "there is also a
Temple of Athena Polias"). Finally, he mentions the sacred olive tree of
Athena and the shrine of Pandrosos, which he says adjoins the Temple
of Athena Polias. At all events, the descriptions of the Erechtheion, the
Temple of Athena Polias, and their holdings run together in a way that
is peculiar and vague even for Pausanias.

Pausanias on the Erechtheion/Temple of Athena Polias

[1.26.5] There is also a building called the Erechtheion: before the entrance is an altar of Zeus Hypatos (the Highest), on which they sacrifice no living thing but offer cakes, the custom also being not to use wine. Those who enter find altars of Poseidon, on which they also sacrifice to Erechtheus according to an oracle, of the hero Boutes, and, third, of Hephaistos. On the walls are paintings of members of the Boutadai family, and also inside – for the building is double – there is sea water in a reservoir. This is no great marvel, for other peoples who live inland also have such things – the Aphrodisians in Karia, for example. But this cistern is worth writing about because it produces the sound of waves when a south wind blows. And in the rock there is the form of a trident: these marks, it is said, appeared as evidence for Poseidon during the dispute over the land.

[6] The rest of the city and the whole of Attica alike are sacred to Athena – for even those who have established the worship of other gods in their demes hold Athena no less in honor – but the object considered by all most holy, even in the many years before the demes were unified, is the statue of Athena, kept on what is now known as the Acropolis but which was then known as the *polis* (city). Legend has it that the statue fell from heaven. Whether this is so or not I will not get into, but Kallimachos made the golden lamp for the goddess. [7] Having filled the lamp with olive oil, they wait for the same day one year later (to refill it), for the oil is enough for the lamp in the meantime, though it burns day and night. Its wick consists of Karpasian flax,

which is the only kind that is fire-proof; a bronze palm tree above the lamp reaches up to the ceiling and draws off the smoke. The Kallimachos who made the lamp, though inferior to the very best in this craft, was nonetheless the best of all in cleverness, so that he first drilled through stones and took the name *katatexitechnos* [refiner of art], or else adopted the name for himself after others had given it to him.

1.27.1. There is in the temple of (Athena) Polias a Hermes made of wood, said to have been a dedication of Kekrops; it is not fully visible because of myrtle branches. The dedications worth mentioning include, among the old ones, a folding chair made by Daidalos and spoils taken from the Medes [Persians] – the cuirass of Masistios, who commanded the cavalry at Plataia, and a short sword said to have been Mardonios's. Masistios, I know, was killed by Athenian horsemen, but, since Mardonios was killed fighting the Lakedaimonians by a Spartan, the Athenians could not have acquired the sword to begin with, nor is it very likely that the Lakedaimonians would have let them carry it away. [2] About the olive tree they have nothing to say, other than it was the goddess's evidence during the contest for the land. They also say that the olive was completely burned when the Medes set fire to Athens, but that on the very day it burned it grew back 2 cubits high.

[3] Adjacent to the Temple of Athena is the Temple of Pandrosos; Pandrosos was the only one of the sisters (that is, the three daughters of Kekrops) who was guiltless in the matter of the child (Erichthonios) entrusted to their care.

Ever since the seventeenth century AD, it has been assumed that throughout this long and difficult passage Pausanias is, in fact, describing a single complex: namely, the elegant, asymmetrical, multilevel Ionic marble structure standing across from the Parthenon on the north side of the Acropolis, the building with the six maidens serving as columns in its south porch – Karyatids (as they are known) that Pausanias unhelpfully does not mention anywhere (Figs. 2, no. 9; 16–17; CD 120–130). This building was, in the opinion of most scholars, the Classical Temple of Athena Polias. As we have noted, it succeeded a modest complex reconstituted on the site in the Early Classical period: the Pre-Erechtheion (Fig. 51), whose small but still functioning shrine of Athena Polias would, in fact, be preserved within the new temple's eastern room, at a lower level (Fig. 66) – another example of a Classical building absorbing yet displaying an earlier one (cf. Fig. 24).[4] Ultimately, though, the Classical temple would have been regarded as the replacement for the much larger late Archaic temple that, before its destruction by the Persians in 480, had stood just to the south (Fig. 61). This, then, was the new (and last) home of the sacrosanct cult statue of Athena Polias and so was officially known in inscriptions as "the temple on the Acropolis in which the ancient image is," or simply the *Archaios Neos*, "the ancient temple," ancient and venerable because of the antiquity of the olivewood statue within it.

The consensus is also that this "Karyatid temple," the most sacred on the summit of the rock, was much more than a reliquary for the shrine and image of Athena Polias. It was a multipurpose temple with a variety of sacred places and cults, including that of Poseidon-Erechtheus. According to the popular view, Athena and the god-hero were so closely associated in myth and cult that "Erechtheion," which may have originally designated only a portion of the complex, became a nickname for the whole thing. In short, Pausanias does not distinguish the Erechtheion from the Temple of Athena Polias because it would not have occurred to him to do so; they were one and the same building.

This view has recently come under repeated fire from a couple of different directions. Some critics believe that the Karyatid temple is, in fact, the Classical Temple of Athena Polias, but that it is not the Erechtheion Pausanias describes. For them, the real Erechtheion was a completely different building, either the so-called House of the Arrhephoroi to the northeast (Fig. 2, no. 8) or the so-called Heroon of Pandion in the southeast

angle of the Acropolis (Fig. 2, no. 16).[5] Another critic believes that the Karyatid temple is the Erechtheion, all right, but that it did not serve as the Classical Temple of Athena Polias. In this view, the Archaic Temple of Athena Polias was extensively restored after the Persian destruction (in what would have been a major violation of the Oath of Plataia) and continued to function as such until antiquity's end. The Erechtheion was simply an "ornate and elegant appendage," a mere annex whose Karyatid porch was snugly inserted into a gap in the remains of the older temple.[6]

But, despite some genuine problems and legitimate concerns, there are still good reasons for maintaining the traditional identification of the Karyatid temple with both Pausanias's Erechtheion and the last Temple of Athena Polias. After all, the idea that Erechtheus and Athena shared the same space goes back at least as far as Homer,[7] and the close connection was continually reinforced in the imagery of the Acropolis. Erechtheus (probably) stands beside the goddess and her sacred olive tree on one Acropolis relief (CD 176) and nonchalantly shakes her hand on another (Fig. 43),[8] whereas a painting of Erechtheus driving his chariot even hung on the wall behind the statue of Athena Polias in her temple.[9] In his fragmentary play *Erechtheus*, written while the Karyatid temple was under construction, Euripides explicitly associates the establishment of the cult of Poseidon–Erechtheus with the establishment of the priesthood of Athena Polias;[10] he even makes Praxithea, Erechtheus's widow, the first priestess of the goddess. Historically, the priest of Poseidon-Erechtheus and the priestess of Athena Polias were both chosen from the ranks of the Eteoboutadai, the same clan whose portraits, Pausanias says, hung in the Erechtheion. The sacred snake of Athena is, by one source, said to live in the Temple of Athena Polias, by another source in the sanctuary of Erechtheus – which, if it does not prove the identity of the two, suggests that the temple of the goddess and the precinct of the hero somehow intersected.[11] We have the testimony of the Roman geographer Strabo,[12] who (though he does not have much to say about the Acropolis) says he saw Athena's eternal lamp in the Temple of Athena Polias (Pausanias, again, mentions the lamp after introducing the Erechtheion but before specifically mentioning the temple). We have an inscription datable to 409/8 that states unequivocally that the "overseers of the temple on the Acropolis in which the ancient statue is" oversaw work on the building we call the Erechtheion – pretty good evidence

that the two buildings were one and the same.[13] And, we also have Herodotos,[14] who notes that in his day (the mid-fifth century) there was already on the Acropolis a sanctuary of earth-born Erechtheus that included the olive tree of Athena as well as Poseidon's salt sea – presumably, the Pre-Erechtheion (Fig. 51). That is, an Early Classical shrine named after Erechtheus had within it the sacred tree that Pausanias would centuries later see in the Pandroseion adjacent to the Polias temple. If an early fifth-century temple of Erechtheus could have included Athena's famous token, there is no reason a late fifth-century Temple of Athena Polias could not have included the cult of Erechtheus. Finally, as we have seen, the Karyatid temple rose directly over and around the cult room of the Pre-Erechtheion – almost certainly the home of the statue of Athena Polias in the Early Classical period – absorbing it and its function as the locus of the most vital cult on the Acropolis (Fig. 66). Grounds for believing that the building with the Karyatids was, in fact, the Erechtheion, and that the Erechtheion was (or contained) the Temple of Athena Polias, remain strong.

The main block (or cella) of the Erechtheion had on the east a porch with six Ionic columns standing nearly 6.6 meters tall (Fig. 65; CD 124). These columns lean slightly inward toward the east cella wall but lack any swelling (*entasis*): optical refinements of the sort so common in the Doric Parthenon across the way or in the Propylaia are not as much in evidence here (the Erechtheion shows no upward curvature of its horizontals whatsoever and, in this respect, is a rarity among Classical temples).[15] The western wall of the cella had two levels: below, a basement of ashlar masonry pierced by a doorway and, above, a story with four Ionic half-columns set between antae (the thickened ends of the cella's side walls) (Fig. 117; CD 129). Between the half-columns were five tall windows, four grilled, one (the southernmost) open; these windows, once considered elements of the original building, are Roman additions, inserted when the building underwent massive renovations early in the reign of the emperor Augustus (in the 20s). Five much smaller, wedge-shaped slit windows, however, were cut into the bottom of the north and south cella walls as part of the original design, possibly to help illuminate special chthonic cult places within.[16]

The interior of the building was gutted in the Middle Ages and after, so its plan is largely conjectural (Fig. 66; CD 125). But, it is clear enough

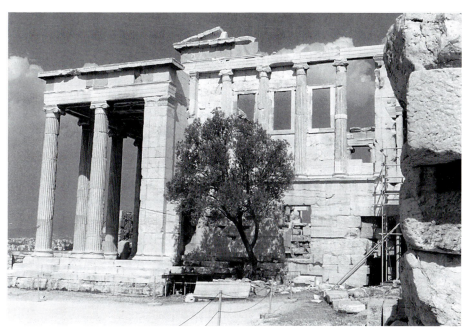

117. Erechtheion from the west. Photo: author.

that the cella was divided into at least two large rooms by a solid north-south wall. There was no commerce between the rooms, and this is what Pausanias may have meant by calling the Erechtheion "a double build-ing" (the walls dividing the cellas of the late-sixth-century *Archaios Neos*, the Older Parthenon, and the Parthenon [Figs. 61, 62, 68] were solid, too, so the Erechtheion, in this respect, exemplifies a fine old Acropolis tradi-tion). The slightly smaller eastern room was, again, almost certainly the location of the older shrine and statue of Athena Polias – a temple within a temple – as well as many of the gold wreaths, gold and silver vases, votive armor, and other treasures inventoried in fourth-century inscrip-tions. Two windows flanking the door would have let natural light in upon the shrine and its precious goods (just as the two large windows in the Parthenon's east cella wall [Fig. 87] let light into its interior, il-luminating the treasures of Athena and, indirectly, the statue of Athena Parthenos). The western room (whose floor was more than 3 meters lower than that of the east) was probably further subdivided into three compartments. An antechamber full of its own cult places (possibly the salt sea and trident marks of Poseidon; a rocky cleft in which Athena's sacred snake, the avatar of Erichthonios, was said to live; a rock-cut shaft and a shelf and tall niche in its southwest corner) provided access to

two smaller rooms set side by side. These were possibly devoted to the cults of the local hero Boutes (the Plowman, who in some accounts was Erechtheus's brother and the priest of both Athena and Poseidon, as well as the founder of the priestly Eteoboutadai family) and Hephaistos (the father of Erechtheus/Erichthonios). As plausible as it is conjectural, this plan imitates the cella of the temple the Erechtheion was built to replace: the late Archaic *Archaios Neos*, whose foundations, again, lay just to the south (Fig. 61).

Without actually naming the temple, the Roman architect Vitruvius[17] singles out the Erechtheion for "transferring to its sides what is normally found in front," and he is clearly talking about the building's north and south porches (Fig. 66). A splendidly ornamented doorway on the north side of the western antechamber connected it with a great porch (Fig. 118; CD 126–128), supported by six tall Ionic columns, that actually extends about 3 meters beyond the western wall of the cella proper (to the east of the north porch was a rectangular paved courtyard; a broad flight of stairs led up to the level of the east façade). Beneath the marble floor in the southeastern part of the north porch is a small crypt,[18] and an opening left in the pavement reveals a cluster of irregular fissures and indentations in the bedrock below. Though often thought to be the marks of Poseidon's trident, the fissures were most likely considered scars left by Zeus's thunderbolt, which put a dramatic end to the contest waged by Athena and Poseidon over rights to Athens. Framing the hole in the floor was an altarlike structure; we are told in inscriptions of an altar in the north porch sacred to an obscure character known as the *Thyekhoos* (pourer of offerings), and most likely this was it. Almost directly above the hole, high above in the marble ceiling and roof of the north porch, there is another elegantly crafted rectangular opening, a kind of skylight. That there was some kind of metaphysical connection between the markings in the rocky crypt below and the bright heavens above seems inescapable.

South of the western antechamber, though on a higher level and connected to it by a stairway, is the famous Porch of the Karyatids, answering on a smaller scale the six columns of the north porch with its six (not quite evenly spaced) maidens (Fig. 67; CD 121–122). The Karyatid porch could also be entered from the outside by a small stairway at its northeast corner, though this is unlikely to have been a common point of entry.

118.　Erechtheion, north porch. Photo: author.

Like most of the south wall of the building, the porch rests upon the foundations of the late sixth-century *Archaios Neos* (Fig. 61) and so, if the plan of the cella of the Erechtheion truly emulated that of the old temple, there was a tangible as well as a formal connection between them, with the substructure of the Archaic temple literally supporting the Classical (just as the Periclean Parthenon stands largely upon the foundations of the late Archaic Older Parthenon; Fig. 4), with the Classical temple serving as a kind of re-creation or reincarnation of the Archaic. Tucked under the Karyatid porch was also a portion of the Kekropeion, the ancient

hero-shrine (and supposedly tomb) of the legendary king in whose time the contest between Athena and Poseidon and the creation of their tokens (the olive tree and trident marks) took place. Perhaps the Karyatids, who held *phialai*, or libation bowls, in their right hands, were to be thought of as participants in the cult of Kekrops. In any case, the Kekropeion extended at an angle to the west, beyond the porch, and a tall stele may have marked its location in the Classical period, as a great Ionic column seems to have done in the Archaic.[19]

To the west of the temple lay the quadrilateral enclosure known as the Pandroseion (Fig. 2, no. 10), the shrine to the one obedient daughter of Kekrops. The priestess of Pandrosos, incidentally, was also priestess of Aglauros, whose sanctuary was located on the east slope of the Acropolis below that massive cave (Figs. 2, no. 19; 9),[20] so that summit and slope were in some sense related by cult. At all events, the principal features of the Pandroseion were a small Ionic stoa (built before the Erechtheion) that ran along its north side, the sacred olive tree of Athena, and, in the shade of the tree, an altar to Zeus Herkeios (Zeus of the Court). The door in the lower story of the west wall of the Erechtheion (Fig. 117) provided direct access between the Pandroseion and the Erechtheion's interior; another doorway directly connected the Pandroseion to the north porch of the Erechtheion. Thus the Pandroseion should be considered an appendage to the temple, part of the same great complex. And complex is just what the Erechtheion was: its irregular, even radical plan was dictated by the need to incorporate within it a variety of preexisting but previously discrete cult places spread over the uneven terrain of the north side of the Acropolis and to combine them all as a new incarnation of the destroyed *Archaios Neos*. Again, the notion of accommodating the old in the new was not original with the Erechtheion architect – it almost seems a Periclean principle (see Chapter Two). At all events, the Erechtheion was not a temple devoted to a single divinity but an assemblage of shrines – a sacred multiplex – devoted to many deities, heroes, and a heroine. It was a composition of shrines, a sanctuary within a sanctuary.

The name of the architect of this unprecedented building is unknown. We do know that a certain Philokles and an Arkhilokhos were each given one-year contracts to help bring the project to completion after an interruption late in the fifth century. We even know the names of the workmen who fluted the columns of the east porch: Laossos of Alopeke,

for example, and Phalakros of Paiania, and their slaves Parmaean, Karion, Thargelios, and Gerys. (Slaves, incidentally, make up about 20 percent of the more than 110 Erechtheion workmen whose names we know, *metoikoi* more than 50 percent.) However, Philokles and Arkhilokhos were most likely just site supervisors or master craftsmen hired to oversee the finishing touches (such as fluting some columns and carving some decorative rosettes) on a building whose architecture was already largely complete. As the original designer of the temple, scholars have proposed such better-known architects as Kallikrates and Mnesikles. Kallikrates – a contractor, a builder of walls and modest shrines – seems not have been as subtle or sophisticated a designer as the Erechtheion required.[21] But, there are, in fact, a number of similarities between the temple and Mnesikles's Propylaia: the general asymmetry of the buildings, for example; the way they incorporate various blocks into one complex; the split-level nature of the designs, necessitated by the irregular ground, with floors and colonnades at different levels; the use of Eleusinian limestone for details (CD 107, 130) or, more technically, the use in the north porch of a "double anta" that seems modeled on the double anta of the Propylaia's southwest wing (Fig. 55); and the fact that the Erechtheion, like the Propylaia, has column–drums apparently belonging to the interior order of the Archaic gateway to the Acropolis (the Older Propylon) built into its foundations.[22] Certainly, the Athenians could have found no better architect for the Erechtheion than the genius of the Propylaia. On the other hand, there are also a number of technical similarities with the Ionic Temple of Athena Nike (Fig. 76), built in the 420s: the same use of a rare kind of dowel, for example, or the use of the same formulae in decorative mouldings,[23] or the optical refinement of inward-leaning columns (unknown in any other Ionic building). These correspondences need not mean that the same architect designed both temples, only that the same well-trained labor force worked on both and brought their special skills and techniques from one to the other.[24] Still, one wonders whether Mnesikles figured in the Nike Temple project, too.

Neither "the Erechtheion" nor "the temple in which the ancient image is" is mentioned in the Kallias Decrees (434/3), and neither is mentioned in Plutarch's list of Periclean building projects. The inference has long been that the temple was not part of the Periclean program, that Pericles essentially ignored the more sacred cult of Athena Polias in favor of

the more ideological and imperial Athena Parthenos (Fig. 21), and that while he lived he was content to leave the ancient olivewood statue in the modest Early Classical shrine on the north side of the rock (Fig. 51). In fact, the inception of the Erechtheion has typically been dated to 421, eight years after Pericles's death (the Peace of Nikias, it is thought, would have been the most propitious moment after the start of the Peloponnesian War for the beginning of so large and expensive a project on the Acropolis). Still, there is no hard evidence for the date of the groundbreaking. The concluding lines of Euripides's fragmentary *Erechtheus*, in which Athena directs Praxithea to build a shrine for the hero, have been taken to allude to construction already underway in the late 420s (when the play was written), even before the peace. And, it is increasingly clear that, despite its absence from Plutarch's list, the Erechtheion had been projected or even begun long before that, in the 430s – and so during the Periclean regime after all.[25] It is difficult to imagine the Athenians initiating a major project after 434/3, when the assembly had just passed an injunction (in the form of the Kallias Decrees) to wrap everything up in anticipation of conflict, even to the point of leaving the Propylaia unfinished. One possible scenario is that the Erechtheion was begun around the same time as the Propylaia (437), that construction did not progress very far before the outbreak of war and Pericles's death, and that full-scale work proceeded only in fits and starts thereafter (hence its absence from Plutarch's list). Most of it would have been built by 413, when the Sicilian disaster and fiscal exigencies probably brought the project to another halt. Work on the temple definitely resumed, inscriptions inform us, in 409, when a commission was appointed to report on the state of the building (that is when Philokles was appointed site architect; Arkhilokhos took over the next year). Perhaps the confidence-building and very profitable victories won by Alkibiades at Kyzikos and the Hellespont in 410 provided the inspiration (and some of the funds). There is some questionable evidence that an accidental fire on the night of a full moon caused one last delay[26] but, if so, the temple was essentially completed soon after, in 406/5 – essentially completed, because even here a few details (some rosettes in the architrave above the Karyatids and a portion of the egg and dart moulding below them on the west side of the porch) were never carved.

The Erechtheion had three pediments (east, west, and north porch); all were empty. There is no evidence for any *akroteria*. The sculptural adornment of the building was thus limited to the maidens of the south porch and a continuous Ionic frieze. The Karyatids (Fig. 67; CD 122) are appropriately stocky and powerful (they do the work of columns, after all) and although at first glance they seem to differ only in the distribution of their weight (three stand with the right, three with the left leg relaxed), a closer look reveals that they all vary in the treatment of their coiffures and drapery (which may also have been painted differently on each statue). They were carved and set in place during an early phase of construction and so may be dated around 420. Inscriptions refer to them as *korai* and the choice of words may not be coincidental: these maidens – who, like many Archaic *korai*, wear their hair long in spiraling locks and originally held a *phiale* in their right hand and tugged at their dress with their left – might have been considered public or state replacements for the private votive *korai* destroyed by the Persians in 480 (cf. Fig. 45), or even for Karyatids that once stood in Archaic buildings on the Acropolis.[27] At the same time, the Karyatids face south, toward the Parthenon, and in profile view they look like three-dimensional versions of the maidens of the Parthenon's east frieze, some of whom carry *phialai*, too (Fig. 105; CD 087–088, 098). The style of Agorakritos or Alkamenes has sometimes been detected in the statues; Alkamenes's "Prokne" (Fig. 119; CD 172), dedicated near the northwest corner of the Parthenon around 430–420, looks a lot like a Karyatid that has stepped down from the building and entered a myth. But, chains of attribution are only as strong as their weakest links. And, although the Karyatids may well have been the product of a single workshop under the direction of a known master responsible for the model or prototype – and Alkamenes is an excellent candidate – it is likely that the individual statues were carved by artists whose names we would not recognize. That, indeed, is the case with the Ionic frieze that ran around the top of the exterior of the cella and the north porch.

The Erechtheion frieze (probably carved toward the end of the project, around 409–406) displays a technique that was never again attempted for architectural sculpture (Fig. 120; CD 130–132): separately carved, high-relief marble figures or groups pegged (by means of iron dowels)

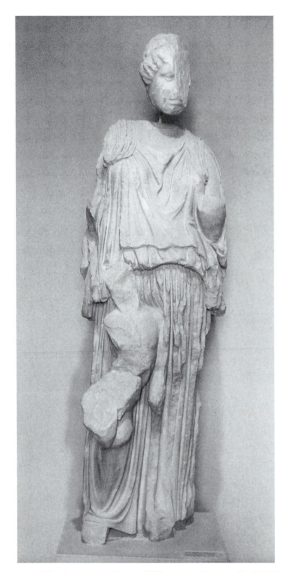

119. The Prokne and Itys of Alkamenes (Acropolis 1358), c. 430–420. The head has now been removed. Photo: author.

to a background of dark bluish Eleusinian limestone (on the Parthenon frieze, the background was painted blue).[28] Though no figure is still in situ, over a hundred marble fragments of the frieze remain. Some are Roman replacements or additions, attached when extensive repairs were made (especially to the western part of the building) during the reign of Augustus. A few female figures (at least one with her breast exposed) run to the left or the right. Other women stand or crouch or sit on

120. Erechtheion frieze (Acropolis Museum). The third figure from right (a seated Apollo) is a Roman replacement or addition. Photo: author.

chairs or rocks. A youth kneels at the feet of a man caught in a strikingly contorted pose (he resembles the twisting Itys of Alkamenes's Prokne group; Fig. 119). A figure of uncertain gender rises from a throne. A seated Apollo holds an *omphalos* in his lap (this piece is of Roman date); a seated woman holds a young boy in hers. Inscriptions tell us of other figures: a youth writing something down, for example, or wagons and mules. Most of the preserved figures are posed fairly quietly, and there is not much that helps identify the undoubtedly mythological content of the frieze. A recently published fragment with a Corinthian helmet lying on a rocky outcropping suggests that Athena, shown seated with her armor at her side, appeared at least once.[29] The woman with the boy in her lap also naturally makes one think of (or hope for) Athena and Erechtheus/Erichthonios, but there were other such mother–child groups, so the identification is weakened. No doubt, there were several different subjects (the frieze on the north porch was at a different level and on a slightly larger scale than the rest, and so might have called for separate treatment).

An important inscription of 408/7 identifies some of the artisans who worked on the frieze (a large percentage, again, were *metoikoi*) and tells us

what they were paid (the going rate was 60 *drakhmai* per figure, human or animal):

Phyromachos of Kephisia, the youth beside the breastplate. 60 *drakhmai*.

Praxias resident at Melite, the horse and the man seen behind it who is turning it. 120 *drakhmai*.

Antiphanes of Kerameis, the chariot and the youth and the pair of horses being yoked. 240 *drakhmai*.

Phyromachos of Kephisia, the man leading the horse. 60 *drakhmai*.

Mynnion resident at Agryle, the horse and the man striking it; he afterwards added the pillar. 127 *drakhmai*.

Soklos resident at Alopeke, the man holding the bridle. 60 *drakhmai*.

Phyromachos of Kephisia, the man leading on his staff beside the altar. 60 *drakhmai*.

Iasos of Kollytos, the woman embraced by the girl. 80 *drakhmai*.[30]

Without the inscription, we would never have heard of Phyromachos and his fellows, who evidently were assigned different figures in a single scene of harnessing four horses to a chariot.[31] However, not even the carver of the inscription specifically identifies the figures. They are described generically ("the man leading the horse," "the woman embraced by the girl"); it is as if even he did not know who they were. Still, the prevalence of horses and chariot in this passage and the predominance of women in the extant fragments raises the possibility that at least some of the frieze represented the career and family of Erechtheus himself. He (and not Athena) was in some accounts the inventor of the chariot, and the only major myth dealing with him (besides the story of his birth) involves the sacrifice of his own daughter (and other daughters' self-sacrifice) to save the city from the invading Eumolpos (the story was told in Euripides's *Erechtheus*, which, as we have seen, may have other connections with the Erechtheion). This story, which has been read (implausibly) into the Parthenon frieze, was more likely depicted or alluded to here instead.

Although not as sculpturally loaded as the Parthenon or the Temple of Athena Nike, the Erechtheion was a remarkably luxurious building. Mouldings or bands carved with lotus-palmette chains, egg-and-darts, leaf-and-darts, bead-and-reels, guilloches, rosettes (carved or gilt bronze), and other patterns were everywhere: around the frame of the north door (Fig. 118); around the windows of the east wall; around the aperture in

the ceiling of the north porch; around and in the ceiling coffers; or atop the cella walls (the contrast between the lush decoration at the top of the south wall and the vast plainness of the wall beneath [Fig. 17; CD 130] is startling). Column capitals even had gilding and column bases were enlivened with multicolored beads of glass. This, in short, was an exceptionally rich jewel box of a temple and yet, for all its external elegance, it was still a place of mystery and curiosities within – a place unparalleled for its asymmetry (in a culture where symmetry was a metaphor for rationality), a place of strange thunderbolt and trident marks, of holes left in the roof and floor, of a salt-water sea, of tombs, of snake-inhabited crevices and underground crypts, and of a statue that had fallen down from heaven.

It may seem remarkable that temples as different as the Ionic Erechtheion and the (mostly) Doric Parthenon could stand just 40 meters apart on the summit of the Acropolis. Indeed, for some, the Erechtheion has seemed in some measure an eccentric, even critical, response to the Periclean building, a reassertion of the primacy of the oldest cult places of Athens that had been neglected during the years of Pericles's dominance. In this view, the building represents a late fifth-century resurgence of fundamentalism or the irrationality of religious belief in the face of the symmetrical, colonnaded Parthenon's promotion of its own imperial Athena (Fig. 21) and Periclean rationalism. Naturally, this view is weakened if the Erechtheion was, in fact, designed as early as the 430s. In any case, the Erechtheion and the Parthenon should not be regarded as architectural antagonists; the buildings do not clash. We need instead to stress the role they together played in the spatial and iconographic composition that was, finally, the Classical Acropolis. The Karyatids, looking a lot like Parthenon sculptures themselves, acknowledge the Parthenon and direct our attention to it. In turn, the Erechtheion gave spectacular shape to the north-side cult places that the Parthenon itself had already alluded to in its sculpture. There, in the west pediment, after all, was Athena's olive tree and Poseidon's trident and Kekrops and possibly even Zeus's thunderbolt (Figs. 25, 28, 92), now all incorporated within the confines of the admittedly unorthodox new building across the way. Erechtheus himself probably appeared in the west pediment. Hephaistos, the object of an Erechtheion cult, appeared several times on the Parthenon (cf. Fig. 32). Boutes, the object of another Erechtheion cult, may have appeared in one of the lost Parthenon south metopes.[32] And,

of course, the object of the Panathenaic procession – the recipient of the *peplos* found in the middle of the Parthenon's east frieze (Fig. 20) – was not the gold-and-ivory Athena Parthenos but rather Athena Polias, the ancient wooden statue that had always been housed on the north side of the rock.[33] The building of the Erechtheion only made that side more glamorous and worthy of the Parthenon's allusions. Different the two buildings certainly are, but they are also complementary.

CHAPTER SEVEN

THE SANCTUARY OF ATHENA NIKE

The cult of Athena Nike, Athena (Goddess of) Victory,[1] seems to have been established atop the old Mycenaean tower beside the entrance to the Acropolis by the middle of the sixth century (Fig. 60). The crown of the ancient bastion was at that time rebuilt and a new, if modest, precinct was laid out on top. Its focus was an altar and a cult statue originally set into a poros limestone base (two blocks of which survive).[2]

Like so much else, the precinct was sacked by the Persians in 480, but the statue somehow survived (like the image of Athena Polias, it was probably carried off to Salamis before the Persians arrived). Where it spent the Early Classical period is uncertain. If the Athenians left the sanctuary in ruins in accord with the Oath of Plataia, the image was presumably stored elsewhere on the Acropolis. But, beneath the pavement of the sanctuary in its final form there are the remains of a small limestone temple (a *naiskos* only a few meters wide) and another altar. Whether the *naiskos* was built soon after 480 or closer to 450 is a matter of dispute. However, there is no question that it was there by the middle of the fifth century, and that the image would have been displayed inside.[3] As for the image of Athena Nike itself, we cannot say much. It is likely to have been under life-size, wooden, and standing, and we are told that the goddess held a pomegranate in her right hand and a helmet in her left (the many-seeded fruit was a symbol of fertility and the abundance victory brings, whereas the helmet, because it was not in place on the goddess's head, symbolized the peace and security won by military success).[4]

181

Text of a marble inscription[5] authorizing the appointment of a Priestess of Athena Nike, setting her annual compensation, and directing Kallikrates to build a temple, altar, and doors to the sanctuary:

... [Glau]kos made the motion: For Athena Nike a priestess who shall be appointed [by lot] from all Athenian women, and the sanctuary shall be fitted with doors as Kallikrates shall specify. The Poletai shall contract for the project in the prytany of [the tribe] Leontis. Payment to the priestess shall be fifty *drakhmai* plus the legs and hides from public sacrifices. A temple shall be built as Kallikrates shall specify and an altar of marble. Hestiaios made this motion: three men shall be elected from the Council. They, together with Kallikrates, after making the specifications, shall (submit to the Council) the manner in which ...

The date of the inscription is controversial, but most scholars place it around 450–445. A second decree,[6] inscribed on the back of the same stone and firmly datable to 424/3, reaffirms the fifty *drakhmai* payment to the priestess.

Probably in the early 440s, the Athenian people passed a decree authorizing, first, the appointment of a priestess by lot (and apparently for life) and, second, the complete rebuilding of the sanctuary of Athena Nike, monumentalizing it in keeping with the spirit of the other major works of the Periclean Acropolis. Under the direction of Kallikrates (one of the two architects of the Parthenon), the entire bastion received a new sheath of limestone that straightened its lines (it was now trapezoidal in plan, widening toward the east), increased its area, and raised the level of the sanctuary above (Figs. 58, 116). As we have seen, near the base of the bastion's west face, two large rectangular niches re-created the crude double-niche of the old Mycenaean tower located behind (cf. Fig. 57), and an eye-catching, eye-level polygonal opening was left in the north face of the bastion so that pilgrims climbing the new Classical ramp leading up to the Propylaia could view the Cyclopean masonry encased inside (CD 133–135). The limestone sheathing is crowned by a moulding of Pentelic marble, the same material used for the little but elegant and profusely adorned Temple of Athena Nike itself (Fig. 76; CD 137–138).

If the temple was, indeed, authorized and Kallikrates hired in the early 440s, construction of the Parthenon and Propylaia apparently took precedence and (along with the outbreak of the Peloponnesian War) caused delays in execution. However, the relationship between the Propylaia and the Nike bastion was close and intricate. The Propylaia is the earlier of the two buildings, and it is clear that one of the Nike architect's

tasks in remodeling the bastion was to bring its level up to that of the gateway. But, if the new bastion plainly acknowledged the existence of the great Mnesiklean structure, the design of the southwest wing of the Propylaia was, as we have noted, itself revised several times to accommodate the rebuilding of the Nike bastion and precinct and permit easy passage between the two. It is, thus, likely that work on the Propylaia and at least the earliest stages of the rebuilding of the Nike bastion overlapped, and that the monumentalization of the bastion had already begun by 432, the year work on the Propylaia was abandoned.[7] In short, the new, grander sanctuary of Athena Nike should be considered part of Pericles's own vision for the Acropolis – and this, despite the fact that Plutarch does not list it among the projects of the Periclean building program and that Pericles did not live to see the temple's completion.

The Nike temple itself may have been begun around or before 430 but it was not finished until the 420s. In 424/3, another decree reconfirmed the amount of the priestess's salary, and the assumption is that the temple was complete by then. It is fair to wonder whether Kallikrates, originally appointed twenty or twenty-five years before, was still architect.[8] At any rate, the temple could not have taken very long to build. It is a dainty Ionic structure (c. 9.36 by 6.6 meters), set flush against the western edge of the bastion, with a tiny cella that is wider than it is deep and with four slender columns set front and back (that is, tetrastyle amphiprostyle). It was built with some of the same kind of optical refinements that distinguish the Parthenon and other Periclean buildings (the north and south walls of the cella, for example, lean inward slightly and the columns lean back) and with some of the same decorative motifs that adorned the Erechtheion.[9] A new altar was built less than 2 meters to the east of the temple, and the entire sanctuary was paved in marble. The precinct, which lies outside the Acropolis fortification wall and, thus, technically outside the confines of the sanctuary of Athena Polias on the summit, could be entered either from the east, via the southwest wing of the Propylaia, or from the north, up a small stairway leading from the Classical ramp (Figs. 58, 122; CD 136).

Upon completion of the temple, the Archaic cult statue of Athena Nike was installed inside on a marble base, which was itself possibly decorated with a relief frieze (there is a fragmentary Nike that might belong). The exterior of the temple was decorated with what might be, pound

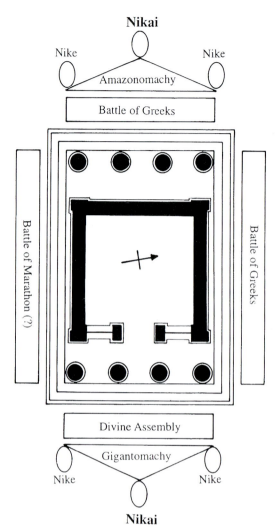

121. Sculptural Program of Temple of Athena Nike. Based on Stewart 1990, pl. 414, with revisions.

for pound, the richest sculptural program of the Classical Acropolis (Fig. 121), and it is no surprise that the principal theme was victory (*nike*) itself. The theme was expressed mythologically, allegorically, and historically,[10] and it started at the top, in the gilded bronze *akroteria* of the roof. Each central *akroterion* (east and west) apparently consisted of a nearly life-size winged Nike shown as if descending from Olympos, alighting above a shield (possibly decorated with a scene of Bellerophon riding Pegasos against the Chimaira) and flanked by Nikai left and right. Individual Nikai were set at the four corners of the roof, making ten rooftop Nikai in all – one for each Athenian tribe.[11]

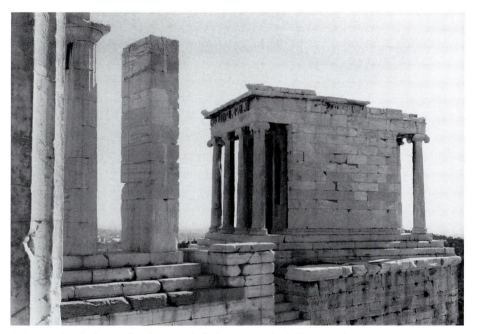

122. Temple of Athena Nike, from north (before restoration). Photo: author.

Below the roof, the victory of the gods over the giants filled the east pediment, and the victory of the Athenians over the Amazons filled the west: the marble remains are sparse. Below that, in a continuous frieze (0.45 meter high) running around the temple (for a length of about 26 meters), there is both myth and, exceptionally, history (or history mythologized). The battles on the north (Figs. 122–123; CD 137, 144) and west (CD 145)

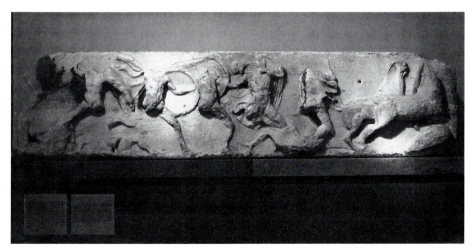

123. North frieze (detail), Temple of Athena Nike: battle between Greeks. Photo: author.

are problematic but most agree that they show, remarkably, Athenians fighting other Greeks.[12] The question is whether the fights are historical or mythological. Possibly they depict struggles between Athenians and their enemies in the early years of the Peloponnesian War; that is, these could be very recent fifth-century battles, fought by Athenians who were still alive to see themselves commemorated in marble. But, it has been argued that the west frieze depicts legendary Athenians fighting to recover the bodies of the seven heroes who fought against Thebes, while the north showed the Athenians defeating the forces of Eurystheus, king of Argos – mythological antecedents for Athens's more recent historical battles against the Thebians and Argives, Spartan allies. Whatever the case on the north and west, the battle on the south (Figs. 74–75; CD 142–143) is very likely the quite historical but, by the end of the fifth century, almost legendary Marathon.[13] In the Classical Athenian mind, the line between history and myth was not clear, and Marathon existed easily in both realms (the Marathon dead were, in fact, worshipped as heroes).

On the east frieze (Figs. 76, 124; CD 139–141), thought by some to be in the style of Pheidias's pupil Agorakritos, a host of widely spaced standing and seated divinities (and perhaps a hero or two as well) gather around a central group of a fully armed Athena and another, virtually lost male figure (just parts of his legs survive). Poseidon sits on a rock to the left of Athena (as we look at them), Zeus on his throne to the right of the mostly missing figure. The gods are generally quiet and most are posed frontally: they, therefore, face east. Hermes, the Graces, and Hygieia (Health), all probably to be found on the frieze, were worshipped nearby, and so on the frieze they may be looking in the direction of their own shrines. Aphrodite and Peitho (Persuasion) are found at the south end of the frieze, and so they loom above their own sanctuary: the shrine of Aphrodite Pandemos, set beneath the south face of the Nike bastion almost directly below (Fig. 2, no. 31). What the divine assembly has to do with the battles on the other sides of the temple is uncertain. One explanation is that the gods have come together to honor Athena as guarantor of the victories depicted around the corners; the battles are manifestations of her province and power, and the male god at her side would, in that case, be Ares, the god of war.[14] It is also worth noting that divine assemblies had been juxtaposed to heroic battles in architectural sculpture as early as the sixth

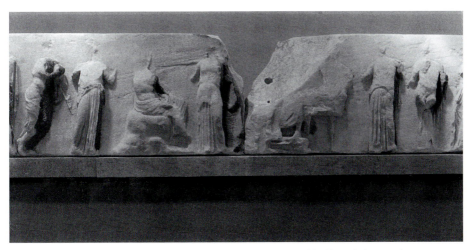

124. East frieze (detail), Temple of Athena Nike. Divine Assembly (from left to right: Dionysos?, Amphitrite, Poseidon, Athena, Hephaistos?, Zeus, Hera, Herakles or Hermes?). Photo: author.

century[15] and that a few figures apparently rushing in from the south and north ends supply a slender formal connection to the dynamic battles on those sides of the temple. A new theory, however, suggests that the east frieze depicts the birth of Athena. The lost figure at her side would be Hephaistos, who assisted at the delivery, and the rushing figures would, in fact, be dancing.[16]

The sculptural program of the Nike temple was, in its way, a variation of or comment on the Parthenon's. Bellerophon's winged steed Pegasos (likely seen on the shields below the central Nikai *akroteria*) was seen again (twice) on the helmet of the Athena Parthenos. The use of Nikai as *akroteria* mimicked their use on the Parthenon (Fig. 90). The combination of Amazonomachy and Gigantomachy on the west and east pediments repeats the same back-to-back relationship between those myths on the outside and inside of the shield of the Athena Parthenos and on the west and east metopes of the Parthenon. Certain passages in the battle friezes seem to have quoted portions of the shield of the Athena Parthenos; the battle on the south frieze even recalls that the Parthenon itself was considered a monument to Marathon. If the east frieze depicts the birth of Athena, its relation to the Parthenon east pediment is clear. But, even if it does not, the east frieze repeats a common Parthenon theme – the divine assembly (east pediment, east frieze, and the base of the Athena Parthenos). Carved in response to the Parthenon program, the Nike temple sculptures, rising above the visitor as he first ascended the Acropolis,

fittingly introduced or prefigured what he would find on the summit. In fact, the Nike bastion is to the Acropolis what the chryselephantine Nike is to the statue of Athena Parthenos (Figs. 5, 21). The Acropolis, with the bastion projecting like an arm from its west slope, its three faces covered with shields captured from the Spartans, seems to extend Victory to the city of Athens in the same way that the Athena Parthenos, with her outstretched right hand, presented Nike to the visitor inside the Parthenon.[17]

The Nike Parapet

The Nike bastion juts out sharply from the Acropolis (Fig. 58). Its summit is high, exposed, and none too spacious; its sides are sheer and steep. It is a perilous place, and the dangers would have increased when people in some numbers gathered around the altar on days of sacrifice. What was needed was something to keep visitors from falling off, and so a waist-high marble parapet or balustrade was built along the three edges of the bastion (Fig. 116). The parapet has usually been considered an architectural afterthought, but it was possibly part of the original conception of the Periclean bastion and precinct.[18] There was also a short return beside the small stairway leading up to the sanctuary from the great ramp below (Fig. 122), and the whole thing was about 34 meters (100 feet) long. The balustrade itself was framed below by the projecting Pentelic marble crown of the bastion and by a moulding above. For added security, a bronze grille was set into its upper surface. Between the mouldings, on the outer face, ran a continuous figured frieze about nine-tenths of a meter high (the height of the frieze plus the upper moulding is almost exactly the same height as the Parthenon frieze). Though it was not visible to anyone standing within the Nike sanctuary itself, the parapet frieze was the architectural sculpture closest to the pilgrim climbing the west slope up to the (sculptureless) Propylaia.[19] Looming above the visitor on the right, the parapet would certainly have been among the first figured works to catch the eye. In this sense, it was (along with the shields hung on the bastion and the sculptures of the Nike temple itself) the visitor's introduction to the iconography of the Classical Acropolis – the initial statement of its pervasive theme of victory.

The frieze was filled with approximately fifty figures (more, if the south frieze extended past the line of the Nike temple's east façade towards

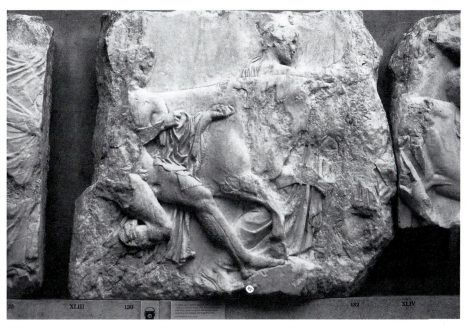

125. Parthenon south frieze, detail: youth restraining heifer. Photo: author.

the relic of the Cyclopean wall). Because Athena Nike herself, seated on a rocky throne, seems to have appeared at least once on each side of the parapet (near the center on the west, and on the westernmost slabs of the north and south sides) (Fig. 77; CD 149), the parapet frieze had no single goal (as the Parthenon frieze did).[20] Instead of forming a continuous progression around the top of the bastion, each side of the parapet was discrete and self-contained; taken together, they were purposefully repetitive. Thus, to someone standing below the northwest corner of the bastion on the way up the Acropolis ramp (Fig. 58), two Athenas would have been visible at once, and the theme of victory would have been clear. For around the Athenas, who merely sat and watched, were flocks of winged Nikai who approached the goddess (one held a helmet in her hand) or stood on tiptoe to trim battle trophies (CD 148), or casually untied their sandals (Fig. 78; CD 152), or pushed and pulled cattle to the sacrifice (Fig. 79; CD 147, 151), all with the grace and grand gestures of ballerinas at the barre.

It is worth noting that a fourth-century inscription detailing the massive Panathenaic sacrifice says that one of the most beautiful cows brought to the Acropolis was to be sacrificed on the altar of Athena Nike.[21] However, the gender of only one of the animals preserved on the Nike parapet is clear. It is male, and male animals were not normally

sacrificed to a goddess. The Nike parapet, then, probably does not represent sacrifices to Athena; it represents sacrifices that Athena herself attends or supervises. Possibly this is the kind of sacrifice made by warriors before battle, here undertaken by divine figures on the Athenians' behalf. In this view, the Nike parapet, telescoping time, represents both the requisite sacrifice before battle and the erection of trophies afterwards: victory is sought, assured, and won at once.[22] But, more likely, the sacrifice is not to the gods at all but to dead Athenian heroes – heroes like those defending Athens in history and myth on the friezes of the Nike Temple above, heroes like those who fell at Marathon (Figs. 74–75).[23]

The trophies the Nikai built (CD 148) are variously hung with hoplite armor, naval equipment (apparently), and Persian spoils, and the differences may be significant. It could be, for example, that there was some relation between the sides of the parapet and the sides of the frieze on the Nike temple above. The Persian trophies, for example, seem confined to the south side of the parapet, corresponding to the battle of Marathon depicted in the south-temple frieze. Still, those trophies may also commemorate victories more recent than Marathon. The parapet is often thought to have been carved around or just after 421 (incidentally, it was not carved *in situ*)[24] and, at that date, it would have put an elegant Athenian spin on the Peace of Nikias. But, stylistic evidence suggests a date closer to 415 or even 410, when Athenian spirits, crushed by the failure of the Sicilian expedition just a few years before, were rapidly reviving. Near the beginning of Aristophanes's comedy *Lysistrata* (produced in 411),[25] the chorus of old men – they are veterans of Marathon – stand before the Propylaia and appeal to Lady Nike for a trophy of victory over the women who have seized the Acropolis. This may be an allusion to the carving of the parapet then underway (if not to the Nikai *akroteria* on the temple's roof). So, too, the Athenians won a string of victories over the Peloponnesians in the eastern Aegean and Hellespont between 411 and 407 (Alkibiades won most of them) and so frustrated the designs of the Persians (who now subsidized Sparta) in the area. The display of Persian spoils hanging on trophies on the parapet may well refer to these late successes against their ancient foes as well as to Marathon, conflating recent and ancient history. Finally, though dating sculptures on the basis of style alone is an inexact science to say the least, some figures on the parapet seem earlier than the Erechtheion frieze (Fig. 120, dated c. 409–406), whereas others seem about the same date or even later.

One artist probably designed the frieze, but the work was turned over to a fairly large and heterogeneous team of sculptors. Six or seven distinct hands have, in fact, been identified, and two artists with very different styles could even work on the same slab (one might carve drapery in thick, deep, flourishing folds, for example, whereas the other might carve flimsier, revealing material with sharp, shallow furrows; Fig. 79). It has been nearly impossible to resist identifying these Nike Masters A, B, and so on with known sculptors of the last quarter of the fifth century – A with Agorakritos or Kallimachos, B with Paionios or Kallimachos, D with Kresilas, for example – but the temptation should probably be avoided. It is likely that some of the sculptors had already worked on the Nike temple pediments and friezes or even the Parthenon frieze or, at least, knew them well.[26] The famous Nike unbinding her sandal before treading upon sacred ground (Fig. 78), for example, seems a variation of the Aphrodite who bends over, placing her foot on a rock, near the south end of the Nike temple's east frieze. And the artist who carved the Nike bracing her foot on a rock as she tries to control a recalcitrant if diminutive bull (Fig. 79) or another Nike leading a bull from the south side[27] seems to have known (could he, earlier in his career, have carved?) a passage on the Parthenon's south frieze, where a youth similarly restrains a heifer (Fig. 125). Still, as in the case of the Erechtheion frieze, a list of the sculptors of the parapet would likely be filled with the names of unknowns.

At all events, the parapet below and the *akroteria* above establish an allegorical frame for the mythological–historical sculptures of the Nike temple itself (Figs. 58, 121). There, on the sides of the temple most visible to those climbing the Acropolis, Athenians fight Persians (south frieze), Amazons (west pediment), and other Greeks (west and north friezes). On the roof, Nikai crown Athens with victory and, on the parapet, dozens of similar personifications either perform the necessary sacrifices before battle or sacrifice to honor the Athenian heroes of battles past. By building trophies, they celebrate the victories such sacrifices and honors guaranteed. If the victories are not those depicted on the temple above, then the Athenians were here engaging in sculptural wish fulfillment, using divine figures to assure their success in the last years of a war they were destined to lose.

THE REST OF THE PROGRAM

The nineteenth-century clearing, excavation, and restoration of the Acropolis essentially left it a composition of the four principal parts of the Periclean building program: the Parthenon, the Propylaia, the Erechtheion, and the sanctuary of Athena Nike, all of them conceived, built, or begun in the 440s and 430s (Figs. 1, 5).[1] But, the marble tableau we see today, with wide spaces tastefully separating the monuments, allowing the visitor to continually reframe his views and so enjoy the Romantic pleasure of ruins without hindrance, is misleading. The Acropolis as it stood at the end of the fifth century was a very different place. Filling the openness we see and feel today, surrounding the major Periclean buildings and sometimes blocking them from view, were many other buildings, precincts, and walls, not to mention scores if not hundreds of stelai, statues, and statue groups set on bases on the ground (cf. Figs. 56, 115, 129). The Classical Acropolis was a crowded, complicated place (Fig. 53). Still, in its basic outlines, it was the product of an integrated Periclean design, and this can be seen especially well in the layout of several shrines and precincts on the west side of the summit, in the area between the Propylaia and the Parthenon itself (Fig. 2).

The Shrine of Athena Hygieia

During the construction of the Propylaia, Pericles's favorite workman fell from a great height. As he lay near death, Athena appeared to Pericles

in a dream and told him what medicine to administer (the herb came to be known as *parthenion*). The man was cured and, not far from an earlier altar, Pericles dedicated a bronze statue to Athena Hygieia (Health) to commemorate the miracle. This is a tale told by Plutarch[2] and, like much of his *Life of Pericles*, it is more colorful than accurate.

Just inside the Propylaia, set against the southernmost column of its east porch, is a roughly semicircular inscribed base for a bronze statue (Figs. 23, 55; CD 111–112). The inscription reads, "The Athenians to Athena Hygieia. Pyrrhos the Athenian made it."[3] We know nothing else about Pyrrhos, but the dowel holes atop the base indicate that his statue of Athena stood with her right foot advanced, her left hand holding an upright spear, and her left foot raising its heel and just touching the base with its toes – a pose reminiscent of the goddess on the "Mourning Athena" relief (Fig. 49; CD 168).[4] Approximately 3.6 meters east of this base are the remains of a nearly square platform and altar, and this is probably the earlier altar of Plutarch's anecdote.

The cult of Athena Hygieia is, in fact, at least as old as the late Archaic period: the potter-painter Euphronios, for example, apparently made a dedication to the goddess toward the end of his distinguished career (c. 475).[5] If the cult had originally been centered in this area of the Acropolis, the construction of the Propylaia and the adjacent precinct of Artemis Brauronia (Fig. 126) would most likely have necessitated a reorganization of its (unwalled) space. The setting of the statue base itself against the Propylaia's southeast column suggests that the dedication dates sometime after work on the Propylaia came to a halt in 432. Although the inscription states that the dedication was offered by the Athenians as a whole, not Pericles alone, it is possible that he was responsible and receded democratically behind "the people," making the dedication on their behalf. However, the forms of the inscribed letters suggest a date after 430, and despite Plutarch's story, it is likely that the dedication was made to thank Athena not for a single miraculous cure but for a respite from the great plague.[6] If so, Pericles, who died of the plague in its first year (429), cannot have been involved, and the shrine of Athena Hygieia is best considered a small posthumous appendage to his building program, tucked into the general scheme of the western portion of the Acropolis and aligned with adjoining Periclean monuments. The axis between the

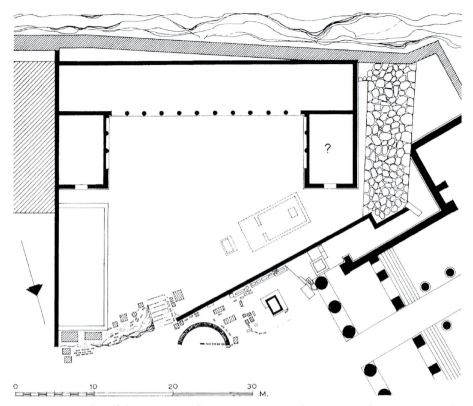

126. Plan of the Sanctuary of Artemis Brauronia. The existence of a west wing on the south stoa is uncertain, as is the form and position of the temple and altar in the open-air precinct. Based on Travlos 1971, Fig. 169, and Despinis 1997, Fig. 1.

statue and its altar, for example, is virtually parallel to both the axis of the Propylaia and that of the next major precinct found within the gates: the sanctuary of Artemis Brauronia.

The Sanctuary of Artemis Brauronia

The worship of Artemis Brauronia atop Athena's rock almost certainly goes back to the days of the Peisistratid tyrants (c. 546–510), who came from the east Attic coastal town of Brauron (Fig. 14) where Artemis's principal sanctuary was located (Athena and Artemis – two divine *parthenoi* – are also often found together on Archaic vases). What Artemis's precinct on the Acropolis looked like in the sixth century we do not know, and the exact course of its development in the Classical period is uncertain as well.

In its final form, the sanctuary of Artemis Brauronia occupied the quadrilateral area between the still mighty stretch of Mycenaean fortification wall on the west (CD 015), the new citadel wall on the south (this wall was built in the 460s, but its height was increased in the early years of the Periclean building program, c. 447–438),[7] and the so-called Chalkotheke court on the east (Fig. 2, no. 5; Fig. 126). The northern boundary of the precinct was formed by a scarp cut vertically out of bedrock; additional courses of poros limestone blocks were laid above, to a height of perhaps 4 meters (Fig. 127). Toward the eastern end of the wall are eight low steps (about 2 meters wide), again cut out of bedrock, that formed the entrance to the sanctuary (CD 117–118).

Most of the preserved remains within are found in the eastern portion of the precinct, and these rock-cut beddings and limestone foundations reveal as many as three building phases. The first phase saw the construction of the east precinct wall itself, running from the northern edge of the sanctuary all the way to the south citadel wall, and a simple Doric stoa extending at least 15 meters west from the south end of the east precinct wall. In the second phase, the stoa was rebuilt and a modest wing

127. View, Sanctuary of Artemis Brauronia, rock-cut north precinct wall. (The upright block of dark Eleusinian limestone atop the wall may have formed part of the base of the Bronze Athena). Photo: author.

(c. 8.25 by 5.50 meters) begun on the east. Some modern reconstructions envision a double-winged stoa more than 38 meters long, but evidence for this length and a west wing is, in fact, sparse: it is just as likely that there was no west wing at all. In the final phase, the incipient east wing was replaced by a new one extending all the way to the northern edge of the sanctuary. The rock-cut entrance belongs to this third phase.[8]

The best clue to the date of the sanctuary is the orientation of the rock-cut north precinct wall. It is almost exactly parallel to the axis of the Mnesiklean Propylaia, which, as we have seen, is almost exactly parallel to the axis of the Parthenon, which has always suggested that the layout of the entire sanctuary was contemporary with the construction of the Propylaia in the 430s and so figured in the same grand Periclean vision for the remaking of the Acropolis. This suggests not only a Periclean date for the precinct but Mnesiklean involvement in the project as well (it was, again, Mnesikles whom the Kallias Decrees charged with putting the summit in order in 434/3, and one wonders if completing the landscaping or general redesign of the area between the Propylaia and the Parthenon was what the assembly had in mind).

The principal Attic sanctuary of Artemis was, again, located at Brauron itself (her temple there, incidentally, was called the Parthenon) and the precinct on the Acropolis seems to have been, in essence, an urban satellite of the rural sanctuary. But, it was still a place for the performance of the *arkteia*, a rite in which Athenian girls (ten years old or so) pretended they were she-bears (*arktoi*) and danced around the altar of the goddess of the wild. By the middle of the fourth century, the Acropolis precinct seems to have boasted a temple and a statue of Artemis by the Late Classical sculptor Praxiteles – a colossal marble head in the Acropolis Museum is now thought to belong to it (Fig. 128; CD 178).[9] There were most likely older images as well. Though the east wing and south stoa presumably contained a wealth of offerings to the goddess (women's robes may have been especially common gifts), many gold and silver objects dedicated to her (for example, a gold ring on a plaque dedicated by one Kleinomakhe sometime before 398/7) were stored in the Periclean Parthenon.[10]

At all events, the precinct of Artemis Brauronia and its environs were an important arena for the display of votives and statues. A field of cuttings for stelai and other, larger monuments (the largest held a semicircular,

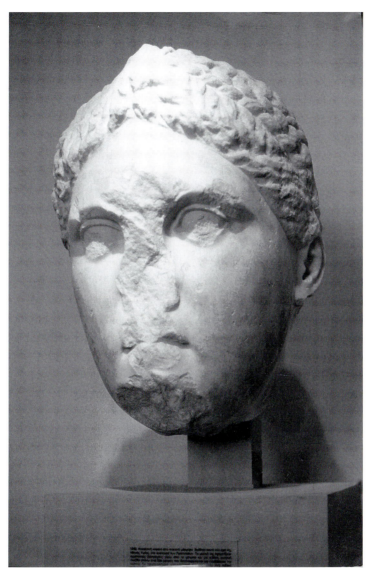

128. Head of a colossal statue, probably Artemis Brauronia, by Praxiteles. Acropolis Museum 1352. Photo: author.

late Classical monument to the general Kephisodotos)[11] is found just north of the rock-cut precinct wall and in the area of the stepped entrance to the sanctuary (Figs. 126, 129). In this area, Pausanias saw such works as Myron's group of Perseus holding the severed head of Medousa. Within the precinct itself there stood, along with Praxiteles's Artemis and other things, a colossal (almost 6 meters tall) bronze rendering of the wooden Trojan Horse – life-size Greeks peeked out of it – made by Strongylion

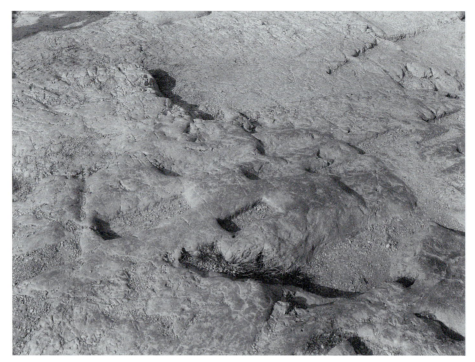

129. Cuttings in Acropolis bedrock for placement of *stelai*. Photo: author.

and dedicated by Khairedemos, son of Euangelos, around 420 (Fig. 115; CD 174). The horse was the ruse that finally made the sack of Troy possible, and less than 100 meters farther east the moving visitor, having moved, would see the devastation in progess, on the north metopes of the Parthenon (Fig. 35).

The Chalkotheke Precinct

The ancient visitor (like the modern) reached the center of the Acropolis by means of a road – Center Street, to give it a name – that veered right from the Propylaia and rose steeply as it passed between the area of the Bronze Athena on the left (Fig. 56) and the Artemis sanctuary on the right (Fig. 2). A few meters past the Brauronion, a simple propylon (gateway) set into another high wall led from the street into another open quadrilateral precinct or terrace (Fig. 2, no. 6). This wall, running east-west, was more or less parallel to the north wall of the Artemis sanctuary (and thus also to the axis of the Propylaia), and so the terrace it defines was almost certainly laid out as part of the same Periclean scheme, with

both the Brauronion and the Propylaia in mind (its western boundary was, in fact, the back wall of the Brauronion's east wing). Across the terrace from the propylon, set along the edge of the Acropolis, was the Chalkotheke, or Bronze Depot (Fig. 80).

The function of this building was primarily utilitarian. As the name implies, it was a warehouse for bronze (and iron) objects, above all armor and weapons (shields, greaves, spears, and so on), chariot wheels and axles, and even catapults and naval equipment – some, presumably, captured from Athens' foes. In addition to military matériel, however, the Chalkotheke stored a variety of miscellaneous objects – empty bronze chests, iron pebbles, twenty-one gold letters of the alphabet,[12] clothing (including a hair net), even the key to the east room of the Parthenon, the so-called *hekatompedon* – as well as stuff that can only be considered junk (such as broken iron objects). Unlike the treasures stored in other Classical buildings on the Acropolis, many of the objects kept inside the Chalkotheke do not seem to have been votive in character.

The Chalkotheke in its final form consisted of a wide, long room, its roof supported by five or six interior columns, set against the south wall of the Acropolis (its back wall actually used the upper, Periclean part of

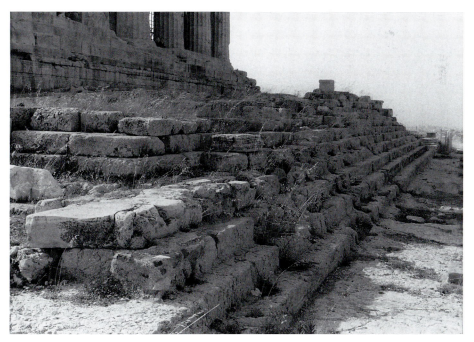

130. Great flight of steps west of Parthenon. Photo: author.

the south wall as a footing). A portico with eighteen (probably Doric) columns defined the building on the north and may have displayed the building's more impressive holdings. The northeast corner of the portico sliced into the impressive flight of steps that both formed the eastern edge of the Chalkotheke precinct and led up to the greatest victory monument of all, the Parthenon (Fig. 130; CD 113–114).

The entire Chalkotheke precinct has routinely been considered a Periclean project datable to the third quarter of the fifth century and, again, the line of its north wall is good evidence of that. However, the date of the Chalkotheke itself is, in fact, not so clear-cut. Because the warehouse perches atop the south Acropolis wall (without structurally binding with it), it would seem to date after 438, when the Periclean addition to the wall was evidently complete. And because its portico cuts into the great steps west of the Parthenon (themselves datable to the 430s), the portico at least must be later than they are. There is no literary evidence that might help us out, and the earliest inscription mentioning the building by name dates to 371/0. Moreover, despite its size, the Chalkotheke was built more cheaply than other Periclean monuments and this, together with some inscriptions and inferences from some historical evidence, argues against a Periclean date. As a result, the Chalkotheke has been considered post-Periclean, perhaps even as late as the early fourth century (380s–370s).[13] Perhaps the solution lies in a Periclean conception of the precinct as a whole, integrating it into the general design of the western Acropolis, and a post-Periclean construction of the warehouse proper (or perhaps just its portico).

At all events, the presence on the Classical Acropolis of what seems to have been primarily an arsenal asserts the citadel's enduring military character even after the Periclean monumentalization of its cult centers. At the same time, if spoils of war were exhibited in the portico, even this warehouse would have taken on the character of a victory monument. Like the nearby Bronze Athena and the Parthenon looming above it, it symbolized Athenian military might and *nike*.

The Great Steps West of the Parthenon

Pausanias may have climbed the great flight of sixteen steps that defines the eastern edge of the Chalkotheke court (Fig. 130; CD 113–114), but

he does not mention them (and neither does any other ancient source). The stairway, much of it carved out of bedrock, was originally about 33 meters wide and 3.5 meters high. The number of steps actually cut out of the rock varies from a maximum of nine toward the southern end to two at the north and, where there was not enough rock to cut, the steps were laid in blocks of poros limestone. (Some of these blocks were taken from the top step of the *Archaios Neos*, destroyed by the Persians in 480 [Fig. 61], which became available for quarrying when construction of the Erechtheion began.)[14]

The flight of steps is precisely parallel to the west façade of the Parthenon (Fig. 29). And, like the steps of the Parthenon, they reveal an intentional (though less regular) upward curvature, a refinement clearly meant to harmonize its lines with the curving horizontals of the Parthenon, especially for anyone who passed through the propylon of the Chalkotheke court.[15] Their alignment and curvature leave little doubt that the steps were cut and laid with the Parthenon in mind, and that the project was part of the general Periclean building program, datable to the 440s or 430s.

The treads of the rock-cut steps are covered with thirty-eight cuttings for stelai and statues of various sizes and dates, and the missing blocks of the limestone steps were undoubtedly cut for more. The cuttings thin out toward the center of the steps, but it is difficult to believe so many monuments would have been placed on them if these steps were meant to be a principal ceremonial approach to the Parthenon, some 8 meters to the east. The Panathenaic procession took another route altogether, down Center Street, and the Parthenon was not its ultimate goal (or the goal of any ancient procession) in any event. The steps were surely intended for individual tourists or pilgrims rather than formally processing crowds, serving also as a gallery for votive display, which it remained for the rest of antiquity.[16] At the northern end of the steps, a large, nearly square (c. 8 by 7 meters) foundation supported a different sort of monument: a small precinct or shrine, perhaps. It was in his visit to this general area that Pausanias apparently saw something to do with Athena Ergane and a shrine shared by a *daimon* (spirit) of some sort, but his text at this point is corrupt, and it is difficult to associate the foundation (which, in its latest form, seems Roman) with anything Pausanias mentions.[17]

The Parthenon Terrace

The north end of the great flight of steps seems to have abutted an extension of the north wall of the Chalkotheke court, which continued east to serve both as the south (or right-hand) edge of Center Street and as the retaining wall for the north side of the huge artificial terrace that originally surrounded the Parthenon (Fig. 2). The flight of steps itself served as the western retaining wall for the mostly earthen terrace, which was presumably filled in at the same time that Pericles raised the south citadel wall (c. 447–438). Virtually flat and possibly surfaced in gravel, the terrace covered the foundations of the Parthenon below its *euthynteria* (or leveling course, the course below the bottom step) and extended from the top of the great flight of steps all the way to the southeast corner of the citadel, and from Center Street to the south citadel wall – something less than half the total area of the Acropolis summit. East and northeast of the Parthenon, where the natural elevation of the Acropolis is highest, the level of the terrace fused with the level of dressed bedrock. Though there is little to help us imagine its original appearance, the terrace very likely became another place for monumental display as soon as it was created: we have to assume that the Athenians quickly began to fill it with statues and dedications and, perhaps, planted the broad and particularly sun-drenched south side with trees or shrubs.[18]

The terrace east of the Parthenon was certainly marked by statues in the fifth century: Pausanias saw a bronze Apollo by Pheidias and portraits of the poet Anakreon and Pericles's father Xanthippos still standing in the vicinity.[19] In later centuries, the east terrace was filled with even greater monuments: a massive pillar, topped by a bronze chariot, commemorating the Panathenaic victory of a Hellenistic king, was set against the northeast corner of the Parthenon c. 178 (Fig. 81); a huge group of under life-size statues of defeated Giants and Amazons – the same enemies of civilization disposed of in the Parthenon east and west metopes – and Gauls and Persians were set on bases near the south citadel wall by another Hellenistic king c. 200 (Fig. 131); and, directly east of the Parthenon, set exactly along its central axis, the little round Temple of Roma and Augustus (Fig. 2, no. 15; Fig. 89) was built c. 20/19 by the Athenians to honor the city and emperor who then controlled their fate.[20]

131. Defeated Gaul (Roman copy) from Attalid Group (Louvre MA 324). Photo: author.

Farther to the east, however, in the southeast angle of the Acropolis, there was another fifth-century and probably Periclean precinct: the *heroon* of Pandion.

The *Heroon* of Pandion (Building IV)

In the Athenian Agora, Pausanias saw a monument with statues of the Eponymous Heroes, who lent their names to the ten Athenian tribes (cf. Fig. 106).[21] One statue represented Pandion, and though Pausanias was

unsure which Pandion this was – the son of Erichthonios (this Pandion was the father of Erechtheus, Boutes, and Prokne [Fig. 119]) or the son of King Kekrops the Second (this Pandion was the father of Aigeus, father of Theseus) – he mentions in passing that there was another statue of Pandion on the Acropolis. Despite his note that the Acropolis statue was "well worth seeing," Pausanias does not mention this image or any precinct sacred to the early king when he tours the Acropolis itself. Still, a handful of late Classical inscriptions (the earliest dates to the end of the fifth century) confirms that there was a *heroon*, or hero shrine, of Pandion somewhere on the citadel.

Tucked into the southeast angle of the Acropolis, more than 50 meters east of the Parthenon, are the overlapping remains of two large but simple structures known as Buildings IV and V (Fig. 2, no. 16; Fig. 132). Building V appears to be Early Classical in date and was torn down to make room for Building IV, built almost directly atop it. The dates of the demolition of Building V and the construction of Building IV are hard to determine with precision, but a date in the 440s or 430s is likely. Interestingly, such Archaic works as the Moschophoros (Fig. 44) and the head of the Athena from the pediment of the *Archaios Neos* (Fig. 40), victims of the Persians in 480, were found in the fill of its foundations and so must have lain about the Acropolis for decades before their Periclean burial.

Building IV actually consisted of two parts; both were actually sunk a few meters below the level of the Parthenon terrace, which, again, extended all the way to the east citadel wall. The larger space was an open-air precinct entered via a columnar porch. Behind it, with a doorway of its own, was a slightly smaller, less well-built court that seems to have been a service area or *ergasterion* (more than one *ergasterion*, or workshop, are, in fact, mentioned in the building accounts of the Parthenon). Though there can be no certainty, and though it is unclear why Pandion, of all the ten tribal heroes, should have merited so large a shrine,[22] Building IV is usually identified as his *heroon*: the statue of the hero Pausanias saw presumably stood inside. The strictly utilitarian court behind it was perhaps a workplace for masons and sculptors, including those employed in the Periclean building program (large amounts of marble chips were found in the area when excavated).

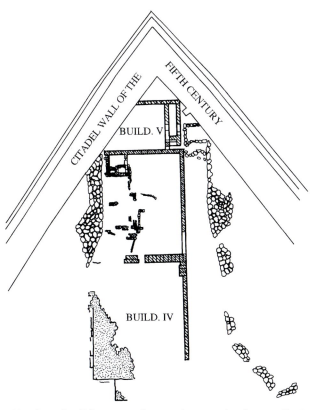

132. Plan of Buildings IV and V, southeast angle of Acropolis. Drawing by I. Gelbrich, after Stevens 1946, Fig. 22.

The Central Terrace

Center Street, some 8 meters wide, divided the Parthenon terrace from the central terrace of the citadel, which was ultimately Mycenaean in origin and was still retained on the west and south by walls that, though repaired throughout antiquity, were ultimately Mycenaean, too (cf. Fig. 56). It was atop this terrace (several meters lower than the Parthenon's) that the *Archaios Neos* stood in the late sixth century (Fig. 61) and the *Opisthodomos* (if there really was one) stood in the fifth. If there was no *Opisthodomos*, or if it was dismantled at the time of the building of the Erechtheion, the terrace in the Periclean era would have been essentially an open space charged by the presence of the Karyatids, who gazed over it toward the Parthenon (Fig. 67). The terrace's south wall (the left-hand side of Center Street) decreased in height as the natural limestone of the

Acropolis rose to the east. And where the eastern side of the terrace itself fused with bedrock, there stood the great Altar of Athena.

The Altar of Athena Polias

Pausanias does not mention the Altar of Athena in his description of the Acropolis. He certainly could not have missed it: it was a venerable and important structure sizable enough to accommodate the sacrifice of a large herd of cattle during the Panathenaia. The altar was at least as old as the seventh century, and it must have been large even then,[23] but its history undoubtedly goes back much farther. Though monumental and ritually significant, the altar Pausanias saw might still have had a conventional or relatively unprepossessing character, which could explain why he passed by it in silence.[24]

A cutting in the bedrock about 12 meters east of the foundations of the *Archaios Neos* probably marks the site of the altar (Fig. 2, no. 12), only slightly off the axis of the temple. The cutting itself preserves the corners of a rectangular structure about 8.5 meters deep (east-west): it probably consisted of a broad flight of steps leading up to the sacrificial platform itself. The Archaic altar must have been severely damaged during the Persian sack, but it must also have been repaired in the Early Classical period: the cult of Athena Polias needed to be served and sacrifices needed to be made. The possibility that the altar was completely remodeled during the Periclean remaking of the Acropolis is also strong, but attempts to assign some late fifth-century mouldings to the Classical structure are purely speculative – as is a suggestion that the base of the Classical altar was decorated with a marble frieze, about 85 centimeters high, carved in a style derived from that of the Parthenon frieze and possibly representing the birth of Pandora, the same subject as the base of the Athena Parthenos itself (the fragments of this frieze were found in the Agora).[25]

It was here, in any case, that the Panathenaic procession, having moved up Center Street, ended, and it ended with mass slaughter. After one especially handsome cow was killed on the altar of Athena Nike and one ewe (or more) was sacrificed to Pandora (or Pandrosos),[26] at least a hundred cows (a *hekatomb*, hence the name of the month, Hekatombaion, in which the Panathenaia was held) were then sacrificed, one by one, upon the altar of Athena Polias, their fat burned as an offering to the goddess

> **Pausanias on the Sacrifice to Zeus Polieus[27]**
>
> And there is both a statue of Zeus by Leokhares, and one called Polieus: the established method of sacrificing to him I will write down, but not the traditional reason for it. Having placed barley mixed with wheat upon the altar of Zeus Polieus, they leave it with no guard. The ox, which they have prepared for sacrifice and watch over, roams over to the altar and sets upon the grain. They call one of the priests "the ox-slayer," and he kills the ox, throws the axe down – for that is the custom – and flees. And they, as if they did not know who did the deed, bring the axe to trial. These things they do in the manner I have described.[28]

(the meat was roasted and distributed to the people in the city below). The practice of Greek state religion was often a long, noisy, and violent affair. On the main day of the Panathenaia, the city must have echoed with the bellowing of the cattle and the ritual screaming of attendant women. Thick smoke and acrid smells must have drifted over it. And the altar of Athena and the Acropolis rock must have run with blood for hours.

The Sanctuary of Zeus Polieus

East of the altar of Athena Polieus was the large precinct of Zeus Polieus (protector of the city). Although we know the central event of the ancient festival of Zeus Polieus in some detail (the *bouphonia*, or ox-killing), the literary evidence concerning the appearance of his sanctuary is meager, and the sparse archaeological evidence is open to interpretation. Accounts of the *bouphonia* (in which an ox was driven, or else allowed to roam, around a bronze offering table before the sacrifice) suggest that the rite required a large but enclosed space, and Pausanias's itinerary indicates that it was not far from the Parthenon's northeast corner (Fig. 2, no. 14). It was in that vicinity that he saw a statue of Zeus by the fourth-century sculptor Leokhares, another statue of Zeus Polieus (sculptor unknown), and the altar of Zeus Polieus. Neither Pausanias nor any other source mentions a temple for the god, and it may be significant that a silver goblet dedicated to Zeus Polieus (and silver *phialai* dedicated to Zeus without epithet) were stored in the Parthenon. However, starting about 8 meters northeast of the Parthenon's northeast corner, and then extending to the east and north, is a complex of rock-cut walls, leveled bedrock, shallow trenches,

133. Area of Sanctuary of Zeus Polieus. Photo: author.

and holes (plus a few poros-limestone foundation blocks) that have been almost universally interpreted as traces of Zeus's precinct (Fig. 133). The area includes the highest point on the Acropolis rock (more than 156 meters above sea level), a fitting location for the worship of Zeus, great lord of the sky.

The conventional interpretation of the rock-cuttings is that the sanctuary (which must go back to a very early period) had in its final form two connected parts (Fig. 134): on the west, a large, slightly trapezoidal, open-air precinct with a doorway near its southwest corner; and a large adjoining polygonal precinct on the northeast (the precincts were linked by a door in the middle of a shared wall). In the southern portion of the northeast precinct, there was a small shrine (facing atypically north) and a long offering table. In the cella of the shrine was a rectangular rock-cut pit. This modest building partly overlapped the western portions of five nearly parallel rows of small rectangular cuttings in the rock (fifty-five cuttings remain). These holes, it has been suggested, held the wooden posts of wattle fences and a barnlike structure for the stabling of oxen. Because construction of the shrine erased some of the postholes, it is later than the original installation, which may have been remodeled to suit the new building.

The possibility that oxen were stabled behind rustic fences for any length of time on the elegant, mostly marble Periclean Acropolis gives one pause (which is not to say it did not happen). Still, the traditional reconstruction of the paltry remains is largely hypothetical. It is possible, in fact, that the western precinct was much larger than has usually been thought, extending north all the way to the citadel wall and west almost to the great Altar of Athena (covering a huge area approximately 42 by 35 meters) (Fig. 2, no. 14). It is worth remembering, too, that a large herd of cattle was brought up to the Acropolis and sacrificed on that very altar on Hekatombaion 28 (at the Panathenaia), and one wonders whether the west precinct served as their corral (and had little or nothing to do with Zeus and the *bouphonia*). Moreover, the small shrine of Zeus Polieus (if such it was) may not have stood in a fully walled precinct of its own but may simply have been set off from the rest of the Acropolis by the east

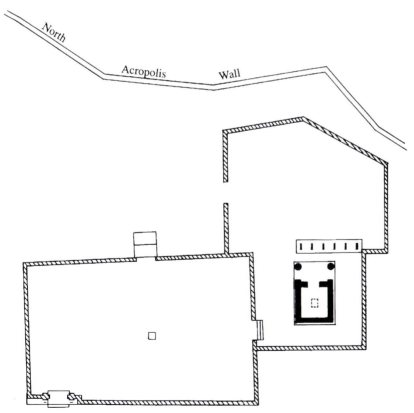

134. Plan of Sanctuary of Zeus Polieus. Drawing by I. Gelbrich, after Stevens 1946, Fig. 17.

wall of the west precinct and another wall to the south. As a result, it is unclear how or if the west and east precincts were related in practice or in cult.

It is difficult to date rock cuttings per se, but there are indications that the west precinct was originally laid out with the late Archaic Older Parthenon in mind, and that its southern, rock-cut boundary was cut back and rotated slightly to the north (resulting in its trapezoidal plan) when the Periclean Parthenon was built, in order to maintain the same distance between the precinct and temple (a distance equal to the width of Center Street). It is also likely that the flat, broad, rock-cut expanse to the south and east of the west precinct was leveled during the Periclean period as part of the general relandscaping of the Acropolis. The remodeling of the entire area east and northeast of the Parthenon may then be dated to the third quarter of the fifth century.

The House of the Arrhephoroi (Building III)

Two more buildings complete our survey of the summit of the Periclean Acropolis. The first is located some 25 meters west of the Erechtheion, behind that part of the north citadel wall built with triglyphs, metopes, and architrave blocks from the *Archaios Neos* to memorialize the Persian sack of 480 (Fig. 64). Thick foundations belong to what must have been a fairly impressive, virtually square structure with a single room and columnar porch facing south – Building III (Fig. 2, no. 8).[29] The foundations just touch but are not structurally bonded to the north wall, and so probably date after its construction (that is, after the 470s). No remains of the superstructure are known. Adjacent to Building III on the west was an oblong, open-air court which on its north side incorporated an entrance to a deep natural cleft in the rock leading down to the underground fountain constructed at the end of the Mycenaean age.

Each year, the chief religious official of Athens (the so-called *Archon Basileus*, or Royal Archon, probably shown handling the *peplos* in the Parthenon's east frieze [Fig. 107]) selected two *Arrhephoroi*, girls seven to eleven years old and of noble birth, from candidates nominated by the people. They dressed in white robes and lived atop the Acropolis for some unspecified length of time, though just where is never explicitly stated. Their basic duties were to assist in the daily maintenance of

Pausanias on the Arrhephoroi[30]

Adjacent to the temple of Athena is the Temple of Pandrosos: Pandrosos was the only one of the sisters [i.e., the daughters of Kekrops] who was guiltless in the matter of the child [i.e., Erichthonios] entrusted to their care. There is something that amazed me here, and since it is not well known to everyone I will write down what happens. Two maidens dwell not far from the Temple of Athena Polias, and the Athenians call them *Arrhephoroi*. These girls live beside the goddess for some time, but when the festival arrives they do, at night, the following things. They put on their heads what the priestess of Athena gives them to carry – neither she who gives nor they who carry know what it is. There is a precinct in the city not far from [the sanctuary of] Aphrodite, nicknamed "in the Gardens," and through this there is a natural underground path. Down this the maidens go, and they leave below what they have carried down, but receiving something else – it is covered – they carry it back up. At that point they release the girls from service, and bring other maidens to the Acropolis in their stead.

the cult of Athena Polias; they may even be shown with her priestess on the Parthenon frieze (Fig. 20, left). More important, they somehow assisted at the workers' festival known as the *Chalkeia* (sacred to Hephaistos, Athena's colleague as god of craftsmanship) when the loom for the weaving of Athena's *peplos* was set up, possibly in their house on the Acropolis (most of the work, though, was apparently done by other aristocratic maidens or women known as the *ergastinai*). But, most important, the *Arrhephoroi* played the principal role in the strange nocturnal rite named after them, the *Arrhephoria*. According to a difficult passage in Pausanias, the priestess of Athena Polias gave them covered baskets holding secret objects or *arrheta* (neither the priestess nor the girls knew what the objects were, and we are not told who did), and the *Arrhephoroi* (the word could mean "bearers of secret things") then carried them down an underground path to a place not far from a sanctuary of Aphrodite. The girls deposited the mysterious objects below and were given others to take back up the Acropolis. They were then dismissed from service and new *Arrhephoroi* took their place on the Acropolis.

It is usually assumed that the *Arrhephoroi* began their mysterious journey atop the Acropolis itself, took a dark and damp stairway part-way down the underground passage of the Mycenaean fountain, emerged through a cave high on the north slope, and then passed to or through the sanctuary of Aphrodite and Eros below (Fig. 2, no. 18), sometimes equated with the sanctuary of Aphrodite in the Gardens that Pausanias

mentions. None of this is certain, and it is not even clear that Aphrodite was directly involved in the rite: her sanctuary was not the final destination of the *Arrhephoroi*, according to Pausanias, it was just nearby.[31] Because we do not know what things the *Arrhephoroi* carried on their heads or even what their precise goal was, it is difficult to say what the ritual signified. Some scholars, maintaining that the *Arrhephoroi* literally moved from the sanctuary of a virgin goddess to the precinct of a goddess of love and fertility, suggest the ceremony represented the coming of age or sexual maturation of the girls. Others suggest that the ritual was a corrective reenactment of the myth of the disobedient daughters of Kekrops, Aglauros and Herse, the two girls who (unlike their good sister Pandrosos) had looked where they were forbidden to look (in the basket with the baby Erichthonios and his guardian snakes) and perished.[32] On the other hand, the *Arrhephoria* may in origin have been a fertility ritual, guaranteeing the coming of nurturing dew (that is what both Pandrosos and Herse mean, and some have translated *Arrhephoroi* as "dew-bearers") and thus the health of Athens's olive trees (hence the possible involvement of Aphrodite, the garden goddess). But, whatever it meant, Pausanias implies the *Arrhephoria* began and ended on the Acropolis, and the possibility remains that the ritual spatially, if cryptically, linked north slope and summit and their principal goddesses. Aphrodite and Athena may at first glance seem an odd pair, but the ancient Athenian would not have thought them incompatible. For the state to prosper, it had to enjoy the benefits of both goddesses, and the necessary link was reinforced in many other ways.[33]

Almost from the time of its discovery, and almost by default, Building III (probably built in the second half of the fifth century, though nothing definitely associates it with the Periclean building program) has been identified as the House of the *Arrhephoroi*, who, again, lived (for a while) not far from the Pandroseion, served Athena, and somehow helped with the weaving of the *peplos* presented to Athena Polias at the Panathenaia (perhaps working on it in this very building). We are also told that the *Arrhephoroi* had a ball court atop the Acropolis and that there was a statue of a young boy (said to have been the orator Isokrates) playing field hockey in it. The setting of Building III and its adjacent court fit what we know of the *Arrhephoroi*, their enigmatic passage, and their playground, but the evidence remains circumstantial. Some believe

Building III was too monumental a structure to house a couple of young girls (though it is possible the venerable priestess of Athena Polias lived there, too, in a supervisory role) and have proposed other identifications, unpersuasively.[34]

The Northwest Building

Forty meters west of Building III is the last major structure to have stood on the Classical Acropolis: the so-called Northwest Building (Fig. 2, no. 4; Fig. 50). Its exact date, however, is in dispute. Recent investigations have suggested that it was begun at the same time as the Propylaia (437–432), that it should therefore be considered an element of the Periclean program, and that it was designed by Mnesikles himself after he realized that he would not be able to immediately complete the northeast wing he had originally conceived for the Propylaia. As initially planned, the Northwest Building was to contain two rooms of unequal size (the larger one, about 9 meters wide and 11 meters deep, was to be on the east) and an entrance portico on the south. It is possible that the building was originally intended as a banquet hall (its plan resembles ritual dining rooms elsewhere in Greece); but, the substructure was never finished, the superstructure was not completed as designed, and the porch was never built. The original plan seems to have been abruptly abandoned when Mnesikles went ahead with his plans for the Propylaia's northeast wing and even laid down the foundations of its eastern wall, which sliced into the area assigned to the Northwest Building. Though the Propylaia's northeast hall was itself soon aborted, the change in plan forced the conversion of the Northwest Building into an open-air courtyard, which may ultimately have functioned as a service court or storage area. It was probably the approaching Peloponnesian War and, specifically, the provisions of the Kallias Decrees (which, again, called upon the architect of the Propylaia to put the Acropolis in order), that necessitated the curtailment of both projects.[35]

This history has, however, been strongly challenged by Manolis Korres, who argues that the Northwest Building is (as older scholarship maintained) an Early Classical building dating to the 470s or 460s, and that Mnesikles could have had nothing to do with its design.[36] Whatever the case, the building must have stood in some (unfinished) form in the

second half of the fifth century – a feature of the Periclean Acropolis if not a Periclean addition.

The South Slope

The Odeion of Pericles

State-sponsored activity on the north slope of the Acropolis seems to have been virtually nonexistent in the Periclean period: there, cults continued to function, as they long had, in caves and rock shelters, like the shrine of Aphrodite and Eros (Fig. 2, no. 18; Fig. 135).[37] On the south slope, major state activity seems to have been limited to a single, if huge, building: the so-called Odeion, or Music Hall, the earliest in Athens (Fig. 2, no. 20; Fig. 136; CD 119). Although Vitruvius states that the Odeion was built by Themistokles (who, he says, roofed it with the yards and masts of Persian ships), most scholars follow Plutarch, who says the building was a replica of Xerxes's pavilion and credits Pericles with the project (Pericles is even said to have acted as building supervisor).[38] Pericles evidently built the Odeion to accommodate the several kithara and flute competitions held during the Panathenaia – *mousikoi agones* that he probably reorganized and that are probably alluded to in the Parthenon frieze (CD 079).[39] But, the Odeion served as more than a concert hall. It soon became (if Pericles did not originally intend it to be) the setting for the annual event known as the *proagon* ("before the contest"), where Athenian dramatists, accompanied by their actors and choruses, introduced to the people the plays they would be seeing a few days later in the nearby Theater of Dionysos during the City Dionysia (it was here, at the *proagon* of 406, that Sophokles famously appeared in black to mourn the death of Euripides). According to a line in Aristophanes, the Odeion could also be used as a courtroom and some sources suggest philosophers taught there, too. Other uses were less intellectual; on occasion it stored grain. And, in the sad days of 404/3, it was even transformed into a military headquarters: the Spartan garrison called in to prop up the Thirty Tyrants was probably stationed here, and after the Thirty were deposed, the Athenian cavalry and their horses were for a time quartered inside.

Built into and against the rising rock of the south slope, the Odeion was almost 60 meters square and had nine or ten rows of interior columns

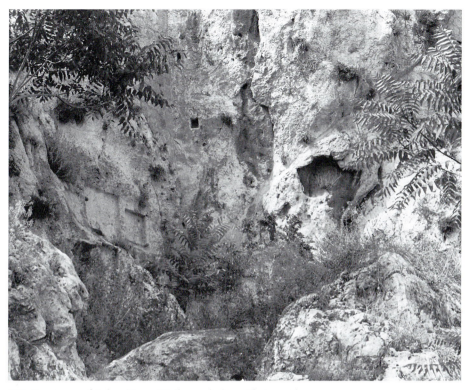

135. Sanctuary of Aphrodite and Eros, north slope. Photo: author.

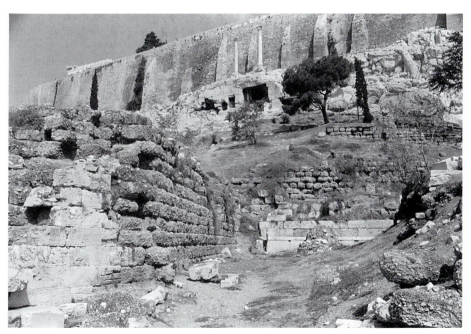

136. View, area of Odeion of Pericles. Photo: author.

supporting a steep, pyramidal wooden roof – the peak evoked comic comparisons to the pointy-headed Pericles. It is not certain whether the building had solid exterior walls (with entrances on the west, east, and, probably, the south) or whether it was instead an open columnar pavilion reminiscent of Persian hypostyle halls (which would have made the quartering of horses a little easier). There were, presumably, seats inside, but the precise arrangement is unknown and the forest of interior columns must have obscured many views (on the other hand, anyone who had followed the course of the Parthenon frieze from outside the temple's peristyle [cf. Fig. 95] would have been used to that).

In 86, the Athenians themselves burned down the Odeion to deny the Roman general Sulla the use of its precious and plentiful supply of wood for his siege of the Acropolis. The Odeion that Vitruvius, Pausanias, and Plutarch knew (and whose scanty remains we mostly see) was the one rebuilt along the original design a few decades later by Ariobarzanes II, king of Cappadocia. It is uncertain whether the original timber really did come from the spars and masts of Persian ships (presumably those captured at Salamis) – the wood would have had to be preserved for thirty years or more before Pericles's architects could use them. And, it is unclear how much the building really resembled the famous tent of Xerxes captured at Plataia (which itself was probably displayed nearby).[40] But, the stories told in our sources are enough to suggest that the Odeion, like the Parthenon and so much else atop the Acropolis, was in the Athenian mind closely associated with the Persian Wars. In its own way, it was another victory monument.

The Periclean Sanctuary and Theater of Dionysos

The relationship between the Odeion, where Athenian dramas were previewed, and the Theater of Dionysos just to the west, where they were actually performed (and had been since the end of the sixth century), was obviously close (Fig. 2, no. 21; Fig. 137; CD 159). But, in the second half of the fifth century, the Odeion seems to have been the more impressive place architecturally. It is difficult to believe that the Periclean program would have created so vast a building as the Odeion without paying at least some attention to the theater next door, and there is the possibility of some kind of Periclean refitting. As far as the larger Sanctuary of

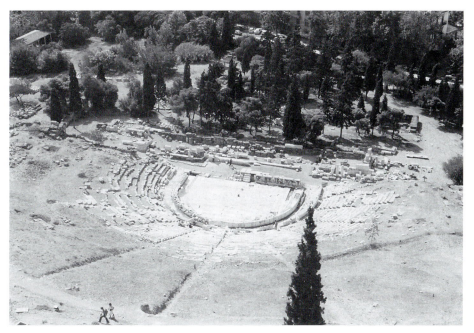

137. View of Theater of Dionysos, south slope. Photo: author.

Dionysos is concerned, however, Pericles was content to leave a small and simple Archaic temple of the god as the focus of cult, though perhaps some sort of Periclean structure was built nearby to house a new chryselephantine statue of Dionysos, said to have been made by Alkamenes (who may have learned the technique while working as Pheidias's apprentice on the Athena Parthenos).

The perplexing archaeological and literary evidence suggests that in the second half of the fifth century – the heyday of Sophokles, Euripides, and Aristophanes – the Theater of Dionysos (like the temple just to the south) remained a surprisingly modest place. It had three distinct parts: a flat *orchestra* ("dancing place," where the actors and chorus performed), which was probably oblong rather than round (cf. Fig. 138); behind this a low, broad wooden *skene* (the stage building, which provided an all-purpose architectural setting as well as a place for the actors to change their costumes); and, fanning out above the *orchestra*, the *theatron* ("the seeing place"), where the mass of Athenians sat on wooden bleachers set into the rising, natural curve of the south slope (the front seats were reserved for dignitaries, such as the priest of Dionysos and victorious generals, and were of stone).[41] In short, below the marble shrines of the Acropolis summit, nestled into the bowl of the slope, fifth-century

Athenians watched the greatest dramas of antiquity in a simple, open-air theater that exploited but did not seriously alter the hillside. But, the best ancient poets knew that they could create more with words than architects could with wood or marble, that they built monuments more lasting than stone. It is significant that the Theater of Dionysos was not enlarged and rebuilt fully in stone – and a new, larger Temple of Dionysos was not constructed – until the fourth century, when Athenian tragedy at least had declined: the monumentalization of the theater almost seems compensation for the falloff in Athenian dramatic energy. In the second half of the fifth century, however, the play, not the theater, was still the thing.

The Sanctuary of Asklepios and Hygieia

In 420, nine years after Pericles's death, with the last major outbreak of the plague six years past and a recently negotiated treaty (the Peace of Nikias) allowing greater freedom of travel within Greece, a wealthy Athenian citizen named Telemakhos, apparently acting on his own, sailed to the Peloponnesian site of Epidauros, the preeminent sanctuary of the healing god Asklepios, and on the seventeenth day of the month of Boedromion brought the god (and his daughter Hygieia, "Health") back with him. Precisely what form the god took is unclear.[42] Though some sources say that the great Sophokles himself received Asklepios's snake – his avatar – in his own house and fed it eggs (did the author of *Antigone* really believe a reptile was Asklepios incarnate?), the god (in the form of a possibly wooden statue) was more likely housed temporarily in the Eleusinion north of the Acropolis (Fig. 6) until Telemakhos could construct a suitable shrine. There is no question that the sanctuary he built (and no doubt served and administered as chief priest) was located west of the Theater of Dionysos, between the *peripatos* (the belt-line pathway that ran all around the Acropolis) and the steep rocky face of the citadel (Fig. 2, no. 25; Figs. 12–13; CD 153–157). But, there is some debate over the exact location, extent, and appearance of the earliest sanctuary. The remains we see today – the so-called Doric stoa on the north side and the temple and altar on the marble pavement – date principally to the fourth and early third centuries, whereas the smaller south stoa and propylon date to the Roman Imperial period.

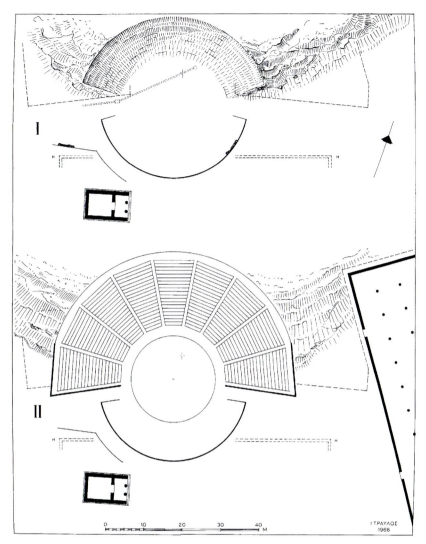

138. Plans of early Theaters of Dionysos. After Travlos 1971, Fig. 677. It is now thought the round orchestra of the early theater was actually rectangular. Reproduced by permission of DAI–Zentrale, Berlin.

The sanctuary that Telemakhos built over the eight or nine years following Asklepios's arrival in Athens must have included a modest temple or *naiskos* for the cult statue as well as a sacrificial altar. It probably also included a curious stone-lined hole in the ground called the *bothros*, which was incorporated later into the Doric stoa and covered with a stone canopy, or *baldacchino*, supported by four columns. The *bothros* could have been a reservoir, a sacrificial pit, or a home for snakes, but it has now been interpreted as the center of a *heroon*, or hero shrine, for

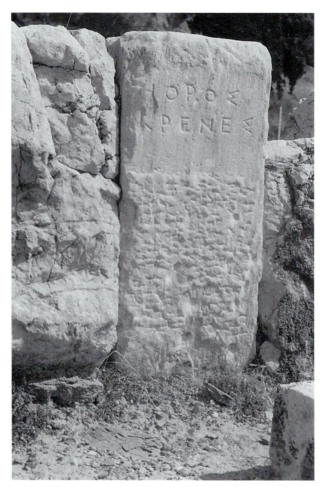

139. The boundary of the spring (*horos krenes*), south slope. Photo: author.

Asklepios himself.[43] Water was an essential part of the healing cult –
plenty was needed to treat women who had trouble nursing or men with
kidney stones, for example – and so Telemakhos incorporated into his
sanctuary a natural grotto and spring in the cliff (it was later entered
through a short tunnel in the back wall of the Doric stoa). A few years
into the project, Telemakhos built a wooden propylon to serve as a for-
mal entrance to the precinct: the gateway was pictured in relief at the top
of the so-called Telemakhos Monument, an inscribed pillar set up by the
founder around 400 to commemorate his good works (and, it has been
suggested, to correct the popular belief that it was Sophokles who in-
troduced Asklepios to Athens).[44] In short, the fifth-century Asklepieion

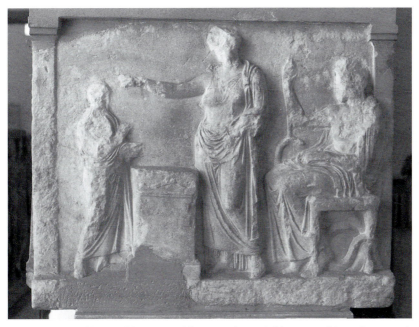

140. Votive relief from Asklepieion: Asklepios and Hygieia bless a worshipper (NM 1338), c. 400. Photo: author.

141. Votive relief from Asklepieion: Epione, Asklepios, and daughter receive worshippers (NM 1377), c. 350. Photo: author.

probably occupied the same terrace as the later one; so little of it is left because the original structures, like the propylon, were of wood.

To the west of this area, however, there was another large building – the so-called Ionic stoa – that is often thought to have formed part of Telemakhos's original installation (Fig. 2, no. 26; Fig. 13; CD 158). The building consisted of four rooms large enough (6 meters square) for the dining of priests, suppliants, or pilgrims (it is less likely, though possible, that the rooms were used for the ritual incubation of Asklepios's patrons). This interpretation of the stoa is not universal, however, and some would disassociate it from the Asklepieion altogether. Yet, the archaeological date for the building – c. 420 or so (the columnar porch was actually added a decade or two later) – accords too well with Telemakhos's foundation and elaboration of the sanctuary to be coincidence. From the inscription on the Telemakhos Monument we know, too, that early on in the history of the sanctuary there was a territorial dispute with the priestly family known as the Kerykes – and, because the Ionic stoa was built astride an old precinct wall, it may have been the source of the argument.[45] It was probably its construction, in fact, that led to the clearer definition of the boundaries of yet another sacred zone a little farther to the west – the South Slope Spring, as it is known, originally sacred to nymphs and then to Pan. This spring (rather, the springhouse built over it) originally dates to the late sixth century. Its sacred territory was not officially marked off, however, until the last quarter of the fifth century – the era of Telemakhos's beneficence – when a marble boundary stone inscribed with the words *horos krenes* ("boundary of the spring") was set up along the *peripatos* (Fig. 139).[46]

Remarkably, then, the initiative of a private citizen in the late fifth century reshaped, directly or indirectly, a roughly 80-meter-long strip along the south slope of the Acropolis. Votive reliefs depicting Asklepios and Hygieia blessing worshippers were dedicated in the sanctuary by 400 or so (Fig. 140). But, the state would not assume official control over the Asklepieion and its treasures until around 350, and the takeover would be marked by a boom in splendid votive reliefs and other dedications (Fig. 141) and by the translation of wooden architecture into stone. Still, for nearly three-quarters of a century, an unofficial healing cult served ailing Athenians in the shadow of the public state cults of the Acropolis summit.

The sanctuary's impact on Athenian life seems to have been immediate, and sacred patterns atop the Acropolis itself did not go untouched. After 420, no private dedication is ever made again to Athena Hygieia, whose shrine still stood just inside the Propylaia (Fig. 23). One of the goddess's cultic roles was apparently usurped at a stroke by the popular newcomer Telemakhos brought to town.

CHAPTER NINE

CONCLUSION: THE PERICLEAN ACROPOLIS AS A WHOLE

The Problem of the Parthenon Frieze

The Parthenon frieze (Fig. 85) has been the center of so much attention and controversy over so many years that it is easy to think it the key to the iconography and ideology of the entire Periclean Acropolis. If we could only figure out what the frieze represents and what it meant to fifth-century Athenians, it is tempting to believe, we would come close to understanding the Acropolis – and Athens and Greece – as a whole. This is a lot of weight to place upon a work that was only one element of one building's rich sculptural program – and a relatively inconspicuous element at that. And, yet, there remains the stubborn sense that the proper interpretation of the frieze is fundamental to our diagnosis of the Periclean temper and the Athenians' conception of themselves. It probably is.

But, back to basics: either the Parthenon frieze represents the Panathenaic procession, the highlight of the Athenian religious year, or it does not. Either the frieze is an idealized rendering of a contemporary and recurring event, or it is not. These have been the traditional terms of the long debate over the subject and significance of the one piece of the Parthenon sculptural program that is relatively well preserved. The traditional terms of the debate turn out to be inadequate.

Let us assume for the moment that the parade of horsemen (Figs. 31, 101), chariots (Fig. 104), and pedestrians (Figs. 97, 102–103, 105) is indeed the Panathenaic procession (as the prominence of the Panathenaia

in Athenian civic and religious life and in Athenian political history, as well as the centrality of the cloth-handling scene in the east frieze [Fig. 20], have not unreasonably led the majority of scholars to conclude).[1] The question then becomes: which or what kind of Panathenaic procession is this – mythological, historical, or generic?

We instinctively, reflexively, think myth. After all, we *expect* to find myths and heroes in Greek architectural sculpture. That is what the rest of the Parthenon sculptures represent (cf. Figs. 19, 28, 30, 35, 38, 42, 69). That is what Greek architectural sculpture had almost always represented (cf. Figs. 40, 59). And there are now two comprehensive mythological in- terpretations from which to choose. The first makes this the very first Panathenaia, the one founded by Erechtheus/Erichthonios (who, in one tradition, also invented the chariot, shown so often in the north and south friezes). The participants are, thus, the heroes and heroines – the legendary population – of early Athens. So, in the central scene on the east (Fig. 20), the cloth is the inaugural *peplos*, the small child is Erechtheus/Erichthonios himself, the man King Kekrops, the woman Gaia or Ge (Earth, from whom the child sprung), and the young women carrying things on their head two of Kekrops's daughters.[2] But there is nothing that clinches the mythological identity of any of the figures – no attribute (such as, say, a snake beside "Kekrops") that would decide the issue – and there is a general reluctance to assign specific names to more than a few of the 360 figures on the frieze who are clearly not gods.

According to a more recent and provocative mythological reading, however, the frieze depicts not only the legendary first Panathenaia but also, in a kind of narrative flashback, the mythological occasion or ex- planation for its establishment.[3] In this reading, the central scene in the east frieze, far from representing the benign handling of the first *peplos* by Kekrops and the boy Erechtheus/Erichthonios, in fact represents an adult King Erechtheus, aided by his wife Praxithea, tragically preparing to sacrifice their youngest daughter – the small child at Erechtheus's side – to save the city from the invading forces of Eumolpos, son of Poseidon. The cloth is not the Panathenaic *peplos* at all but rather a shroud in which the littlest daughter will be ceremoniously wrapped before hav- ing her throat slit. Her two older sisters approach their mother with shrouds of their own on sacrificial tables: in accordance with a sisterly vow, they will patriotically submit themselves to the knife as well. The

central scene, then, presents a different, earlier mythological moment from that shown in the rest of the frieze. For there, on the north, south, and west friezes (and even on the north and south ends of the east frieze itself), we see (once again) the very first Panathenaia, held not to honor Athena's birthday or her role in the Gigantomachy but to commemorate the heroic death of Erechtheus (who, in the meantime, had been destroyed by Poseidon) and the noble sacrifice (and self-sacrifice) of his daughters. The horsemen, chariot-borne warriors, and pedestrians who occupy so much of the frieze represent heroic Athenians who, having just triumphed over Eumolpos, now participate in the inaugural procession.

Now, it is likely that Erechtheus, and conceivable that Eumolpos, appeared somewhere in the Parthenon's west pediment (Figs. 25, 28).[4] In this new interpretation, the story of their continuation of Athena and Poseidon's *agon* (contest) over Athens was foretold in the pediment only to be developed further on the frieze. Still, there are more than the usual number of problems with the theory. The tragic tale itself may have been known before the Parthenon was begun, but that is not certain. The first known literary treatment of the myth is Euripides's fragmentary play, *Erechtheus*, written in the late 420s, a decade or more *after* the frieze was finished (so the play cannot fairly be used as if it were the source of the sculpture). In crucial details, the story might even have been Euripides's invention (he is notorious for putting his own peculiar spin on myths). Critically, there is no other extant representation of the story in pre- (or, for that matter, post-) Periclean art. It is difficult to believe that Pheidias would have inserted at the center of the frieze a myth that is found, as far as we can tell, absolutely nowhere else in Athenian art: without a standard iconography to guide them, and without even a sacrificial altar to indicate the setting or a sacrificial knife to indicate the action, how could spectators have been expected to recognize the central scene as the solemn prelude to grisly human sacrifice?[5] It is, perhaps, not so hard to explain the presence of the gods on either side of the unhappy family (Figs. 32, 98, 100): with their backs turned to the central passage, they can be read as belonging to the depiction of the first Panathenaia rather than to the earlier scene of impending human sacrifice (where, according to Greek religious taboos, they should not be present at all). Still, the juxtaposition between what is supposedly a very tragic royal family and two groups of very blasé gods to left and

right is jarring, to say the least.[6] Everything about the frieze, in fact, is casual and relaxed: there is no hint of grief or torment over the bloody deaths of patriotic innocents. Hera is unveiling herself before Zeus like a bride (Fig. 99), and Hephaistos almost seems to be leering at Athena, the object (once upon a time) of his affections (Fig. 32): the mood is all wrong. Moreover, the bearded man (whoever he is) seems to be folding *up* the cloth, not unfolding it: how, then, could he be about to cover his child with it before the sacrifice? As for the two young women to the left of "Praxithea," they are almost certainly carrying cushioned stools (and one footstool), not tables laden with shrouds (there are no visible folds as there are in the shroud/*peplos*). They are probably standard-issue processional *diphrophoroi* (stool-bearers), familiar and expected sights in Athenian festivals, bringing seats for the use of the adult woman and man to the right.[7] Alternatively, they might be the two *Arrhephoroi*. But, in any case, they cannot be Erechtheids: according to the *Erechtheus* itself (promoted as the key to the frieze), Praxithea is adamant about sacrificing only *one* girl for the good of the city – she should not be assisting two other daughters in their suicide pact. Furthermore, the interpretation of the procession as the very first mythological Panathenaia held to honor the memory of Erechtheus and his daughters does not jibe with the tradition that Erechtheus (or his *doppelgänger* Erichthonios) established the festival himself, with Homer's and even Euripides's indications that bulls and rams were sacrificed to Erechtheus and the Erechtheids (not the heifers and ewes depicted on the frieze),[8] or with the numerology of at least the south frieze, where the clear organization of the horsemen into ten ranks suggests not a legendary Panathenaia but one held after Kleisthenes's quite historical establishment of the ten Attic tribes in 508/7. Absolutely crucial to this mythological interpretation of the frieze, however, is the gender of the small child handling the cloth (Fig. 107). If this is the saga of the Erechtheids, the child must be a girl, and indeed the so-called Venus rings on the child's neck and the curvaceous line of the child's exposed buttocks have often been taken as female indicators. But there are sculptures of boys with such rings as well (they are signs of well-fed plumpness, not gender), arguments based on bottoms are subjective, and the garment the child on the frieze wears is an *himation*, worn in this fashion (without an undergarment) exclusively by males. Now, even if the small child *is* a girl, we are still not required to accept the mythological

reading of the work. She seems about the right age for an *Arrhephoros*, who could be as young as seven.[9] But, if the child is, in fact, a boy (as I think it must be), the interpretation of the frieze as a representation of the Erechtheus story simply collapses.[10]

If the frieze does not depict legend, there would appear to be only two choices left: either it depicts an historical procession – that is, the procession of a particular year – or it depicts a generic procession, one that stands for any and all such processions without representing a specific one, a generalized and idealized procession.

The problem with an historical reading of the frieze is that such a thing had never appeared in Greek architectural sculpture before and a lack of precedent makes cowards of us all. We might, however, take courage in the fact that historical events had appeared in *paint* before, on a large scale and on a public building not far from the Acropolis: around 460 or so, Mikon and Panainos depicted the Battle of Marathon within the Stoa Poikile (Painted Colonnade) in the Agora (Fig. 6).[11] One cannot deny Pheidias the same capacity for innovation so recently displayed by the painters of the Stoa Poikile or, for that matter, the designers of the Temple of Athena Nike, whose Ionic frieze, carved only a decade or two after the Parthenon's, represented at least one historical battle, Marathon (Figs. 74–75) and possibly others. Marathon was the defining event of fifth-century Athenian history. It was the greatest of all Athenian victories, one that quickly acquired quasilegendary status as proof of the virtuousness of the democracy and the favor of the gods. And Marathon may be implicit in the Parthenon frieze as well. The year 490 was a Greater Panathenaic year and, John Boardman once argued, the Parthenon frieze represents the procession that happened to take place just six weeks before the critical battle – a procession in which the warriors who fought at Marathon surely took part. Boardman counted the horsemen, *apobatai*, marshals, and grooms in the cavalcade and chariotry portions of the frieze and came up with a total of 192, which is precisely the number of Athenians who fell at Marathon and who, in fact, came to be worshipped as heroes thereafter. The frieze, then, not only represents a particular procession but also retrospectively idealizes and heroizes the Marathonian dead besides.[12]

Now, a Marathonian connection for the frieze is appealing in several ways. In the Stoa Poikile, the painting of the battle was juxtaposed with

paintings of an Amazonomachy and the sack of Troy, two of the myths depicted in the Parthenon's own sculptural program (west metopes, exterior of the shield of the Athena Parthenos, north metopes). The association between this history and those legends – and with it the blurring of the boundaries between history and legend – was thus already well-established in Athenian art, and it would have been natural for Pheidias, as putative designer of the Parthenon program, to rely on and develop the connection (especially if his earlier creation, the Bronze Athena [Fig. 56], really had been paid for out of the spoils of Marathon).[13] The topography of the Acropolis itself had Marathon connections: Pan, the goat god who favored the Athenians in the battle, had his cult in a cave on the northwest slope (Fig. 8). Moreover, as we have seen, the Parthenon itself was in some measure a restoration of a temple (the Older Parthenon) begun in the heady days after the battle as a thank offering to Athena for the victory. And, such fourth-century Athenians as Demosthenes even conceived of the Periclean building as a war memorial, financed out of Persian spoils.[14] The Marathon theme, then, would have resonated with bell-like clarity on the Parthenon frieze (and it would have rung even more loudly after the carving of the Nike Temple's south frieze) – had it only been there; but, it probably was not. Boardman's theory relied on an arbitrary muster of processional figures (why count the grooms and marshals but not the charioteers?) and his numbers may not quite add up, either. Portions of the relevant sections of the frieze are missing, so we cannot be sure of an exact count. More important, perhaps, we have to ask who in antiquity would have taken the trouble to count the figures so high above their heads between the peristyle columns in reflected light and who – having counted – would instantly have drawn the connection between, on the one hand, the horsemen and the chariot-borne *apobatai* and, on the other, Marathon, where the Athenians – to a man – fought on foot?[15]

So, by a process of elimination, we seem to be left with the standard interpretation of the Parthenon frieze as a generic image of a recurring, contemporary event – the sort of Panathenaic procession with which the inhabitants of Periclean Athens were intimately familiar because they either participated in it or observed it from the sidelines. In this reading, the figures represent the idealized inhabitants of Pericles's city, male and female, young and old. Real Athenians (and even some resident aliens who

served as *skaphephoroi*) would have looked up at the frieze, seen themselves, and been pleased at how well they looked. The frieze, in other words, is a flattering Athenian self-portrait, with the Athenians represented as uniformly handsome, uniformly pious, and uniformly contemplative, with the plane of their idealized humanity fusing easily with the higher plane of the Eponymous Heroes (Fig. 106) and the even higher plane of the gods on the east frieze (Figs. 98, 100). (The difference between the Athenians and the heroes and the gods is not one of kind but merely of degree.) In this reading, the *peplos* scene (Fig. 20) represents a young temple boy helping the Archon Basileus (the city's chief religious official) with the sacred robe; the matronly woman is either the Priestess of Athena Polias or the Basilinna, the wife of the Archon Basileus, who played an important role in Athenian civic religion; and the two younger females approaching her are *diphrophoroi* or *Arrhephoroi* (though these girls seem a little too old for that). Such an interpretation still makes the Parthenon frieze an anomaly; no earlier work of architectural sculpture had ever represented a contemporary event and contemporary Greeks – a human present rather than a heroic past – even in an idealized fashion. But, votive reliefs had done so (Fig. 96), and no earlier work of architectural sculpture had ever approached the Parthenon frieze in scale, either. The building's sculptural program is full of original, even radical, choices (the decision to carve all ninety-two exterior metopes, for example, or the unprecedented choice of the contest between Athena and Poseidon for the west pediment, and so on). The decision to fill the frieze with a generic procession – a vast votive relief[16] – could have been simply one more stroke of originality.

The basic reading of the frieze as an idealized Panathenaic procession, depicting the Athenians not as they were but as they wished to see themselves, permits a large number of variants, some of which actually cut across the boundaries between myth, history, and genre – boundaries that the Greeks bothered about less than we do anyway. For example, even some scholars who reject a comprehensive mythological or historical reading of the frieze are still prepared to find a hero or portrait among the mortal crowd. The bearded horse-tamer in the center of the west frieze has been identified as Theseus (Fig. 101) – his breaking of the horse would be an allegory for his *synoikismos*, his legendary unification of Athens – while the Archon Basileus in the center of the east frieze (Fig. 107) has (improbably) been identified as none other than Pericles himself.[17] Other

scholars more plausibly suggest that the figures in the *peplos* scene, though idealized mortals and not figures of legend, may nonetheless be *reenacting* the heroic foundation of the Panathenaia, with the young women standing in for the daughters of Kekrops, the Archon Basileus for Kekrops (his royal ancestor), and the boy for Erechtheus/Erichthonios.[18]

Some scholars who accept the generic character of the frieze nonetheless also raise issues of time and place. One, relying on the numerology of the frieze, accepts the south frieze as a generalized Periclean-era procession (again, its organization around the number ten refers to the ten tribes into which the Athenian populace had been divided ever since Kleisthenes's reforms of 508/7) but believes that the north frieze (where the number four plays so large a role) alludes to the Panathenaic procession of pre-Kleisthenic times, when the population was organized into four tribes. In this reading, the frieze, though generic, in a way summarizes the history of the procession and the political history of Athens.[19] Another sees two distinct (if still generic) processions, with two distinct directions and goals, instead of one: the north side depicts a procession in honor of both Athena Polias and Pandrosos (the four cows would be sacrificed to Athena, the four sheep to Pandrosos), whereas the south side depicts a procession in honor of Athena Parthenos (the recipient of the ten cows) – this, despite the fact that the two streams come together as one on the east side (Fig. 98), and despite the fact that there is no evidence that Athena Parthenos was ever the object of cult in the first place.[20] Some scholars, believing that the Classical temperament would have insisted on the dramatic "unity of place," set all the action of the frieze in the Agora. Others more flexibly distribute the action over different parts of Athens, from the Dipylon Gate (where the procession began and where the riders shown in the west frieze [Fig. 101] would have mounted their horses), through the Classical Agora (where, for example, the *apobates* competition [Fig. 104] may have taken place), to the summit of the Acropolis itself (where the sacrifices were made and the *peplos* was presented). To follow the frieze around the building would have been to take an imaginative journey through Athens (Fig. 6).[21] There are also interpretations that accept the generalized Panathenaic character of the frieze but emphasize its political messages. Style, it is argued, is often a political rather than purely aesthetic choice, and the stylistic homogeneity of the detached or introspective figures on the frieze (Fig. 31) is an attempt to emphasize the equality of the Athenian populace under Pericles.

Those who look alike, the argument goes, not only think alike and act alike but are also alike under the democracy.[22] According to another generic theory, the frieze represents the Panathenaia all right but, in doing so, deliberately synthesizes the iconographies and conventions of the art of Athens's Ionian subjects and allies. Equestrian and processional subjects and chariot races had already been depicted in the sculpture of East Greek temples, for example, and Pheidias incorporated such images here to argue for the ideological unity and ethnic kinship of the entire empire. Athens's subject-allies, visiting the Acropolis, would have been reassured by the inclusive nature of the image.[23] And, according to yet another generic reading (one that takes into account sexual practices between men and boys prevalent in Classical Athens), there is a homoerotic dimension to the frieze: the naked or half-naked horsemen (Fig. 31), depicted as eternally handsome youths with downcast eyes, are the passive objects of the aggressive male gaze. They would been seen as potential *eromenoi* (modest young beloveds) for the viewing *demos*, composed of *erastai* (courting adult lovers).[24]

The generic reading of the frieze is, then, a broad umbrella covering a large cluster of interpretations. Still, the assumption fundamental to them all – that the frieze basically represents a contemporary but generalized Panathenaic procession of idealized mortals – is hardly unassailable. Again, we need not be bothered by the fact that such a subject would be unprecedented in Greek architectural sculpture; there is a lot about the Parthenon that is unprecedented. Rather, the problem is that if the Parthenon frieze was really intended to represent an idealized but still recognizable Periclean-era procession, it does a poor job of it. It is not often enough realized that someone who had never been on the Acropolis before, making his or her way from the west end of the Parthenon to the east, would have had no real clue as to what this frieze was all about until the very end. Keats asked, "What men or gods are these? What maidens loth? What mad pursuit?" and so might the ancient spectator, viewing for most of the way horsemen, chariots, and pedestrians with nothing specific to identify them or their ultimate goal. Only at the east end is an image that might have explained everything that had gone before: the *peplos* scene (Fig. 20).

But, even so, there are people and things missing from the frieze that we know from literary sources should be there if it depicted a Periclean

Panathenaic procession: representatives of Athens's imperial allies bearing suits of armor, for example, and female water-jar carriers (the *hydriaphoroi* on the frieze are male [Fig. 103]), and possibly *thallophoroi* ("branch-bearers" chosen from among the best-looking Athenian elders),[25] and, most conspicuous by their absence, the force of armed hoplites that marched, and the large ship on wheels that rolled (with the huge tapestry-*peplos* rigged as its sail), down the Panathenaic Way. Artistic license can explain away some of this: the depiction of a full-size ship in a relief only a meter high would have wreaked havoc on the scale of the frieze (either the ship or the figures would have had to be jarringly miniaturized). Or perhaps, in a telescoping of time and place, the pilgrim, following the course of the procession down the side of the Parthenon, imaginatively mimicking its progress from the Dipylon Gate to the Acropolis summit, was at some point toward the eastern end of the cella supposed to think of the ship as already docked at the foot of the citadel and, therefore, absent from the festivities depicted as taking place atop it. Or, perhaps this is not the quadrennial Greater Panathenaia at all but rather the annual festival, when the ship did not roll and Athena Polias was presented the human-sized robe-*peplos*. Still, the missing persons are harder to explain. There were 160 meters of frieze: could the great Pheidias (or whoever designed the frieze) find no room for any hoplites at all? Then, too, there are things present on the frieze that were almost certainly not there in the course of the actual procession. *Apobatai* (Fig. 104) may have participated in the parade, but they could not have actually engaged in their dramatic sport, as they do on the frieze, without trampling the pedestrians walking in front of them and causing bloody mayhem (a few of the elders on the north frieze look nervously over their shoulders). Indeed, the apobates competition probably took place the day *after* the procession[26] so, in this respect, at least there can be no unity of time in the frieze. Finally, there are participants for whom there is no independent evidence – the male *hydriaphoroi* (Fig. 103), for example, and – remarkably – even the horsemen (Fig. 31). Although the cavalcade occupies nearly half of the total length of the frieze and equestrian events certainly loomed large in Panathenaic contests held in the days before the climactic parade, there is not a single ancient source that states unequivocally that horsemen participated in the Panathenaic procession itself.[27] Now, no one expects the frieze to be a completely accurate, documentary record of the event: this

is sculpture, not videotape. And, it is true, most of our literary evidence for the Panathenaia is much later than the fifth century. Things could have changed a lot over time, and what a late Roman source says about the procession may not apply to a Periclean one centuries earlier. However, there are still so many discrepancies between what the frieze shows and what the procession is thought to have included that either (a) the frieze, as a depiction of a Panathenaic procession, is unsuccessful; or (b) it does not represent a Panathenaic procession at all.

So, let us now assume that the frieze does not depict a Panathenaic procession of any kind. What, then, is going on? According to one theory, it is a *symbolic* representation. Just as the Periclean Parthenon was a kind of restoration of the Older Parthenon destroyed by the Persians, so the figures on the frieze are renewals, in relief, of the Archaic statues and votives that fell victim to barbarian impiety in 480 – dedications that Athenians over the age of fifty might well have remembered seeing in their youth and whose loss they would have lamented still. The prominent maidens of the east frieze (Fig. 105), for example, are in this view really Archaic *korai* (Fig. 45) put in fashionable Classical clothes; the youths leading cattle (Fig. 97) are evocations of works like the Moschophoros (Fig. 44); the horsemen are restorations of Archaic equestrian statues; even the *peplos* in the east frieze (Fig. 107) is a symbolic replacement for all those *peploi* that went up in smoke. The frieze, then, depicts an ideal procession, but it is a parade of restored monuments, not people.[28] According to another kind of symbolic theory, the Parthenon frieze has less to do with actual Athenian processions than with the stereotyped parades of subjects and tribute-bearers carved on the palatial façades of Persian kings: either the frieze, with its freely posed, introspective, and individualistic figures (cf. Figs. 31, 102), is a democratic critique of rigid Persian totalitarianism, or, conversely, it is sympathetic to it, with Pheidias co-opting Persian iconography to assert the new dominance of Periclean Athens over its empire and the rest of Greece (the frieze would then present Athens as a new Persia – an unlikely tactic, to say the least).[29]

The Parthenon frieze simply cannot accommodate all these divergent, even contradictory, interpretations. Now, ambiguity is good and great works of art should have more than one level of meaning and all that, but they should not mean just anything. Still, there is one more

interpretation to consider, one that goes a long way toward resolving the problems of the frieze, and it is this: the frieze does not represent a single event at all (mythological, historical, or generic) but is a synopsis of many events, a collection of excerpts. The fact that *apobatai*, horsemen, and musicians prominently appear on the frieze, when their competitions took place on different days of the Panathenaia (as well as in different places), suggests that the frieze does not represent the *procession* but selects or alludes to episodes from the whole multiday *festival*, and blends them artfully in processional form.[30] But, perhaps even this theory is too limiting, and the frieze depicts not "the idea of the Panathenaia" but, as J. J. Pollitt suggests, "the idea of Religious Festival" itself – an idea fundamental to Athenian life and to Athenian self-representation in general (as Pericles himself noted with pride in his Funeral Oration, citing the many "contests and sacrifices" held throughout the year).[31] Lavish processions characterized several Athenian festivals besides the Panathenaia: the one held yearly at the start of the City Dionysia (with gorgeously dressed citizens, *metoikoi*, and colonists, and with sacrificial animals and attendants galore) was nearly as grand. Virtually every feature of the Parthenon frieze could be found in any number of Athenian holidays. The procession at the City Dionysia, for example, also boasted *skaphephoroi*, *hydriaphoroi*, and a *kanephoros* carrying a ritual golden basket. It is worth noting that imperial tribute was displayed in the theater in sacks and *hydriai*, and it is worth wondering whether the youths on the frieze are carrying coins, not water, in their heavy jars (Fig. 103): one talent – "a man's load" – per pot.[32] *Kanephoroi* (Fig. 105) and *diphrophoroi* were regular features of Athenian sacrificial processions and festivals in general. But, if the girls (or young women) carrying things on their heads on the left side of the central scene on the east (Fig. 20) are not *diphrophoroi*, then, again, they might be *Arrhephoroi*:[33] their burdens may not be the secret objects they transported by torchlight on the night of their own festival, the *Arrhephoria*, but they are carrying something, and carrying something is what the *Arrhephoroi* were known for (they also spent a lot of their time assisting the priestess of Athena Polias, and that is what they may be doing here). Horsemen may or may not have ridden in the Panathenaic procession, but horsemen certainly served as escorts at other festivals (such as the *Eleusinia* and *Plynteria*). One of the more spectacular equestrian displays in Classical Athens was a mock cavalry battle known as

the *anthippasia*, but this is not specifically attested as a Panathenaic event until the third century, and even then it was not uniquely Panathenaic.[34] The Panathenaic *apobates* competition was clearly the most important in Athens, but *apobatai* probably performed at other celebrations as well (such as the *Anthesteria*, a festival sacred to Dionysos).[35] So did flute players and kitharists, who regularly attended sacrifices of all sorts. And whoever the staff-bearing men flanking the gods in the east frieze are (Figs. 98, 106) – the Eponymous Heroes of the ten Attic tribes or archons or commissioners of sacrifice – their presence would be entirely appropriate as the overseers of Athenian political, cultural, and religious life in general.[36]

Now, I side with those who believe that the central scene in the east frieze (Fig. 20) is, indeed, Panathenaic and that the cloth really is a *peplos*. (This may be why Athena, just to the right, has placed her *aigis* in her lap: she is getting ready for a change of costume [Fig. 32].) But other Athenian rites involved garments, too (robes were regularly offered to Artemis Brauronia, certainly at Brauron and probably on the Acropolis), so even here other non-Panathenaic associations could have come to mind. The important point is that the Panathenaia, though given pride of place on the east frieze, is only one element in the rich panorama of Athenian sacred life – and, thus, of Athenian society – that the entire frieze surveys. This is perhaps the best explanation for the presence of all the Olympians on the east (Fig. 98). Just as the Panathenaia itself probably celebrated a cosmic battle won by *all* the gods – the Gigantomachy, woven into the *peplos* – rather than simply Athena's birthday, so the frieze glorifies Athenian piety toward all the gods, not just Athena.[37] Though placed symmetrically about the *peplos* scene with Zeus, Athena nonetheless takes her place beside the other gods, just as her special holiday, the greatest Athenian holiday of them all, is subsumed under the abstraction festival.

One important question remains, however: what does the Parthenon frieze – a distillation of the many processions, athletic and cultural contests, ritual presentations, and sacrifices that characterized Athenian life in the age of Pericles – have to do with the rest of the Parthenon's decidedly mythological sculptural program or, indeed, with the imagery of the Classical Acropolis as a whole?

Agon and Nike: Thematic Unity on the Acropolis

By the time Pheidias's gold-and-ivory Athena Parthenos was dedicated in 438 (Fig. 21), his Bronze Athena (Promakhos) had stood out in the open on the Acropolis for almost twenty years (Fig. 56). It was complete, but it was not quite finished. Sometime after the dedication of the Athena Parthenos (and presumably after Pheidias's departure from Athens around 438), Parrhasios (a painter and designer active around 400) and Mys (a metalworker and engraver) were commissioned to return to Pheidias's earlier work and add to the surface of its shield, among unnamed other things, a Battle of Lapiths and Centaurs – a myth that had been virtually nonexistent on the Acropolis before the Periclean era but that now decorated the Parthenon's south metopes (Figs. 19, 30) as well as the sandals of the Athena Parthenos.[38] There can be no doubt that the addition was made to harmonize the great older bronze statue, which had apparently lacked any mythological decoration before, with the great new chryselephantine one, which was loaded with it. This High Classical modification of the Early Classical bronze is one indication that the Athenians themselves conceived of the Acropolis not as a random assemblage of distinct, unrelated monuments but as a continually evolving and expanding "text." Every new monument not only changed the Acropolis; it also had the potential to alter the way everything that had been set there before was seen. The Acropolis was, thus, a composition where images could allude to other images, where images could even be made to respond to other images, and where unity was supplied by the moving spectator's recognition of thematic repetition, variation, or elaboration.

Another case in point: around 420, a certain Khairedemos, for reasons unknown, hired the sculptor Strongylion to create a bronze statue of the Trojan Horse. The work was a colossus: according to one estimate, it stood nearly 6 meters high, and at least four life-size Greeks (Menestheus, Teukros, and the sons of Theseus) were shown peeking or perhaps even climbing out of it. Pausanias saw the statue within the precinct of Artemis Brauronia, and that is where inscribed blocks from its base still lie (Fig. 115; CD 174).[39] In any case, as he set about his enormous task, Strongylion must have been aware that episodes from the Trojan War,

including the sack, were represented not far away on the Parthenon's north metopes (Fig. 35). In other words, the immediate artistic environment of his creation already included an extensive if episodic treatment of the myth.[40] As far as we can tell, the Trojan Horse itself did not appear on the Parthenon metopes, and so Strongylion could have conceived of his monument as a complement to the earlier reliefs, as one more episode in the saga. But the sons of Theseus (Damophon and Akamas), whom Strongylion showed looking out of his Wooden Horse, almost certainly appeared again on the north metopes (they rescued their grandmother, Aithra, from the burning citadel). Thus, Strongylion's work essentially explained how the pair entered Troy in the first place, and their progress on the night of Troy's sack could be traced from monument to monument, from bronze to marble. More generally, it would have been difficult for any attentive visitor to move from the Brauronion, with its colossal horse, to the north flank of the Parthenon, with its Trojan metopes, without making a connection: one's reading of the story of Troy extended from one Acropolis site to the other.

So, too, Pausanias saw (apparently near the northwest corner of the Parthenon) a statue group representing Athena's birth from the head of Zeus and another group (apparently near the northeast corner of the Parthenon) of Athena and Poseidon displaying their tokens (the olive tree and the salt sea) and awaiting the outcome of their competition.[41] Athena's birth and her contest with Poseidon were, of course, the subjects of the east and west pediments of the Parthenon (Figs. 28, 38), and so the statue groups transported each myth to the ground on the side of the Parthenon opposite its treatment in a pediment; the narratives of the birth and the contest in a sense criss-crossed the Parthenon terrace. We have no evidence for the date of the statue groups but, with their addition to the sanctuary, the visitor was presented not so much different versions of the myths told in the pediments as different moments in the stories – one a preface, the other an epilogue. In the birth of Athena group on the ground, Athena was apparently shown actually emerging from Zeus's head (in the pediment she stood, fully emerged, beside the god); in the other group, Athena and Poseidon were evidently standing quietly by, awaiting the final verdict (in the pediment, their violent contest is still underway). So, the spectator who visited both ends of the

Parthenon found in the pediments above and the monuments below a kind of mythological self-commentary.

The visitor who traversed the summit of the Classical Acropolis was enmeshed in a network – an Acropolis-wide web – of meaning and reference. The web expanded organically as each new monument found itself in some fashion linked to monuments already there, unavoidably participating in a kind of discourse (both iconographic and stylistic) with other images or sites. The spectator who noted the reclining figure of Kekrops near the north angle of the Parthenon's west pediment, the marble (or bronze) olive tree of Athena at its center, and the figure of Erechtheus somewhere up there (Fig. 28) had only to turn a little farther to the north to locate Kekrops's tomb, the "real" olive (Fig. 117), and, probably, one or more images of Erechtheus again (on the Erechtheion frieze [Fig. 120] or in the large bronze group Pausanias saw, in which he fought Eumolpos).[42] The spectator who noted the group of deities on the east frieze of the Temple of Athena Nike (Fig. 124) would find the leitmotif of divine assembly repeated on the Parthenon's east frieze (Fig. 98) and on the base of the Athena Parthenos (Fig. 21). The theme of divine birth linked the base of the Parthenos with the Parthenon's east pediment (and possibly with the Nike temple's east frieze as well). The Erechtheion Karyatids (Fig. 67) seem like monumental versions of the maidens on the Parthenon east frieze (Fig. 105). Alkamenes's Prokne and Itys (Fig. 119), set near the northeast corner of the Parthenon, may have alluded to a myth possibly depicted in the lost south metopes (Fig. 19): Prokne was, in any case, the daughter of Pandion, worshipped in the *heroon* in the southeast angle of the Acropolis (Fig. 2, no. 16).[43] Sculptors working on the Nike parapet quoted passages on the Parthenon frieze (see Figs. 79, 125); and so on. The perception of this topography of allusion depended on the movement and short-term memory of the visitor, and few visitors would have viewed one treatment of a given theme or myth without recalling and comparing others already seen and already in mind. The experience of the Acropolis (as of any Greek sanctuary) would thus have been a dynamic, cumulative, and extremely resonant one. The imagery of the Acropolis constantly alluded to itself. Its unity was a natural product of intricately evolving lines of self-reference.

Any number of themes or leitmotifs can be traced on the fifth-century Acropolis. Some were even architectural. The use of the Ionic order for the Nike Temple, inside the mostly Doric Propylaia, for the Erechtheion, and inside the mostly Doric Parthenon, for example, imposed a broad contrapuntal rhythm on the place. Another particularly significant theme, as we have noted before (see Chapter Two), was the Periclean evocation, preservation, and renewal of Early Classical, Archaic, and even Mycenaean monuments and remains: in the fabric of the new Periclean Acropolis, there was the constant revelation and, thus, memorialization of past Acropolises (cf. Figs. 24, 54, 58). But, if there was one strand that was most conspicuous in the sanctuary's web of allusion, if there was one theme that ran throughout the iconography of the Parthenon in particular and the Classical Acropolis as a whole, it was *nike* (victory) – Victory Personified, Victory Commemorated, and Victory Represented.

Victory Personified – Nike herself – was a very common sight. Statues of Nikai were certainly not new to the Classical sanctuary; assorted Archaic Nikai were already there when the Persians came in 480 and knocked them down.[44] But, the Nike population boomed afterward. Pheidias's Bronze Athena (Promakhos) may have held a Nike in her hand (Fig. 56). The chryselephantine Athena Parthenos certainly did (Fig. 21) – another possible thematic link between the two monumental goddesses of the Classical sanctuary. Nike appeared elsewhere in the sculptural program of the Parthenon. She hovered beside Athena in east metope 4 (Fig. 42), preparing to crown the goddess for her victory over the giants; she drove the goddess's chariot in the west pediment (Fig. 28); she probably appeared in the east pediment (Fig. 38); she may be the winged figure beside Hera in the east frieze (though Hebe may be a better candidate) (Fig. 99); and four Nikai probably alit on the corners of the Parthenon roof, as if bringing news of victory down from Olympos itself (Fig. 90). On the brink of the Peloponnesian War, there were at least eight Golden Nikai stored in the Parthenon; more would be dedicated in the course of the war (two are recorded for the year 426/5, for example).[45] A bronze Nike was dedicated somewhere on the summit to commemorate the victory over the Spartans at Sphacteria (425).[46] More Nikai perched on the roof of the Temple of Athena Nike (in imitation of the Parthenon *akroteria*). And, of course, by the end of the fifth century, there were Nikai galore on the Nike Temple parapet (Figs. 77–78), participants in a procession

142. Kallias base (*IG* I³ 893), c. 430. Photo: author.

that conditioned the visitor for the even greater processional frieze of the Parthenon. All in all, Victory Personified was as familiar a sight on the Classical Acropolis as the goddess of the place, Athena herself.

The Acropolis was also full of victory monuments – either war memorials set up by the state or memorials to competitive success enjoyed by individuals. The Bronze Athena itself, for example, commemorated Marathon but was also purposefully aligned so it could gaze toward Salamis (the site of yet another great victory over the Persians) (Fig. 2, no. 7; Fig. 14), and it was probably paid for out of the spoils taken from the Persians at a number of battles. There was the restored monument marking the victory of the early democracy over the Boiotians and Chalkidians in 506 (Fig. 56). And there was a bronze group of a man and horse dedicated at mid-century by the newly constituted Athenian cavalry (*hippeis*) to commemorate its first victory.[47]

But Nike was manifest on the Acropolis in other ways, and not every victory monument was military. The Classical sanctuary was loaded with the dedications of victorious athletes, musicians, and others – private citizens wishing to commemorate their public triumphs. Perhaps just before construction of the Parthenon began, for example, the military commander Pronapes dedicated a bronze chariot to commemorate his own athletic victories at Nemea, Isthmia, and the Panathenaia.[48] And

possibly around 430, Kallias, son of Didymios, dedicated a bronze statue (now lost) on a circular base inscribed with a laconic tabulation of his victories at the major athletic competitions of Greece (Fig. 142):

> Kallias son of Didymios dedicated this.
> Victories:
> Olympia.
> Pythia [Delphi]: twice.
> Isthmia: five times.
> Nemea: four times.
> Great Panathenaia.[49]

And, at some point, a portrait of Alkibiades, commemorating an equestrian victory at Nemea, was hung on a wall of the Pinakotheke.[50]

Victorious athletes were always well represented on the citadel (some Panathenaic champions even dedicated their prize amphorae after emptying them of their oil), but the thank offerings of victorious musicians may have been common, too. Even tragedians may have commemorated their success in the Theater of Dionysos down below with dedications up above. Although it does not look much like a victory monument with the mother about to kill her own fearfully contorted son, it has been suggested that the Prokne and Itys of Alkamenes (Fig. 119) marked the dramatic victory of a trilogy by Sophokles performed in the 420s.[51]

Of course, Nike was particularly manifest in the Acropolis's many representations of battles, battles that were deeply woven into the iconographic fabric of the sanctuary and that presented the visitor with assorted narrative threads to follow – battles between the gods and the giants (carved on Parthenon east metopes, painted or inlaid on the interior of the shield of the Athena Parthenos, possibly painted on the *peplos* in the east frieze, certainly woven into the many *peploi* displayed or stored inside the Erechtheion, and depicted in the Nike Temple east pediment); battles between Greeks and centaurs (Parthenon south metopes, sandals of Athena Parthenos, exterior of the shield of the Bronze Athena); battles between Athenians and Amazons (Parthenon west metopes, exterior of shield of Athena Parthenos, Nike Temple west pediment); battles between Greeks and Trojans (Parthenon north metopes and Strongylion's Wooden Horse); and historical battles between Greeks and Greeks, and Greeks and Persians (Nike Temple friezes).

What is interesting about these battles, however, is that the issue is often yet to be decided. Acropolis monuments typically commemorate not the triumph but the conflict. On many of the Parthenon's south metopes, for example, centaurs are (or are about to be) victorious (Fig. 19; CD 067). On the west metopes, Greeks lose to the Amazons about as often as they defeat them. On the shield of the Athena Parthenos (Fig. 91), at least one defender of the Acropolis (the so-called Kapaneus, near the top) was badly wounded in the back. Even the outcome of the battle friezes on the Nike Temple is still in the balance (Figs. 74–75, 123). So, if the iconography of the Acropolis constitutes a paean to Nike, it is not simple-minded exultation or gloating: Athenians and Greeks will win the battles and the wars but not without struggle and not without loss.

In fact, it may be the struggle rather than the conquest that is at the core of the Acropolis's imagery and ideology – not so much *Nike* but the even broader idea of *Agon* (conflict, contest, rivalry), an idea that encompasses not just warfare but also musical and athletic competition and even the kind of divine struggle depicted in the Parthenon's west pediment (Fig. 28).[52] The *agon* is one of Athena's many fields of operation:[53] her sacred olive tree, the tangible sign of her defeat of Poseidon,[54] was not only the Acropolis's first victory monument but was also, according to tradition, the mythical first olive tree, the one that engendered all others, including those whose oil was awarded in handsome black-figure containers to victors in the Panathenaic competitions.[55] The mythical *agon* that determined the identity of Athens was, thus, directly tied to the actual *agones* held at the Panathenaia, the civic festival that best defined what it was to be Athenian. At all events, the breadth and intricacy of the conception of *agon* as both armed struggle and civic competition is perhaps symbolically represented in, of all places, the Periclean Odeion on the south slope (Fig. 2, no. 20; Fig. 136). As the setting for both the musical contests of the Panathenaia and the preliminaries to the tragic competitions of the City Dionysia, this monumental hall, supposedly a replica of Xerxes's pavilion built with the spars of captured Persian ships, was one place where the significance of military victory and peaceful civic victory fused.

Containing and defeating the Persians had been the principal goals of Athenian foreign and strategic policy for thirty years before the construction of the Parthenon began, and it is a truism that the mythological

battles depicted in the metopes, on the shield and sandals of the Athena Parthenos, and then on the shield of the Bronze Athena, are analogues or allegories for the historical victory over the evil Eastern empire.[56] All these myths had, of course, appeared in Greek art before, and Archaic Gigantomachies (Figs. 39–41), for example, obviously had nothing to do with the Persian Wars (which had not happened yet). Still, these old tales were invested with new meaning after 480, and the way the myths were told in art (as well as poetry) could be adjusted to accommodate historical events. For example, Amazonomachies in which the women warriors actually attacked the Acropolis, as they did on the shield of the Athena Parthenos (Fig. 91) – do not antedate the Persian sack of the Acropolis in 480, nor did the story (first told by Aeschylus) that the Amazons used the Areopagos (CD 014) as their base of operations (as Xerxes and the Persians, in fact, did). In other words, Classical Athenian art and literature made the Amazons of their ancient legends act like the Persians of their recent history and, in so doing, converted myth into polemic.[57]

Now, it may be that the Athenians appreciated their own victories above all as concrete historical demonstrations of the universal truths or abstractions inherent in the myths – that piety will defeat impiety, that justice will triumph over injustice, that order will overcome chaos, that rationality will defeat bestial violence, that the west will triumph over the east, and that the male will overcome the female. However, all those antitheses could be read into the history of the Persian Wars as well, and the implicit message of the metopes and *akroteria* of the Parthenon – that most grandiose of victory monuments – as well as of the sculptural program of the Nike Temple, whose Marathon frieze was juxtaposed with the Gigantomachy and Amazonomachy of its pediments (Fig. 121), is that Athenian military success against Persia is to be ranked with those other great – even cosmic – victories, those assertions of moral right. The Athenians of the Periclean era would have considered the inherited myths prefigurations and even justifications for their own recent struggles with the Persians – easterners who, after all, were garbed like Amazons and attacked the Acropolis like Amazons and acted barbarously, impiously, and unjustly like giants and centaurs.[58] There may even be in the north metopes (Fig. 35), where allied Greeks defeated a common eastern foe (the Trojans), an allusion to the necessity of the Delian League (by then, really the Athenian Empire), an alliance ostensibly held together by animosity

toward another common eastern enemy (the Persians) but which would prove essential in future struggles against other common foes (such as Sparta and its league). In short, recent (and even anticipated) history injected new meaning into the old tales; the myths were not only ripe for expropriation but could also be promoted as grounds for imminent action.

Now, time undoubtedly changed the temper of the imagery. In the midst of new wars, the implications of the old myths would correspondingly shift. The battles of the Parthenon metopes, in the 440s taken as allusions to the Athenian victory over the Persians, might in the late 430s and 420s also be taken as predictors of future Athenian success over the Spartans. So, too, the Acropolis's "victory text" was read quite differently in, say, 403 (in the bitterness of a defeat largely financed by the hated Persians themselves) than in 431 (on the brink of the Peloponnesian War, when its array of victories must have seemed reassuring and programmatic). Like a great work of literature, the Acropolis was subject to different readings at different times, in the shifting lights of history. Its text was also subject to emendation, and that was something that later conquerors, Hellenistic kings, and Roman-era Athenians relied upon. Three examples will serve to make this point.

Around 334, after a crucial victory over the Persians, Alexander the Great (Fig. 143; CD 179), son of Philip of Macedon (who ended Greek independence in 338), sent 300 suits of Persian armor to the Acropolis and dedicated them to Athena inside the Parthenon. He also had fourteen large gilded shields nailed to the east architrave of the building, below the Gigantomachy metopes, to commemorate the victory; their round "ghosts" are still visible (Fig. 144). The correspondence between Alexander's battle for world dominion and the gods' cosmic struggle with the giants was exact – one shield for each metope. And so, Alexander transformed the Parthenon, a monument commemorating Athenian victory over the Persians, into a monument commemorating his own victory over them.

When around 200, Attalos I, king of Hellenistic Pergamon, dedicated a large group of defeated or dying Giants, Amazons, Persians, and Gauls (Fig. 131) east of the Parthenon, near the south Acropolis wall, he placed his own recent victory over the Gauls in venerable company, elevating himself to the level of Giant-, Amazon-, and Persian-slayer, enlisting

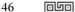

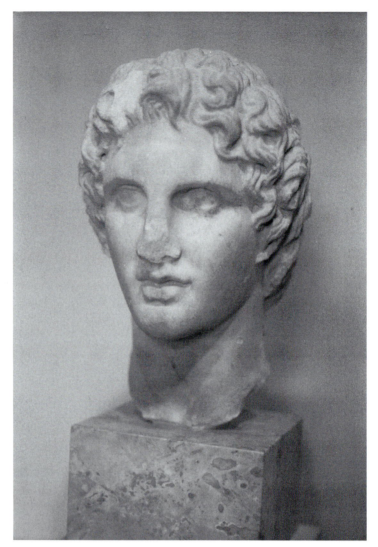

143. Portrait of Alexander the Great, late fourth century? (Acropolis 1331). Photo: author.

Pergamon in the same eternal struggle fought by gods, heroes, and Athenians in the sculptures of the Parthenon and Nike Temple. That is, the full meaning of the Attalid Monument was revealed only in relation to the Parthenon and, in turn, the Parthenon itself acquired a new dimension after the Attalid dedication was made. For just as in the fifth-century Amazonomachies and Gigantomachies and all the rest were considered mythical prefigurations of the Persian Wars, so now the battles depicted on the Parthenon would have seemed to prefigure Attalos's Gallic Wars; Athens, through the Parthenon, promised Pergamon.

144. East architrave of Parthenon. Photo: author.

Finally, early in the reign of Augustus, founder of the Roman Empire, the Athenians took the extraordinary step of building a temple to him and the personified Roman people – the last significant architectural addition to the ancient summit and the only one of the Roman period (Fig. 2, no. 15; Figs. 82, 89).[59] Placed about 23 meters east of the Parthenon, set on a roughly square foundation just where the natural bedrock begins to fall down and away, this Temple of Roma and Augustus – a small, low, cellaless ring of nine Ionic columns less than 9 meters in diameter – did nothing to interfere with the relationships among the principal Classical buildings on the summit. Still, the Temple of Roma and Augustus had plenty of formal links to past Athenian architectural greatness. Its material was classic Pentelic marble; its Ionic columns were imitations of the Erechtheion's; and a block of the Erechtheion (which had recently undergone a major renovation) was even built into its foundation, almost as if the Classical stone were set there to magically sanction or bless the Roman. But, its primary architectural associations were with the Parthenon – it is aligned exactly along the Parthenon's east-west axis (Fig. 89) – and so were its symbolic associations. For this temple was built not only to introduce the worship of a living emperor to Athens but also to commemorate Augustus's victory (more diplomatic than military) over

the Mesopotamian kingdom of Parthia in the summer of 20 (the Parthians were to Rome what the ancient Persians had been to Greece and Athens five centuries before: eastern *barbaroi* and bogeymen beyond the boundaries of civilization). Begun by the Athenians shortly after Augustus's "triumph" over the east, the temple was probably completed in time for his third and final visit to Athens late in the summer of 19. The Temple of Roma and Augustus, then, was both the house of the new imperial cult and, like the Parthenon itself, in the nature of a victory monument. Nor was its position randomly chosen. It plotted a new angle in a "field of Nike" already defined by the east façade of the Parthenon and by the Attalid Monument on the south. Perfectly aligned with the Parthenon and thus with the Nike-bearing Athena Parthenos (Fig. 21), the Temple of Roma and Augustus essentially marked an eastward extension of the Parthenon's own ideological geometry, an imperial insertion into the Acropolis's complex network of allusions to the west's triumph over the east – a theme eminently stated, of course, by the Parthenon itself but in the intervening centuries rephrased by Alexander's dedication of Persian shields (Fig. 144) and Attalos I's representations of the fallen enemies of civilization (Fig. 131). The Athenians, in other words, appropriated Augustus's eastern triumph and injected it into the Acropolis's ancient web of Nike, making his success the latest manifestation of their own, all the while sincerely honoring the emperor and the city that now stood as the bulwark of the west.[60]

The Acropolis, in short, was and would always be a complex essay on competition and victory – it was a vast field of *Agon* and *Nike* – and it remains to be seen how the Parthenon frieze fit into the original Periclean scheme.

The School of Hellas

Whatever else it is, the Parthenon frieze is a glorification of the Athenians themselves. The makers of the Classical Acropolis depicted Athens as it wished to be seen, with its Acropolis (the setting of the west Parthenon pediment, Fig. 28) literally placed on the same plane as Olympos (the setting of the east, Fig. 38), with its many victories analogous to divine and heroic victories. The makers of the frieze depicted the Athenians as they wished to be seen: as a people composed of perfect youths (Fig. 31),

pure maidens (Fig. 105), and handsome elders (Fig. 102); as a people whose idealized nature is nearly godlike and whose relaxed, conversing gods (Figs. 32, 99) act like human beings; as a people who even exist and move in the same sculptural field as their gods. The divine and the mortal spheres intersect; divine and human images blend. There is no modesty here.

"Man," said Pericles's friend Protagoras, "is the measure of all things," and the Athenian, the frieze seems to argue, is the measure of all men. It is the character of the Athenians – their reverent virtue, their excellence or *arete* – that is the point of the frieze, and it is a character revealed once again through the sacrifices and *agones* of Athenian life and through the Athenian history and promise of military success.[61] One such *agon* is, of course, overt: the *apobates* competition (Fig. 104; CD 077, 084), an event that had its origin in the kind of chariot warfare remembered in Homer's *Iliad*, where heroes are driven to the field of battle in chariots and dismount to fight. This kind of battle chariotry was obsolete long before the fifth century, but the Athenians regularly heard about it during the institutionalized recitations of Homer at the Panathenaia. Thus, the military and heroic character of the Classical sport would have been obvious.[62] Apparently, only citizens – and only "the best men" among them at that – could act as *apobatai* in Periclean Athens and so on the frieze (as in reality) the finest Athenians display the same extraordinary skills that Homeric heroes possessed.[63] Other less militaristic competitions are implicit in the frieze: the flute-players and kitharists, as we have noted, might have recalled Panathenaic musical contests, and the male *hydria*-bearers (Fig. 103), if they did not allude to the display of imperial wealth at the City Dionysia, possibly brought to mind torch races held the night before the Panathenaic procession (the prizes were *hydriai*).[64]

Still, the martial character of the frieze is pervasive. The center of the east frieze – the side that is most clearly Panathenaic – represents, after all, preparations for the presentation of a representation of battle (the Gigantomachy of the *peplos*; Fig. 20). The Panathenaia was probably founded to celebrate Athena's role in the Gigantomachy, and the Panathenaic procession (which, again, can be read into the frieze along with others) was the only occasion when Athenians could bear arms within the city without arousing suspicion.[65] Most significant, there is the cavalcade, by far the single longest (and, therefore, most conspicuous) passage

of the entire frieze (Fig. 31; CD 073–076, 083). Just as many different religious events could be read into the frieze as a whole, so the cavalcade was no doubt subject to different readings. But, while the horsemen might have called to mind the riders who regularly escorted Athenian sacred processions or the entrants in Panathenaic (and various other Athenian) equestrian events, they would also (as J. J. Pollitt has argued) have evoked pride in a brand-new Periclean fighting force, a new instrument of Athenian *nike*. In the early 450s, Athens had established a 300-man cavalry to guard Attika from attack, and all 300 *hippeis* seem to have come from Athens's wealthiest, aristocratic families. But, sometime between 445 and 431, in an effort to strengthen the defense of the *polis*, Pericles more than tripled the size of this force, creating a new 1,000-man cavalry commanded by two hipparchs and divided into ten tribal squadrons (because members would have had to be recruited from a broader base than the traditional Athenian aristocracy, Pericles's cavalry was more democratically based than the old force of 300). Although the gaps in the frieze call for caution, the division of the horsemen on both the north and south friezes into ten ranks and the presence of only two bearded horsemen (who may be the hipparchs; Fig. 101) suggest that the Periclean expansion took place just early enough to inspire the designers of the cavalcade on the frieze.[66] Again, the frieze would, in this case, simply be an evocation of the new fighting force: only a portion of the full 1,000-man cavalry could be represented, few of the riders bear weapons or wear armor, and action is not imminent.[67] Still, this is very likely an idealized image of the men who made up the new Periclean arm of military policy: the men whose skill, courage, and Olympian self-control will ensure that Athens in the future will win battles as significant as those depicted in the metopes. Shown in peaceful civic procession, they are the guarantors of future *nikai*.

All in all, the message of the Parthenon frieze, available to any who negotiated the difficult circumstances of its viewing, was not simply the piety of the Athenians but also their capacity for achievement, their special character, their *sophrosyne* (moderation, self-control) and virtue among the Greeks, their elevated status (expressed above all through horsemanship, with its time-honored connotations of heroic valor and, ironically, aristocratic status).[68] It is much the same message as the one found in Pericles's Funeral Oration (431/0), that great statement of

Athenian civic ideology delivered just a few years after completion of the frieze:

> Putting it all briefly, then, I say that our city is the school of Hellas, and that, so it seems to me, each and every man among us offers to it his own person with exceptional grace and readiness. That this is no mere boast but rather the reality of hard facts, the very power of our city, which we have gathered by means of such character traits as I have described, is the proof.[69]

The power of Athens depends on the *arete* of those depicted here. The Athenians are represented as worthy protegés and "children" of the goddess whose birth and *agon* with Poseidon were depicted in the Parthenon pediments. The men on horseback are worthy successors of the legendary heroes who defeated Amazons, Trojans, and Centaurs and noble emulators of the gods who defeated the giants (who tried to scale Olympos as the Persians had scaled the Acropolis), and the *apobatai* certainly recall the chariot-racing Athena and Poseidon of the west pediment. The maidens on the east frieze – well-born *parthenoi* like the goddess of the rock – display the virginal purity required of future mothers to ensure the health and well-being of the Athenian people. On the frieze, then, the Athenians, male and female alike, are depicted as a chaste, reverent, agonistic, heroic, and vigilant folk; a people of timeless beauty whose lives are filled with sacrifices, processions, and *agones*; a people who had already won great *nikai* and who are prepared to win more; a people who have earned the favor of Athena and all the gods. In his speeches, Pericles repeatedly told the Athenians that "so far as it was in his power they would live forever and be immortals."[70] And, again in his Funeral Oration, he boasted that the Athenians did not need a Homer to sing their praises. In the sculptural programs of the Periclean Acropolis, and especially in the Parthenon frieze, the Athenians did that well enough themselves and achieved the kind of immortality that Pericles had promised.

APPENDIX

CHRONOLOGY

NEOLITHIC PERIOD 6000–3100 BC

BRONZE AGE 3100–1065 BC
Late Helladic 1600–1065
 or Mycenaean
 Period

c. 1270?	Terracing of summit
	Palace constructed
1259/8	*Synoikismos* (unification) of Attika according to Parian Marble
c. 1225/1200	Cyclopean fortification walls
	Mycenaean fountain (north slope)
c. 1070/65	Palace goes out of use?

DARK (IRON) AGE 1065–760 BC

ARCHAIC PERIOD 760–480 BC

c. 750–700	First (Late Geometric) Temple of Athena Polias, north side of Acropolis?
c. 700–650	Second Temple of Athena Polias?
575–550	Monumental ramp up west slope
	Establishment of Sanctuary of Athena Nike on old Mycenaean bastion
566/5	Founding of Greater Panathenaia
565–560	Bluebeard Temple (Third Temple of Athena Polias or first temple on Parthenon site)
561/0	Peisistratos's first attempt at tyranny
c. 560	Moschophoros dedicated
	Earliest Acropolis *korai*

557/6	Peisistratos's second attempt at tyranny
c. 550?	*Naiskos* of Athena Ergane?
546–510	Continuous tyranny of the Peisistratids
550–540	First Temple of Dionysos Eleuthereus (south slope) Earliest Sanctuary of Aphrodite and Eros (north slope)?
527	Death of Peisistratos; son Hippias becomes tyrant
525–500	First Sanctuary of Artemis Brauronia
514	Assassination of Hippias's brother Hipparkhos by "Tyrannicides" (Harmodios and Aristogeiton)
510	Overthrow of Peisistratid tyranny
508/7	Kleisthenes's democratic reforms
506	Victory monument commemorating defeat of Boiotians and Chalkidians
506?	Inauguration of *Archaios Neos* (Old Temple of Athena Polias), north side
c. 500	Building B First Theater of Dionysos (south slope)
490	Battle of Marathon
490–480	"Older Parthenon," "Older Propylon" begun Sanctuary of Pan established (northwest slope cave)
480	Persian sack of Acropolis, destruction of Athens Battle of Salamis

CLASSICAL PERIOD 479–322 BC

479	Battle of Plataia
479–475	Kritios Boy, Blond Boy
478/7	Founding of Delian League
470s	North citadel wall Repair of Opisthodomos?
c. 466	Battle of Eurymedon
460s	South citadel wall Pre-Erechtheion reconstituted Klepsydra Fountain (northwest slope)
465/60–455/50	Bronze Athena (Promakhos) by Pheidias
460–450	"Mourning Athena" relief
454	Transfer of reserves of Delian League to Athens; League becomes Athenian Empire
449	Pericles proposes building program
450–445	Temple of Athena Nike authorized?

447–432	Parthenon and Parthenon terrace
	Periclean addition to south citadel wall
438	Athena Parthenos dedicated
	Architecture of Parthenon complete
437	Propylaia of Mnesikles begun
c. 435	Erechtheion (Last Temple of Athena Polias) conceived or begun?
430s	Nike sanctuary begun
	Sanctuary of Artemis Brauronia
	Chalkotheke precinct
	Great Steps west of Parthenon
	Odeion of Pericles (south slope)
434/3	Kallias Decrees
432	Propylaia left unfinished
431	Peloponnesian War begins
early 420s	Shrine of Athena Hygieia
426	Major earthquake rocks monuments
424/3	Temple of Athena Nike completed
421	Peace of Nikias
420	Asklepieion founded on south slope
415–400	Nike Temple parapet
406/5	Erechtheion finished
404	Peloponnesian War ends
	Spartans stationed on Acropolis
403	Athenian democracy restored
380s/370s	Chalkotheke built?
c. 353	Demolition of Opisthodomos?
330s	Theater of Dionysos rebuilt in marble
334	Battle of Granikos
	Alexander dedicates shields on Parthenon's east architrave
323	Death of Alexander

HELLENISTIC PERIOD 322–31 BC

320/19	Khoregic Monuments of Nikias and Thrasyllos (south slope)
304/3	Demetrios Poliorketes inhabits *opisthodomos* of Parthenon
300/99	Doric Stoa added to Asklepieion
	New Temple of Asklepios built
295	Lakhares reportedly strips Athena Parthenos of gold; statue eventually refitted with gilt sheets (Athena Parthenos II)
c. 200	Attalid Monument (Attalos I)
c. 178–150	Panathenaic Monuments of Eumenes II and Attalos II

86	Capture of Acropolis by Roman general Sulla
c. 63–52	Rebuilding of Odeion of Pericles by Ariobarzanes II, king of Cappadocia

ROMAN PERIOD 31 BC–330 AD

31 BC	Battle of Actium; Octavian defeats Anthony
27 BC	Octavian becomes Augustus
Early 20s BC	Restoration of Erechtheion
c. 25 BC	Monuments of Eumenes II and Attalos II rededicated to Agrippa and Augustus
20/19 BC	Temple of Roma and Augustus
c. 45 AD	Emperor Claudius funds marble stairway to Propylaia
117–138 AD	Reign of Hadrian Repair of Athena Parthenos II?
160–174 AD	Odeion of Herodes Atticus (south slope)
202 AD (?)	Empress Julia Domna assimilated to Athena Polias; her portraits displayed in Erechtheion and Parthenon
267 AD	Herulian Sack of Athens Parthenon burns, Athena Parthenos II destroyed
c. 270–280 AD	Beulé Gate Post-Herulian Wall

LATE ROMAN (EARLY BYZANTINE) PERIOD 330 AD–582/3 AD

360s	Parthenon repaired; Athena Parthenos III installed
396	Alaric and Visigoths sack Athens
450–485	Bronze Athena (Promakhos) moved to Constantinople Athena Parthenos III removed and destroyed by Christians
529	Justinian closes philosophical schools
582/3	Destruction of Athens by Slavs

GLOSSARY

agon contest; competition; struggle

aigis a cloak-like attribute of Athena, worn over the shoulders and chest like a breastplate and adorned with a gorgoneion (the head of Medousa) and a fringe of snakes, used to terrify enemies and shield friends

akroterion (*pl.* **akroteria)** an ornament or statue placed on the corner of a roof or apex of a pediment (q.v.)

amazonomachy a battle between Greeks and Amazons

anathema dedication; votive offering

anta the thickened end of a wall

aparkhe (*pl.* **aparkhai)** a dedication representing the "first fruits," or a respectable portion, of a gift, profit, or some other income

apobates (*pl.* **apobatai)** an armed athlete whose sport consisted of leaping on and off a moving chariot and racing to the finish line

archaios ancient; old-fashioned; venerable

archon ruler; magistrate; one of the chief officials of Athens

archon basileus the "royal" archon; the chief religious official of Athens

arete valor; prowess; excellence

Arrhephoroi young girls of noble birth (7–11 years of age) who served the cult of Athena Polias, helped weave the Panathenaic peplos (q.v.), and played the main role in the Arrheophoria festival

athlothetai officials who managed the Greater Panathenaia (q.v.) and awarded the prizes

bouphonia "ox killing"; the sacrifice that was the central event of the festival of Zeus Polieus on the Acropolis

cella the inner, main room of a temple, where the cult statue of the divinity was usually placed

257

centauromachy a battle against centaurs

Cyclopean masonry built with large, irregular blocks of limestone, with small stones and mud filling the cracks, characteristic of the Mycenaean (or Late Bronze) Age

demos people

diphrophoros a stool- or chair-bearer

Doric order an architectural style characterized by a frieze of metopes (q.v.) and triglyphs (q.v.) and by columns that stand directly on the stylobate (q.v.) without a base and that have capitals in the form of a square slab (abacus) above a simple, circular cushion- or cone-like form (echinus)

drakhma a unit of weight or coinage; an Attic silver coin weighing about 4.3 grams

entablature the upper elements of a temple, supported by the columns

entasis lit., "tension"; a bulging or swelling, as in the columns of the Parthenon; an optical refinement

Eponymous heroes the legendary figures (e.g., Erechtheus, Pandion, Aias) after whom the ten tribes of democratic Athens were named

ergane "worker"; a cult title of Athena

ergasterion workshop

ergastinai Athenian women who helped weave Athena's sacred peplos (q.v.)

frieze any decorative or representational continuous horizontal band

gigantomachy the battle between the gods and the giants

guttae peglike features carved below the regulae (q.v.) in a Doric entablature (q.v.)

hekatompedon a building, temple, or precinct 100 ancient feet long

hellenotamiai "treasurers of the Greeks"; Athenian officials who managed the finances and tribute of the Athenian Empire

heroon a shrine for the worship of a hero

himation a cloak or mantle

hippeis horsemen; cavalry

hoplite a heavily armed foot soldier

hydriaphoros a water-jar (*hydria*) carrier

hygieia health; a cult title of Athena

Ionic order an architectural style characterized by a continuous frieze and by columns that stand on a curving base and that have elaborate capitals in the form of volutes or spirals

kanephoros a basket-carrier; specifically, a noble maiden who carried an offering basket (*kanoun*) full of grain for use in sacrifices

karyatid a column in the form of a woman

khoregos a wealthy man chosen to sponsor and train choruses for tragedies, comedies, and *pyrrhikai* (q.v.) and allowed to set up monuments if victorious

kore (*pl.* **korai**) girl; an Archaic statue of a maiden

metoikos (metic) a resident alien

metope a panel – plain, painted, or sculptured – set between triglyphs (q.v.) in the Doric frieze

naiskos a small temple or shrine

neos the house of a god; temple; sometimes its innermost room or cella (q.v.)

nike victory; the personification of victory

odeion concert or music hall

oikema (*pl.* **oikemata**) building; room

oinochoe wine jug

opisthodomos the porch behind the neos (q.v.) or cella (q.v.) of a standard temple

Panathenaia the principal religious festival of Athens, sacred to Athena Polias, held annually (the Lesser Panathenaia) and on a grander scale every four years (the Greater Panathenaia)

parthenos maiden; virgin

pediment gable; the triangular space above the columns at the end of a temple or similar building

peplos a woman's simple woolen dress, with a belt and an overfold; a human-scaled peplos, decorated with a gigantomachy (q.v.), was offered to Athena Polias at each annual Panathenaia (q.v.), a sail-sized peplos to her at each Greater Panathenaia

peripatos the path or roadway that encircles the Acropolis and gives access to many shrines on its slopes

peripteral having a continuous colonnade or peristyle (q.v.)

peristyle a surrounding colonnade

phiale a shallow bowl for the pouring of libations

polias, polieus "of the city"; cult titles of Athena and Zeus

polis city; city–state; sometimes meaning the Acropolis

promakhos "fighter in the forefront"; defender; champion

proneos the porch in front of the neos (q.v.) or cella (q.v.) of a temple

propylon gateway

pyrrhike a dance in armor

regula a narrow strip or band set below the triglyphs (q.v.) in a Doric entablature (q.v.)

skaphephoros tray-bearer

stele an upright stone slab, often inscribed or carved in relief

stoa a colonnaded hall

stylobate the top step of a temple, on which the columns stand

talent a unit of weight roughly equivalent to 57 pounds (25.86 kg)

tamiai the Treasurers of Athena; the principal religious civil servants and managers of the Acropolis

tekhne skill, craft

thallophoros an olive-branch or twig-bearer

thymiaterion incense-burner

triglyph a vertically grooved block alternating with metopes (q.v.) in the frieze (q.v.) of the Doric order (q.v.)

NOTES

1. The Rock and the Goddess

1. The Acropolis rises 156.63 meters (or about 514 feet) above sea level at its highest point; Mt. Lykabettos rises 277 meters (about 909 feet) above sea level. Conveniently, the Acropolis rises only about 70 meters (230 feet) above its immediate surroundings. The summit covers an area of roughly 30,000 square meters, or more than 7 acres.
2. Cf. Mountjoy 1995, 22.
3. Hurwit 1999, 78–79.
4. These several springs, Plato suggests in a geological flight of fancy (*Kritias* 112c – d), are the remnants of a single great fountain on the site of the primeval Acropolis that was choked off by an earthquake.
5. Herodotos 7.140.
6. Thucydides 2.15.6 ("Up to the present day the Athenians still call the Acropolis 'the Polis,' because of their ancient settling of the place"); see also Meiggs and Lewis 1988, 58.
7. Herodotos 8.44. Korres 1994b, 35, suggests "Kekropia" or "Kranaa."
8. *Odyssey* 7.78–80.
9. Herington 1955, 55.
10. Cf. Thucydides 2.39–41; Euripides, *Suppliants* 1127–1231; Herington 1955, 56; and Loraux 1993, 66 (quoting Hegel: "Athena the goddess is Athens itself – i.e., the real and concrete spirit of the citizens").
11. Vermeule 1972, 280.
12. See, for example, Plato, *Laws* 828. Cf. Burkert 1985, 19, 201–02; and Scullion 1994.
13. Hurwit 1999, 13–14.
14. The tablet is Knossos V 52. The other deities mentioned are *E-nu-wa-ri-jo* (Enualios, later an alternative name for Ares), *Pa-wa-jo* (Paieon, an alternative for Apollo), and *Po-se-da-o* (Poseidon). See Chadwick 1976, 88–89. *A-ta-na* may also have occurred on a Linear B tablet from Mycenae itself (MY X 1), but the line is damaged and the restoration uncertain.

15. Cf. *Iliad* 6.305, and *IG* I³ 607 (the Glaukias base, c. 530–520) and 718 (the Smikros base, c. 500–480); also Brouskari 1974, 36, and Fig. 45. Hesiod calls her *potnia*, too (*Theogony* 926).

16. The Mycenaean Potnia seems to be associated in the Linear B tablets with many of the same activities or spheres – craftsmanship and horses, for example – as Athena herself. Perhaps Athena was originally just one aspect of a greater goddess – the supreme Potnia. See Demargne 1984, 1016.

17. Amyx 1988, 619.

18. Variants of Athena Polias were Athena Polioukhos ("protector of the city") and Athena Arkhegetis ("founder" or "leader"); see Kroll 1982, 69.

19. Tertullian, *Ad Nationes* 1.12.13.

20. For the texts, see Mansfield 1985, 185–88.

21. See Kroll 1982, 69–70; Jung 1982, 53–64; Shapiro 1989, 25.

22. See Mantis 1997, 77–79.

23. For the Dresden statue, see Barber 1992, 115, Fig. 74.

24. Pallas is also sometimes thought to mean "virgin" or "young girl" (see, for example, Loraux 1993, 137–141; N. Robertson 1996, 29) or "brandisher of weapons," or to refer to one of Athena's military conquests (Pallas, according to Apollodoros 1.6.2, was a giant whom Athena killed and flayed, using his skin as protection in battle). The word was problematic even in the days of Plato, who (*Kratylus* 406d–407a) has Socrates state the popular notion that "Pallas" derives from the practice of dancing in armor and thus shaking (*pallein*) the body and hand-held weapons: Athena is said to have danced such an armed dance (the so-called *pyrrhike*) at her birth. Despite all that, the word may be an old title (meaning something like *Potnia*) originally borrowed from Semitic, its exact meaning lost over time; see Burkert 1985, 139; and Heubeck, West, and Hainsworth 1988, 315.

25. Cf. Pseudo-Hesiod, *Shield of Herakles* 339. Athena Nike seems primarily to have been the goddess of military victory, though her province may have encompassed other forms of victory (athletic, poetic) as well; see Parker 1996, 90.

26. She even helps Diomedes wound Ares at *Iliad* 5.855–61; Ares does not care for her, either (*Iliad* 5.875–76). On the other hand, in Hesiod (*Theogony* 926) and in the *Homeric Hymn to Aphrodite* (10–11), she is described as taking pleasure in war and strife.

27. *IG* II² 4318 records an early fourth-century Acropolis dedication (by Deinomenes and his children) to "Athena Ergane Polias," which reminds us not to insist too much on rigid distinctions among her various aspects.

28. *Odyssey* 13.298–299.

29. See Detienne and Vernant 1991 generally and, for Athena's role in the *agon* or contest, esp. 228–29.

30. As early as Hesiod (*Works and Days*, 430), makers of plows were called "servants of Athena." Boutes, a relatively obscure Attic hero whose name means ploughman or ox-man, had an altar in the temple of Athena known as the Erechtheion (Pausanias 1.26.5); see Simon 1986.

31. See *Homeric Hymn to Aphrodite*, 12–13. At Corinth there was a sanctuary of Athena *Chalinitis*, Athena the Bridler; Pausanias 2.4.1. According to the Parian Marble, however, Erichthonios invented the chariot.

32. *Odyssey* 13.288–89; cf. 16.157–59.

33. The quotation appears in Plutarch, *Moralia* (*Precepts of Statecraft*), 802B. In this passage, Plutarch contrasts the worshippers of Athena Ergane, who work with

their hands, with the worshippers of Athena Polias (and Themis), speakers who work with words (and implicitly with their brains).

34. *Homeric Epigram* 14.
35. *Odyssey* 6.232–234.
36. Pindar, *Olympian* 7.50–51.
37. Boardman 1975, Fig. 322. Conspicuously uncrowned is a woman artisan working to one side. For differing interpretations of this vase, see Green 1961 and Kehrberg 1982.
38. *Iliad* 5.733–35; 14.178–79. On a terracotta loomweight from Tarentum in South Italy, even Athena's sacred owl is shown spinning wool; see Neils 1992, 107 and 151 (cat. 12).
39. *Odyssey* 2.116–18; 7.109–11.
40. *Works and Days* 63–64, 72; *Theogony* 573–75.
41. See Mansfield 1985; also E. J. W. Barber 1992.
42. Diodoros 4.14.3; cf. Apollodoros 2.4.11.
43. *Iliad* 8.362–69.
44. *Iliad* 1.197–222. It is interesting to contrast Athena's appeal to Achilles' reason with her very different strategy for stopping Herakles's murderous madness, as Euripides (*Herakles* 1001–08) describes it. She does not engage him in rational conversation; instead, she simply knocks him senseless with a rock. Unsubtle heroes call for unsubtle methods.
45. The *aigis* is a strange attribute, sometimes said to belong to Zeus – and, at any rate, inconsistently described in our sources – that seems most of the time to be a cloak or mantle of goatskin fringed with snakes. In general, see Gantz 1993, 84–85.
46. *Iliad* 18.202–18.
47. Apollodoros 2.4.3 (shield); Pherekydes, frag. 26 (*aigis*). The head of the Gorgon (along with other visions of horror) is also said to be at the center of her *aigis* at *Iliad* 5.738–42 and in Euripides, *Ion* (987–97), where it is said that Athena killed a monster named Gorgo (there is no mention of Perseus in this version of the myth) and took its skin, fringed with serpents, to wear as her *aigis*. In many Archaic and Classical images of Athena, the gorgoneion is often found in both places, on both shield and *aigis*, as if Medousa had two heads cut off. There is, in any case, no question of the gorgoneion's apotropaic function – that is, its ability to ward off evil. According to Euripides (*Ion* 1000–21), Kreousa, Erechtheus's daughter, tries to save her father's house by warding off usurpers with poisonous blood taken from the Gorgon's veins.
48. Pindar, *Olympian* 13.63–83.
49. Apollonios Rhodios 1.19.
50. *Odyssey* 13.332.
51. Herodotos 1.60.2–5. For more on Peisistratos, see Hurwit 1999, 100–102.
52. Thucydides 1.70.
53. *Theogony*, 886–900.
54. *Theogony*, 924–926.
55. Athena was said to have been born on the third day of the month of Hekatombaion, and so the epithet may mean simply "Born on the Third Day"; see Mikalson 1975, 23.
56. *Odyssey* 8.266–332. Pindar, *Olympian* 7.35–38, is the first literary source to mention Hephaistos's role, though the artistic tradition is much older; see Gantz 1993, 51–52. Pindar here also, unusually, places the birth of Athena on the island of Rhodes.

In Archaic Greek art, the newborn goddess is fully formed though necessarily diminutive. Her immediate physical maturity in art seems a way of denying her a childhood since, in the Greek mind, childhood was a state of moral, intellectual, and physical imperfection; see Garland 1990, 161.

57. *Theogony* 927–929.
58. Apollodoros, I.6.1–2. For the myth generally, see Gantz 1993, 445–54.
59. See Pinney 1988; Euripides, *Ion* 1528–29.
60. See Moore 1995; Stähler 1972. Marszal 1998 questions this reconstruction.
61. Schrader, et al. 1939, 288–90, and pls. 161–62 (no. 413); Brouskari 1974, 129 and Fig. 247.
62. There is slight inscriptional evidence for a *peplotheke*, or peplos-depot, on the Acropolis; see Nagy 1984.
63. Herodotos 8.55.
64. Apollodoros 3.14.1.
65. Pausanias 1.26.2, 27.2.
66. Herodotus 8.55.
67. Chadwick 1976, 88–89.
68. Hesiod, *Theogony* 278–80.
69. See Shapiro 1989, 105–08. Mansfield 1985, 251–52, pointedly asks how the olive tree, trident marks, and so on were explained before the fifth century if the myth of the contest was, in fact, Classical in origin.
70. The identification of the Erechtheion with the Classical Temple of Athena Polias is sometimes questioned; for the problem, see Chapter Six.
71. *IG* I³ 873; Raubitschek 1949, 412 (no. 384).
72. Herodotos 8.44; Pausanias 1.27.4; Spaeth 1991. The story of the war with Eleusis is told in Apollodoros 3.15.4–5. For possible remains of the base of the statue group, see Korres 1994f, 124.
73. See Kron 1976, 37–39. Also Kron 1988; Gantz 1993, 233–37; and Dowden 1992, 86. Another etymology for "Erechtheus" derives the name from the Greek verb for "rend, break, or shake violently," which might cast some light on the hero's relationship with Poseidon, the earthshaker.
74. *Iliad* 2.546–551.
75. Reeder 1995, 250–66; Gantz 1993, 239–42; Parker 1986, 201. Cf. Euripides, *Ion* 267–70.
76. Mikalson 1976, 141 n. 1.
77. Apollodoros 3.14.6; for the daughters of Kekrops, see also Gantz 1993, 235–39. A rival tradition concerning Aglauros was that she voluntarily and heroically leapt to her death to save the city in time of war; Philochoros, *FGrHist* IIIB, 328 F 105.
78. *Eumenides* 13.
79. "Mother of our *polis*" is precisely what Euripides once calls her in the *Herakleidai*, 770–72.

2. Landscape of Memory

1. Cf. I. M. Shear 1999, 119.
2. Ruins northwest of the Erechtheion have now been interpreted (by A. Papaniko-laou) as remnants of a defensive work hastily thrown up just before the Persian attack; see Korres 1994c, 178.
3. Herodotos 8.53.

4. For more on the Early Classical Acropolis, see Hurwit 1999, 138–153.

5. See Lindenlauf 1997; Hurwit 1989.

6. Within the Sanctuary of Artemis Brauronia, for example, Pausanias (1.23.9) saw a statue of the athlete Epikharinos by Kritios and Nesiotes, a work probably of the late 470s, and the team also created a bronze Athena (perhaps the inspiration for the smaller Angelitos's Athena) that stood on a signed base now in the Acropolis Museum (Acro 13270; CD 162); Keesling 2000. The Kritios Boy is so named because of a perceived resemblance to the style of Kritios and Nesiotes; see Hurwit 1989.

7. The simple temple in this Pre-Erechtheion complex – it was the precursor of the east room of the Classical Erechtheion – may date as early as the late sixth century. It was aligned with the east façade of the Archaic Temple of Athena Polias, which is unlikely to have been coincidence. Korres 1997b, 229, 242–243.

8. Plutarch, *Life of Pericles*, 12.1, 13.1, 13.4–5.

9. Cf. Rhodes 1995, 28–41; Hurwit 1999, 158–159; and Ferrari 2002.

10. For the Bronze Age Acropolis generally, see Hurwit 1999, 67–84.

11. There is evidence that the wall had an upper segment added or rebuilt in a different style of masonry sometime between the Persian destruction and the construction of the Propylaia; Shear 1999, 97.

12. On the Cyclopean walls and tower see, most recently, Shear 1999.

13. Korres 2003, 7, and 1997b; Holtzmann 2003, 75–81; Goette 2001, 29–30; Shear 1999, 108–109, on the other hand, is a recent advocate of the theory that the Bluebeard temple stood on the north side of the rock; cf. Preisshofen 1977.

14. If the Hekatompedon, or Bluebeard temple, existed on this site and not on the north side of the Acropolis, it was dismantled to make way for the Older Parthenon. Some blocks of the Hekatompedon were built into the south wall of the Acropolis in the 460s; Korres 1997b, 226; Goette 2001, 29. The fundamental study of the Older Parthenon remains Hill 1912.

 Korres 2003, 8–9, argues that the great podium was originally built around 500 to support another limestone temple – a successor to the Hekatompedon and predecessor of the marble Older Parthenon – that was, because of uneasy relations with Persia, never built. He also believes that work on the Older Parthenon, begun around 490, was abandoned around 485 for fiscal reasons. All available resources, he believes, were needed to prepare for the second Persian invasion. I do not understand, however, why the heavy scaffolding of the building (certainly set on fire by the Persians in 480, since burning timber severely damaged and cracked the marble) would have been left in place for those five years.

15. Goette 2001, 27.

16. Korres 1997b, 227–229, 242; cf. Pausanias 1.24.3.

17. Dinsmoor 1932. A recent variant of the theory goes farther. Ferrari 2002, argues that far more of the Archaic Temple of Athena Polias survived the Persian destruction than has usually been thought: not just its western section and porch but also its eastern room, and much of the surrounding colonnade still stood or underwent extensive repairs. In her view, this restored structure – its back rooms constituted the *Opisthodomos* of the inscriptions, its eastern room continued to be called the *Archaios Neos* – remained the functioning Temple of Athena Polias, the focus of the most important cult of Athena on the Acropolis, until the end of antiquity. If so, the Erechtheion was built as a mere "appendage" or annex and housed lesser cults but not the statue of Athena Polias. Ferrari's theory is

meticulously argued, but I believe she minimizes evidence suggesting that the temple we call the Erechtheion also functioned as the home of the ancient statue of Athena Polias (see Chapter Six). One also wonders, if so much of the Temple of Athena Polias remained standing throughout antiquity, what happened to it?

18. Korres 2003, 10, believes that the fire damage (cracking, flaking) suffered by the Athena Polias temple during the Persian sack was so severe that it left the building "unusable." See also Korres 1997b, 243; Goette 2001, 27; Casanaki and Mallouchou 1983, 92.

19. See Hollinshead 1999, 210–13; Hurwit 1999, 143–144, 162–163; D. Harris 1995, 4, who notes that at least one inscription (*IG* II² 1455) referring to the *opisthodomos* surely means the western room or porch of the Parthenon and not a totally different building.

20. Scholiast to Demosthenes, *Against Androtion* 13 (597.5).

21. Pausanias 1.28.2.

22. Pausanias 1.28.2; 9.4.1; Demosthenes, *De Falsa Legatione* 272. The scholiast on Demosthenes, *Against Androtion* 13 (597.5), however, agrees with Pausanias.

23. *IG* I³ 435; Mattusch 1988, 169–72; Meritt 1936, 362–80; Dinsmoor 1921. The inscription is arranged in three columns covering three years each; the length of time needed to create the work is consistent with other ancient monumental bronzes (such as the Colossos of Rhodes, which took twelve years; Pliny, *NH* 34.41).

24. For the bronze-casting workshop on the south slope, see Zimmer 1996; Lundgreen 1997, 191–192.

25. See Vanderpool 1966.

26. Hurwit 1999, 23–24.

27. Plutarch, *Themistokles* 12.1; Aristophanes, *Wasps* 1086. Boardman 1985, 203, and Fig. 180; also Lundgreen 1997 and Djordjevitch 1994. Cf. Imhoof-Blumer, Gardner, and Oikonomides 1964, 128–29, pl. Z, i–vii. Having stood on the Acropolis for more than 900 years, the Bronze Athena was, it seems, transferred to Constantinople in the late fifth century AD, where it was set on a massive pedestal of marble and porphyry in the Forum of Constantine. It was, according to a Byzantine chronicler, pulled down and destroyed by a mob of superstitious drunks in 1203 AD.

28. Demosthenes, *De Falsa Legatione* 272.

3. Pericles, Athens, and the Building Program

1. Hansen 1982. There were perhaps 100,000 slaves in mid-fifth-century Attika, and thousands more *metoikoi*.

2. The first time they did so to overthrow the comparatively benevolent Peisistratid tyranny (510), the second time to abet the oligarchic Isagoras in his political struggle with Kleisthenes, founder of Athenian democracy (508/7).

3. To be ostracized was to be exiled from Athens for ten years. The banishment was the result of a popular vote in which the names of candidates were inscribed on potsherds (*ostraka*).

4. Thucydides 2.65.9.

5. Thucydides 1.23.6.

6. On the almost endlessly controversial Kallias Decrees (*IG* I³ 52), see Kallet-Marx 1989, 254–59; Meiggs and Lewis 1988, 154–61 (no. 58); Meritt 1982; Meiggs 1975, 200–01.

7. Thucydides 2.13.

8. The 600 talents in allied contributions must include funds beyond the normal annual tribute, which did not exceed 400 talents. Thucydides's figure of 9,700 talents for the maximum accumulation of reserves on the Periclean Acropolis has been questioned; see, for example, Meritt 1982.

9. Thucydides 2.17.

10. Thucydides 3.89; Tanoulas 1994a, 53; Korres 1994e, 138.

11. Pausanias 4.36.6.

12. Xenophon *Hellenika* 1.6.1. It was either the just-completed Erechtheion or what remained (or what had been restored) of the late sixth-century Temple of Athena Polias (the *Archaios Neos*). Is this the same fire that, according to Demosthenes (*Against Timocrates* 136), burned down the *Opisthodomos*?

13. *IG* I³ 341; Harris 1991, 201–02.

14. Krentz 1979, 63, notes that for the democracy to melt down Acropolis dedications to finance the war in 407/6 was one thing, but for the Thirty to do it to pay mercenaries was quite another.

15. Badian 1987, 17, 31–33, has introduced the idea of a second Peace of Kallias; Fornara and Samons 1991, 171–175, reject his argument.

16. Plutarch, *Life of Pericles* 17 (our only ancient source for the Congress Decree); Stadter 1989, 201–04; Meiggs 1975, 512–15.

17. The oath's provision to leave the temples destroyed by the Persians as memorials of their impiety might have been considered satisfied by the memorial built into the north Acropolis wall (Fig. 64).

18. Pericles is elsewhere said to have been *epistates* for Pheidias's statue of Athena Parthenos, but it is unlikely he was more than one member of the board; Stadter 1989, 177.

19. See especially Ridgway 1999, 193–196, and Himmelmann 1977; also Stewart 1990, 60–61; Stadter 1989, 166–67; and Boersma 1970, 69.

20. See Stadter 1989, 294; Preisshofen 1974.

21. According to Meiggs and Lewis 1988, 88, it is unlikely that the total tribute of any year before 433 would have surpassed 400 talents. But, even generously assuming an average of 400 talents for all fifteen years of work on the Parthenon and Propylaia, the *aparkhai* would not have exceeded a mere 100 talents in all (400 x 15 x 1/60). The Parthenon alone (not even counting the statue of Athena Parthenos inside) seems to have seven or eight times that much.

22. For more on the *hellenotamiai* and *tamiai*, see Hurwit 1999, 48–50.

23. Dinsmoor 1913, esp. 64–65 and 78–79; also Meiggs and Lewis 1988, 165–66 (No. 60); and I. T. Hill 1953, 160. On the financing of the building program in general, see Kallet-Marx 1989 (who argues that the treasuries of Athena and the Greeks were not merged and that Athens was wealthy enough to afford the building program without drawing heavily on imperial tribute); also Lapatin 2001, 65–66. For different views, see Meiggs 1975, 154–55, 515–18; Samons 1993.

24. According to Thucydides 2.70, the siege of Poteidaia (432–430) cost 2,000 talents, and Poteidaia was hardly Athens's only military expense in those two years; see also Burkert 1985, 92.

25. Vitruvius (VII, praef. 16) attributes the Telesterion to Iktinos. See Korres 2003, 34–35.

26. Peiraieus "Corn Stoa": schol. Aristophanes, *Acharnians* 548; Lykeion: Harpokration, s.v. *Lykeion*.

27. *IG* I³ 49; Davies 1993, 97.

28. *IG* I³ 433; Boersma 1970, 230 (cat. 117).

29. See Korres 2003, 21–22; Goette 2001, 81, 101, 204–207. During the reign of the Roman emperor Augustus, the Pallene temple was completely relocated to the Athenian Agora and rededicated to Ares as well as Athena.

30. For the controversial date of the building and its sculptures (which often show the influence of Parthenon sculptures), see Goette 2001, 76; Camp 2001, 102–104; Delivorrias 1997; Mark 1993, 102 n. 47; and Ridgway 1981, 26–29, 88. Also Wyatt and Edmonson 1984; Coulton 1984; Boersma 1970, 59–61.

31. See Hurwit, 2004b.

32. There were other structures on the Acropolis in the second half of the fifth century besides the "principal" ones – workshops, for example, and a small poros-limestone building (the so-called Building D) known only from some stray architectural fragments. See Klein 1991b, 33–35. For the development of the Late Classical, Hellenistic, and Roman Acropolis, see Hurwit 1999, 246–282.

33. Pericles here exaggerates in his own defense. For example, a number of allies did, in fact, supply ships and hoplites for several military campaigns; see Meiggs 1975, 139.

34. It is pleasant to think that one of the "workers in stone" or sculptors involved early on in the building program was the great Socrates who, born in 469, was the son of a stonemason or sculptor and who may have practiced that trade in his youth before taking up more rarified pursuits (cf. Pausanias 1.22.8).

 Inscriptions detailing the last years of work on the Erechtheion (*IG* I³ 474–79) provide a remarkably similar list of the sorts of workers involved in that project: stoneworkers, sculptors, builders, woodworkers, scaffolding makers, joiners, encaustic painters, paint-pot carriers, sawyers, gluers, gilders, column-channelers, modellers in wax, and so on.

35. The word Plutarch uses is *arkhaios* (old, ancient) but the connotations here are "venerable," even "classic"; Stadter 1989, 165.

36. Literally, the Hundred-Footer Parthenon.

37. It is thought by some that the first architect of the Periclean Telesterion was Iktinos. After he was called to Athens to begin the Parthenon, Koroibos took over the project and altered Iktinos's plan; Boersma 1970, 72–73; above n. 25.

4. The Parthenon

1. Roux 1984, 304–305; Herington 1955, 13. It is oddly symptomatic that in Pericles's speech praising the achievements and monuments of Athens (Thucydides 2.35–46), the Parthenon is not even mentioned by that or any other name.

2. The first time the term certainly refers to the entire building occurs in Demosthenes's speech *Against Androtion* (13, 76) composed in 355.

3. Pausanias 1.24.5; Plutarch, *Pericles* 13.7. In his *Life of Cato* (5.3), Plutarch calls it just *Hekatompedon*.

4. Pedersen 1989, has argued that these columns were not Ionic but Corinthian – the earliest of their kind. Cf. Korres 2003, 13.

5. *Parthenos* (as an epithet rather than as a cult title) appears in Acropolis inscriptions as early as 500; see *IG* I³ 728 (Hurwit 1999, Fig. 32), 745, 850. The epithet is found in earlier poetry as well; cf. Lapatin 2001, 63–64.

6. Plutarch, *Demetrios* 23.

7. According to Harpokration, Mnesikles and Kallikrates called the Parthenon the *Hekatompedos* not because of any actual dimension but because of "its beauty and happy proportions"; see Roux 1984, 304–305.

8. See D. Harris 1995, 2–5, 30. In 405/4, all the treasures seem to have been moved to the *hekatompedon*; some inventories of the *hekatompedon* thereafter mention objects "from the *parthenon*," indicating that it was a separate room.

9. At least not until the fourth or fifth century AD, by which time the far more ancient and sacrosanct statue of Athena Polias may no longer have existed; see Mansfield 1985, 203. It may be significant that Pausanias, whose concerns were primarily religious, spends only a few sentences on the Parthenon itself, but many paragraphs on the Erechtheion, clearly the holier place; cf. Camp 2001, 93.
 For different views on the cult status of the Athena Parthenos, see Holtzmann 2003, 106; Nick 1997; Schmaltz 1997; and Linders 1997.

10. *Contra* Neils 2001, 259, n. 17; Ridgway 1992, 135; and Mansfield 1985, 232 n. 19. If Korres's reconstruction of the history of the "Parthenon site" is correct – a mid-sixth-century limestone temple (not an open-air precinct) known as the Hekatompedon, followed by another late sixth-century limestone temple (never built), followed by the marble Older Parthenon, and then by the Periclean Parthenon – the sacred character of the site and thus the Periclean building would be a much stronger possibility; see Korres 2003, 7–9; 1997b. According to his restored plan (1997b, Fig. 2; with scale in Goette 2001, 30, Fig. 11), however, the sixth-century Hekatompedon was much longer than 100 feet, and so the origin and meaning of the term remain problematic.

11. There is no evidence for a cult statue in the Temple of Poseidon at Sounion (c. 440) while some temples housed more than one. The Hephaisteion, like the Parthenon, appears to have lacked an altar; Goette 2001, 77. For the distinction between temples that were true sanctuaries or shrines and temples that were treasuries, see Roux 1984, 1984b.

12. Based on D. Harris 1995, 25–27; 1991, 188–189.

13. Brulotte 1993; Korres 1984.

14. D. Harris 1995, 28–29; Meiggs and Lewis 1988, 227–29 (cat. 76); Fornara 1977, 161–62.

15. Demosthenes, *Against Androtion,* 13, 76–77.

16. Vitruvius 7. *Praef,* 12.

17. Pollitt 1972, 75.

18. McCredie 1979; Korres 2003, 12–13. Significantly, perhaps, Iktinos is cited as the lone architect of the Parthenon by both Strabo (9.395, 396) and Pausanias (8.41.9).

19. There were larger temples in Ionia and Sicily, and the unfinished Peisistratid Temple of Olympian Zeus southeast of the Acropolis (Fig. 6) would have been larger, too.

20. For the relationship between the two buildings, see Hurwit 2004a.
 It is sometimes thought that in its combination of the Doric and Ionic orders – genuinely regional architectural styles – the Parthenon was a distinctively Periclean attempt to claim symbolic leadership of all the Greeks, Dorian and Ionian alike. In fact, Doric and Ionic had been combined on the same building long before the Periclean building program. The Doric Temple of Athena at Assos (c. 530, in the Troad), for example, had an Ionic frieze as well as metopes, and the Doric Temple of Athena at Paestum in south Italy (c. 500) had Ionic columns in its porch. On the Acropolis itself, the *Archaios Neos* may have already had a continuous Ionic frieze (Hurwit 1999, 123; Ridgway 1999, 199) and the walls of the Older Parthenon had an Ionic base moulding. In the Early Classical Agora, the *Stoa Poikile* (or Painted Stoa, built in the 460s) had exterior Doric and interior Ionic columns; Camp 2001, 68–69.

21. Korres 1999, 87.
22. The *entasis* of the columns of the peristyle amounts to 1.75 centimeters over a column shaft height of 9.56 meters; the *entasis* of the columns of the east porch (*proneos*) was much greater: 2.45 centimeters. The *entasis* of the cella walls was extremely muted: only 0.27 centimeters. See Korres 1999, 94–98.
23. Haselberger 1999, 32.
24. On the flanks, the rise of the curvature is 10.25–11.25 centimeters over the 69.5-meter length of the stylobate; on the façades, the rise is 6.25–6.5 centimeters over a length of 31 meters; Haselberger, ed., 1999, 182 (Table 9.1).
25. Not every element of the Parthenon deviates from the perpendicular, however. The lines of the pedimental walls, the columns of the *proneos* and *opisthodomos*, the walls of the doors, and the crosswall dividing the two rooms of the cella were, for example, purely vertical; Korres 1994d, 66.
26. Haselberger 1999, 65–66, rightly dismisses any real technical or structural reason for the refinements, and he is right to stress that not all refinements need to have had the same explanation.
27. Vitruvius 3.3.11, 3.4.5, 3.5.13. For Vitruvius and his tradition, see Haselberger 1999, esp. 56–63.
28. For discussions of the aesthetic character of the refinements, see Haselberger 1999, 24 and 56–67; Korres 1999, 79; Coulton 1977, 108–12; Pollitt 1972, 74–76; and Mavrikios 1965.
29. Korres 2003, 12–13; Rhodes 1995, 109; Coulton 1977, 115.
30. Korres 1994a. In a paper delivered in 2004, B. Barletta defended the traditional notion that the Ionic frieze was part of the original design. There is now architectural evidence (an upper moulding) that another frieze ran around the top of the walls within the *proneos* – that is, above the *proneos* columns on the interior, over the east cella door and wall, and over the side walls of the *proneos* – thus emphasizing the distinct, compartment-like nature of the porch (Fig. 87). We are unable to say whether this interior frieze was ever executed or whether its subject was distinct from or the same as that of the much longer frieze on the cella exterior. See Korres 1994a, 33; Korres and Bouras 1983, 668–69.
31. Such as a deepening of the *proneos* by 16 centimeters and a 6-centimeter reduction in the diameter of its columns. Korres 1994a, 31–33; 1994c, 176; also Neils 2001, 38–39.
32. Plutarch, *Pericles*, 31.2–3; E. B. Harrison 1996a, 40, 50; Palagia 1993, 8. One or two names (Xanthias and Thrax, or perhaps Xanthias the Thracian) have recently been found painted in red on the once-hidden faces of blocks in the entablature of the Parthenon, though it is unclear who he or they were – workers (even slaves) involved in construction or even in the carving of the metopes? See *AR* 1988–89, 9.
33. For the debate over Pheidias's role in the sculptural program, see Ridgway 1999, 193–200, who doubts an "all-pervasive Pheidian influence."
34. Despinis 1986.
35. Schwab 1994 identifies the charioteer in North 1 as Athena.
36. Schwab 1996.
37. Mantis 1997; 1989; 1986; Korres 1994c, 175. Ridgway 1999, 142 n. 66, wonders whether the central metopes had their backgrounds painted to distinguish them visually as well as iconographically from the centauromachy metopes (their backgrounds, she believes, were left in the color of the marble).
38. Mantis 1997, 72; 75–79. As Mantis concedes, a ritual interpretation of S19–21 cannot easily explain the semi-nudity of the female figure on the right side of

S21. Barringer 2004, revives a suggestion that S19 and 20 represent the myth of Prokne and Philomela, which involves a "story cloth" like the Panathenaic *peplos*. For the Daidalos story in the central metopes, see M. Robertson 1984. In a paper given in 2004, H. E. Westervelt has argued plausibly that the intrusive metopes in fact depict the disrupted wedding procession.

39. Korres 1994a, 33; 1994c, 176. *Contra* Neils 2001, 259, n. 3; Ridgway 1999, 197.

40. Ridgway 1999, 117, suggests the pedimental wall may have been left plain. For the west pediment in general, see Palagia 1993, 40–59; J. Binder 1984. In a paper delivered in 2004, P. Schultz argued that Poseidon's extremely muscular torso was covered by a metal cuirass, and there are indeed iron dowels for attachments to his shoulders.

41. For the theory that Zeus's thunderbolt appeared at the center of the pediment, see Simon 1980.

42. Spaeth 1991; cf. also Weidauer and Krauskopf 1992.

43. Palagia 1997 and 1993, 18–39.

44. B. F. Cook 1993.

45. Stillwell 1969.

46. Osborne 1987.

47. Kroll 1979.

48. Neils 2001, 77–78, is among those who believe the entire frieze was carved in situ.

49. I. Jenkins 1994, 19.

50. Neils 2001, 70–71.

51. Younger 1991.

52. Beard 2003, 136; also above, n. 30. Neils 2001, 260, n. 5, does not consider the implications of the existence of this secondary Ionic frieze for our interpretation of the primary one. She does suggest (216, 272 n. 28) that a very fragmentary but appropriately sized marble relief possibly depicting the myth of Pandora may have decorated this inner frieze. Those fragments were, however, found in the Agora; see Harrison 1986. It is possible the reliefs could have descended from the Acropolis when the Parthenon was converted into a church (and its east room and porch severely remodelled) at the end of antiquity.

53. Neils 2001, 127–128; but see Moore 2003 and Stevenson 2003, 633.

54. The similarity and visual association between this great animal and the rearing horses of Athena and Poseidon in the west pediment have often been pointed out. Yet, if the frieze was carved before the pediments, as is usually thought, the horse on the west frieze cannot technically echo those in the pediment above. Perhaps the sculptor of this panel had seen the model for or drawings of the west pediment, or perhaps the designer of the west frieze was also the designer of the pediments. Perhaps, too, the execution of the frieze and the pediments substantially overlapped, occurring mostly in the 430s.

55. Jenkins 1994, 98–99; Neils 2001, 54–55, detects only eight ranks on the north but two more on the west (132).

56. These men are often identified as *thallophoroi*, elders chosen for their good looks to carry olive branches in procession; see Neils 2001, 142. But, see Boardman 1999, 321–330, who believes they are the honored veterans of the battle of Marathon.

57. E. B. Harrison 1984; Stevenson 2003, argues that there was no such thing as a cavalry uniform, and that the individual horseman was responsible for his own outfit.

58. Boardman 1977, 40–41, argues these objects are not *thymiateria* but the legs of a loom, presumably the one on which the Panathenaic *peplos* was woven.

59. Roccos 1995.

60. See Mattusch 1996, 44–45. The beardlessness of some of these figures argues persuasively for the heroic identity of them all. Athenian magistrates or officials were too old to be shown without a beard. Neils 2001, 158–161.

61. If Pheidias did indeed design the frieze, he may have been influenced by the assemblage of seated gods on the east frieze of the Archaic Siphnian Treasury at Delphi, where he had undertaken the Eponymous Heroes commission earlier in his career; see Boardman 1978, Fig. 212. For the identification of the figure attending Hera as Hebe, see Neils 2001, 164–166.

62. Neils 2001, 61–66, 198–200, argues that the gods (who she thinks are gathered together in front of Athena's temple and altar) are, in fact, seated not in two groups but in a continuous semicircle – that Zeus and Athena are really to be imagined as sitting back to back – and that the *peplos* scene is taking place within the curve of the arc (hence, in the same location as the gods). The designer has, in other words, split open the putative semicircle and extended its two parts flat on either side of the *peplos* scene. It is hard to see how an ancient viewer, seeing figures (like Zeus and Athena) turning their backs on the *peplos* scene, could have easily concluded that they were really facing toward it. Neils perhaps too hastily dismisses the notion that the *peplos* scene had a different background color from the groups of gods on either side, thus indicating a different locale (89–90); see Ridgway 1999, 117.

63. For "Pheidias's Workshop" (Building VI, partly built, like the north citadel wall and the Parthenon itself, of Older Parthenon column–drums and blocks), see Ashmole 1972, 97–99; Bundgaard 1976, 76; and Lapatin 2001, 69. The title of the statue, like the name of the building that contained it, seems at first to have been a little vague; it is often just called, for example, "the statue in the *hekatompedon*" or "the golden statue in the *hekatompedon*"; see Lapatin 2001, 63.

 A slightly later date for the dedication of the statue (435/4) has sometimes been argued; see Stadter 1989, 286.

64. Still, a good collection of the evidence is Leipen 1971. For the vase painting (in the Hermitage), see Shefton 1982 and 1992. We are not sure how much of the Athena Parthenos that Pausanias saw in the second century AD (or that Roman copies like the so-called Varvakeion Athena [Fig. 108] replicate) was original and how much restored. The Parthenon itself is known to have suffered damage several times in antiquity, and the statue is not likely to have escaped unscathed. There seems to have been at least one intentional mutilation of the Parthenos's Nike even before the mid-fourth century (Demosthenes, *Against Timocrates* 24.121), and a tyrant, Lakhares, desperate for funds, is said to have stripped the entire statue of her gold at the start of the third century (Pausanias 1.25.7; Hurwit 1999, 262; Lapatin 2001, 88–89). Even without such abuse, the statue suffered from normal wear and tear over time. For example, four petals from the Nike's golden wreath fell off at some point before 402 or 401 (jarred loose, perhaps, by the earthquake of 427/6) and were inventoried among the treasures of Athena; see D. Harris 1995, 133 (V.95). In addition, at least one repair may have taken place during the reign of the emperor Hadrian, a few decades before Pausanias's visit.

65. Pausanias 1.24. 5–7.

66. Pliny, *NH* 36.18, gives the height of the statue as 26 cubits, and the dimension he gave probably included the base. The base was more than 8 meters wide and 4 meters deep and its height (frieze plus lower and upper mouldings) has been variously estimated as 1.22 to 1.437 meters, the figured frieze itself as 0.88 to 0.937 meters; see Leipen 1971, 23; and E. B. Harrison 1996a, 49, n. 150. Only a few blocks of the base and its poros limestone foundations in the floor of the Parthenon (including a rectangular cutting for the huge wooden timber that functioned as the statue's backbone) survive.

67. For the construction of the statue, see Lapatin 2001, 68–78.

68. E. B. Harrison 1981. The dramatically posed figure near the bottom of the shield with the arm covering the face is now considered an Amazon; E. B. Harrison 1997, 47, n. 143.

69. Plutarch, *Pericles* 31.3–5; Stadter 1989, 294; Preisshofen 1974.

70. Herodotus 8.41; Pausanias 1.24.7.

71. Originally, the Nike-bearing arm may have lacked artificial support, as in Alan LeQuire's full-scale Athena Parthenos in Nashville (Fig. 21), and Athena's snake may originally have coiled itself at her right side. The supporting column seen in many later copies of the statue (cf. Fig. 108) may have been a later addition beneath a wavering arm, requiring the transfer of the snake to a position within the shield. See Camp 2001, 80; Hurwit 1999, 26, 329–330 n. 78; also Lapatin 2001, 86–88.

72. For the suggestion that the myth of Pandora was also the subject of the (hypothetical) interior *proneos* frieze, see Neils 2001, 216, 272, n. 28.

73. See most recently Palagia 2000 and Boardman 2001, who both claim that Hesiod's version of the story would have been virtually ignored or suppressed by the Athenians.

74. Hurwit 1999, 235–245; Hurwit 1995; Jenkins 1994, 40–42.

75. Hurwit 1999, 313; Lapatin 2001, 65 (between 705 and 996 talents).

76. For the water basin (yet another example of the many revisions and adjustments made to the architecture of the building), see Pausanias 5.11.10; Lapatin 2001, 85–86; and Hurwit 2004a. The water (drawn, perhaps, from five deep wells dug into bedrock along the north flank of the Parthenon) may have slightly increased relative humidity in the room (and so protected the ivory and glue of the statue), but the principal purpose of the pool would have been aesthetic; see Gaugler and Hamill 1989.

5. The Propylaia

1. *Pericles* 13.12. For the Propylaia in general, see now Korres 2003, 16–20; Camp 2001, 82–90; Goette 2001, 17–21.

2. Goette 2001, 20.

3. Hurwit 1999, 124–125, 130–132; on the history of the Older Propylon, see now Shear 1999, 107 and 110–118.

4. Korres 2003, 18; Coulton 1977, 119–20. Though parts of Building B were built into the Propylaia's foundations, evidence for its precise location is admittedly scant; Eiteljorg 1995, 58, n. 104, finds no reason to put it in the vicinity of the Propylaia, nor does Shear 1999, 107.

5. The cutting for the ridge beam of the southeast hall is smaller than that of the northeast hall, for example.

6. Korres 2003, 17 (Fig. 16); Tomlinson 1990.

7. T. L. Shear, Jr., 1981, 367. The ramp acquired a marble stairway in the Roman period.

8. Plutarch, *Pericles* 32.2; Meiggs 1975, 283, 500.

9. Tanoulas 1994a, 53, suggests that the rock-cut passageway through the center of the gatehouse received a marble floor by the end of the fifth century, but this would have been to facilitate the progress of the sacred Panathenaic procession.

10. Hellström 1988, 117–18; *IG* I³ 343–57.

11. Interestingly, Pausanias (1.22.6) notes that "the building with pictures" is "to the left of the Propylaia," as if he did not consider them parts of the same building. It is, indeed, possible that the term "Propylaia" referred only to the central gatehouse; see also Tomlinson 1990, 411–13.

12. Dinsmoor 1950, 201, mentions evidence for unrealized *akroteria* in the form of florals and griffins.

13. See Tanoulas 1994b, 167.

14. Hurwit 1999, 315; Ridgway 1999, 210, n. 11.

15. Demosthenes 22.13, 76; 23.208; Aeschines 2.74. For a critique of the sumptuousness of the building, see Cicero, *De Officiis* 2.60 (citing Demetrios of Phaleron).

6. The Erechtheion

1. Pseudo-Plutarch, *Lives of the Ten Orators: Lykourgos* 843E.

2. Although it is usually assumed that the trident marks on the Acropolis were caused by the blow Poseidon struck against the rock during his contest with Athena, it should be noted that according to Euripides (*Ion* 281–82), Poseidon also destroyed Erechtheus with his trident.

3. On this lamp and its possible location, see Palagia 1984; see, however, Mansfield 1985, 236–37, n. 30.

4. Goette 2001, 27.

5. Jeppesen 1987 (House of the Arrhephoroi); N. Robertson 1996, 37–44 (Heroon of Pandion). Mansfield 1985, 245–52, finds the Erechtheion in the Sanctuary of Zeus Polieus. For more, see Hurwit 1999, 202.

6. Ferrari 2002, and above, Chapter Two.

7. Homer *Iliad* 2.546–51.

8. Lawton 1995, 86–87 (cat. no. 8), 89–90 (cat. no. 14).

9. Mansfield 1985, 210.

10. Austin 1968, frag. 65.

11. See Mansfield 1985, 247–48.

12. Strabo 9.1.16.

13. *IG* I³ 474 (the Chandler stele); for a different interpretation, see Ferrari 2002, 17–21.

14. Herodotos 8.55.

15. The columns of the north porch, on the other hand, have a very slight but intentional *entasis* (the swell is no more than 6 millimeters over a column shaft height of 6.20 meters). It is clear, then, that such refinements as *entasis* or horizontal curvature were not obligatory but were stylistic choices. Haselberger 1999, 18, 28, n. 90.

16. For the west and slit windows (once thought to be medieval), see Korres 1994b, 48; 1994c, 178; and Casanaki and Mallouchou 1983, 92.

17. Vitruvius 4.8.9.

18. The crypt continued by means of a small passageway beneath the north side of the cella.
19. For the meaning of the Karyatids and their relation to the Kekropeion, see Scholl 1995. For the Ionic column, see Korres 1997a.
20. Dontas 1983.
21. But cf. I. M. Shear 1963.
22. Dinsmoor 1950, 203; Korres 1988.
23. Korres 2003, 29.
24. Mark 1993, 85, 141.
25. The discovery of Older Propylon column-drums in its foundations, as well as in the Propylaia's, has suggested not only that Mnesikles designed both buildings but also that he began them at the same time. See also Korres 1997b, 243 (who dates the building of the Erechtheion precisely to 438–431), and 1988; Ridgway 1992, 126; and Dix and Anderson 1997.
26. Xenophon, *Hellenika* 1.6.1, mentions a fire in "the ancient temple of Athena." The phrase he uses is *palaios neos* instead of the usual *Archaios Neos* and, because the reference is most likely an interpolation, the whole story is suspect. Camp 2001, 99, accepts the story and its reference to the Erechtheion.
27. Stewart 1990, 167–68; Hurwit 1999, 113–115, and Fig. 88.
28. Boulter 1970. The technique was evidently used for the base of the cult statues of Hephaistos and Athena in the Hephaisteion in the Agora and, because Alkamenes created those statues, some would see him as the designer of the Erechtheion frieze as well; see M. Robertson 1975, 345.
29. Glowacki 1995.
30. Quoted from M. Robertson 1975, 364.
31. It is possible but not certain that the Erechtheion's Phyromachos is the same as the Pyromachos said to have made (or decorated) Alkibiades's chariot; see Pliny, *NH* 34.80.
32. Simon 1975; E. B. Harrison 1979. Spaeth 1991, finds Boutes in the west pediment's reclining figure A (CD 045); E. B. Harrison 1984, tentatively finds him in the west frieze as well.
33. I wonder whether the massive sail-*peplos* of the Greater Panathenaia, too large to be draped over the little statue of Athena Polias, was somehow hung and displayed over the otherwise strikingly blank south wall of the Erechtheion (Fig. 17).

7. The Sanctuary of Athena Nike

1. Pausanias (3.15.7) calls her "Wingless Victory," reflecting a popular confusion between Athena and the personification.
2. Hurwit 1999, 105–106. At the eastern end of the bastion there was a second shrine – a small enclosure sacred, perhaps, to Hekate Epipyrgidia (on the Tower). See Pausanias 2.30.2; Giraud 1994, 32–34; Fullerton 1986.
3. Mark 1993, 129–130, argues that the destroyed sanctuary was left as it was throughout the Early Classical period, and that the limestone *naiskos* and altar were built only around 445, as an early Periclean project (in his view, *IG* I^335 authorizes this project, not the construction of the elegant marble temple that would stand there by 424/3). Giraud 1994, 34–38, on the other hand, argues that the *naiskos* and altar date to the years immediately after the Persian destruction (if so, the construction might not have been considered a violation of the oath,

because no real temple had stood there before). Shear 1999, 120–123, agrees with Giraud, believing it "unthinkable" that Pericles's architects, at the time they were reconceiving the Acropolis as a grand composition of Pentelic marble monuments, would have designed a small, unimpressive limestone shrine to stand as its introduction.

4. Mark 1993, 22–28, 93–98, argues for a seated marble cult image. But, Pausanias twice (3.15.7, 5.26.6) refers to the statue as a *xoanon* (literally, "scraped thing"), and for this and other reasons many scholars prefer a standing wooden image. See Donohue 1988, 54–57; also Shapiro 1989, 27 and 31; Stewart 1990, 165; Ridgway 1992, 135–37.

5. *IG* 1³ 35.

6. *IG* 1³ 36.

7. For the relationship between the Propylaia and the Nike temple, see Korres 2003, 19; Hoepfner 1997; and Tomlinson 1990, 411–13.

8. Korres 2003, 29, dates the temple between 430 and 424/3; Goette 2001, 21, believes it was probably designed by Kallikrates in 437. Another inscription (*IG* 1³ 64, dated to the mid-420s) dealing with the Nike temple project mentions the architect but gives no name. At all events, the richness and elaborate character of the Temple of Athena Nike does not seem to jibe with what we know of Kallikrates, whose talent seems to have been better suited for more utilitarian projects, like the building of the middle Long Wall to the Peiraieus; see McCredie 1979.

9. The design of the Nike temple was a resounding success, because several very similar temples were built elsewhere in Athens and Attika at about the same time – for example, on the banks of the Ilissos River, at Ambelokipi, and, most nearly, atop the Areopagos just to the west; see Korres 2003, 30–31; 1996; Goette 2001, 22. The temple was also widely imitated later: an Athenian choregic monument seems to have been an exact replica.

10. See especially Stewart 1985.

11. Schultz 2001. The central Nikai in the central *akroteria* may have been modeled on the Nike held in the hand of the Athena Parthenos (Fig. 21), or they may have resembled a Nike made by Paionios for Olympia just after 425; Boardman 1985, Fig. 139.

12. Felten 1984, 123–31, suggests that the subjects were Greeks against Trojans.

13. For the interpretation of the battle friezes, see Harrison 1972, 1997. In a paper given in 2003 ("History and Image on the Nike Temple Frieze"), P. Schultz suggests the west frieze depicted the historical victory of the Athenians over the Ambraciots in 426, just a year or two before the completion of the temple itself. Camp 2001, 91, assumes the north frieze showed Greeks and Persians.

 One notes that the temple on the Ilissos, a virtual twin of the Nike temple, was probably dedicated to Artemis Agrotera, and that her festival (the *Charesteria*) was a celebration of Marathon.

14. Harrison 1997, 112–13. The war god would seem a fitting companion for the goddess of victory. Still, Ares is the god the other gods love to hate, and is rarely afforded so prominent a place in Classical iconography.

15. Cf. the east frieze of the Siphnian Treasury at Delphi; Boardman 1978, Fig. 212.2.

16. Palagia 2004.

17. As noted by Rhodes 1995, 116. In a paper given in 2004, P. Schultz has cogently argued that shields captured from the Spartans at Pylos in 425 were hung as victory monuments on the sides of the Nike bastion (Fig. 58).

18. Schultz 2002.
19. Anyone who delayed passing through the Propylaia and took a right from the ramp up the steps leading into the sanctuary of Athena Nike would have found his progress mirrored by a Nike, carved on the short eastern return of the parapet, who climbs a stairway of her own (CD 146).
20. Brouskari 1998, 81, cites evidence for a fourth seated Athena, which would diffuse the formal concentration on each side of the parapet.
21. *IG* II² 334.20–1; Jameson 1994, 312; Parke 1977, 48.
22. Jameson 1994.
23. Simon 1997; see also Hölscher 1997. Thöne 1999, 64–73, associates the frieze with Panathenaic tribal victories.
24. Brouskari 1998, 53–55, for example, argues for c. 420–417; Schultz 2002, however, argues for a date even before 421.
25. *Lysistrata* 317–18.
26. Cf. Carpenter 1929. Agorakritos, again, has been credited with the Nike temple's east frieze, and Paionios – the greatest Nike sculptor of the late fifth century – has been credited with the Victories of the central *akroteria* of the temple as well; Schultz 2001.
27. Simon 1997, Fig. 15; CD 147.

8. The Rest of the Program

1. For the clearing of medieval and Turkish houses and towers and the early archaeological program, see Hurwit 1999, 291–302.
2. Plutarch, *Pericles* 13.12–13; also Pliny *NH* 22.44.
3. *IG* I³ 506.
4. The so-called Hope or Farnese Athena is often thought to be a Roman version of the Athena Hygieia; see Boardman 1985, Fig. 206.
5. *IG* I³ 824.
6. We know that Athena Hygieia received state sacrifices at the annual Panathenaia (at least in the fourth century), but no private dedications to her can be dated after 420/19, when the cult of another healing god, Asklepios, was introduced to Athens and a new sanctuary founded on the south slope of the Acropolis (Fig. 2, no. 25). Pausanias (1.23.4) saw a statue of Hygieia herself (Asklepios's daughter) very near that of Athena Hygieia.
7. Korres 1997b, 243.
8. See Rhodes and Dobbins 1979.
9. Pausanias 1.23.7; Despinis 1997.
10. See D. Harris 1995, 141 (V.151). The Parthenon stored gold and silver objects dedicated to other deities as well (such as Aphrodite, Athena Nike, and Zeus Polieus).
11. Hurwit 1999, 251, 293–4.
12. Rouse 1976, 75.
13. La Follette 1986; cf. Downey 1997. The Chalkotheke could, of course, post-date the south wall (438) and still be Periclean.
14. Korres 1999, 91, n. 50; Goette 2001, 24.
15. Korres 1999, 85–91.
16. A monument with seven life-size bronze statues was inserted atop the ninth step at the southern end of the flight (just above the northeast corner of the Chalkotheke), evidently in the Hellenistic period.

17. Pausanias 1.24.3. The shrine of Athena Ergane is now thought to be the *naiskos* in the north colonnade of the Parthenon (Fig. 24); Korres 1997b.

18. See, generally, Keesling 2003, 165–198. Potted plants were artistically arranged and sunk into the terrace of the Hephaisteion in the Agora below; Goette 2001, 77.

19. Pausanias 1.24.8–25.1.

20. For these later monuments, see Hurwit 1999, 270–272, 279–280.

21. Pausanias 1.5.1–4.

22. In fifth-century art, Pandion seems particularly associated with warriors departing for battle, and the role of warfare and victory in the iconography of the Acropolis as a whole, as well as his familial connections with Erechtheus-Erichthonios, Boutes, Prokne, and so on, would make him an especially appropriate Eponymous Hero here.

23. See Thucydides 1.126.

24. In contrast, he is fascinated with the Great Altar of Zeus at Olympia, a pile of ash 22 feet high, which he discusses at great length; Pausanias 5.13.8–14.3.

25. E. B. Harrison 1986, 117; E. B. Harrison 1996a, 50, withdraws that suggestion but just as speculatively places the frieze around the putative "precinct of Athena Ergane" at the north end of the great flight of rock-cut steps west of the Parthenon. For the suggestion that it belonged to the Parthenon *proneos* (and that its theme, Pandora, thus related the frieze to the base of the Athena Parthenos), see Neils 2001, 216, 272, n. 28.

26. Simon 1983, 61; but see Mansfield 1985, 238–39.

27. Pausanias 1.24.4.

28. Cf. Pausanias 1.28.10–11 on the origins of the rite in the days when Erechtheus was king.

29. There are traces of an earlier building on the same spot.

30. Pausanias 1.27.3.

31. For the traditional interpretation, see Simon 1983, 39–46; for a different view, see N. Robertson 1992, 15–16, and 1996, 60–62. On this troublesome passage, see also Kadletz 1982. The phrase "in the city" (*en tei polei*) often means "on the Acropolis" (cf. Pausanias 1.26.6), and so many scholars have placed the *Arrhephoria* entirely on the Acropolis itself. Elsewhere (1.19.2), Pausanias locates the Sanctuary of Aphrodite of the Gardens in the southeast part of the city, far from the Acropolis's north slope.

32. Two dedications made by former *Arrhephoroi* to both Athena and Pandrosos offer some support for the theory connecting them to the daughters of Kekrops; see *IG* II² 3472, 3315; Larson 1995, 39–41. N. Robertson 1992, 16, suggests the rite had something to do with the feeding of Athena's sacred snake.

33. Aphrodite and Peitho were important players in the mythological unification of Athens, with Theseus invoking their assistance. The fire that lit the altar of Athena during the Panathenaia was taken from the altar of Eros (the son of Aphrodite) outside the Dipylon gate; Parke 1977, 45. Some late Archaic Athenian coins have Athena on one side, Aphrodite Pandemos on the other; Simon 1983, 50. It is interesting to note as well that in ancient Mediterranean cultures, warrior goddesses such as Ishtar or Astarte were also love goddesses; Athena and Aphrodite were, in a sense, two sides of the same coin. Also, Loraux 1993, 151.

34. Bundgaard 1976, 34–35, identifies Building III as the sanctuary of Aphrodite in the Gardens; Jeppesen 1987, 13–14, as the Erechtheion. I wonder whether the House of the *Arrhephoroi* also served as a storeroom or exhibition hall for old

peploi. The girls were intimately involved in the production of new ones, and a *peplotheke* is, in fact, mentioned in an Acropolis inscription, though the meaning is not clear; see Nagy 1984.

35. Tanoulas 1992a, b.

36. Korres 1997c.

37. The Sanctuary of Eros and Aphrodite had already been established on the north slope by the middle of the fifth century (it may even have been Peisistratid in origin), and the cults located here seem to have been personal or individual in nature rather than state-sponsored; see Glowacki 1991, 46–64.

38. In his tour of the south slope, Pausanias (1.20.4) speaks of the Odeion (said to be a copy of Xerxes's tent) without actually naming or dating it. For the building and its symbolism, see Papathanasopoulos 1999; M. C. Miller 1997, 218–42; and Robkin 1979.

39. Shapiro 1992, 57, cites the precedent of Hipparkhos's reorganization of the Panathenaic Homeric recitations in the late sixth century. Before their removal to the Periclean Odeion in the 440s, the *mousikoi agones* were possibly held in the Archaic Agora northeast of the Acropolis; S. G. Miller 1995, 218–19.

40. Cf. Herodotos 9.70, 82; Camp 2001, 101.

41. Some of these seats are preserved and they are straight, not curved, suggesting a rectangular plan for the theater instead of a round one; see Goette 2001, 50–51.

42. Telemakhos brought back either a statue of the god, one of his sacred snakes, or both. In any case, his trip took him through Zea, in the Peiraieus, where there was another sanctuary of the god, founded perhaps just a year or so earlier. It is the goings-on at this sanctuary, at Zea, that Aristophanes is probably parodying in his play *Ploutos* (or Wealth); see Aleshire 1989, 11; and Parker 1996, 175–85.

43. Riethmüller 1999.

44. For the Telemakhos Monument, see Beschi 1967/8; Ridgway 1983, 199–200; Clinton 1991.

45. Wycherley 1978, 183; see Ridgway 1983, 199.

46. Travlos 1971, 138. The wall into which the boundary stone is now set seems to date, however, to the early fourth century; Aleshire 1989, 22–23.

9. Conclusion: The Periclean Acropolis as a Whole

1. As Shapiro 1994, 128, has pointed out, many of the major events in Athenian history took place in years during which the Greater Panathenaia was celebrated: 514 (the death of Hipparkhos), 510 (the fall of the Peisistratid tyranny), 506 (the victory over Boiotia and Chalkis), 490 (Marathon). The Athenians must have come to associate the Panathenaia with those critical events and victories, making the festival – "the birthday party of Athenian democracy, as well as of Athena herself" – an even more appropriate subject for a public work of art.

2. Kardara 1961.

3. Connelly 1996.

4. Cf. Spaeth 1991. According to Pausanias (1.27.4), Erechtheus and Eumolpos also appeared in a bronze group standing near the Erechtheion; for possible remains of the monument, see Korres 1994f, 124.

5. Connelly 1996, 55, n. 16, herself concedes that in the "Greek iconographic system [images should be] immediately recognizable to the viewer." It may be that the tragic tale of the Erechtheids appeared on the Erechtheion frieze later but, if so, the myth there would surely have been identifiable; cf. Neils 2001, 269, n. 21.

6. If Neils 2001, 61–66, is right that the gods are to be thought of as sitting in a semicircle around the *peplos* scene, this can be no human sacrifice.

7. Boardman 1999, 307–314.

8. Apollodoros 3.14.6; *Iliad* 2.550–51. In one of the fragments of the *Erechtheus* so fundamental to Connelly's theory (*Pap. Sorbonne* 2328), Athena ordains the sacrifice of bulls in honor of the daughters; Connelly 1996, 58.

9. Boardman 1991 and 1999, 314–320, for example, insists the child is a girl but rejects Connelly's thesis.

10. For a decisive critique of Connelly's thesis, see E. B. Harrison 1996b. See also DeVries 1994; I. Jenkins 1994, 29 and 35; and Neils 2001, 168–171, 178–180. Neils (170) notes that in Athenian reliefs (and elsewhere in the Parthenon frieze itself; cf. Figs. 100, 105) women's or girls' ankles are always covered by drapery. Because this child's ankles are exposed, they must be male ankles.

11. For the Stoa Poikile and the Marathon painting, see Camp 2001, 68–69; 1986, 66–72; and Pollitt 1990, 141–45.

12. Boardman 1977 and 1984.

13. Pausanias 1.28.2; Scholiast on Demosthenes, *Against Androtion* 13.

14. Demosthenes, *Against Androtion* 13.

15. Boardman knows the Athenians fought and died at Marathon as hoplites, not cavalrymen; but, he suggests that by being put on horseback on the frieze, they have been literally and figuratively elevated and thus heroized. For two criticisms of the Marathon theory, see Simon 1983, 58–60, and I. Jenkins 1994, 26. Boardman 1999, 325–330, has now withdrawn the theory but maintains a Marathonian connection for the frieze, arguing that the old men (Fig. 102) are not *thallophoroi* (olive-branch-bearers chosen for their good looks) but the *Marathonomachoi*, now elderly veterans of the battle.

 It is worth pointing out that there was a separate Athenian holiday of thanksgiving for the victory (the *Charisteria*, sacred to Artemis), in which armed *epheboi* (youths training to be hoplites – not, incidentally, horsemen) apparently marched on foot. Given this precedent – a sacred parade of infantry honoring the Marathonian dead – it would have been doubly hard for Athenians to read Marathon into the cavalcade. For *epheboi* at the *Charisteria*, see Simon 1983, 82; and Parke 1977, 55.

16. For the view that the Parthenon frieze is votive in character, see Kroll 1979.

17. E. B. Harrison 1984, 234 (Theseus); Nagy 1992 (Pericles).

18. I. Jenkins 1994, 36.

19. E. B. Harrison 1984. Harrison's theory does not, however, adequately account for the ten ranks of horsemen or the eleven chariots on the north, nor does it explain why the pre-Kleisthenic Panathenaia – and that would essentially be a Peisistratid Panathenaia – would be represented on the north side of the Parthenon (by which most traffic passed), while the contemporary Periclean procession would be placed on the less conspicuous south side. If she is correct, the Panathenaia of the bygone age of tyrants would be privileged over the Panathenaia of the age of democracy – an odd choice for Pericles's friend Pheidias to have made.

20. Simon 1983, 55–62; for criticism of Simon's theory, see I. Jenkins 1994, 28–29; and Hurwit 1995, 183, n. 61.

21. Gauer 1984; Boardman 1977; 1984; 1999, 325–326; Fehl 1961.

22. Osborne 1987. The uniformity of style on the frieze can, perhaps, be overstated; and, in any case, the idealized sameness of the figures – which is found in other non-Athenian works of the fifth century where democratic feelings cannot have

been the motive – seems to have had a more philosophical, humanistic point: when mortals on the frieze resemble, through their good looks, the heroes and gods on the frieze, then the differences between human and divine are blurred, to the benefit of human beings.

23. Castriota 1992, 184–229.
24. Stewart 1997, 75–85; cf. Younger 1997; DeVries 1992.
25. If the elders represented on the frieze (Fig. 102) are, in fact, the *thallophoroi* (as, for example, Neils 2001, 142, believes), and if the olive branches they carried were painted (they certainly are not carved), it is odd that only some of the elders have their hands clenched as if to hold them. Boardman 1999, 322–323, again, rejects their identification as *thallophoroi*.
26. Neils 1992, 15.
27. See Pollitt 1997, 53. At the same time, no ancient source says they did *not* participate.
28. Holloway 1966. For a criticism, see I. Jenkins 1994, 26.
29. Lawrence 1951; Root 1985; for criticisms, see Neils 2001, 182–183.
30. Beschi 1986.
31. Thucydides 2.38. For this view, see above all Pollitt 1997 and Wesenberg 1995; Neils 2001, 183–185, rejects it.
32. See Wesenberg 1995, 168–172; cf. Goldhill 1987, 61 and n. 20; cf. Hurwit 1999, 228, Fig. 197.
33. As Wesenberg 1995, 151–164, argues; Boardman 1999, 313, rejects this identification, arguing they are too old and wear adult clothes.
34. Simon 1983, 59–60; Bugh 1988, 59–60; Kyle 1992, 94. The *anthippasia* was also held at the *Olympieia*, a festival sacred to Zeus; see Parke 1977, 144.
35. Kyle 1987, 45–46.
36. For the debate over the identity of the "Eponymous Heroes" (which is who they probably are), see most recently Neils 2001, 158–161.
37. Cf. Ridgway 1981, 78. It is worth noting that choral dances in the City Dionysia apparently took place at the Altar of the Twelve Gods in the Agora, so the Panathenaia was not the only Athenian festival to involve all the Olympians; Pickard-Cambridge 1968, 62.
38. Pausanias 1.28.2. Pausanias notes Parrhasios and Mys added other decoration or imagery to the shield but does not say what it was. It is just possible that a young Parrhasios was active in the Periclean era, but his was primarily a fourth-century career; see M. Robertson 1975, 324, 411–12, and Boardman 1985, 203.
39. See Pausanias 1.23.7–8 and *IG* I^3 895; Hamdorf 1980; Raubitschek 1949, 208–09, no. 176; and Stevens 1936, 460–61. Aristophanes may refer to the statue in his *Birds* (line 1128), in which case the statue was dedicated by 414, when the play was produced.
40. Felten 1984, 123–31, argues that the north and south friezes of the Temple of Athena Nike (carved perhaps no more than a year or two before the Wooden Horse was created) also represented battles of Greeks and Trojans. The Trojan element in Strongylion's artistic environment would, in that case, have been even stronger and more obvious still.

 Another work at the entrance of the Acropolis that would have prepared for the north metopes was a painting Pausanias (1.22.6) saw in the Pinakotheke representing Diomedes taking the Palladion from Troy; the statue was depicted in north metope 25 (Fig. 69).
41. Pausanias 1.24.2–3.

42. Pausanias 1.27.4; Korres 1994f, 124.
43. Barringer 2004.
44. See, for example, Hurwit 1999, 130, Fig. 105.
45. *IG* I³ 468.
46. Pausanias 4.36.6.
47. For the Hippeis monument, see Hurwit 1999, 58, 147.
48. *IG* I³ 880; Keesling 2003, 171; Holtzmann 2003, 96–97. The monument included a statue of Pronapes himself standing beside the chariot.
49. *IG* I³ 893.
50. Pausanias 1.22.7.
51. M. Robertson 1975, 286–87; Stewart 1990, 164; see now Barringer 2004.
52. Cf. Korres 1994a, 33.
53. Detienne and Vernant 1991, 226.
54. Aristides, *Panathenaic Oration* 41.
55. For Panathenaic amphorae, see Hurwit 1999, 23–24, 45–46; Neils 1992, 29–51.
56. See, for example, Castriota 1992, 138–83; for a skeptical view, see Ridgway 1981, 18–19. But that the imagery of the Acropolis as a whole was read in antiquity as a promotion of the victory of the west over the east seems clear especially from later Hellenistic and Roman attitudes toward it; see, for example, Plutarch, *Anthony* 34, and Hurwit 1999, 261–282.
57. Hall 1993, 115. For Amazons on the Areopagos, see Aeschylus, *Eumenides* 685–90.
58. In south metope 32 (CD 070), the Greek fighting the centaur may be Theseus. He is, in any case, posed like one of the Tyrannicides (Boardman 1985, Fig. 3), so that the Centauromachy not only becomes an analogue for the Persian Wars but also for the victory of democracy over tyranny.
59. See W. Binder 1969.
60. For this reading of the Temple of Roma and Augustus and this "Persian War corner" of the Acropolis – though virtually every corner of the Acropolis was a Persian War corner – see also Carroll 1982, 67–69; Spawforth 1994, 234–35; and Hoff 1996.
61. As Pollitt 1997, 62, notes, sacrifices, contests, and military training are the three elements of Athenian civic life that Pericles emphasizes in his Funeral Oration (Thucydides 2.38–39).
62. Cf. I. Jenkins 1994, 32–33.
63. Crowther 1991.
64. Simon 1983, 63–64. Pausanias (1.22.7) saw a painting of the same subject – a youth carrying water jars – in the Pinakotheke.
65. Thucydides 6.56.
66. Pollitt 1997; Bugh 1988, 66–67, 74–78. The 1,000-man cavalry had appended to it a contingent of 200 mounted archers who, admittedly, do not appear on the frieze. Still, the horsemen on both the north and south friezes number 120 – neatly one-tenth of the 1,200 total.
67. One problem with the interpretation of the cavalcade as a rendering of the new Periclean cavalry is that, except for the two hipparchs, all the horsemen are beardless and thus youths, when there is evidence that the cavalrymen served well into their thirties and should be bearded; Bugh 1988, 62–65. But, the beardlessness of the horsemen is probably symbolic: Greek artistic tradition endowed anyone fighting on behalf of his city with youth, and anyone who died on behalf of the city with eternal youth. The "youthening" of the horsemen is thus ideological and idealizing, not literal. See Osborne 1987, 103–04; cf. Stewart 1997, 75–85.

68. Castriota 1992, 218–19. There is, admittedly, a discrepancy between the expanded but still élitist cavalry and the complete absence from the frieze of any sign of the *thetes* – the poor Athenian citizens who rowed the ships of the Athenian fleet – who were, therefore, the real foundation of Athenian imperial might but who are represented only rarely on the fifth-century Acropolis (CD 175). The frieze, in other words, is not nearly as democratic as Periclean political life. Still, it may not be beside the point that Pericles's own sons were said to be the finest cavalrymen in Athens; Plato, *Meno* 94B.

69. Thucydides 2.41.

70. Plutarch, *Pericles* 18.1.

WORKS CITED

Aleshire, S. B. 1989. *The Athenian Asklepieion: The People, Their Dedications, and the Inventories.* Amsterdam.

Amyx, D. A. 1988. *Corinthian Vase Painting of the Archaic Period.* Berkeley.

Ashmole, B. 1972. *Architect and Sculptor in Classical Greece.* London and New York.

Austin, C. 1968. *Nova Fragmenta Euripidea in Papyris Reperta.* Berlin.

Badian, E. 1987. "The Peace of Kallias," *JHS* 107, 1–39.

Barber, E. J. W. 1992. "The Peplos of Athena," in Neils 1992, 103–17.

Barringer, J. M. (2004). "Alkamenes' Prokne and Itys in Context," in *New Perspectives on Periclean Athens.* Austin.

Beard, M. 2003. *The Parthenon.* Cambridge, Mass.

Berger, E. 1977. "Parthenon-Studien," *AntK* 20, 124–41.

Berger, E., ed. 1984. *Parthenon–Kongress Basel: Referate und Berichte.* Mainz.

Beschi, L. 1967/8. "Il Monumento di Telemachos, fondatore dell'Asklepieion ateniese," *ASAtene* 29/30, 381–436.

Beschi, L. 1986. "*He Zophoros tou Parthenona: Mia Nea Prostase Hermeneias,*" in Kyrieleis 1986, vol. II, 199–224.

Binder, J. 1984. "The West Pediment of the Parthenon: Poseidon," in *Studies Presented to Sterling Dow. Greek, Roman, and Byzantine Studies Monographs 10.* Durham, N. C. 15–22.

Binder, W. 1969. *Der Roma–Augustus Monopteros auf der Akropolis in Athen und sein typologischer Ort.* Stuttgart.

Boardman, J. 1975. *Athenian Red Figure Vases: The Archaic Period.* London.

Boardman, J. 1977. "The Parthenon Frieze – Another View," in U. Höckmann and A. Krug, eds., *Festschrift für Frank Brommer.* Mainz. 39–49.

Boardman, J. 1978. *Greek Sculpture: The Archaic Period.* New York and Toronto.

Boardman, J. 1984. "The Parthenon Frieze," in Berger 1984, 210–15.

Boardman, J. 1985. *Greek Sculpture: The Classical Period.* London.

Boardman, J. 1991. "The Naked Truth," *OJA* 10, 119–21.

Boardman, J. 1999. "The Parthenon Frieze, A Closer Look," *Revue Archéologique*, 305–30.

Boardman, J. 2001. "Pandora in the Parthenon: A Grace to Mortals," in *Kallisteuma: Meletes pros Timen tes Olgas Tzakhou-Alexandri*. Athens. 233–44.

Boardman, J., and Finn, D. 1985. *The Parthenon and its Sculptures*. Austin.

Boersma, J. S. 1970. *Athenian Building Policy from 561/0 to 405/4 BC*. Groningen.

Boulter, P. N. 1970. "The Frieze of the Erechtheion," *Antike Plastik* 10, 7–28.

Brouskari, M. 1974. *The Acropolis Museum*. Athens.

Brouskari, M. 1998. *To Thorakio tou Naou tes Athenas Nikes*. Athens.

Brulotte, E. L. 1993. "Display of Offerings and Use of Space in the Hekatompedon of the Parthenon," *AJA* 97, 310 (abstract).

Bugh, G. R. 1988. *The Horsemen of Athens*. Princeton.

Buitron-Oliver, D., ed. 1997. *The Interpretation of Architectural Sculpture in Greece and Rome. Studies in the History of Art, 49.* Center for Advanced Study in the Visual Arts, Symposium Papers XXIX. Hanover and London.

Bundgaard, J. A. 1976. *Parthenon and the Mycenaean City on the Heights*. Copenhagen.

Burkert, W. 1985. *Greek Religion*. Oxford.

Camp, J. McK., II. 1986. *The Athenian Agora*. New York.

Camp, J. McK., II. 1996. "Excavations in the Athenian Agora, 1994–95," *AJA* 100, 394–95 (abstract).

Camp, J. M. 2001. *The Archaeology of Athens*. New Haven.

Carpenter, R. 1929. *The Sculpture of the Nike Temple Parapet*. Cambridge, Mass.

Carroll, K. K. 1982. *The Parthenon Inscription*. Durham, N. C.

Casanaki, M., and Mallouchou, F. 1983. *The Acropolis at Athens: Conservation, Restoration, and Research, 1975–1983*. Athens.

Castriota, D. 1992. *Myth, Ethos, and Actuality: Official Art in Fifth-Century BC Athens*. Madison, Wis.

Chadwick, J. 1976. *The Mycenaean World*. Cambridge.

Clinton, K. 1991. "The Epidauria and the Arrival of Asclepius in Athens," in R. Hägg, ed., *Ancient Greek Cult Practice from the Epigraphical Evidence*. Stockholm. 17–34.

Connelly, J. B. 1996. "Parthenon and *Parthenoi*: A Mythological Interpretation of the Parthenon Frieze," *AJA* 100, 53–80.

Cook, B. F. 1993. "The Parthenon, East Pediment A–C," *BSA* 88, 183–85.

Coulson, W. D. E., Palagia, O., Shear, T. L., Jr., Shapiro, H. A., and Frost, F. J., eds. 1994. *The Archaeology of Athens and Attica under the Democracy*. Oxbow Monographs 37. Oxford.

Coulton, J. J. 1977. *Ancient Greek Architects at Work*. Ithaca, N.Y.

Coulton, J. J. 1984. "The Parthenon and Periklean Doric," in Berger 1984, 40–44.

Cromey, R. D. 1991. "History and Image: The Penelope Painter's Akropolis," *JHS* 101, 165–73.

Crowther, N. B. 1991. "The Apobates Reconsidered (Demosthenes lxi.23–9)," *JHS* 101, 174–76.

Davies, J. K. 1993. *Democracy and Classical Greece*. Second ed. Cambridge, Mass.

Delivorrias, A. 1997. "The Sculpted Decoration of the So-called Theseion: Old Answers, New Questions," in Buitron–Oliver 1997, 83–107.

Demargne, P. 1984. "Athena," *LIMC* II, 955–1044.

Despinis, G. 1986. "*Thrausmata anaglyphon apo te notia pleura tes Akropoles*," in Kyrieleis 1986, vol. I, 177–80.

Despinis, G. 1997. "Zum Athener Brauronion," in Hoepfner, ed., 1997, 209–17.

Detienne, M., and Vernant, J. P. 1991. *Cunning Intelligence in Greek Culture and Society*. Chicago.

DeVries, K. 1992. "The 'Eponymous Heroes' on the Parthenon Frieze," *AJA* 96, 336 (abstract).

DeVries, K. 1994. "The Diphrophoroi on the Parthenon Frieze," *AJA* 98, 323 (abstract).

Dinsmoor, W. B. 1913. "Attic Building Accounts, I: The Parthenon," *AJA* 17, 53–80.

Dinsmoor, W. B. 1921. "Attic Building Accounts, IV: The Statue of Athena Promachos," *AJA* 25, 118–29.

Dinsmoor, W. B. 1932. "The Burning of the Opisthodomus at Athens," *AJA* 36, 143–72, 307–26.

Dinsmoor, W. B. 1950. *The Architecture of Ancient Greece*. London.

Dix, T. K., and Anderson, C. A. 1997. "The Eteocarpathian Decree (*IG* I³ 1454) and the Construction Date of the Erechtheion," *AJA* 101, 373 (abstract).

Djordjevitch, M. 1994. "Pheidias' Athena Promachos Reconsidered," AJA 98, 323 (abstract).

Donohue, A. A. 1988. *Xoana and the Origins of Greek Sculpture*. Atlanta.

Dontas, G. 1983. "The True Aglaurion," *Hesperia* 52, 48–63.

Dowden, K. 1992. *The Uses of Greek Mythology*. London and New York.

Downey, C. 1997. "The Chalkotheke on the Athenian Acropolis: Form and Function Reconsidered," *AJA* 101, 372–73 (abstract).

Economakis, R., ed. 1994. *Acropolis Restoration: The CCAM Interventions*. London.

Eiteljorg, H., II. 1995. *The Entrance to the Athenian Acropolis before Mnesikles*. Boston.

Fehl, P. 1961. "The Rocks on the Parthenon Frieze," *Journal of the Warburg and Courtauld Institutes* 24, 1–44.

Felten, F. 1984. *Griechische tektonische Friese archaischer und klassischer Zeit*. Waldsassen–Bayern.

Ferrari, G. 2002. "The Ancient Temple on the Acropolis at Athens," *AJA* 106, 11–35.

Fornara, C. W. 1977. *Archaic Times to the End of the Peloponnesian War*. Baltimore and London.

Fornara, C. W., and Samons, II, L. J. 1991. *Athens from Cleisthenes to Perikles*. Berkeley.

Fullerton, M. D. 1986. "The Location and Archaism of the Hekate Epipyrgidia," *AA* 1986, 669–75.

Gantz, T. 1993. *Early Greek Myth: A Guide to Literary and Artistic Sources*. Baltimore and London.

Garland, R. 1990. *The Greek Way of Life*. Ithaca.

Gauer, W. 1984. "Was geschieht mit dem Peplos?" in Berger 1984, 220–29.

Gaugler, W. M., and Hamill, P. 1989. "Possible Effects of Open Pools of Oil and Water on Chryselephantine Statues," *AJA* 93, 251 (abstract).

Giraud, D. 1994. *Melete apokatastaseos tou naou tes Athenas Nikes*. Athens.

Glowacki, K. T. 1991. *Topics Concerning the North Slope of the Akropolis at Athens.* Diss. Bryn Mawr 1991. Ann Arbor: UMI.

Glowacki, K. T. 1995. "A New Fragment of the Erechtheion Frieze," *Hesperia* 64, 325–31.

Goette, H. R. 2001. *Athens, Attica, and the Megarid: An Archaeological Guide.* London and New York.

Goldhill, S. 1987. "The Great Dionysia and Civic Ideology," *JHS* 107, 58–76.

Green, J. R. 1961. "The Caputi Hydria," *JHS* 81, 73–5.

Hall, E. 1993. "Asia Unmanned: Images of Victory in Classical Athens," in J. Rich and G. Shipley, eds., *War and Society in the Greek World.* London and New York. 108–33.

Hamdorf, F. 1980. "Zur Weihung des Chairedemos auf der Akropolis von Athen," in *STELE: Tomos eis mnemen N. Kontoleontos.* Athens. 231–35.

Hansen, M. H. 1982. "The Number of Athenian Citizens, 451–309 BC," *American Journal of Ancient History* 7, 172–89.

Harris, D. 1991. *The Inventory Lists of the Parthenon Treasures.* Diss. Princeton U. 1991. Ann Arbor: UMI.

Harris, D. 1995. *The Treasures of the Parthenon and Erechtheion.* Oxford.

Harrison, E. B. 1972. "The South Frieze of the Nike Temple and the Marathon Painting in the Stoa," *AJA* 76, 353–78.

Harrison, E. B. 1979. "Apollo's Cloak," in G. Kopcke and M. B. Moore, eds., *Studies in Classical Art and Archaeology: A Tribute to Peter Heinrich von Blanckenhagen.* Locust Valley, N.Y. 91–98.

Harrison, E. B. 1981. "The Motifs of the City-Siege on the Shield of the Athena Parthenos," *AJA* 85, 281–317.

Harrison, E. B. 1984. "Time in the Parthenon Frieze," in Berger 1984, 230–34.

Harrison, E. B. 1986. "The Classical High-Relief Frieze from the Athenian Agora," in Kyrieleis 1986, vol. II. 109–17.

Harrison, E. B. 1996a. "Pheidias," in Palagia and Pollitt 1996, 16–65.

Harrison, E. B. 1996b. "The Web of History: A Conservative Reading of the Parthenon Frieze," in Neils 1996a, 198–214.

Harrison, E. B. 1997. "The Glories of the Athenians: Observations on the Program of the Frieze of the Temple of Athena Nike," in Buitron-Oliver 1997, 109–25.

Haselberger, L., ed. 1999. *Appearance and Essence: Refinements of Classical Architecture: Curvature.* Philadelphia.

Haselberger, L. 1999. "Old Issues, New Research, Latest Discoveries: Curvature and Other Classical Refinements," in Haselberger, ed., 1999, 1–68.

Hellström, P. 1988. "The Planned Function of the Mnesiklean Propylaia," *OpAth* 17, 107–21.

Herington, C. J. 1955. *Athena Parthenos and Athena Polias: A Study in the Religion of Periklean Athens.* Manchester.

Heubeck, A., West, S., and Hainsworth, J. B. 1988. *A Commentary on Homer's Odyssey, Vol. I.* Oxford.

Higgins, M. D., and Higgins, R. 1996. *A Geological Companion to Greece and the Aegean.* Ithaca.

Hill, B. H. 1912. "The Older Parthenon," *AJA* 16, 535–58.

Hill, I. T. 1953. *The Ancient City of Athens*. London.

Himmelmann, N. 1977. "Phidias und die Parthenon-Skulpturen," in *Bonner Festgabe Johannes Straub*, Bonn. 67–90.

Hoff, M. C. 1996. "The Politics and Architecture of the Athenian Imperial Cult," in A. Small. ed., *Subject and Ruler: The Cult of the Ruling Power in Classical Antiquity*. *JRA Supplement* 17. 185–200.

Hollinshead, M. B. 1999. "'Adyton,' 'Opisthodomos,' and the Inner Room of the Greek Temple," *Hesperia* 68, 189–218.

Holloway, R. R. 1966. "The Archaic Acropolis and the Parthenon Frieze," *Art Bulletin* 48, 223–26.

Hölscher, T. 1997. "Ritual und Bildsprache: Zur Deutung der reliefs an der Brüstung um das Heiligtum der Athena Nike in Athens," *AM* 112, 143–66.

Hoepfner, W., ed. 1997. *Kult and Kultbauten auf der Akropolis. Intern. Symposium Berlin 7.-9.7.1995*. Berlin.

Hoepfner, W. 1997. "Propyläen und Nike-Tempel," in *Kult and Kultbauten auf der Akropolis. Intern. Symposium Berlin 7.-9.7.1995*. Berlin. 160–77.

Holtzmann, B. 2003. *L'Acropole d' Athènes*. Paris.

Hurwit, J. M. 1989. "The Kritios Boy: Discovery, Reconstruction, and Date," *AJA* 93, 41–80.

Hurwit, J. M. 1995. "Beautiful Evil: Pandora and the Athena Parthenos," *AJA* 99, 171–86.

Hurwit, J. M. 1999. *The Athenian Acropolis: History, Mythology, and Archaeology from the Neolithic Era to the Present*. Cambridge.

Hurwit, J. M. (2004a). "The Parthenon and the Temple of Zeus at Olympia," in *New Perspectives on Periklean Athens*. Austin.

Hurwit, J. M. (2004b). "The Setting," in J. Neils, ed., *The Parthenon: From Antiquity to the Present*. Cambridge.

Imhoof-Blumer, F., Gardner, P., and Oikonomides, A. N., 1964. *Ancient Coins Illustrating Lost Masterpieces of Greek Art*. Chicago.

Jameson, M. 1994. "The Ritual of the Athena Nike Parapet," in Osborne and Hornblower 1994, 307–24.

Jenkins, I. 1994. *The Parthenon Frieze*. Austin.

Jeppesen, K. 1987. *The Theory of the Alternative Erechtheion*. Aarhus.

Judeich, W. 1931. *Topographie von Athen*. Munich.

Jung, H. 1982. *Thronende und sitzende Götter*. Berlin.

Kadletz, E. 1982. "Pausanias 1.27.3 and the Route of the Arrhephoroi," *AJA* 86, 445–46.

Kallet-Marx, L. 1989. "Did Tribute Fund the Parthenon?" *ClAnt* 8, 252–66.

Kardara, Ch. 1961. "*Glaukopis–Ho Arkhaios Naos kai to Thema tes Zophorou tou Parthenonos*," *AE* 1961, 61–158.

Keesling, C. M. 2000. "A Lost Bronze Athena Signed by Kritios and Nesiotes," in *From the Parts to the Whole*, ed. C. Mattusch, A. Brauer, and S. Knudsen (*JRA* Supplementary 39). Portsmouth, R. I. 69–74.

Keesling, C. M. 2003. *The Votive Statues of the Athenian Acropolis*. Cambridge.

Kehrberg, I. 1982. "The Potter-Painter's Wife," *Hephaistos* 4, 25–35.

Klein, N. L. 1991. *The Origin of the Doric Order on the Mainland of Greece: Form and Function of the Geison in the Archaic Period*. Diss. Bryn Mawr 1991. Ann Arbor: UMI.

Korres, M. 1984. "Der Pronaos und die Fenster des Parthenon," in Berger 1984, 47–54.

Korres, M. 1988. "Acropole: Travaux de restauration," *BCH* 112, 612.

Korres, M. 1994a. "The Sculptural Adornment of the Parthenon," in Economakis 1994, 29–33.

Korres, M. 1994b. "The History of the Acropolis Monuments," in Economakis 1994, 35–51.

Korres, M. 1994c. "Recent Discoveries on the Acropolis," in Economakis 1994, 175–79.

Korres, M. 1994d. "The Architecture of the Parthenon," in Tournikiotis 1994, 55–97.

Korres, M. 1994e. "The Parthenon from Antiquity to the 19th Century," in Tournikiotis 1994, 137–61.

Korres, M. 1994f. *Melete Apokatastaseos tou Parthenonos*, 4. Athens.

Korres, M. 1994g. "Der Plan des Parthenon," *AM* 109, 53–120.

Korres, M. 1997a. "An Early Attic Ionic Capital and the Kekropion on the Athenian Acropolis," in O. Palagia, ed., *Greek Offerings: Essays on Greek Art in Honour of John Boardman*. Oxford. 95–107.

Korres, M. 1997b. "Die Athena-Tempel auf der Akropolis," in Hoepfner, ed., 1997, 218–43.

Korres, M. 1997c. "Some Remarks in the Structural Relations between the Propylaea and the NW Building of the Athenian Akropolis," in Hoepfner, ed., 1997, 244–45.

Korres, M. 1999. "Refinements of Refinements," in Haselberger, ed., 1999, 79–104.

Korres, M. 2003. "Athenian Classical Architecture," in Kh. Bouras et al., eds, *Athens: From the Classical Period to the Present Day (5th Century BC–AD 2000)*. New Castle, Delaware, and Athens. 5–45.

Korres, M., and Bouras, Ch. 1983. *Melete Apokatastaseos tou Parthenonos, 1*. Athens.

Krentz, P. 1979. "*SEG* XXI, 80 and the Rule of the Thirty," *Hesperia* 48, 54–63.

Kroll, J. H. 1979. "The Parthenon Frieze as a Votive Relief," *AJA* 83, 349–52.

Kroll, J. H. 1982. "The Ancient Image of Athena Polias," in *Studies in Athenian Architecture, Sculpture, and Topography Presented to Homer A. Thompson. Hesperia Supplement 20*. Princeton. 65–76.

Kron, U. 1976. *Die zehn attischen Phylenheroen (AM Beiheft 5)*. Berlin.

Kron, U. 1988. "Erechtheus," in *LIMC* IV, 923–51.

Kyle, D. G. 1987. *Athletics in Ancient Athens*. Leiden.

Kyle, D. G. 1992. "The Panathenaic Games: Sacred and Civic Athletics," in Neils, ed., 1992, 77–101.

Kyrieleis, H., ed., 1986. *Archaische und Klassische griechische Plastik*. Mainz.

La Follette, L. 1986. "The Chalkotheke on the Athenian Acropolis," *Hesperia* 55, 75–87.

Lapatin, K. D. S. 2001. *Chryselephantine Statuary in the Ancient Mediterranean World.* Oxford.

Larson, J. 1995. *Greek Heroine Cults.* Madison, Wis, and London.

Lawrence, A. W. 1951. "The Acropolis and Persepolis," *JHS* 71, 111–19.

Lawton, C. L. 1995. *Attic Document Reliefs: Art and Politics in Ancient Athens.* Oxford.

Leipen, N. 1971. *Athena Parthenos: A Reconstruction.* Toronto.

Lindenlauf, A. 1997. "Der Perserschutt der Athener Akropolis," in Hoepfner, ed., 1997. 46–115.

Linders, T. 1997, "Gaben an die Götter oder Goldreserve," in Hoepfer, ed., 1997, 31–36.

Loraux, N. 1993. *The Children of Athena.* Princeton.

Lundgreen, B. 1997. "A Methodological Enquiry: The Great Bronze Athena by Pheidias," *JHS* 117, 190–97.

Mansfield, J. M. 1985. *The Robe of Athena and the Panatheniac "Peplos."* Diss. University of California at Berkeley. 1985. Ann Arbor: UMI.

Mantis, A. 1986. "Neue Fragmente von Parthenonskulpturen," in Kyrieleis 1986, vol. II, 71–76.

Mantis, A. 1989. "Beiträge zur Wiederherstellung der mittleren Südmetopen des Parthenon," in H.-U. Cain, H. Gabelmann, and D. Salzmann, eds., *Festschrift für Nikolaus Himmelmann.* Mainz. 109–14.

Mantis, A. 1997. "Parthenon Central South Metopes: New Evidence," in Buitron-Oliver 1997, 67–81.

Mark, I. S. 1993. *The Sanctuary of Athena Nike in Athens: Architectural Stages and Chronology. Hesperia Supplement 26.* Princeton.

Marszal, J. R. 1998. "An Epiphany for Athena: The Eastern Pediment of the Old Athena Temple," in K. J. Hartswick and M. C. Sturgeon, eds. *Stephanos: Studies in Honor of Brunilde Sismondo Ridgway.* Philadelphia. 173–80.

Mattusch, C. C. 1988. *Greek Bronze Statuary.* Ithaca and London.

Mattusch, C. C. 1996. *Classical Bronzes: The Art and Craft of Greek and Roman Statuary.* Ithaca and London.

Mavrikios, A. 1965. "Aesthetic Analysis Concerning the Curvature of the Parthenon," *AJA* 69, 264–68.

McCredie, J. R. 1979. "The Architects of the Parthenon," in G. Kopcke and M. B. Moore, eds., *Studies in Classical Art and Archaeology: A Tribute to P. H. von Blanckenhagen.* Locust Valley, N.Y. 69–73.

Meiggs, R. 1975. *The Athenian Empire.* Oxford.

Meiggs, R., and Lewis, D. 1988. *A Selection of Greek Historical Inscriptions to the End of the Fifth Century BC.* Revised ed., Oxford.

Meritt, B. D. 1936. "Greek Inscriptions," *Hesperia* 5, 355–441.

Meritt, B. D. 1982. "Thucydides and the Decrees of Kallias," in *Studies in Attic Epigraphy, History, and Topography. Hesperia: Supplement 19.* Princeton. 112–21.

Mikalson, J. D. 1975. *The Sacred and Civil Calendar of the Athenian Year.* Princeton.

Mikalson, J. D. 1976. "Erechtheus and the Panathenaia," *AJP* 97, 141–53.

Mikalson, J. D. 1983. *Athenian Popular Religion.* Chapel Hill and London.

Miller, M. C. 1997. *Athens and Persia in the Fifth Century BC.* Cambridge and New York.

Miller, S. G. 1995. "Architecture as Evidence for the Identity of the Early *Polis*," in M. G. Hansen, ed., *Sources for the Ancient Greek City–State*. Copenhagen. 201-42.

Moore, M. B. 1979. "Lydos and the Gigantomachy," *AJA* 83, 79-100.

Moore, M. B. 1995. "The Central Group in the Gigantomachy of the Old Athena Temple on the Acropolis," *AJA* 99, 633-39.

Moore, M. B. 2003. "Unmounted Horses on the Parthenon Frieze, Especially West XII," *AntK* 46, 31-43.

Mountjoy, P. A. 1995. *Mycenaean Athens*. Jonsered.

Nagy, B. 1984. "The Peplotheke: What Was It?," in *Studies Presented to Sterling Dow on his Eightieth Birthday, Greek, Roman and Byzantine Studies Monographs* 10. Durham, N. C. 227-32.

Nagy, B. 1992. "Athenian Officials on the Parthenon Frieze," *AJA* 96, 55-69.

Neils, J., ed. 1992. *Goddess and Polis: The Panathenaic Festival in Ancient Athens*. Hanover and Princeton.

Neils, J., ed. 1996a. *Worshipping Athena: Panathenaia and Parthenon*. Madison, Wis.

Neils, J. 1996b. "Pride, Pomp, and Circumstance: The Iconography of the Procession," in Neils 1996a, 177-97.

Neils, J. 2001. *The Parthenon Frieze*. Cambridge.

Nick, G. 1997. "Die Athena Parthenos - ein griechisches Kultbild," in Hoepfner, ed., 1997. 22-24.

Omont, H. 1898. *Athènes au XVIIe siècle*. Paris.

Osborne, R. 1987. "The Viewing and Obscuring of the Parthenon Frieze," *JHS* 107, 98-105.

Palagia, O. 1984. "A Niche for Kallimachos' Lamp?" *AJA* 88, 515-21.

Palagia, O. 1993. *The Pediments of the Parthenon*. Leiden.

Palagia, O. 1997. "First Among Equals: Athena in the East Pediment of the Parthenon," in Buitron-Oliver, 1997, 29-49.

Palagia, O. 2000. "Meaning and Narrative Techniques in Statue-Bases of the Pheidian Circle," in N. K. Rutter and B. A. Sparkes, eds., *Word and Image in Ancient Greece*. Edinburgh. 53-78.

Palagia, O. (2004). "Interpretations of Two Athenian Friezes: The Temple on the Ilissos and the Temple of Athena Nike," in *New Perspectives on Periclean Athens*. Austin.

Palagia, O., and Pollitt, J. J. eds., 1996. *Personal Styles in Greek Sculpture. Yale Classical Studies 30*. Cambridge.

Papathanasopoulos, Th. 1999. *To Odeio tou Perikle*. Rethymnon.

Parke, H. W. 1977. *Festivals of the Athenians*. Ithaca, N.Y.

Parker, R. 1986. "Myths of Early Athens," in J. Bremmer, ed., *Interpretations of Greek Mythology*. Totowa, N. J., 187-214.

Parker, R. 1996. *Athenian Religion: A History*. Oxford.

Pedersen, P. 1989. *The Parthenon and the Origin of the Corinthian Capital*. Odense.

Pickard-Cambridge, A. 1968. *The Dramatic Festivals of Athens*. Second ed., Oxford.

Pinney, G. F. 1988. "Pallas and Panathenaia," in J. Christiansen and T. Melander, eds., *Proceedings of the Third Symposium on Ancient Greek and Related Pottery*. Copenhagen. 465-77.

Pollitt, J. J. 1972. *Art and Experience in Classical Greece*. Cambridge.

Pollitt, J. J. 1990. *The Art of Ancient Greece: Sources and Documents*. Cambridge.

Pollitt, J. J. 1997. "The Meaning of the Parthenon Frieze," in Buitron-Oliver 1997. 51–65.

Preisshofen, F. 1974. "Phidias-Daedalus auf dem Schild der Athena Parthenos?" *JdI* 89, 50–69.

Preisshofen, F. 1977. "Zur Topographie der Akropolis," *AA*, 74–84.

Raubitschek, A. E. 1949. *Dedications from the Athenian Acropolis*. Cambridge, Mass.

Reeder, E. D., ed. 1995. *Pandora: Women in Classical Greece*. Baltimore.

Rehak, P. 1984. "New Observations on the Mycenaean Warrior Goddess," *AA*, 535–45.

Rhodes, R. F. 1995. *Architecture and Meaning on the Athenian Acropolis*. Cambridge.

Rhodes, R. F., and Dobbins, J. J. 1979. "The Sanctuary of Artemis Brauronia on the Athenian Acropolis," *Hesperia* 48, 325–41.

Ridgway, B. S. 1981. *Fifth-Century Styles in Greek Sculpture*. Princeton.

Ridgway, B. S. 1983. "Painterly and Pictorial in Greek Relief Sculpture," in W. Moon, ed., *Ancient Greek Art and Iconography*. Madison and London. 193–208.

Ridgway, B. S. 1992. "Images of Athena on the Akropolis," in Neils 1992, 119–42.

Ridgway, B. S. 1999. *Prayers in Stone: Greek Architectural Sculpture (Ca. 600–100 B.C.E.)*. Berkeley.

Riethmüller, J. W. 1999. "Bothros and Tetrastyle: The Heroon of Asclepius in Athens," in R. Hägg, ed., *Ancient Greek Hero Cult*. Stockholm. 123–43.

Robertson, M. 1975. *A History of Greek Art*. Cambridge.

Robertson, M. 1984. "The South Metopes: Theseus and Daidalos," in Berger 1984, 206–8.

Robertson, N. 1992. *Festivals and Legends: The Formation of Greek Cities in the Light of Public Ritual*. Toronto.

Robertson, N. 1996. "Athena's Shrines and Festivals," in Neils 1996a, 27–77.

Robkin, A. L. H. 1979. "The Odeion of Perikles: The Date of its Construction and the Periklean Building Program," *Ancient World* 2, 3–12.

Roccos, L. J. 1995. "The Kanephoros and Her Festival Mantle in Greek Art," *AJA* 99, 641–66.

Root, M. C. 1985. "The Parthenon Frieze and the Apadana Reliefs at Persepolis," *AJA* 89, 103–20.

Rouse, W. H. D. 1976. *Greek Votive Offerings*. Reprint ed. Hildesheim and New York.

Roux, G. 1984. "Pourquoi le Parthénon?" *CRAI* 1984, 301–17.

Roux, G. 1984b. "Trésors, temples, tholos," in G. Roux, ed., *Temples et sanctuaires*. Lyon. 1984. 153–72.

Samons, L. J., II, 1993. "Athenian Finance and the Treasury of Athena," *Historia* 42, 129–38.

Schmaltz, B. 1997. "Die Parthenos des Phidias, zwischen Kult und Repräsentanz," in Hoepfner, ed., 1997, 25–30.

Schneider, L., and Höcker, C. 1990. *Die Akropolis von Athen*. Köln.

Scholl, A. 1995. "Choephoroi: Zur Deutung der Korenhalle des Erechtheion," *JdI* 110, 179–212.

Schrader, H., Langlotz, E., and Schuchhardt, W.-H. 1939. *Die archaischen Marmor-bildwerke der Akropolis.* Frankfurt am Main.

Schultz, P. 2001. "The Akroteria of the Temple of Athena Nike," *Hesperia* 70, 1–47.

Schultz, P. 2002. "The Date of the Nike Temple Parapet," *AJA* 106, 294–95 (abstract).

Schwab, K. A. 1994. "The Charioteer in Parthenon North Metope 1," *AJA* 98, 322 (abstract).

Schwab, K. A. 1996. "Parthenon East Metope XI: Herakles and the Gigantomachy," *AJA* 100, 81–90.

Scullion, S. 1994. "Olympian and Chthonian," *ClAnt* 13, 75–119.

Shapiro, H. A. 1989. *Art and Cult under the Tyrants in Athens.* Mainz am Rhein.

Shapiro, H. A. 1992. "*Mousikoi Agones*: Music and Poetry at the Panathenaia," in Neils 1992, 53–75.

Shapiro, H. A. 1994. "Religion and Politics in Democratic Athens," in Coulson et. al. 1994, 123–29.

Shear, I. M. 1963. "Kallikrates," *Hesperia* 32, 375–424.

Shear, I. M. 1999. "The Western Approach to the Athenian Akropolis," *JHS* 119, 86–127.

Shear, T. L., Jr. 1981. "Athens: From City-State to Provincial Town," *Hesperia* 50, 356–77.

Shefton, B. 1982. "The Krater from Baksy," in D. Kurtz and B. Sparkes, eds., *The Eye of Greece: Studies in the Art of Athens.* Cambridge. 149–81.

Shefton, B. 1992. "The Baksy Krater Once More and Some Observations on the East Pediment of the Parthenon," in H. Froning, T. Hölscher, and H. Mielsch, eds., *Kotinos: Festschrift für Erika Simon.* Mainz. 241–51.

Simon, E. 1975. "Versuch einer Deutung der Südmetopen des Parthenon," *JdI* 90, 100–20.

Simon, E. 1980. "Die Mittelgruppe in Westgiebel des Parthenon," in H. H. Cahn and E. Simon, eds., *Tainia: Roland Hampe zum 70. Geburtstag.* Mainz. 239–55.

Simon, E. 1983. *Festivals of Attica: An Archaeological Commentary.* Madison.

Simon, E. 1986. "Boutes," in *LIMC* III, 152–53.

Simon, E. 1997. "An Interpretation of the Nike Temple Parapet," in Buitron-Oliver 1997, 127–43.

Spaeth, B. S. 1991. "Athenians and Eleusinians in the West Pediment of the Parthenon," *Hesperia* 60, 331–62.

Spawforth, A. 1994. "Symbol of Unity? The Persian-Wars Tradition in the Roman Empire," in S. Hornblower, ed., *Greek Historiography.* Oxford. 233–47.

Stadter, P. A. 1989. *A Commentary on Plutarch's Pericles.* Chapel Hill and London.

Stähler, K. 1972. "Zur Rekonstruction und Datierung des Gigantomachiegiebels von der Akropolis," *Antike und Universalgeschichte* (Festschrift H. E. Stier). Münster. 88–112.

Stevens, G. P. 1936. "The Periclean Entrance Court of the Acropolis of Athens," *Hesperia* 5, 443–520.

Stevens, G. P. 1946. "The Northeast Corner of the Parthenon," *Hesperia* 15, 1–26.

Stevenson, T. 2003. "Cavalry Uniforms on the Parthenon Frieze?" *AJA* 107, 629–54.

Stewart, A. 1985. "History, Myth, and Allegory in the Program of the Temple of Athena Nike, Athens," in *Studies in the History of Art*, 16. National Gallery of Art, Washington. 53–73.

Stewart, A. 1990. *Greek Sculpture: An Exploration*. New Haven and London.

Stewart, A. 1997. *Art, Desire, and the Body in Ancient Greece*. Cambridge.

Stillwell, R. 1969. "The Panathenaic Frieze: Optical Relations," *Hesperia* 38, 231–41.

Tanoulas, T. 1992a. "The Pre-Mnesiklean Cistern on the Athenian Acropolis," *AM* 107, 129–60.

Tanoulas, T. 1992b. "Structural Relations between the Propylaea and the Northwest Building of the Athenian Acropolis," *AM* 107, 199–215.

Tanoulas, T. 1994a. "The Propylaea and the Western Access of the Acropolis," in Economakis 1994, 52–68.

Tanoulas, T. 1994b. "The Restoration of the Propylaea," in Economakis 1994, 150–67.

Thöne, C. 1999. *Ikonographische Studien zu Nike im 5. Jahrhundert v. Chr.* Heidelberg.

Tomlinson, R. 1990. "The Sequence of Construction of Mnesikles' Propylaia," *BSA* 85, 405–13.

Tournikiotis, P., ed. 1994. *The Parthenon and its Impact in Modern Times*. Athens.

Travlos, J. 1971. *Pictorial Dictionary of Ancient Athens*. New York.

Vanderpool, E. 1966. "A Monument to the Battle of Marathon," *Hesperia* 35, 93–105.

Vermeule, E. 1972. *Greece in the Bronze Age*. Chicago.

Weidauer, L., and Krauskopf, I. 1992. "Urkrönige in Athen und Eleusis: Neues zur 'Kekrops'-Gruppe des Parthenonwestgiebels," *JdI* 107, 1–16.

Wesenberg, B. 1995. "Panathenäische Peplosdedikation und Arrhephorie: Zur Thematik des Parthenonfrieses," *JdI* 110, 149–78.

Wyatt, W. F., Jr., and Edmonson, C. E. 1984. "The Ceiling of the Hephaisteion," *AJA* 88, 135–67.

Wycherley, R. E. 1978. *The Stones of Athens*. Princeton.

Younger, J. G. 1991. "Evidence for Planning the Parthenon Frieze," *AJA* 95, 295 (abstract).

Younger, J. G. 1997. "Gender and Sexuality in the Parthenon Frieze," in A. O. Koloski-Ostrow and C. L. Lyons, eds., *Naked Truths*. London. 120–53.

Zimmer, G. 1996. "Bronze-Casting Installations on the South Slope of the Acropolis," *AJA* 100, 382–83 (abstract).

INDEX